46
Prints

# Prints & People

# Prints & People

### a social history of
### printed pictures

## A. Hyatt Mayor

Curator Emeritus, Department of Prints
The Metropolitan Museum of Art

The Metropolitan Museum of Art, New York

Published In Association with Princeton University Press

Designed by Peter Oldenburg
Type set by Finn Typographic Service, Inc.
Printed by The Meriden Gravure Company

Copyright © 1971 by The Metropolitan Museum of Art
Library of Congress catalog card number 80-7817
International Standard Book Number 0-87099-108-6 (Metropolitan)
0-691-03958-5 (Princeton)

# Foreword

**W**hy were prints made? How? Who bought them? How did they travel? What became of them? What new techniques were devised and how were they affected by costs? What new subject matter appeared? How did print publishers attract new publics? What printmakers discovered new ways of seeing? What resulted from innovations?

Even though guesses must serve for answers to some of these questions, the questions themselves help art history to astonish by making it part and parcel of human history. As Emerson said, "There is properly no History; only Biography." Approached from this angle, familiar facts regroup into unexpected patterns, like the tiles on the bathroom floor, especially when you try to see recent prints as the outcome of old traditions, and old prints as though their ink still smelled.

Since this book concerns innovators above all, you will meet some obscure artists whose inventions became famous in other hands, and you will look in vain for some familiar refiners of worn routines. Inventions of technique will be explained in principle, omitting the cookbook instructions available in any manual of printmaking. (It is odd that the processes of the black art of printing fascinate people who care nothing for the equally intricate and ingenious processes of painting and sculpture.)

For the comfort of that ultimate arbiter, the interested general reader, many factual details have been cleared out of the narrative into the captions and the index. Footnotes seemed unnecessary for information mostly derived from standard biographical dictionaries, well-known monographs, Paul Kristeller's *Kupferstich und Holzschnitt in vier Jahrhunderten*, and A. M. Hind's *A History of Engraving and Etching* and *An Introduction to a History of Woodcut*. However, it seemed useful to list more fully than usual the terms and abbreviations inscribed on prints.

This book results from years of working in the stimulating disquiet of William M. Ivins' questioning, and from being immersed in the Metropolitan Museum's print collection that he put together with foresight for almost any future need. It gradually became a pious duty to harvest all that I could from my lucky chance and to sort out the whole crop for others to use. I was cheered to persevere by a welcome grant from the Chapelbrook Foundation.

During a decade of rewriting I have pestered more of my generous colleagues than I can list, but I must thank some who helped for months on end: Peter Oldenburg, who fitted together the illustrations with a mastery of jigsaw; Polly Cone, who ferreted out an upsetting heap of errors; and the Museum's editor, Leon Wilson, who trued the sense, tuned the language, and heartened me to hope that the result might justify the labor of so many associates. I could have done nothing at all if my old friends in the Department of Prints and Photographs had not allowed me to continue working in the familiar departmental library after my retirement. They not only welcomed my staying on among them but even gave me the typewriter on which I wrote the book. It is to them, my other family, that I dedicate this work that they made possible.

A.H.M.

# Contents

| | ILLUSTRATION NUMBERS |
|---|---|
| The Chinese invent paper | 1–4 |
| The oldest European woodcuts | 5–8 |
| The first dated prints | 9, 10 |
| Holy pictures | 11–13 |
| Playing cards and others | 14–18 |
| The first printed books | 19, 20 |
| The Bible of the Poor | 21, 22 |
| The Art of Dying | 23–25 |
| Printing breaks away from manuscript | 26–29 |
| Printers' shortcuts | 30–32 |
| Illustrated books in Augsburg | 33, 34 |
| Illustrated books in Ulm | 35–37 |
| Woodcutters' distortions | 38, 39 |
| Venice observed | 40–46 |
| Personal styles emerge | 47, 48 |
| Netherlandish illustrations | 49, 50 |
| Parisian illustrations | 51–55 |
| Illustrating Virgil | 56, 57 |
| Italian painters and woodcutters | 58–65 |
| Prophets and sibyls in Rome | 66–69 |
| Contrast of temperaments | 70–73 |
| Ratdolt | 74–78 |
| Bookplates | 79–82 |
| Almanacs for wall and pocket | 83–86 |
| Prints for pasting | 87–93 |
| Aesop | 94–99 |
| Herbals and scientific illustration | 100–103 |
| Engineering illustrated | 104–108 |
| The beginnings of engraving | 109–113 |

| | |
|---|---|
| Dotted prints | 114 |
| The Master of the Playing Cards | 115–117 |
| Master ES | 118–123 |
| The Housebook Master and drypoint | 124–129 |
| Schongauer | 130–135 |
| Early Netherlandish engravers | 136, 137 |
| Van Meckenem | 138–140 |
| Florentine engraving | 141–146 |
| The Triumphs of Petrarch and Maximilian | 147–151 |
| Dante | 152–156 |
| Savonarola | 157, 158 |
| Florentine woodcut illustration | 159–163 |
| Business books | 164–166 |
| Lettering and writing | 167–172 |
| Perspective | 173–178 |
| Maps | 179, 180 |
| Copyright and patronage | 181–183 |
| Anatomy in Florence | 184–186 |
| Mantegna | 187–197 |
| Caricature | 198–200 |
| Hawkers and walkers | 201–205 |
| Book covers | 206–210 |
| Title page and frontispiece | 211–214 |
| Milanese woodcuts | 215–217 |
| Full tide in Venice | 218, 219 |
| Hypnerotomachia Poliphili | 220–224 |
| Giorgione's twilight | 225–227 |
| Etching and aquatint | 228–230 |
| Gods and personifications | 231–236 |
| Illustrations for architects | 237–242 |
| Grotesque ornament | 243–246 |
| Books of hours | 247–252 |
| Royal progresses | 253–258 |
| Dürer's four horsemen | 259–264 |
| Dürer in Italy | 265–270 |

|  | ILLUSTRATION<br>NUMBERS |
|---|---|
| Dürer's print styles | 271–276 |
| Dürer's figures | 277–281 |
| Portrait engraving | 282–292 |
| Burgkmair and the emperor | 293–297 |
| Cranach | 298–303 |
| Altdorfer | 304–309 |
| Baldung and Weiditz | 310–314 |
| The German Little Masters | 315–317 |
| Figure-drawing books | 318–323 |
| Holbein | 324–329 |
| Lucas of Leiden | 330–334 |
| Marcantonio | 335–340 |
| Marcantonio's workshop | 341–343 |
| Imitations of drawings | 344–346 |
| Color printing | 347–349 |
| Parmigiano | 350–353 |
| The Fontainebleau school | 354–357 |
| Duvet | 358, 359 |
| Cousin | 360, 361 |
| Pleasure gardens | 362–366 |
| Eternal Rome | 367–372 |
| Printselling in Antwerp and London | 373–376 |
| For needle and bobbin | 377–382 |
| Man's variety | 383–387 |
| Furniture designs | 388–393 |
| Anatomy becomes a science | 394–396 |
| Artists as block-cutters | 397–402 |
| Titian | 403–407 |
| Engraving standardized | 408–410 |
| Last woodcut books | 411, 412 |
| Jewelry designs | 413–416 |
| Northern mannerists | 417–421 |
| Brueghel | 422–426 |
| Rubens | 427–432 |
| Van Dyck | 433–435 |

| | |
|---|---|
| Barocci | 436–438 |
| Twilight's gradual veil | 439–444 |
| How-to-do-it manuals | 445–449 |
| Children's books | 450–452 |
| Bellange | 453, 454 |
| Callot | 455–460 |
| Life in France | 461–466 |
| Dutch etchers before Rembrandt | 467–471 |
| Rembrandt's portraits | 472–478 |
| Rembrandt's techniques | 479–484 |
| Rembrandt and the Bible | 485–489 |
| Rembrandt and Italy | 490–493 |
| Rembrandt's figures | 494–499 |
| Rembrandt's landscapes | 500–505 |
| Rembrandt's contemporaries | 506–510 |
| Mezzotint | 511–515 |
| Central Italian etchers | 516–521 |
| Italy and Rembrandt | 522–527 |
| Landscape | 528–532 |
| Art exhibitions | 533–537 |
| Interior decoration | 538–543 |
| Stage scenery | 544–549 |
| The copyrighted picture story | 550–555 |
| Trade catalogues | 556–561 |
| 18th-century books | 562–565 |
| Rococo and classicism in Germany | 566–568 |
| Wallpaper | 569–573 |
| On cloth, china, and enamel | 574, 575 |
| Venetian and Roman printmakers | 576–580 |
| G. B. Tiepolo and Piranesi | 581–584 |
| Watteau and Boucher | 585–590 |
| Etching in France and Switzerland | 591–595 |
| The estampe galante | 596–601 |
| Rowlandson and Debucourt | 602–606 |
| English romantics | 607–611 |

|  | ILLUSTRATION NUMBERS |
|---|---|
| Early lithography | 612–616 |
| Géricault and Delacroix | 617–623 |
| Goya | 624–631 |
| 19th-century Germans | 632–634 |
| Banknotes | 635 |
| A quarter turn of the wood | 636–639 |
| Posters | 640–642 |
| Girtin and Turner | 643–645 |
| Folk prints | 646–652 |
| Photography | 653–658 |
| Daumier | 659–670 |
| Lami and Gavarni | 671–673 |
| Artists' colonies | 674–676 |
| Late French romantics | 677–679 |
| Manet and Fattori | 680–682 |
| Degas and Cassatt | 683–688 |
| Illustration in the English-speaking 1860s | 689–693 |
| Light from the East | 694–699 |
| Meryon and Whistler | 700–704 |
| The line block | 705–707 |
| Toulouse-Lautrec | 708, 709 |
| Gauguin and Munch | 710–712 |
| International virtuosos | 713–715 |
| Prints by French sculptors and painters | 716–722 |
| Villon | 723, 724 |
| Matisse | 725–730 |
| Picasso | 731–741 |
| The expressionists | 742–746 |
| The American scene | 747–749 |
| The world within | 750–752 |

TERMS AND ABBREVIATIONS FOUND ON PRINTS
NOTES ON THE ILLUSTRATIONS
INDEX

# Prints & People

**1**
Fool's cap watermark with laid lines and chain lines. France or Switzerland, 1650–1700

**The Chinese invent paper** Shortly after A.D. 100 the Chinese perfected paper by adapting old crafts to new needs. Accustomed to making felt for their nomad tents and clothing by treading animal hair in shallow puddles, they shredded plant or rag fibers and sieved the mash to deposit a vegetable felt, which is paper. At first they seem to have strained their felt on some sort of a weave. Such "wove" paper (in France, "vellum" paper) shows an even translucence when held to the light. Like the very first paper, the page in your hand is wove. Later, the Chinese speeded papermaking by straining the fibers on a sieve of parallel strips of reed or bamboo, for which Europeans substituted parallel wires. As the soup of fibers drains, fewer fibers lodge atop the wires or split bamboo and more across the slits between. This makes "laid" paper thick and thin in a translucent pattern of parallel lines close together (laid lines), crossed at right angles by lines far apart (chain lines) where the laid-line wires or bamboo are stitched to a support. In the West (but never in the old Orient) wires bent in a design, lettering, or a date were often stitched on the sieve to form a watermark. The first watermark, a simple cross, appeared in paper made about 1282 at Fabriano or nearby Bologna. Watermarks identified paper mills or, sometimes, sizes. The fool's cap [ 1 ] of the later 1600s has given its name to the long sheets of our wills and deeds.

Paper provided the ideal material for the ancient and widespread practice of stamping. Babylonians had stamped kings' names on bricks, and Roman wine dealers stamped their names on pottery wine jars. But although the Romans had papyrus, they could not have stamped on its rough ridges, and vellum cost too much. In

**2** Left hands, clouds, mushrooms (?). Modern print from Olmec carved clay tube, Las Bocas, Mexico, 1000–800 B.C.

Mexico, around 1000–800 B.C., the Olmecs baked clay tubes with designs in relief for printing repeat patterns [ 2 ], perhaps on their bodies, or perhaps on a sort of bark paper like the tapa "cloth" that Fijians used for mats and clothing. But the Mexican rolling tubes did not lead to the invention of the cartwheel, and their printing for decoration did not lead to printing for communication.

The Chinese invention of true paper mattered, because they also discovered how to use it. On their new, tough, smooth, cheap sheets they began to print words with stamps like those that had long impressed designs on clay wall tiles [ 3 ]. They dabbed watercolor ink on a relief block essentially like our rubber stamp and pressed it against paper exactly the way Europeans were to make their first prints centuries afterward. By the time of Charlemagne the Chinese were cutting pictures and words on woodblocks like the European woodblocks of 600 years later. 400 years before Gutenberg they were practicing his basic discovery of assembling cast type to print texts. A Chinese historian of printing might logically relegate Guten-

**3** Stamped wall tile. China, Han dynasty (206 B.C.–A.D. 220)

berg to a footnote on the possible inventor of oil ink and the mold for casting type, for it was the Chinese who really discovered the means of communication that was to dominate until our age of radio.

Printing in China produced the world's most elaborately educated civil service, unified a multiphonal empire through a nationalism based on one nonphonetic script, and helped to chronicle man's longest continuous history. By A.D. 1000 the Chinese had anticipated modern commerce by printing banknotes from copper reliefs with inserts for changing denominations. Their first figural prints were pious images, just as they were to be in Europe. The paper of one such [ 4 ], after being walled up in a desert cave for ten centuries, remains as tough as this morning's grocery bag. Paper has preserved pictures in China better than silk.

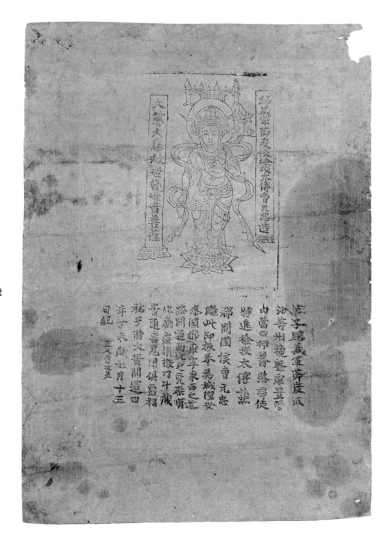

**4**
Kuan-yin (goddess of Mercy). Woodcut by Yen-mei, Tun Huang, A.D. 947

**The oldest European woodcuts** The oldest surviving European woodblock was found in 1899 while a monastery in eastern France was being demolished. The block is cut on both sides, but only one side, a Crucifixion scene, has lasted well enough to print [ 5 ]. The style of the armor is Burgundian, about 1370–90. Since the complete scene measured at least two feet square—larger than any medieval paper—the block must have been made to print the linen of a banner, altar frontal, or hanging for a lectern. The assurance of the line results from centuries of decorating cloth, a craft then so common that Italian children were dressed in prints, probably wearing patterns like one of the few old ones now extant [ 6 ]. This is a flock print, made by "inking" the block with glue and dusting the sticky impression with a fluff of minced wool. Applied to cloth, flock printing approximated cut velvet. This particular impression on paper survived in a German book cover, but it might have been intended to line a coffer or a cabinet.

European cloth printers adopted paper when papermaking spread from China via Samarkand to Spain by about 1150, then to Italy by 1275 and to Germany in 1390. The Italians began to size paper with hard animal glue, or gelatin, instead of the soft oriental rice paste, and speeded production by breaking down the rags with water-powered hammers instead of the oriental pounding by hand. Paper stimulated printing, thus creating a market for more paper. The amount of paper made between 1450 and 1500 can be deduced from the estimated book production. 236 towns together are presumed to have printed from 10,000 to 15,000 texts in 30,000 to 35,000 editions, amounting to something like 15,000,000 to 20,000,000 books. As early as 1395 a German was printing holy images on paper in Bologna. Since the Italians made paper a century before the Germans, and also dominated painting, they would logically have been the first Europeans to print woodcuts. But if so, they did not preserve them, unlike the Germans, by pasting them inside book covers and boxes.

**5**
Crucifixion scene
(fragment). Wood-
cut, Burgundy,
1370–90

**6**
Flock print in red
wool. Woodcut,
Lucca or Venice,
1350–1400

**7** Rest on the Flight into Egypt. Hand-colored woodcut, Bohemia, about 1410

**8** Christ on the Vernicle. Hand-colored woodcut by Hans Schlaffer, Ulm, 1475–90

The earliest surviving cuts were drawn in the suave international style of willowy gestures and swirling loops of drapery [ 7 ]. Here Mary, though Queen of Heaven, settles cozily by a wayside fire where a slightly frantic Joseph scrambles a picnic of eggs. Everybody was still at home with God, for though most of Europe was at war, as usual, the grand ramshackle fabric of the Church seemed likely to shelter all forever. Yet a mere two generations later the stresses that were to split the Church contort the face of Christ on the vernicle [ 8 ]. (When Christ impressed his features on Veronica's veil he sanctified picture printing by making the first monotype [ 527 ].) These woodcuts, like our children's coloring books, provided outlines that each publisher painted with his locality's distinctive pigments. Often

the colors are as bright today as though they had just dried, which is more than can be said of most old paintings, or even drawings. Though pasting in books has kept a few early prints as fresh as medieval miniatures, the vast majority quickly perished, leaving an occasional straggler to survive in one or two impressions. Yet woodblocks could, and did, print enormous editions. From about 1750 to 65 one woodblock decorated some 300 daily printings of Parisian playbills. These 1,000,000 or more impressions have so nearly disappeared that I could not find one to reproduce here. The commonest print always becomes the scarcest. Anybody can buy a Whistler etching, but try to find a Victorian matchbox. In the long run, pictures survive best on a material that withstands fire and burial and is not worth reusing, like the clay of Athenian pottery. If we had as many early prints as we have Greek pots, we would not have to guess about practically all the beginnings of printmaking.

**The first dated prints**  Few early prints can be dated precisely. A Dutch Madonna has 1418 carved on the block, but the surviving impression is too heavily painted and damaged to reproduce clearly. The next preserved date, 1423, occurs on a south German Saint Christopher [ 9 ], whose drapery flows in the wind as it then did in paintings. (After about 1460 northern drapery straightens out and breaks in angles.) The earliest datable Italian print [ 10 ] was the subject of a miracle in 1428, when it was tacked to a schoolroom wall in Forlì. There it certainly would have yellowed until it was thrown away had not the school caught fire one February day. The crowd that gathered outside saw this paper shoot up out of the flames, hover over the hot updraft, and flutter down into their hands. With cries of "Miracle!" (and who could resist?) the print was carried into the cathedral. There, in 1636, a special chapel was dedicated to it—the world's first and still handsomest print room—where the image survives in fair shape behind a gilt-bronze plaque that protects it from light except when it is raised like a theater curtain once a year to the sound of all the town's bells.

The woodcut is adapted from an icon like some now at Mount Sinai, of a type, dating from 1180 to 1200, that must have filled Venice after she plundered Byzantium in 1204. The Byzantine original supplied the semicircular arch resting on colonnettes, the compartments of paired saints, and the row of 14 standees below. (These are not, incidentally, the 14 German Protective Saints, who did not show themselves as a group until 1446.) The Italian woodcutter added the Magdalene kneeling at the cross, probably supplied the lectern for the Annunciation, and certainly crowned the Madonna, who in Byzantium transcended the frippery of jewels. The printed lines flow as limpidly as those in a Venetian blockbook illustration [ 20 ], so both must constitute almost the only survivors of a woodcut production guessed at from Venetian inventories.

**9** St. Christopher. Hand-colored woodcut, south Germany, 1423. "If you St. Christopher should see / That day you'll not die suddenly." *The first dated prints*

**10** The Madonna of the Fire. Hand-colored woodcut, Venice, before 1428

## Holy pictures

When the popes were in Avignon (1309–76) they diverted pilgrims from Rome by granting indulgences to northern shrines. These shrines sold enough holy pictures to help establish woodcut as a medieval industry. The citadel at Nuremberg preserved the German emperors' most sacred treasure: the lancehead that pierced Christ's side. Pilgrims to this famous relic were sold woodcuts of the sacred heart that supposedly had been stabbed by the holy lance but look more as though they had been slashed by a sharp knife [ 11 ]. This particular impression was printed on vellum to make it last as an amulet for health insurance. Most holy pictures disappeared in daily use, for some marked prayer books and some were

**11**

The Sacred Heart of Jesus. Hand-colored
woodcut on vellum, Nuremberg, 1480s

**12**

Lithographs to be swallowed for sickness.
Germany, 19th century

pinned to shrouds for help in purgatory. Printed on linen, some bandaged wounds and sores; pasted on wafers, others were swallowed by sick men and cattle [ 12 ].

In 1520 Martin Luther complained of monasteries being deserted except for a single friar "who sits all day in the church to sell souvenirs and little pictures to pilgrims." The Reformers proceeded to ridicule wonder-working relics so violently that Catholics felt forced to dramatize them with ceremonies, theatrical churches, and pictures. Thereafter the monks in south German and Austrian pilgrim shrines stopped getting crude woodcuts made locally, or making them in the monastery itself, in order to commission sophisticated pictures [ 13 ] by the hundred thousand from industrial engravers in Antwerp, Augsburg, or Nuremberg. These engravers took away half the trade from the woodcutters—who had served both God and the devil by supplying holy pictures and playing cards [ 15 ].

Holy pictures all but disappeared when the wars of the French Revolution and then of Napoleon interrupted travel. With the building of railways in the 1840s and 50s, pilgrimages were organized with unprecedented efficiency, and litho-graphed holy pictures were sold in vast numbers at the sites of new visions, such as those at Lourdes in 1858 and Fátima in 1917.

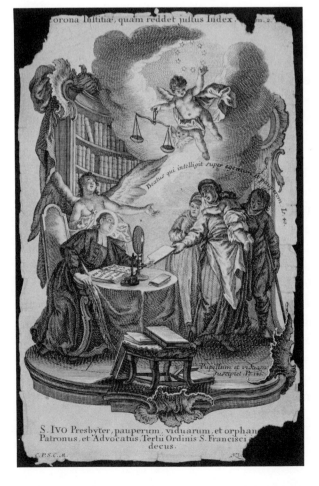

**13**
St. Ivo. Engraving by Joseph Sebastian Klauber, Augsburg, 1740–60

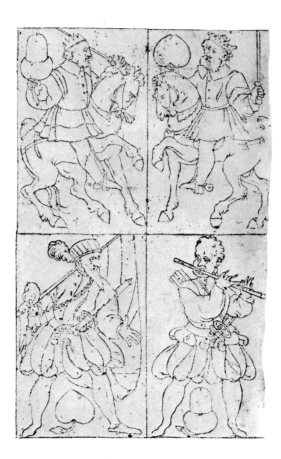

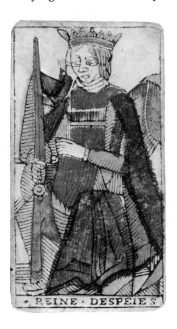

**14**
Playing cards. Woodcut by Hans Forster, Vienna, 1573

**15**
The Queen of Swords. Stencil-colored woodcut playing card, France, 17th–18th century

**Playing cards and others**  Before A.D. 1000 the Chinese seem to have told fortunes with "paper dice." Possibly as early as the 1100s Cairene Arabs played with hand-painted cards resembling a nearly complete pack from the 1400s now in Istanbul. Venetian taroc cards copied the Islamic suits of cup, coin, sword, and polo stick, which last became the staff (*bastone*). The spread of paper made woodcut cards so common that Regensburg and Constance outlawed them in 1378. In the early 1400s cheap woodcut cards contented the masses, while the middle classes played with engraved cards [ 116 ], and princes commissioned painted and gilded masterpieces. It must have been something of a gamble to print playing cards, for remaindered whole sheets were often pasted together to make "cardboard" for book covers. In 1441 Venice protected her block printers by forbidding the importation (from Germany?) of printed cloth and playing cards.

In German lands, during the Wars of Religion, card-makers appealed to the vagrant soldiery by representing the soldiers themselves [ 14 ]. Parisian woodcuts of around 1500 [ 53 ] standardized the stiff headdresses and severe faces that have since petrified on our court cards [ 15 ]. Cards, like musical notation, must conform to type so as to be recognized quickly and accurately by players under pressure. The early woodcutters also standardized their other specialty of saints' pictures,

because prayers go out more readily to images familiar since childhood. Although court cards and Sunday school pictures have always looked like cousins, the queen of hearts has kept her medieval stare more fixedly than the Queen of Heaven.

Alongside the standard cards, a special pack appeared as early as about 1465 with 50 instructive pictures in five suits, lettered A for the planets and spheres [ 16 ], B for the virtues, C for the arts and sciences, D for Apollo and the Muses, and E for the stations of man from pope to peasant. This codification of the medieval cosmos—a pictorial pocket Dante—was formerly misnamed "the taroc cards of Mantegna," even though true taroc packs consist of 62, 78, or 97 cards, never 50, and these cards show the style of Francesco Cossa of Ferrara rather than Mantegna. The captions include Ferrarese or Venetian words such as *artixan* (artisan) and *doxe* (doge). When another engraver copied the set, he kept the dialect words, showing that he worked locally, but changed the E suit to an S, perhaps for *stazioni* (stations, or status). Dürer, in his 20s, copied at least 20 of the original set in pen drawings, his calligraphic exultation wrinkling the clear Italian line with distractions [ 17 ].

**16** Primum Mobile, from the E suit of instructive cards. Engraving, Ferrara, about 1465

**17** Copy from Primum Mobile. Pen drawing by Albrecht Dürer, about 1495

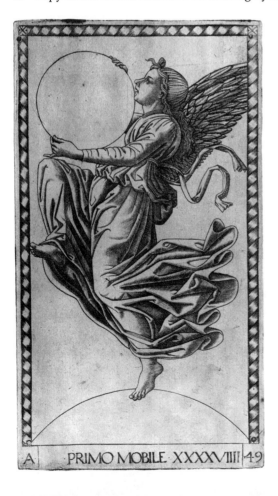
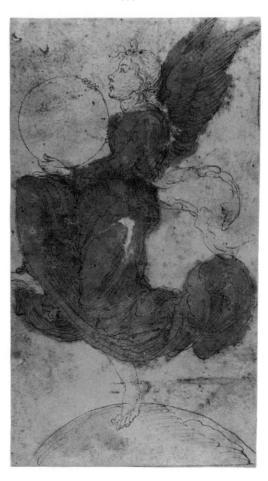

A · PRIMO MOBILE · XXXXVIIII · 49

Modern education acquired instructive card games like Authors and Quotations in 1619 when a Parisian engraver published a pack of The Provinces of France. In 1644 Mazarin had four packs etched to teach geography, classical fables [ 18 ], and his royal ancestry to the six-year-old Louis XIV, already king of France, though hardly graduated from petticoats to his first boy's breeches.

The backs of old cards, almost always undecorated before about 1830, were used to write addresses of shops and announcements of weddings, christenings, and funerals. Around 1800 reused playing cards made the first card catalogues of books.

As early as the 1690s Frenchmen signed their names to improvise calling cards, and they continued to do so even after about 1750 when Italians began to print special calling cards engraved with allegories and scenes of famous places above a space where one signed one's name as we sign Christmas cards today.

**18**
Europa, from pack of mythological playing cards. Etching by Stefano della Bella, 1644

**The first printed books** The Egyptians, Greeks, Romans, and Chinese wrote books on one side only of long strips that readers rolled up with their right hands as they unrolled with their left. (*Volume* comes from *volvere*, to roll.) The Chinese folded their new flexible paper into various kinds of books. Before A.D. 1000 they accordion-pleated a strip into what they called a "whirlwind" book, and then sewed the back into a codex, or modern book, called a "butterfly" book, which busied only one hand instead of the roll's two, making it easier to take notes. Chinese strips, beginning at the right, fold into codices that begin at the right, like Hebrew and Islamic books. Since the Greeks could not fold their brittle papyrus, they started afresh before A.D. 200 by folding wide vellum skins down the middle into paired leaves for sewing at the fold into a binding. The new book began at the left for readers to turn conveniently with the right hand. Europeans around 1400 followed Greek tradition by folding wide printed papers down the middle into two facing pages of woodcut, creating the blockbook. (The Chinese fold two printed pages back to back and bind the edges.) To make books, both Chinese and Euro-

**19**
Back of page Burgundian
blockbook Apocalypse,
1430–50, showing water-
color ink drawn from block
through paper by the
printer's rubbing. Pasted
on is a paper relief (seal
print) of Sts. Dionysius,
Emmerich, and Wolfgang.
Regensburg, 1460s.
Imitates bone or ivory
carving.

peans drew pictures and words on thin paper, which they pasted face down on a
plank. A carver gouged out the wood between the lines that showed through the
pasted paper. A printer inked the wood relief with watercolor, then spread on a
fresh paper that he rubbed to transfer the ink, thereby also pressing the paper
down into the hollows of the carving. (This incidental indenting of the paper may
have suggested the rare experiment of pressing paper pulp into a sculptural mold
to make a paper relief [ 19 ].)

Although the blockbook printer could not print on the blank back of his paper,
since this would smear the printing already on the front, he did not have to invest
in expensive type and a press and could print copies of his book as they sold. The
typographic printer, on the contrary, dared not distribute and reuse his type until
he had struck off as many copies as he might ever expect to sell. About 300 copies
satisfied an average market so long as people kept the manuscript habit of sharing
books. In Venice and Holland, typographic printers reused blockbook blocks by
sawing off the old-fashioned woodcut lettering at the bottom to fit the picture into
their pages of metal type [ 20 ].

**20**
The Agony in the Garden.
Woodcut from a block-
book, Venice, 1440s, short-
ened and reused in St.
Bonaventura, *Medita-
tiones*, Venice (de Sanctis),
1487

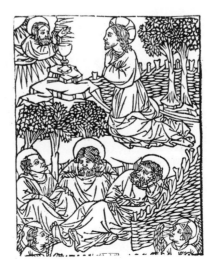

**21** The Annunciation, with Old Testament prefigurations. Woodcut in *Biblia Pauperum*, Netherlands, 1465 or earlier

**The Bible of the Poor**  Several early heretics advocated purging the Bible of the worldly and wicked Old Testament. To demonstrate the holy unity of both testaments, French churchmen of the mid-1100s (some calling themselves Christ's Poor) matched each event in Christ's life with two prophetic events in the Old Testament, one before Moses' law and one after. Such Old Testament prototypes were sculptured on the cathedrals of Paris, Chartres, and Amiens, where priests went to school. These Bibles in stone were summarized in the so-called *Bible of the Poor*, with drawings of a scene of Christ's life, together with their Gospel texts, placed between Old Testament prefigurations. The book began with the Annunciation flanked by two of God's previous reassurances: on the left he punishes the serpent of evil by shearing off its legs to drop it on its belly, and on the right he bedews Gideon's fleece to signal his protection of the Israelites. After 1300 this seminarists' syllabus became a pictorial best seller in Austrian and south German manuscripts, and in the mid-1400s the neater and more legible Netherlandish and German block-books published it for both priests and the laity. The blockbook woodcuts depict men and women moving with sober authority in the orderly detail of daily life [ 21 ], just as they were painted in Haarlem and Louvain by Dieric Bouts. These Netherlandish cuts, closely copied ten or more times, impressed the Bible on the eye of northern Europe and provided the main models for Master ES and Martin Schongauer. Soon after 1300, and possibly in Strassburg, the *Bible of the Poor* gave rise to a much bigger book, the *Mirror of Man's Salvation*. This was best illustrated with woodcuts whose nervous, knobbly figures [ 22 ] look like the work of Erhard Reuwich.

The pictures of the life of Christ in both these books satisfied northern Europe so well that New Testaments in Germanic dialects before 1542 illustrated nothing but the Apocalypse, not shown in the *Bible of the Poor* and the *Mirror of Man's Salvation*. In Italy, where these two books were never published, the complete Bible in Italian, printed at Venice in 1490, was illustrated with 384 little cuts [ 327 ]. No northern Bible was so copiously illustrated until the 1670s.

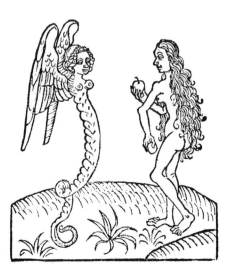

**22**
Eve and the Serpent. Woodcut, possibly by Erhard Reuwich, in *der spiegel der menschen behaltniss*, Speyer (Drach), about 1481

**The Art of Dying** was one of the most widely studied books of the late Middle Ages. It may have been written by some delegate to the Council of Constance in 1414–17. A long version of the text, making no mention of illustrations, survives in some 300 manuscripts, while a much shorter manual for teaching with pictures is known in only half a dozen manuscripts. In contrast to the many illustrated manuscripts of the *Bible of the Poor* [ 21 ], pictures survive in only one manuscript each of the long and short versions of the *Art of Dying*. The short text was printed in over 20 blockbook editions from 13 sets of blocks, while the long text appeared with movable type nearly 100 times before 1500. Both versions echo in devotional books until after 1700. The illustrations show devils tempting the dying man to doubt, despair, anger, pride, and greed, from each of which his good angel rescues him. In the eleventh illustration he has passed his examination and dies in grace. Such a promptbook for our unavoidable last hour became everybody's study when the plague, or just a scratch on the nose, might at any moment eject anybody from this life into the next.

The strong and subtle draftsman of the blockbook had mastered Dieric Bouts' draperies that drop straight down, often to a heap of folds on the floor, his lean,

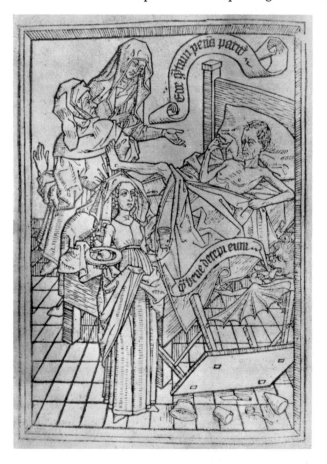
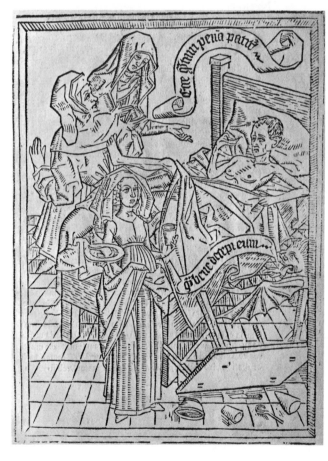

angular elegance, and his contredanse of aristocrats shoving against each other.
Only a painter as excellent as Bouts himself could have enriched woodcut with a
shading in parallels for a black and white "color" so satisfying that it was prac-
tically never painted over, either by publisher or purchaser. If Bouts did indeed
inspire, or even draw the *Art of Dying* illustrations while he was in Louvain from
before 1447 until his death in 1475, the blocks could have been cut by a Jan van den
Berghe who was sued in 1452 by the Louvain carpenters' guild for cutting block-
book woodblocks of religious "pictures and text."

The snappiest blockbook version of the *Art of Dying* [ 23 ] may be the original.
About a decade later this was copied by pasting an impression, picture side down,
on a plank and oiling the paper to make the lines show through for cutting in fac-
simile [ 24 ]. Thus a woodcutter can copy without knowing how to draw. An en-
graver works harder to approach such accuracy [ 25 ] by engraving freehand from
an image that he has to peer at awkwardly in a mirror. When trying to distinguish
an original print from a copy, look for misunderstood details in the marginal litter
(pebbles, twigs), where the copyist takes less care than with the central hands and
faces.

**23**
The Temptation to Anger. Woodcut in *Ars
Moriendi*, Louvain(?), 1466 or earlier

**24**
Woodcut in *Ars Moriendi*, Cologne,
about 1475

**25**
Engraving by Master ES, 1450–67

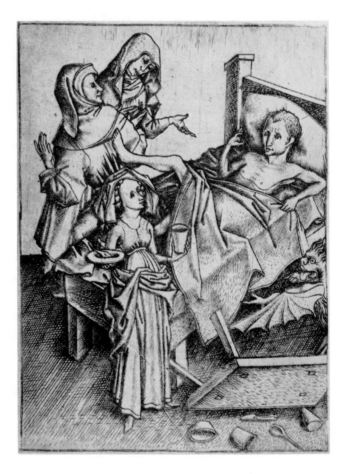

**26**
Colophon with red and blue initial and printer's mark. Illustration from *Der Mainzer Psalter von 1457*, Zürich (Diebekorn), 1969

**27** (OPPOSITE PAGE)
Hand-colored woodcuts in Ulrich Boner, *der edelstein (The Jewel)*, Bamberg (Pfister), 1461

## Printing breaks away from manuscript

Johann Fust, a rich silversmith of Mainz, and his scrivener son-in-law, Peter Schoeffer, financed Gutenberg's experiments that led in the 1450s to the European reinvention of printing from cast metal type. After Fust and Schoeffer ousted Gutenberg from their partnership, they used his inventions in the first book with a printed date, their Psalter of 1457. Schoeffer naturally followed the usual scrivener's practice of leaving blanks in a text for the illuminator to fill with illustrations and fancy initials. The various printings of the Psalter left marginal indentations for adding ornamental initials like those in local manuscripts [ 26 ]. Here, the printers presumably inked a big metal letter in red and dropped it into a trough in a metal block of flourishes, previously inked in blue. The assembly was stamped by hand, sometimes overlapping the black text or a neighboring initial. Similar overlaps show that the first dated typographic book illustrations, printed by Pfister at Bamberg in 1461, were also hand-stamped in blanks left in the text [ 27 ]. The little block of the author reappears at the left of each of the 101 illustrations, now and then overlapping them as well as the worn Gutenberg type. Pfister broke with manuscript practice in a year or so by planing woodblocks to the height of his type (about one inch) so as to print words and pictures together at one economical squeeze of the press.

Illustrations enticed the average German to read, creating a literate public for Luther to rouse with his writings [ 300 ]. Though most poets and storytellers dislike having illustrations compete with their verbal imagery, architects, engineers, anatomists, botanists, and zoologists all built their professional knowledge by printing their findings through pictures explained by words. Pfister's mechanical shortcut to a catchpenny allurement was to prove one of the main tools for communication on all levels.

Gutenberg's cast type perfected the regularity of lettering that scriveners had labored to approximate. The counterfeit was so convincing that Fust and Schoeffer

explained on the last page of their 1457 Psalter that "this book was produced by a skillful invention for pressing and lettering without a pen or graver." One (and only one) of the ten surviving copies ends with the only feature that owes nothing to any manuscript: the first printer's mark [ 26 ]. The two shields appear to be lettered X and L (Greek for Christ and the Logos—the Word: "In the beginning was the Word, and the Word was with God," John 1:1). The three stars may represent the Trinity. The shields are shaped like hallmarks on silver. Was Fust, the silversmith-printer, hallmarking his book like a goblet? Did his silversmith's punch suggest the larger metal stamp with two shields? Certainly his innovation started printers all over Europe designing simple and striking devices to mark their books.

**28**
Border with Johannes Froben's print-
er's mark, displayed by putti below.
Woodcut by Hans Holbein, Basel, 1515

In 1515, when young Holbein began to reshape book design for Swiss publishers,
he absorbed the printer's mark into the title border [ 28 ], where manuscript illu-
minators had put the owner's arms. Like the rest of Holbein's inventions, this one
was much imitated in Venice. He also started a vogue for fixing a printer's name
with a pictorial pun [ 29 ], Froschauer meaning "he who dwells in frog meadow."
Printers' marks varied ingeniously until the late 1700s. Then, as houses were num-
bered and streets cleared of the old wrought-iron shop signs that swung the print-
er's and publisher's emblem in the wind, printers' marks no longer directed buyers
to a shop and so disappeared. (Today's symbolic devices—an Olympic runner, a
house, a penguin, or a borzoi—mark the unity of series of books.)

**29**
Christoph Froschauer's printer's mark. Woodcut by
Holbein, Zürich, 1525

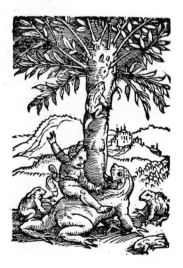

**Printers' shortcuts**  The sainted queen of Hungary is smuggling scraps from the royal table [ 30 ]. They will miraculously become roses when the stingy king uncovers her bowl to accuse her of squandering on the poor. Her head, her bowl, and her name, *elspett*, are all cut on a removable plug, the join showing in a white line. The canny manufacturer, who signed this cut *wolfgang*, must have inserted many plugs into this all-purpose body to print dozens of different female saints in thousands of impressions, of which this one alone escaped destruction by being pasted into the cover of a folio Augsburg Bible of 1477.

**30**  St. Elizabeth of Hungary. Hand-colored woodcut, south Germany, 1470s

**31**  St. Gregory. Venetian woodcut, about 1500, added to St. Gregory, *Moralia in Job*, Florence (Niccolo di Lorenzo della Magna), 1486

About 1500 a Venetian composite cut [ 31 ] helped to sell an unillustrated Florentine book then some 15 years old. The remaindered Florentine edition was apparently bought up by a Venetian bookseller who smartened it with a leaf on which the book's title is printed in red Venetian type, sometimes above the picture, sometimes below. Like the Saint Elizabeth, this Saint Gregory has not survived with any other head or attribute.

**32** Woodcut in Terence, *Comoedie*, Strassburg (Grüninger), 1496

Pfister's experiments with illustrating typographic books [ 27 ] started a custom that entirely shaped Johann Grüninger's Strassburg edition of Terence's *Comedies*. In this, each character is represented on a little cut like a slug of type [ 32 ], to be grouped with other cuts for spelling out pictorially who is on stage in each of 660 scenes. The most recent arrival appears in the center. Each play, furthermore, begins with a full-page curtain call for all its characters, with long hyphens uniting the pairs of lovers.

As printers accumulated working capital and realized the capabilities of the press, they stopped economizing on blocks by combining them and economizing on paper by imitating the old scriveners' shorthand signs, retaining only the contraction of *et* into &.

**Illustrated books in Augsburg** Though printers could not rival the gilded manuscripts of princes, they gave the middle classes more legible texts that cost about one fifth the common run of paper manuscripts and were freer of error. (A student's first task on buying a manuscript textbook was to correct it against the teacher's copy.) Printing took so much work from scriveners and illuminators that some of those who did not become printers themselves were driven to copying printed books by hand, even to the woodcuts. Thus threatened, the established guilds fought the upstart printers, who grew too suddenly to organize themselves into a guild. When Günther Zainer began to print in Augsburg in 1468, he apparently used the initiative of a craft without a guild to cut his own woodblocks. When

the block-cutters' and image-makers' guild stopped him, he must have agreed to employ guild cutters. His settlement paid off, for in 1471/72 he published in two parts the first illustrated best seller, Voragine's *Golden Legend*, making 231 woodblocks look like more by reusing one block for saintly commonplaces like beheadings. In the course of the printing he advanced, as Pfister had advanced ten years before [ 27 ], from handstamping the blocks to printing them along with the type. After his success with the *Golden Legend*, Zainer began the first mass production of illustrated books by publishing 32 texts with 750 woodblocks—often their earliest printed illustrations. Like all the early printers, he played safe with texts that had proved popular in manuscript. He built his business by underselling and improving on local manuscripts [ 33 ] with books printed in type imitating the local script tidily enough to go with neat woodcut copies [ 34 ] of local drawings. Printers in other cities sought his blocks or copied them. Many of his *Speculum* cuts of 1473 were adapted three years later at Basel for the first Swiss illustrated book. In another three years the Basel blocks traveled to Lyons for the first illustrated book printed in France.

**33, 34** The Tree of Jesse. Drawing in *Speculum Humanae Salvationis*, south Germany, 15th century; hand-colored woodcut in *Speculum Humanae Salvationis*, Augsburg (Günther Zainer), 1473

**Illustrated books in Ulm**  Ulm and Augsburg, though only 40 miles apart, illustrated books quite differently in the later 1400s. Ulm's superior painters drew fewer woodcuts but drew them with an exact elegance and a passionate gesture that impressed all Germany. When Ulm blocks proved popular, they were bought by Augsburg's more industrial publishers. Thus Ulm's most distinguished printer,

**35**
The Harrowing of Hell.
Engraving by Martin
Schongauer

Johann Zainer, ceded his Aesop blocks [ 94 ] to his more prosperous kinsman in Augsburg, Günther Zainer. To illustrate the Ulm *Life of Christ*, Johann Zainer may have employed Martin Schongauer's brother Ludwig, then in Ulm, to draw the earliest adaptations of Martin's engravings [ 35, 36 ]. In this same book a different artist drew cuts more in outline that startle by their directness [ 37 ]. The Christ who awaits the carpenters drilling his cross for the nails expresses an intimacy with suffering that appeared in the late Middle Ages. The baroque was also to feel that the crisis of martyrdom preceded the headman's stroke, in the catch of the breath just before it. Such a cut shows the subtlety that the new reading public of the 1480s began to demand of book illustrations, raising them above the by then commercialized single-sheet woodcuts manufactured for the literate and illiterate alike. Though few south Germans attained the erudition of the humanist aristocracy of Italy, they bought more vernacular books than any Italians outside Florence, and, like the Florentines, the south Germans also devoured pamphlets of fresh religious doctrines. Such visually alert readers made up the public for the astonishing woodcuts of Dürer's generation.

**36** The Harrowing of Hell. Woodcut, possibly by Ludwig Schongauer, in *Gaistliche uslegong des lebēs Jhesu Cristi (Homily on the Life of Jesus Christ)*, Ulm (Johann Zainer), 1478 or later

**37** Christ Awaiting Crucifixion. Woodcut by unknown artist in *Gaistliche uslegong* . . .

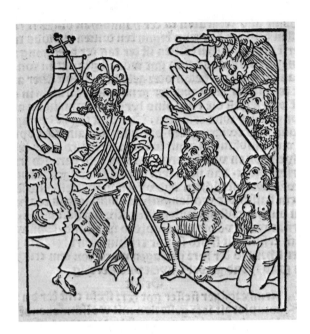
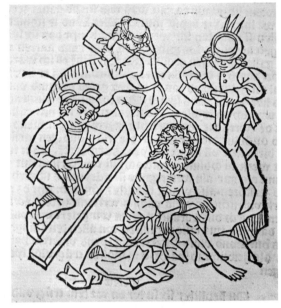

## Woodcutters' distortions

Although routine woodcutting mangled an artist's line, it never quite destroyed the action and proportion of his figures. Thus, only the vehemence of the strongly jointed men and women connects two books to the same Franco-Flemish designer, some of whose personal drawing struggles through the German cutting [ 38 ], while none survives the French slashing [ 39 ]. Since one of his German Bible cuts had already been copied by 1492, the Lübeck Bible must have been made before the French Terence, though published later. In Lübeck, after the artist had illustrated the first eight books of the Old Testament, the publisher ran out of funds to pay him, or angered him by hiring a lesser—and presumably cheaper—artist for a few later illustrations. (Illustrations often worsened, or even stopped, toward the end of big and costly books.) Whatever the reason for his leaving Lübeck, the artist was soon in Lyons drawing 159 Terence cuts for an expatriate German printer from Mainz, who rushed his book through in about ten months, copying his text, dated August 29, 1493, from a Terence printed in Paris the preceding October 11. Some of the Lyonese actors appear in Italian clothes, probably like those worn there by the Italian colony of silk weavers. Both

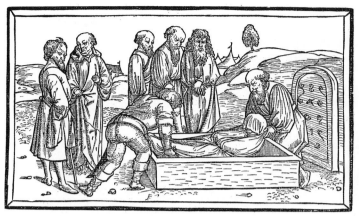

**38** The Burial of Jacob. Woodcut in Bible, Lübeck (Arndes), 1494

**39** Woodcut in Terence, *Comoediae,* Lyons (Trechsel), 1493. From 1539 edition

these books show the style of northern France or Flanders adapted by an observer of the many kinds of people who thronged the great seaport of Lübeck.

As this artist traveled, he appraised men's varied dress and bearing and learned to round out figures in all their bulk and balance on the ground. Yet his Bible had none of the wide impact on art made by the first crude Bible cuts published at Cologne about 15 years earlier [ 261 ]. Unlike the Lübeck masterpieces, the Cologne cuts got there first and illustrated the entire Old Testament and the Apocalypse with forcible shortcomings that challenged Dürer's generation to do better.

## Venice observed   Medieval man recognized reality in allegory, not history, in symbol, not fact. Accordingly, the first printed symbol of an actual place satisfied, even though the designer sketched neighborhood buildings directly on his block so that they printed in reverse [ 40 ]. A year later these buildings were published the right way around [ 41 ] simply because this second block copied an impression of the first. A third Venetian block, six years later, re-reversed the scene by copying the second [ 42 ]. So much for medieval accuracy—and copyright.

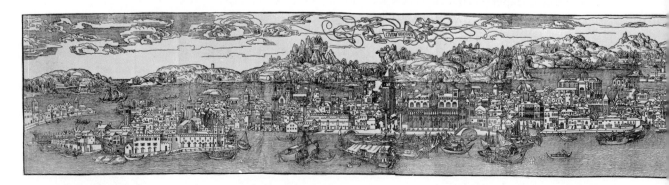

**40**

The Piazzetta. Woodcut in Werner Role-
winck, *Fasciculus Temporum (Anthology of
Chronicles)*, Venice (Walch), 1479

**41**

Woodcut in *Fasciculus Temporum*, Venice
(Ratdolt), 1480

**42**

Woodcut in Jacobus Philippus de Bergamo,
*Supplementum Chronicarum*, Venice
(Benali), 1486

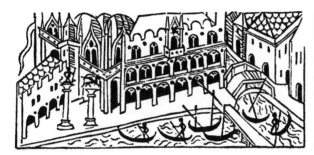
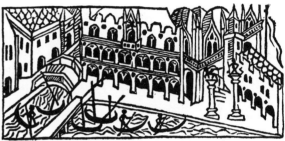

Northern Europe was more factual in the year of the third cut, when a traveling
Dutchman published a panorama of Venice five feet long, the first folding plate in
any book [ 43 ]. Here you can spot the very window you looked out of in the doges'
palace. The illustrator had spent about a month in Venice in 1483/84 on a pilgrim-
age to the Holy Land as staff artist to a rich canon of Mainz. Since he printed the
account of his journey in his own house, he took care to identify himself as Erhard
Reuwich of Utrecht. (This first illustrator to be named in print certainly also drew
some plants in Peter Schoeffer's Mainz herbal of 1485 [ 101 ] and probably made
the drypoints that go under the name of the Housebook Master [ 124 ]). Reuwich's
travel book published views of seven cities, seen from a hilltop or a ship's crow's
nest, as well as studies of Near Eastern costume and the first exotic alphabet printed
in the West. Over some 30 years his book appeared in 13 illustrated editions, his
original blocks being shipped for the printings at Lyons, Speyer, and Zaragoza.

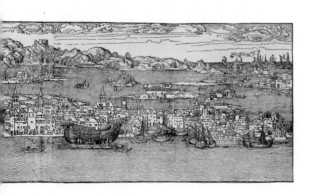

**43**

Venice. Woodcut by Erhard Reuwich in
Bernhard von Breydenbach, *Sanctae
Peregrinationes*, Mainz (Reuwich), 1486

Seven years after their first appearance, Reuwich's blocks were adapted in the *Nuremberg Chronicle* [ 44 ]. This pioneer encyclopedia of world history and geography assembles mythical scenes, foreign peoples, and famous cities in 1809 illustrations printed from 645 blocks. The illustrators copied more or less truthful views of half a dozen foreign cities and made use of unpublished drawings of some 20 Germanic towns, but had to represent many places by a stock cut of roofs inside a wall, repeated up to 11 times to indicate that "here you can read of a city." The artists were Michael Wolgemut, his more talented stepson Wilhelm Pleydenwurff, and possibly their teen-age apprentice Albrecht Dürer, who worked in their shop from 1486 to 89.

Picture printing raised standards of accuracy so fast that only 14 years after the third crude cut of Venice [ 42 ], a Nuremberg merchant living there published a panorama of the whole city drawn from all tower tops at different angles that make the terrain undulate within the accurate boundaries of a shore survey [ 45 ]. These thousands of buildings were cut on six walnut blocks so big (26 by about 36 inches) that the publisher had to order special paper and invent a way of printing that he kept secret. He sold the view for three florins, protecting his three years of work

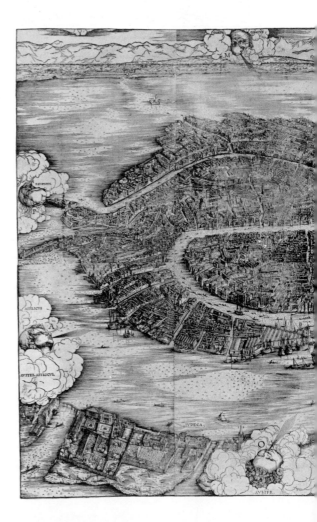

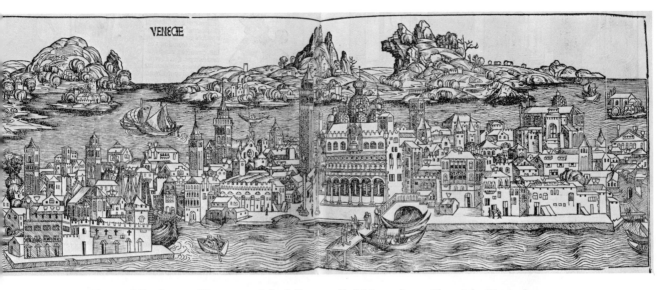

44 Venice. Woodcut in Hartmann Schedel's so-called *Nuremberg Chronicle*, Nuremberg (Koberger), 1493

45 Venice. Woodcut by Jacopo de' Barbari, 1500

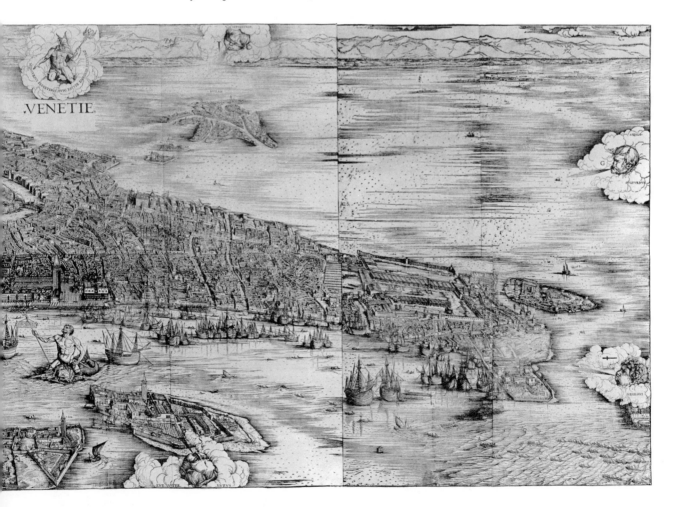

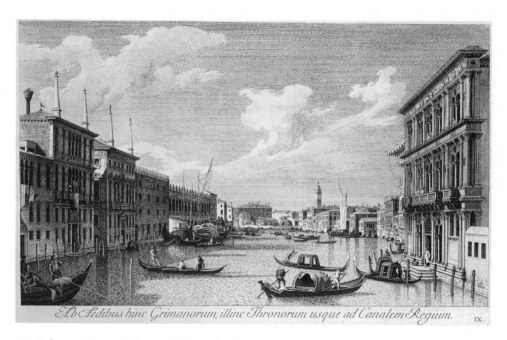

*Ab Aedibus hinc Grimanorum, illinc Thronorum usque ad Canalem Regium.* IX.

**46** Palazzo Grimani, Venice. Etching by Antonio Visentini after Canaletto, 1742–51

by a four-year copyright and exemption from customs duties within Venetian territory. This is the first group portrait of a city as the artist saw it from every high place he could climb to, differing from an earlier engraving of Florence that was projected, building by building, by the rules of perspective [ 173 ]. Venice emerged as a sprawling architectural democracy, shaped by tides and sea trade, free from any overawing cathedral or autocrat's fortress. Barbari's view was copied until after 1800 in every general view of this city that time has changed less than any other.

As people began to travel for pleasure—perhaps as early as the Thirty Years' War (1618–48), which crowded Venice with German refugees—city views ceased to be glimpses of places that you would never visit and became souvenirs of places seen. You would want to remember Rome by its relics of greatness, but from Venice you would enjoy reassembling the drifting fleet of palaces and evoking the clucking of the ripples. Such total recall became possible when Canaletto and his followers began to paint and etch [ 46 ].

**Personal styles emerge**   Two woodcuts neatly distinguish the styles of Holland and Belgium from that of Germany when all three lands were still Catholic. Medieval Germans prayed to the Madonna [ 47 ] with an awe that kept them from

innovating while repetition smoothed the image like a river cobble. Meanwhile, in the Netherlands, a remarkable artist put his personal elegance into a Madonna [ 48 ] with hands that swing like Rogier van der Weyden's and an inventive rhythm of slants like a Z made of bands that contrast with ripples. The baby disconcerts because the artist has penetrated into the idiosyncracy of the recent human—crumpled, out of drawing, and concentrating on something far out. So much personality did not appear in German cuts until the Aesop illustrations printed at Ulm in 1476/77 [ 94 ].

But once the German Reformation began to liberate individuals, as early as the 1490s, Dürer reversed the current of influence that had flowed from the Netherlands into Germany by starting the greatest outburst of Western woodcut and the most personal prints of the whole Renaissance. By 1520/21 Flemings were so eager for Dürer's prints that he could pay for his travel among them by selling about 100 florins' worth as we today might cash traveler's checks. He sold his engraved Passion for two florins wholesale and three florins retail. (Three florins bought him a pair of gloves.) He sold or bartered some 34 sets of his most popular prints, the little woodcut Passion, besides making about 140 drawings, mostly portraits, at one florin each. With this money he shipped home assorted animal horns, fish fins, a branch of coral, and a wooden weapon from Calicut.

47 Madonna. Hand-colored woodcut, south Germany, 1470s

48 Madonna. Hand-colored woodcut, Netherlands, 1460s

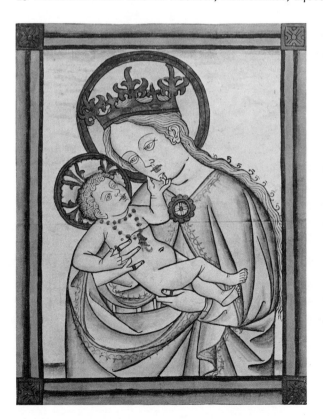
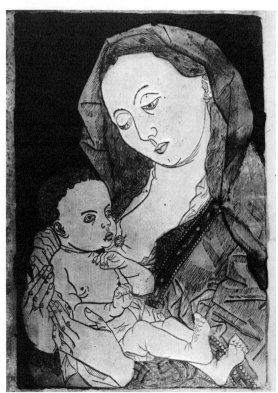

**49**
The Author Dines with
Understanding. Woodcut
in Olivier de la Marche, *Le
chevalier délibéré*, Gouda
(Van Os), about 1486.
From St. Jerome, *Vitas
Patrum*, Leiden, 1511

**Netherlandish illustrations**   Books in Dutch and Flemish have always
appeared in small editions for a small language group. Early Dutch books all but
disappeared along with Dutch medieval paintings when the "Spanish fury" at-
tacked heresy in Flanders in 1568, provoking counterattacks in Holland. There the
bright sidelight of Geertgen tot Sint Jans' paintings also illuminated Dutch wood-
cuts of about 1460 to 96 with sparkling areas of hyphens and square dots, first in
blockbooks, and then, beginning in the 1480s, in woodcuts printed with type. The
most personal cuts in Geertgen's style illustrate *Le Chevalier Délibéré* [ 49 ], the
allegorical autobiography of a courtier in the retinue of the dukes of Burgundy.
The glum and badgered author, de la Marche, supervised the cuts, either personally
or through his manuscript instructions that specify even the colors for his charac-
ters' clothes. This secular *Pilgrim's Progress*, whose English translation of 1594,
*The Resolved Gentleman*, may have inspired Bunyan, was the favorite reading of
Emperor Charles V and of so many others that only three copies survive out of two
editions with these woodcuts. Few pictures convey so intimately the contrasts of
courtly life in the Middle Ages: formality and peasant toughness, intricate accou-
terments and icy rooms, velvet and bedbugs.

The robust Dutch welcome to the daily round of people like you and me begins in prints in the *Life of Saint Lydwina*, who broke her leg while skating [ 50 ] and spent decades working miracles from her bed.

Even the open style of early woodcuts cost three times as much to cut as to design. In the years 1493–97 a Nuremberger prepared illustrations for a book known only through his expense accounts. He paid an unnamed draftsman (Michael Wolgemut?) about two florins for "two sketches on paper" (probably projects for style) and nine florins for paper sketches of 217 illustrations in first drafts (*erstlich*). He gave a carpenter nine florins for 233 big woodblocks and 83 small ones, and gave the craftsman 37 florins for drawing on them. The only craftsman considered worth naming, the woodcutter Sebolt Gallensdorfer, cut the blocks for 148 florins, as compared with 57 florins for all else.

**50**
St. Lydwina Breaks Her Leg while Skating. Woodcut in Jan Brugman, *Vita S. Lidwine*, Schiedam ([Nachtegal]), 1498

**Parisian illustrations**   Beginning in the early 1200s Parisian scribes wrote school texts for Sorbonne students, and Parisian illuminators illustrated manuscripts for rich people everywhere. When Parisian presses began to print book illustrations they hired the drilled and entrenched guild of illuminators to design the woodblocks or metal blocks and to paint special copies so as to cover—even alter—the cuts into fake illuminations. (The more countrified Germans colored their woodcuts with a few bright flat dabs.) The routine Parisian blocks circulated throughout the book trade as each publisher hired various printers, each printer jobbed for various publishers, and everybody borrowed blocks from everybody else. The organized confusion is now past unscrambling.

Printed illustrations began in the 1470s when Jean Dupré published prayer books whose existence can be inferred from the assorted prayer-book illustrations introduced in 1481 into his big missal for the use of Verdun that set the style for French printed missals. Its often imitated and reprinted illustration of the mass [ 51 ] was the first of many cuts framed in the kind of borders that were to make the fame of Parisian churchly books. The hairline of its copper relief block set the delicate "color" for decades of French illustrations. In 1483/84 Dupré stated that

**51** The Mass. Metal cut in Verdun Missal, Paris (Jean Dupré), 1481

his Limoges Missal had been "completed by Venetians superbly expert in the art of printing." What could these Venetians have done that Parisians could not do? Both must have cut relief blocks and cast type equally well, but Venice had specialized for a decade in the fussy presswork of books for priests to use at the altar. The mass requires the priest to chant words printed in black and to make gestures described in red rubrics. In the 1470s Venetian printers were famous for their skill in stenciling black ink on parts of their type, and then red ink through a second stencil to print both colors at one squeeze of the press. By 1490 or earlier Dupré was stenciling black, pink, and green blue on illustrations.

**52**

The Drowning of Marcus Manlius. Hand-colored woodcut in Boccaccio, *des cas et ruyne des nobles hommes & femmes*, Paris (Jean Dupré), 1483/84

**53**

The Root of All Evil. Woodcut in Bible, Paris (Vérard), about 1501

Dupré also printed the first Parisian illustrated book in French [ 52 ], which begins secular book illustration in Paris. Although he supplied church books to France and even England, Dupré probably mismanaged his affairs, for in the 1490s his metal blocks were scattered to Venice, Antwerp [ 247 ], and other centers. In 1485 he printed the first book published by the business boss of Parisian book illustration, Antoine Vérard, who had no press of his own, but hired nine different printers to produce illustrated books in French that he sold through two shops in Paris and perhaps a third in London. Vérard's prayer books [ 248 ] and folios [ 53 ] surpassed all others in lavishness. His determined figures dominated Parisian illus-

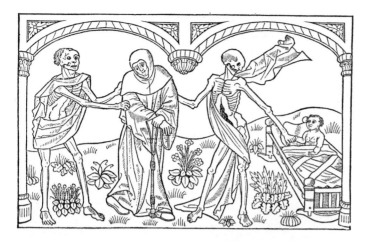 

**54** Woodcut in *La danse macabre*, Paris (Marchant), 1490

**55** Woodcut in Robert Gobin, *Les loups ravissans*, Paris (Vérard), about 1505

tration from 1485 to 1512 and then perpetuated themselves on the playing cards [ 15 ] that still scrutinize us with sour perspicacity from any bridge table.

Parisian woodcut rose to drama, with a grimness that still hurts, in ferocious satires of Death the Leveler that anticipate the *ça ira* of the French Revolution. Marchant's *Danse Macabre* [ 54 ] is based on a cycle painted in 1425 in the cloister that once surrounded the Cemetery of the Innocents in the Marais, where the bones of over 1,000,000 cadavers were stacked after their sketchy burial until the pebbles of the ground were teeth. These cuts are as precise, as elegant, and as disabused as the poems of François Villon, who certainly diced with other rowdies in the stifling graveyard. The blocks were reprinted for some 250 years at Troyes to illustrate chapbooks hawked by peddlers to conservative peasants. The other great Parisian woodcut Dance of Death [ 55 ], not framed by the architecture of a wall decoration, surprises like Holbein's [ 326 ]. This woodcutter ignored shop practice by departing entirely from drawn lines to slash the wood in the tapering parallels handiest for the knife. He must have invented much of the image as he was cutting it, like the illustrator of the Verona Aesop [ 96 ], or like many woodcutters of the 1920s.

**Illustrating Virgil**  The *Aenead* clamors for illustrations to its spectacle of thunderstorm and hell, suicide and conflagration. Enough illuminations survive from the early Christian centuries to show that Roman palace scrolls must have been illustrated while the poem was still being read like a novel. When the *Aenead* became a grammatical study for philologists, most of its illustrations stopped, not to start again until the educational ferment that ushered in the Reformation. Then,

in 1502, the Strassburg satirist and educator Sebastian Brant devised 214 woodcuts to interest schoolboys, saying, "Others have taught Virgil through learned words and writing, but Brant would teach the unlearned through rude pictures." (Three centuries later another school text was to contain the most evocative of all Virgil illustrations: those by William Blake [ 610 ]).

Brant's pictures were indeed rude in dressing Greeks like medieval Strassburgers, and in tracing the identical Trojan horse [ 56 ] into five different scenes. However, illustrations to Virgil were so long overdue that Brant's of 1502 were snapped up for 13 editions of reprints and copies and were widely adapted by embroiderers, woodcarvers, and enamelers [ 57 ]. His publisher, Johann Grüninger of Strassburg, rivaled the complete black and white "color" of Schongauer's engravings with shading too dark to paint over by hand. From 1494 to the 1520s Grüninger saved labor by repeating figures (such as the wooden horse) in various cuts, reassembling little blocks as in his Terence of 1496 [ 32 ], and by avoiding laborious crosshatching in favor of parallel shading that the knife cuts quickly. In 1504 one of his cutters, Jacob of Strassburg, introduced this muddy style to Venice, where it prevailed during the years of Venetian political defeat until Titian came to the rescue in the 1530s [ 406 ].

**56, 57** The Trojan Horse. Woodcut in Virgil, *Opera*, Strassburg (Grüninger), 1502; enamel on copper, Limoges, 1525–30

**58**

The Flight into Egypt. Hand-colored woodcut in Johannes de Turrecremata, *Meditationes*, Rome (Han), 1467. From 1473 edition

### Italian painters and woodcutters
In 1465 two Germans at the monastery of Subiaco, south of Rome, printed the first dated book outside Germany. Two years later the abbot of Subiaco commissioned a third German in Rome to print his *Meditations*, the first Italian book that combined movable type with woodblocks [ 58 ], six or seven years after Pfister had combined them in Bamberg [ 27 ]. The Roman woodblocks may have been printed even earlier than 1467 (as a blockbook?), since certain of the metal-cut copies [ 59 ] show lines that seem to have been cut away in the earliest surviving state of the originals. The author states that the 30-odd illustrations reproduce frescoes (now lost) that he had commissioned in the cloister of the Roman headquarters of his Dominican order at Santa Maria sopra Minerva. At least two of these frescoes must have been painted by Fra Angelico shortly before 1455 when he was buried in the cloister itself. His earlier wood panels of the Flight into Egypt [ 60 ] and the Baptism resemble the Turrecremata illustrations and are even closer to the author's preparatory manuscript illustrations.

Thus, at the very start, painters dominated printmaking in Italy, where their concern with construction has always cleared Italian prints of distracting virtuosity. The Turrecremata woodcuts mirror Fra Angelico's proportion and action the way a Venetian woodcut of 1494 [ 62 ] reflects a processional banner [ 61 ] that Gentile Bellini had painted 30 years before. Did Bellini himself draw the image on the block, using the experience of his mid-60s to add the background that he had left blank in his mid-30s? Or did the cutter do so to suggest how the banner itself was carried in processions?

**59, 60**  The Flight into Egypt. Metal cut in Turrecremata, *Meditationes*, Mainz (Neumeister), 1479; panel painting by Fra Angelico, 1448–53

**61**  Beato Giustiniani. Banner painted by Gentile Bellini, Venice, 1465

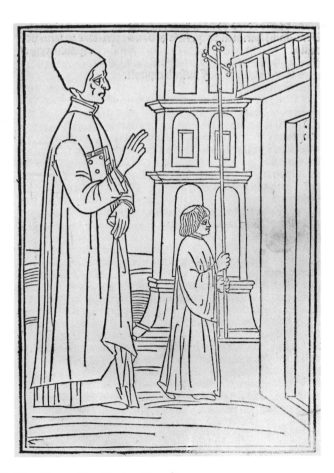

**62**  Woodcut in Lorenzo Giustiniani, *Doctrina della Vita Monastica*, Venice (Benali), 1494

The designer's role shows up only when his sketch survives to compare with the cut. Peruzzi must himself have copied his full-size drawing [ 63 ] onto the block [ 64 ] to reorganize the buildings so clearly and to regroup the nude man more harmoniously with the crouching astrologer. The unidentified IM who cut the block tried harder than most Italians to copy Peruzzi's "handwriting," but even so, the cut would hardly serve to reconstruct the sketch. (The initials on Italian blocks were rarely the designer's; they were introduced by the woodcutter to advertise his expensive knifework.)

Do Italian woodcuts preserve enough of the designer's intentions to attribute the monumental illustrations in Ketham's *Anthology of Medicine* [ 65 ] to Carpaccio? A mural painter would think as big as these most grandiose woodcuts in any Venetian book before the age of Titian, and certainly the robed elders confabulating and the jaunty equipoise of the cocky youth in another of the cuts both occur in Carpaccio's paintings. This medical seminar, as serene as if it took place by Saint Ursula's bed, illustrates the earliest classroom manual of anatomy, listing the parts of the body to be checked off while they were extracted in the order of their decay. The professor in his lofty pulpit drones from a text, while the menial barber-sur-

**63**

The Triumph of Fortune. Quill drawing by Baldassare Peruzzi

**64**

Woodcut by IM in Sigismondo Fanti, TRIOMPHO DI FORtvna, Venice (J. Giunta), 1526

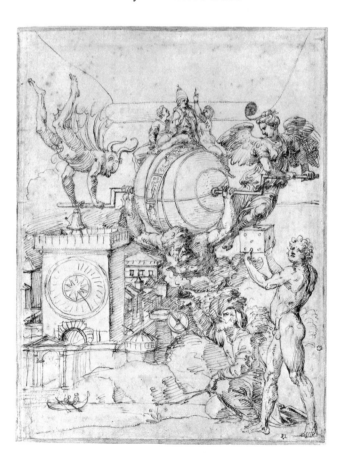

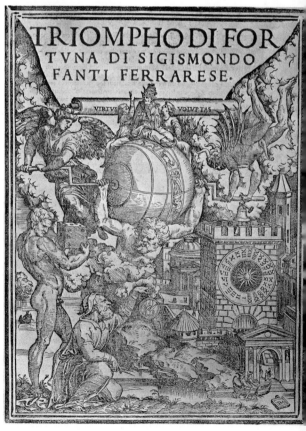

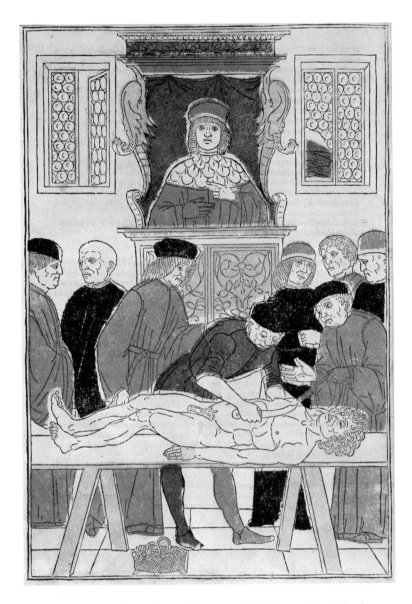

**65** Stencil-colored woodcut in Johannes de Ketham, *Fascicolo di
Medicina*, Venice (Gregoriis), 1493/94

geon chops out what is called for. Such a division of work into reading and chop-
ping explains why the artists who watched the midwinter anatomy demonstrations
learned more anatomy by sketching than the professors taught by intoning. The
woodcut is colored red and green through stencils, making the professor's hand as
red as his robe, because a stencil cannot reserve a blank patch inside a colored one.

More relationships between the Italian painters and prints are bound to come to
light as more preparatory drawings are identified.

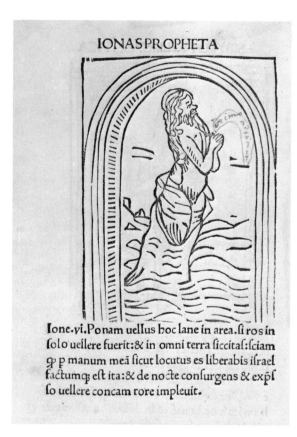

IONAS PROPHETA

Ione.vi.Ponam uellus hoc lane in area.si ros in
solo uellere fuerit:& in omni terra siccitas:sciam
φ p manum meã sicut locutus es liberabis israel
factumꝗ est ita:& de nocte consurgens & exps
so uellere concam rore impleuit.

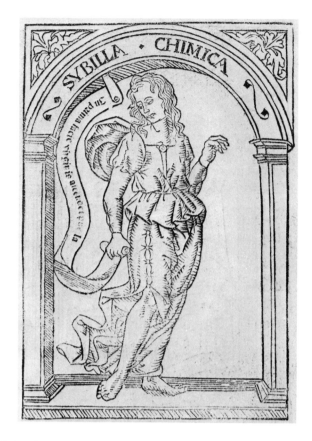

SYBILLA · CHIMICA

66 Jonah. Metal cut in Philippus de Barberiis, *Discordiantiae*, Rome (Lignamine), 1481

67 Sybilla Chimica. Woodcut by Sixtus Riessinger in Barberiis, *Discordiantiae*, Rome (Riessinger), about 1482

## Prophets and sibyls in Rome

Papal Rome, like Washington, Canberra, or Brasília, has been less a city than a bureaucracy issuing administrative documents and guidebooks [ 367 ]. The marketplace for artists born anywhere else, Renaissance Rome illustrated books so fitfully that several styles vacillate in two sets of Roman cuts of the prophets and sibyls who foretell the coming of Christ. The author, Barberiis, describes the style and colors of costumes that he might have seen on girls dressed as sibyls in some Christmas procession or miracle play. He was probably absent in Sicily when a relative in Rome published his manuscript, so ill penned that Gideon's request to God in Iudici (Judges) was printed as from "Ione"—for which the illustrator (reading no Latin) copied the whale spewing up Jonah [ 66 ] from a northern blockbook *Bible of the Poor*. (This alone shows how far blockbooks traveled and were consulted.) 27 years later, when Michelangelo started to fresco the Sistine Chapel with five of the sibyls and seven of the prophets

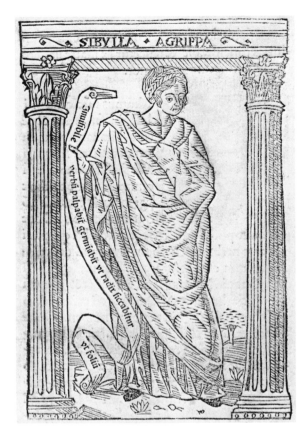

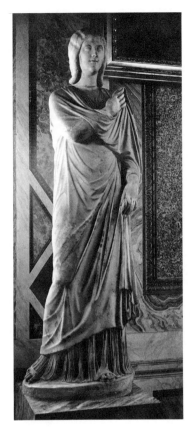

**68** Sybilla Agrippa. Woodcut, probably by Riessinger, in *Discordiantiae . . .*

**69** Marble statue, Rome, 2nd–3rd century

illustrated in Barberiis' book, he put Jonah thrown up out of the whale's jaws (instead of Gideon and the fleece) centrally over the altar. After 22 years this commanding symbol of the Resurrection suggested frescoing the wall below with the Resurrection of Christ, which developed into Michelangelo's stupendous Last Judgment.

A second edition of Barberiis was printed by one of the many Germans who dominated printing in Rome before 1500. One of its cuts bears the mark of Riessinger of Strassburg, who shaded with short parallels as he had learned to do at home under Dutch influence. Some of the cuts are the earliest datable prints in the manner of Botticelli [ 67 ], who arrived from Florence to fresco the Vatican in 1481, just as Barberiis returned to the Vatican from a five-year absence. Barberiis' second edition also contains the first prints based on antique statues [ 68 ], the start of a specialty that Romans continue to this day [ 69 ] with picture postcards.

**70** Woodcut in St. Augustine, *De Civitate Dei*, Basel (Amerbach), 13 February 1489

**71** Woodcut in St. Augustine, *De Civitate Dei*, Venice (Scotus), 18 February 1490

**Contrast of temperaments**   Venetian publishers used so many illustrations that they bought secondhand woodblocks from as far away as Paris and copied any kind of print from anywhere. A year after the publication of a Swiss cut [ 70 ], Venice published a copy [ 71 ]. No two pictures more directly oppose the Teutonic and Italian temperaments. The Swiss cut, with its windblown banderoles and its big figures gesticulating over a jumble of gables, whirls in the storm of emotion that agitates Germanic art whenever it escapes from Italian balance, whether in the Middle Ages, the baroque, or 20th-century expressionism. The Venetian adapter, shading his cut more than usual to approximate the northern "color," has tamed this tempest under the discipline of architecture by shrinking the figures to a more factual size against the buildings, drawing forms impersonally, dividing the picture proportionally, and laying the letters as straight as moldings. (In Italy, architecture and picture-making interpenetrated so much that a woodcut page [ 72 ] resembles a contemporary facade, while the façade [ 73 ] in turn is carved in perspective like a painting.) The northern woodcut has the virtue of a blazing tem-

perament, the southern of intellectual clarity. The difference explains why so many prints can be attributed to individual artists in Germany, so few in Italy.

This diversity of style matches the diversity of backgrounds from which all kinds of men entered an occupation that expanded too unexpectedly for guilds to shut out adventurers. Before 1500 German printers had been booksellers, merchants of various kinds, physicians, an astronomer, a priest, and a monk. Germans seeking work in northern Italy made the densest concentration of presses anywhere in the 1470s. Less is known about the lives of Italian printers. There was a sculptor-printer in Florence, whose foundry experience must have helped him to cast type, and there were patrician printers everywhere, including a 15-year-old count. In Italy, where princes had lived in the tumult of cities since Roman times, not in hilltop castles like the French and German aristocracy, many books were financed by and dedicated to prominent Italians.

Since speakers of Italian slip into Latin more easily than speakers of German or even French, Italy produced more books in Latin than other countries, reducing its

**72** Woodcut in Jacobus Philippus de Bergamo, *De Claris Mulieribus (Of Famous Women)*, Ferrara (de Rubeis), 1497

**73** Scuola di San Marco, Venice. Façade by Moro Coducci and the Lombardi, 1485–95

incunabula in Italian to about one fifth of its total production. Italian illustrations, though choice, were few, since literary stylists have never respected pictures as much as casual readers do. (Even children observe less after they learn to read.) In Paris, the many Sorbonne graduates and associates imposed a monotony of type and woodcut. In all countries one profession, the scriveners, took naturally to printing and to designing type faces in the style of the local lettering that they had learned to write. This beginning diversity coalesced as printers sold fonts and matrices to each other at the international book fairs in Lyons, Frankfurt, and Leipzig, ultimately leaving only the few faces in universal use today.

## Ratdolt

**Ratdolt**   In 1462 the sack of Mainz scattered young printers trained by Gutenberg and his partners. The refugees, who disseminated their revolutionary skill throughout Europe, included an Augsburg sculptor's 15-year-old son, Erhard Ratdolt. The most inventive printer after Gutenberg himself, Ratdolt was to lead with the first sheet of type specimens, list of errata, decoration in white on black [ 74 ], printing in gold, probably the first metal casts of woodblocks, the first modern title page [ 211 ], and the first pictures printed in three colors. In Venice during his 30s he also printed the first geometry with diagrams.

About 300 B.C. Euclid had written voluminously because he had to describe each step in words that scribes could copy but could not refer to diagrams that they would deform. From some manuscript in which a student had worked out his own diagrams, Ratdolt reproduced over 600 geometrical figures by bending metal strips and setting them in plaster or lead [ 74 ]. Once printing had standardized these diagrams for everybody, they eroded Euclid's text to the telegraphic syllabus that plagued us all at school.

In Venice, Ratdolt saw liturgical texts being printed in black and red through stencils. He took the next step when he illustrated the phases of the moon [ 75 ] by printing black, red, and yellow brown from three woodblocks. Even though this necessitated placing the paper exactly in the press three times, it saved labor over hand coloring for big editions. Imagine Günther Zainer's toil in Augsburg if he had hand-painted his illustrations in 1472 when he printed 284 woodcut illustrations in five publications. A normal edition of 300 would have meant painting 85,200 woodcuts in eight months! After Ratdolt had mastered the registering of colors in Venice, the Bishop of Augsburg summoned him home to modernize German churchly printing. In Ratdolt's ensuing book the first real color print imitates a painted Gothic woodcut by printing patches of red, olive, and yellow, and then surcharging them with a complete design in black line [ 76 ]. The book's success established Augsburg as Germany's center for color printing and expensive church books.

THEORICA ECLIPSIS LVNARIS.

**74**

Woodcut border and metal-cut diagram in Euclid, *Geometria*, Venice (Ratdolt), 1482

**75**

Three-color woodcut in Johannes de Sacro Busto, *Sphaera Mundi*, Venice (Ratdolt), 1482

**76**

Bishop Friedrich von Hohenzollern. Three-color woodcut in *Obsequiale Augustense*, Augsburg (Ratdolt), 1487

Shortly after 1500 Germans reproduced drawings made in black ink and white paint on colored paper. The white paint was imitated by grooving the woodblock to let lines of bare paper show through a printing of solid color. Such a tone block might also be printed independently [ 77 ], just as a black-line block might. About 1530, after Dürer had demonstrated the subtleties possible in black and white

**77** Lansquenet with Banner of Canton St. Gall. Woodcut by Urs Graf, Basel, 1521

 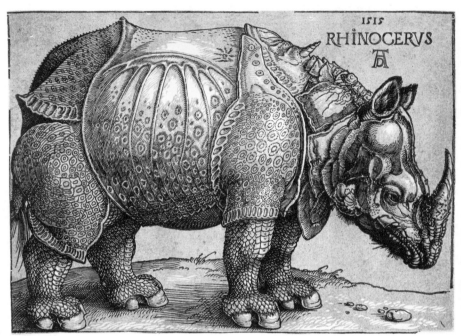

**78** Rhinoceros. Woodcut by Dürer, 1515, with tone block added later

"color," Germans stopped printing in colors. Yet the solid German tone block proved handy for glossing over damages in a black and white block to keep Dürer's cracked woodcut [ 78 ] in print for some 200 years as the best available picture of a rhinoceros. (Dürer, by the way, did not see the actual beast, which drowned while being shipped from Portugal to the Vatican.)

**Bookplates** When a man commissioned a manuscript, he had his arms blazoned on the opening page at the bottom of a decorative border. The earliest mass-produced woodcut borders often included a blank shield for the purchaser to fill

with his arms [ 74 ]. Then, in the 1480s, the south German picture-printing indus-
try invented a still more convenient way of marking ownership: pasting a book-
plate into any book at will. The first such label to survive in quantity [ 79 ] marks
some 40 incunabula that a monk gave to, or bought for, a south German monastery
that he entered about 1494. The woodcut looks as though it had been made at Ulm

**79** Bookplate of Hilprand Brandenburg of Biberach. Hand-colored woodcut,
Memmingen, 1482–85

**80** Arms of the counts of Henneberg. Stencil-colored woodcut, south Germany,
1480–1500

in the 1480s, but it occurs on the backs of spoiled pages of a book printed around
1500 near the monastery itself. It is no bigger than most bookplates, but the con-
temporary cut of the arms of Henneberg (Hen Hill) [ 80 ], too big for most books,
was an expendable poster used by noble German travellers to paste on walls and
doors of their rented lodgings and to leave at inns like distinguished signatures in
a guest book. Such large armorial stickers were dramatically elaborated by Dürer
and his contemporaries.

From about 1600 to 1900 a really fastidious bibliophile stamped his arms in gold
on the outside of his leather book covers, but after about 1700 less fussy people,
who often accumulated books by the thousands, stuck engravings of their arms

**81** George Washington's bookplate. Engraving, London, 1765–75

**82** Bookplate. Etching by Max Klinger, Munich, 1890–1910

inside the covers [ 81 ]. In England such bookplates often record arms that are not registered with the College of Heralds, as arms had to be if displayed more prominently, as on coaches. After the French Revolution broke the prestige of the nobility, book owners with no coats of arms often exposed themselves with confessional whimsies [ 82 ].

## Almanacs for wall and pocket
We slaves of the clock jot engagements in calendars that regulate our minutes like school bells. Medieval man, reminded of vaguer calls by cockcrow and church chime, referred to almanacs to know the seasons for sowing and harvesting and being bled, the saints' days, and above all the astrologers' predictions. Beginning in the 1470s, wall almanacs as large as today's bank calendars printed the saints' days in red: red-letter days. Almanacs also appeared as small sheets folded in pocket-size envelopes and as booklets that must have been given as New Year presents the way we now give Christmas subscriptions to magazines. The almanac cuts often show the occupations of the months [ 83 ], familiar from reliefs on cathedral doors. For anxious reference, the cut of a naked man in almanacs and prayer books [ 84 ] showed which veins were safe to open under each zodiac sign. Under Louis XIV, over half a dozen yearly wall calen-

Ho2nung bín ichs genant erkēn mich⸱
Gaſt du nackendt es gereüdt dich⸱

**83**

February. Woodcut in *Kalendar Deutsch*, Augsburg
(Schönsperger), 1484

**84**

Timetable for venesection. Metal cut in *heures*, Paris
(Pigouchet), 1498

**85** A Concert. Drawing by Louis Licherie, Paris, 1678, drawn reversed for engraving

**86**
Gilt and mica binding
on almanac, *Etrennes
Mignonnes,* with slip-
case, Paris, 1771

dars served the king's absolutism with big engravings of last year's royal christening or wedding. Lacking such headline events (they were rarely lacking in so amorous a royal family), the calendar might celebrate the visit to Paris of Spanish musicians [ 85 ]. To show that they came from the first empire on which the sun never set, the quartet of girls in this touring group dressed their hair in the styles of the four parts of the world. In England in 1674 the Oxford University Press began to decorate calendars with college buildings in a series that continues to this day. Wall calendars, being bulky to store and too big for scrapbooks, were usually discarded after the year's exposure had yellowed and flyspecked them. At the other extreme of size, 18th-century courtiers at Versailles pocketed almanacs too tiny to bulge a fitted coat, where they lurked at hand to verify the hours of opening of the king's library and who was who at court and in the army. The fragility of their painted, gilded, and spangled bindings [ 86 ] had to be protected by slipcases.

**Prints for pasting**   Prints not only transmitted images between painters and decorators, they often served as decorations in themselves or substituted for paintings. When monks in the Austrian monastery of Mondsee wrote little prayer books for home use, they illustrated them by pasting in tiny moon-round woodcuts, so roughly made by a great artist in his earliest years that they were often stuck in sideways [ 87 ]. Much larger prints, mostly Parisian, served as life insurance on the rough-and-tumble Gothic roads when they were pasted inside the lids of couriers' dispatch boxes [ 88 ]. Outside, iron bands took the knocks while iron loops

**87**
St. Acacius of Antioch.
Hand-colored woodcut by
Albrecht Altdorfer for
monastery of Mondsee,
near Salzburg, about 1520

**88**
The Nativity. Hand-colored woodcut in dispatch box, Paris, about 1480

**89**
Judith with the Head of Holo-
fernes. Engraving to decorate
a box, Florence, 1465–80

held straps that brought the curved lid under the messenger's arm as he galloped
with the assurance of protection from the holy image within. Prints pasted on the
outside of boxes have almost always disappeared, like the pretty round engravings
[ 89 ] made for Florentines who could not afford boxes of nielloed silver. 24 of
these very rare roundels survived, unused, in a scrapbook that perhaps was the
earliest known sales catalogue of samples. Florence, like Japan, has for centuries
graced daily life with delightful trinkets.

Before about 1700 prints were commonly tacked (or fixed with wax) to walls like
calendars today, where they perished like the woodcut in the style of Jacob Cor-

**90**
Moses. Hand-colored wood-
cut, probably by Jacob Corne-
lisz van Oostsanen, as tacked
to a wall in The Annunciation,
painting by Joos van Cleve,
Antwerp, 1510–40

nelisz that is now known only as depicted in a painting [ 90 ]. Prints were rarely framed so long as ordinary glass, whirled from a lump, was cut into small, green, bubbly pieces. (Old English law courts barred evidence peered at through window-panes.) In 1786, however, when clear glass was common enough to protect ordinary clock dials, Charles-Germain de Saint-Aubin bequeathed 70 framed and glazed prints that could have lasted excellently.

Some of the earliest prints were intended to substitute for paintings by being pasted on boards to make altars for houses or modest chapels. One of the largest survivors of dust and flyspecks is the remnant of some 15 episodes of the Passion

**91** The Passion. Hand-colored woodcut, region of Amiens, 1430s

that must have made a strip about six feet long [ 91 ]. Colonnettes frame the scenes as in the pages of some blockbooks [ 21 ] or the cloister paintings imitated in Marchant's *Danse Macabre* [ 54 ]. The inscriptions, in the Picard dialect of around Amiens, are the oldest printing of French words. France must have lost masses of early prints when the French Revolutionists pulped monastic books, in which prints were certainly pasted. More prints in book covers must have been thrown away as French bibliophiles continuously rebound their books in fashionable styles.

While Italians differed from northerners in not pasting prints into book covers, they made household altars by gluing a set of Florentine engravings of the Life of the Virgin and Christ [ 92 ] to boards. The assemblage was often completely water-

colored to resemble the sweet, serious paintings with which Fra Filippo Lippi and Alesso Baldovinetti were then charming Florence. These inexpensive approximations of fashionable paintings must have sold well, for the coppers wore enough to need re-engraving twice. Much rarer is the sheet of engraved borders to be cut apart for framing the prints into a row [ 93 ].

The French and Florentine series, made only about 40 years apart, demonstrate how totally styles differed before prints circulated along trade routes for everybody to copy. When printed pictures began to merge styles into the present homogenized world style, printed words began to impose and petrify dialects of capital cities uniformly within national boundaries, the way radio imposes pronunciation today. Before printing, the dialect of the Ile-de-France shaded imperceptibly eastward into Burgundian, which in turn merged into Rhineland German. The centralizing government of France consciously employed printing to impose Parisian French all the way to the Rhine, where Luther's blend of German dialects took over. But printed pictures, deaf to language, have gradually made Europe and then the Americas, Australia, and Japan into one condominium of the eye.

**92** The Nativity, from engravings of the Life of the Virgin and Christ. Broad-manner engraving, Florence, 1470s

**93** Borders for the engravings of the Life of the Virgin and Christ. Florence, 1470s

**94**

Woodcut in Aesop, *leben und fabeln*. Ulm (Johann Zainer), about 1476/77. From Augsburg edition, about 1480

**95**

Metal cut in Aesop, *Fabulae*, Mondoví (de Vivaldis), 1476

De leone apro thauro + aſclo

**Aesop** The weakness or absence of a central government fragmented medieval Germany and Italy into self-governing, fiercely independent towns. So, although the first four illustrated Aesops appeared within a nine-year period, they differ from each other as much as modern illustrations from different decades and different continents. Despite the variations in treatment, Aesop illustrations descend from Eastern prototypes. (Greece and Rome pictured only the inhospitable meals of the fox and the stork.) In the 30 years before 1500 Aesop's *Fables* were printed more often than the Bible. 123 Aesop editions survive out of many more that must be lost, whereas, in the 45 years before 1500 the Bible (which everybody saved) appeared in only 127 editions. The two first illustrated Aesops came out simultaneously in Germany and Italy. The German cuts [ 94 ], which also begin personal draftsmanship in typographic books, may have been drawn by Jörg Syrlin, who was then carving the cathedral choir stalls at Ulm with the same crinkling idiosyncracy. These 205 Aesop blocks passed in a few months from Ulm to Augsburg for three reprints there, and then were copied or adapted in some 20 German editions. Some of the Ulm woodcuts are related by a common manuscript ancestry to the metal cuts published at the same time at Mondoví in north Italy [ 95 ], where a

surprising number of villages had presses, probably subsidized by local bigwigs wanting a fling at the novelty of printing. This rustic booklet with 65 smudgy little cuts is the earliest survivor of the innumerable Italian chapbooks designed to catch the masses with profuse illustrations. However, it did not start the Italian family of Aesop illustrations, which was founded three years later at Verona [ 96 ], where Pisanello's tradition survived in the lithe and lively animals, so often copied throughout Italy. The splintery brilliance of these Veronese illustrations looks as though the illustrator had cut his own blocks in his own way. The cuts are bordered with the kind of type ornament that first became common on Victorian handbills and broadsides. The layout of these Veronese illustrations, but not their sparkle, was adapted six years later in metal cuts for a rich man's hobby press at Naples [ 97 ]. Here the frames, arched like Neapolitan doorways and wall tombs, are filigreed with white-on-black scrollwork in the style of earlier books produced in Barcelona, which then ruled Naples. Since Dutch woodcut practice shows in the

**96** (ABOVE)
Woodcut in Aesop,
FABELLAE, Verona
(Alvise), 1479

short, straight strokes and the floors bricked with hyphens, the *"Germani fidelis-simi"* who printed for Francesco del Tuppo may have been Dutchmen who traveled through Spain to Naples. This masterpiece of provincial eccentricity closed the first outburst of original Aesop illustrations.

After 1485 the old fabulist began to yield place to the beginnings of the modern novel and drama. Then, about 1670, Aesop suddenly jumped back into favor when La Fontaine taught his animals to speak French with inimitable point and grace. Nearly a century later Oudry's illustrations [ 98 ], though a financial disaster for the publisher, promptly became a classic to be copied in countless French paintings, carvings, and tapestries. La Fontaine's tradition has remained local because his effortless accuracy refuses to decant into any other language. Sir Roger L'Estrange, his contemporary, put Aesop into an English journalese rough and ready enough to remain readable to this day, in which it has inspired illustrations as witty as any in the past [ 99 ].

**97** (OPPOSITE PAGE, RIGHT)
Metal cut in Aesop, VITA ET FABULE, Naples (Germani fidelissimi for del Tuppo), 1485

**98**
Engraving after Jean Baptiste Oudry in La Fontaine, *Fables*, Paris (Desaint, Saillant, and Durand), 1755–59

**99**
Linecut by Alexander Calder in Roger L'Estrange, *The Fables of Aesop*, Paris (Harrison), 1931

LE RENARD, LE LOUP ET LE CHEVAL. Fable CCXXX

J.B.Oudry inv.                    P. St. Moitte sculp.

**100**
Plantain, snake, and scorpion. Hand-colored metal
cut in Lucius Apuleius, *Herbarium*, Rome
(Lignamine), about 1483/84

**Herbals and scientific illustration**    When patients knew almost as
much medicine as their doctors, they searched the fields with pictures of healing
plants in their hands. However, the copyists who redrew manuscripts inevitably
degraded drawings of plants into unintelligibility, as old Pliny lamented in his
*Natural History*, wherein he recommended describing plants instead of using in-
adequate pigments for pictures that copyists would smooth out of shape. For cen-
turies after a Byzantine had copied a living plantain to illustrate a herbal, copyists
copied copies, shirking the hard analysis of drawing from the idiosyncracies of
nature. Their game of visual gossip evolved bunches as useless as wallpaper posies
in a manuscript preserved near Rome. In the 1480s a Roman printer, as lazy as the
scriveners, copied these abridged symmetries in 132 cuts for the first herbal printed
with illustrations [ 100 ], which thus did not start a new trend but concluded an
inheritance of apathy. The metal-cutter must have been the same bungler who had
recently mangled the cuts of prophets and sibyls printed at the same press [ 66 ].
A man bitten by a scorpion or snake could identify the prescribed plantain from
more accurate cuts in two herbals published a year apart by Gutenberg's last sur-
viving partner, Peter Schoeffer. Some of the woodcuts in his herbal of 1485 must
have been copied from manuscript pictures [ 101 ], while others were evidently
drawn from nature, probably by Erhard Reuwich on his return from the Holy Land
[ 43 ]. These two versions of "Every Man His Own Doctor" were so much used
that they were reprinted and pirated long after more accurate pictures of plants
had appeared.

The botanists' demand for exactitude cramped Western flower painting with
literalness. In time the academic statements of external fact drove weavers and
embroiderers to their drawing boards, where they hybridized lilies and daisies with
feathers, shells, and fur. Chinese and Japanese designers, on the other hand, sim-
plified and emphasized without distorting the flower's individuality. An iris on a
kimono is unmistakably an iris.

Botany developed from practical quackery toward science in 1530 to 1550 when the first botanical gardens received plants from the New World, and botanists were exchanging enough pressed specimens to make the comparisons that led to the notion of genera. Botanical illustrations improved as publishers competed for an ever more crowded market by hiring better illustrators. The draftsman dominated the cataloguer for the first time in 1530 when a forceful Strassburg publisher yoked a learned physician, Otto Brunfels, with a brilliant and stubborn artist, Hans Weiditz. The uneasy partnership created the first modern-looking botany at about the same time that a similar northern team in Italy was beginning to create modern anatomy [ 394 ]. Weiditz, the artist, took the whip hand by drawing plants just as he found them in woods and fields—wilted, broken, chewed—for the physician to annotate, and the publisher to print at once in the order of receipt so as to forestall competitors. In these first known portraits of individual plants [ 102 ], Weiditz felt his way into the stems' and leaves' growing, as Leonardo had done a generation

101 Plantain. Woodcut in *gart der gesuntheyt*, Mainz (Schoeffer), 1485

102 Plantain. Woodcut by Hans Weiditz in Otto Brunfels, HERBARUM VIVAE EICONES, Strassburg (Schott), 1530

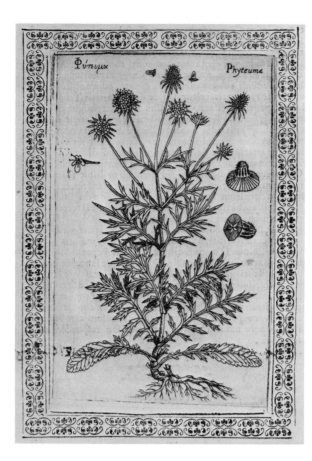

**103**

Groundsel. Etching in Fabio Colonna, *Phytobasanos*, Naples (Carlino and Pace), 1592

before him. Though he never perceived beyond the particular specimen into the swing of the species with Leonardo's mystery of exquisiteness (who has?), Weiditz harmonized exact likeness with rhythmic elegance in such a novel way that his publisher named him in the preface, thus rescuing him from the oblivion of ES and the Housebook Master. The publisher, however, suppressed the dissections of flowers and seed pods that fascinated Weiditz as much as they had Leonardo.

Pressed plants were first illustrated when Fabio Colonna, a 25-year-old Neapolitan botanist, etched them in what he called "a new way that I have devised." Their impersonal exactitude suggests that a pantograph traced flattened specimens directly onto his copperplates [ 103 ]. A pantograph could also have enlarged the anatomical details, which he was the first botanist to publish, thus laying the basis for the modern classification by structure. These first copperplates of plants changed all botanical illustration from woodcut to the more detailed engraving on metal.

German botanical woodcuts began the illustrated printing that enabled descriptive scientists of all sorts to publish their findings on numbered pages of comments written around exactly duplicated pictures. When two observers could discuss an image at a distance as clearly as though they were shoulder to shoulder, science emerged from Plinian fumbling into modern certainty.

The printing of words accelerated what scribes had long been doing adequately, though expensively, but Pfister's 1461 innovation of printing typographic texts with pictures [ 27 ] provided man's mind with a fresh and soon indispensable tool. Printed books stimulated the growth of universities, while actually making it unnecessary to gather information by sitting out most lectures. New ways of picture-making changed the very basis of knowledge. The Greeks and Romans, as they perpetuated words through exact copying, came to think that stability resided in ideas, which writing preserves like blocks of knowledge. They scorned the instability of appearances, whose images shifted when repeated through the only replication then known. Today the emphasis is reversed. Now that photography explores works of art by ultraviolet light and X-rays, tracks particles of energy, and detects nebulae and viruses, images, not words, have become the building blocks of research.

**Engineering illustrated**  Romans built the Colosseum by heft and feel that workman transmitted to workman, because their practice could not have been published pictorially until the 15th century started to print words with pictures, nor codified precisely until the 17th began to calibrate instruments exactly and invent modern mathematics. Technical pictorial publication began with engineering, which attracted an inventor by associating him with important people. The first engineering woodcuts [ 104 ], like blueprints for condottieri, illustrate a catalogue of military hardware in a gathering of tracts on soldiering. The huge, antique wooden

**104**

Portable bridge. Woodcut in
Robertus Valturius, *de re militari*,
Verona (Johannes de Verona), 1472

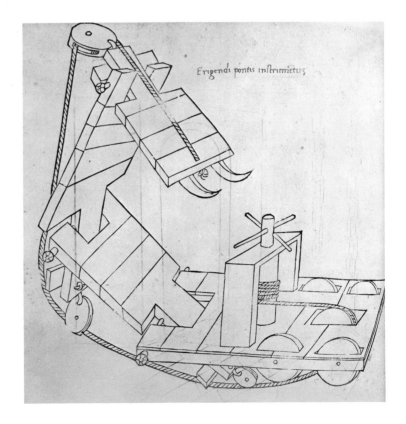

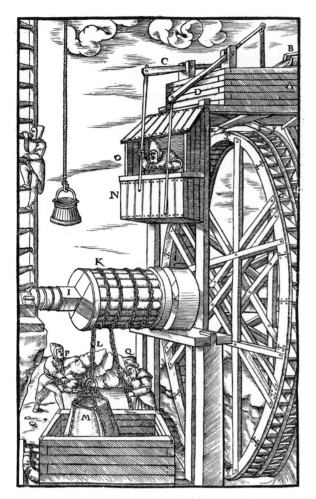

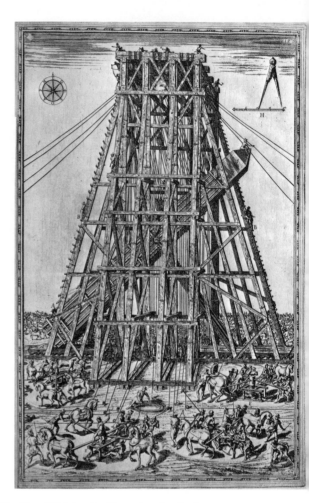

**105** Reversible waterwheel. Woodcut by Basilius Wefring in Georgius Agricola, *De Re Metallica*, Basel (Froben), 1556

**106** The Vatican obelisk. Etching in Domenico Fontana, *Della Trasportazione dell' Obelisco Vaticano*, Rome (Basa), 1590

engines may have been transmitted through drawings in some now lost Byzantine manuscripts for woodcuts that Leonardo da Vinci studied. The Veronese printer was himself not very mechanical, for he made his woodblocks so much wider than his lines of type that both would not fit into the same form for printing together, thus forcing him to stamp his blocks by hand.

The first survey of industrial engineering treated mining, a problem ever since prehistoric times. The author practiced as a physician among Saxon and Bohemian miners, whose occupational diseases got him interested in mining itself. Some 275 woodcuts illustrated the machinery of mining as clearly as its discomforts and dangers [ 105 ].

Even before man began to mine, he was proud that his pigmy muscle could as-

semble pyramids in Egypt and Mexico and lever gigantic stones together in Britain and Japan. Similar shows of strength celebrated the resurgence of the papacy in the later 1500s. Popes, being old men in a hurry, raided antique ruins for quick effects to create baroque Rome. In 1586, when the city's biggest unbroken obelisk (326 tons) was moved from the side of Saint Peter's to the front, the feat was proclaimed by publishing the first exhaustive book on one single engineering problem [ 106 ]. The text avoids speculating on how wind and men's muscles, a millennium or two before, had split 75 feet of granite from the bedrock, sailed it down the Nile, across the Mediterranean, up the Tiber, and into the city. Thousands of slavish arms may then have wasted effort with antique rollers, levers, and wedges, but they accomplished more than the Renaissance engineer did by adding horsepower, capstans, and block and tackle.

His machinery went as far as invention could go before coal and steam forced the great breakthrough. This produced one of its first triumphs in Isambard Kingdom Brunel's iron steamship, the *Great Eastern* [ 107 ], so huge—nearly 700 feet long, displacing nearly 19,000 tons—that she would loom large even beside yesterday's biggest liners. This wood engraving appeared on one of the first illustrated broadsides distributed to industrial investors—for whom she lost more money than any ship ever. However, the *Great Eastern* laid the first Atlantic telegraph cable, and demonstrated that the steamship's quick, cheap, and punctual transport was

**107** The *Great Eastern*. Wood engraving by John William Orr, New York, 1853–58

THE GREAT EASTERN.

DESIGNED BY I. K. BRUNEL, ESQ., F. R. S., &c., &c.

A. MAJOR, Publisher, 300 Pearl St., N.Y.

JOHN A. ROEBLING, C. E.    DESIGNER OF BRIDGE.    NEW YORK TOWER.    BROOKLYN TOWER.    WILLIAM VANDERBOSCH,
WASHINGTON A. ROEBLING,  CHIEF ENGINEER.                                                WILLIAM HILDENBRAND,    DRAUGHTSMEN.
CHARLES C. MARTIN,       1ST ASST. ENGINEER.                                            E. F. FARRINGTON,
FRANCIS COLLINGWOOD,                                                                    THOS. G. DOUGLAS,    MASTER MECHANIC,
COL. WM. H. PAINE,       ENGINEERS.                                                     CHAS. W. YOUNG.    DEPT. OF MASONRY.
GEO. W. McNULTY,                                                                        GEN'L FOREMAN OF LABORERS.

BIRD'S-EYE VIEW OF THE GREAT NEW YORK AND BROOKLYN BRIDGE,
AND GRAND DISPLAY OF FIRE WORKS ON OPENING NIGHT.
[PYROTECHNICS FURNISHED BY DETWILLER & STREET, NEW YORK.]
COMMENCED JANUARY 3, 1870.                    FINISHED MAY 24, 1883.

**108**  The Opening of Brooklyn Bridge, 1883. Chromolithograph by A. Major, New York

to bridge the oceans for man's global migrations. Steel, the other prerequisite for modern life, first displayed all its strength by suspending a long, busy highway from wires in the Brooklyn Bridge [ 108 ]. The bridge's esthetic lesson—that undisguised steel structure can be handsome—has still to be learned in all its consequences.

Since modern technology advances through theory and experiment, any remotely helpful discovery is immediately published. This did not happen while technology relied on craft lore. Thus, before the age of Galileo, Descartes, and Newton, printers tended to leave scientific innovations in manuscript. Commercially, they were right, for in 1543, when Copernicus proved that the planets circle around the sun, and not around the earth, his founding treatise of modern astronomy sold so slowly that it did not need reprinting for 23 years.

**The beginnings of engraving**  Cavemen scratched reindeer bones with designs that one today might fill with ink and print on paper. The oldest long series of printable incised (intaglio) designs on metal began in the 6th century B.C. when

the Etruscans grooved bronze boxes and mirror backs with lines as limber as any drawn with a ballpoint pen [ 109 ]. They sank these grooves by hammering narrow chisels vertically or plowed rougher furrows by tapping a nail point at a driving slant. They sometimes also filed punches to shaped points for dotting backgrounds. When medieval metalsmiths began to use more copper than bronze, they decorated the softer metal by pushing a graver with the mere strength of one hand against the metal held with the other, the way engravers do today [ 110 ]. Unlike the free-running hammered Etruscan lines, these engraved lines swing formally as the graver sweeps curves. Such geometric engraving decorates the chandelier that Emperor Frederick Barbarossa ordered for Aix-la-Chapelle when he exhumed Charlemagne's body there in 1165. 700 years later, when the chandelier was dismounted for cleaning, the gilded copperplates were found untarnished enough to print excellently [ 111 ].

**109**

Odysseus Threatens Circe, Who has Turned His Companions into Swine. Chased bronze mirror back, Etruscan, 375–325 B.C.

**110**

The graver. Engraving in Abraham Bosse, TRAICTE DES MANIERES DE GRAVER, Paris (Bosse), 1645

**111**

A Beatitude. Engraved plaque on chandelier, Aix-la-Chapelle, 1165–70

**112**
The Flagellation. Engraving by
the Master of 1446

To make such prints requires paper (which began to be plentiful in Europe only around 1400), and a thick, oily, densely black pigment. Oily printer's ink suddenly appeared a couple of decades after the Van Eycks had perfected oil painting, and a short distance southwest of them, when an unknown somebody started to rub this newfangled pigment into grooves engraved in copper, wiped the unwanted ink off the smooth unworked metal, and transferred the inked lines to paper by pressing

**113**
The Magdalene. Niello engraving on silver by Baccio Baldini, on a processional cross, Florence, 1464/65

metal and paper hard together. Just then, in the 1430s or 40s, Johann Gutenberg needed this same thick black ink for his experiments with printing from cast lead type. Could Gutenberg, the professional inventor, have boiled down something like the new oil paint into printer's ink for his relief printing, and then passed it on to the engravers? In the time and the region of Gutenberg's experiments, an engraver marked the earliest surviving date—1446—on any intaglio print [ 112 ]. The faceted distinctness of the detail in most of these earliest engravings shows the training of a silversmith, not a painter. Some early engravings represent the chalices, patens [ 119 ], and censers that the silversmiths made for their steadiest patron, the Church. Florentine and Bolognese silversmiths sheathed crosses [ 113 ] and boxes in little silver plates decorated in black with the very ancient technique of niello: melting a black compound of sulfur into engraved grooves. Before filling the grooves, they often recorded their engraving by casting it in pure sulfur (like pressing a seal into sealing wax), then rubbing ink on the raised sulfur ridges to make them show. After about 1450 the Italians engraved niello plates with letters in reverse especially for printing with the new northern oil ink. Pollaiuolo, whose Florentine shop made nielli, grandly expanded the niello contrasts in his Battle of the Naked Men [ 184 ].

Engravings cost more than woodcuts because the graver takes longer to master than the woodcutter's knife, copper costs more than wood, and plate printing requires more equipment, time, and skill of hand. In 1520 Dürer's price per sheet for his engraved Passion was four and a half times that for his little woodcut Passion. Early engravings, therefore, were generally made in towns for the well-to-do, while woodcuts were peddled to poorer folk. Since early engravings were usually smaller than woodcuts, thrifty people saved more of them by pasting them into books. The typical engraving of the later 1400s has survived in two or three impressions, the typical single-sheet woodcut in one.

**Dotted prints** were printed from relief blocks of pewter or copper. Gravers scooped into the soft metal to make lines of white, drills made round white dots, and punches of various shapes were hammered in to print white repeated ornaments, using a technique as old as the Etruscans [ 109 ]. Metal relief prints differ from woodcuts in that the punched dots are never oval like the wormholes in wood [ 217, right border ], and the metal lines curve more smoothly than lines in wood and do not end in splinters. Mishandling knocks a metal edge inward [ 249, right border ], but chips out a wooden edge altogether [ 50 ] and often splits along the grain in a white slash [ 78, lower left ].

Metal reliefs were rare in Italy [ 100, 397 ] but appeared in the Netherlands and Germany from about 1470 to 90. Cologne advertised its specialty in them by

**114** Christ Crowned with Thorns. Dotted metal relief cut, Netherlands, 1470s

marking some with the city's arms of the three crowns of the Magi. The painterly Flemings worked the white into the black for a richer darkness and more dramatic design [ 114 ]. Copper relief plates, nailed to woodblocks to make them the same height as the type, illustrated Parisian prayer books [ 249 ] from before 1480 to 1540. Then the graver was practically abandoned for relief blocks until around 1700, when Englishmen began to use it on type metal for cheap illustrations. At the same time, Englishmen and Frenchmen were clumsily trying the plank-cutting knife on the end grain of boxwood or pear. About 1780 Thomas Bewick in Newcastle combined methods by turning the metal graver to the end grain of boxwood for a white-line style [ 636 ] as richly dark as the old dotted prints. His modification had consequences that he could never have imagined.

## The Master of the Playing Cards

The first engraver to abandon the silversmith's primitive niggling was the painterly Master of the Playing Cards, whose simple parallels model a sidelight sliding around untroubled bulk [ 115 ], as light was later to do in paintings by the Swiss Conrad Witz. The master is named

**115** St. Sebastian. Engraving by the Master of the Playing Cards, Germany, about 1440–55

**116**

The Nine of Beasts of Prey.
Engraving by the Master of
the Playing Cards

**117**

Watercolor in the 42-line
Bible, Mainz (Gutenberg [and
Schoeffer?]), about 1454/55

from some 60 engraved cards in five suits of flowers, birds, deer, beasts of prey [ 116 ], and wild men. Some of these pips were also painted in the margins of manuscripts written at Mainz from 1452 to 82 and in the 42-line Bible that Gutenberg printed there between 1452 and 55 [ 117 ]. The marginal drawings and the engraved cards were both most likely copied from some lost craftsman's model book of designs in which a bear climbed a tree, as he would have room to do in the tall format of a page, but not where a crowded playing card forced his paws to semaphore inanely.

The jumble of the model-book page probably carries over into the disorderly congestion of the playing cards [ 116 ], slowing the player's recognition of the card's value. For some of these cards, each pip was engraved on a separate scrap of copper, then ganged on a woodblock or copperplate. A painter turned engraver might have economized his graver work so cumbersomely, but hardly a profes-

sional metal craftsman. Or was the Master of the Playing Cards close enough to Gutenberg to try composing little coppers into pictures the way Gutenberg was composing slugs of lead type into words?

**Master ES**  Early woodcutters, who reproduced other men's designs, showed local but not personal styles. In contrast, some early northern engravers invented their own designs and signed their quite individual work. The earliest engraver's signature is an e, E, or ES on 18 engravings. 16 are dated 1461, 66, or 67. Since the ten plates dated 1467 are the most elaborate, ES probably died then. On the basis of these 18 initialed engravings, some 300 more have been attributed to ES. Since 50 of these have survived in two impressions, and 95 in only one, ES must have engraved quantities more that have disappeared altogether. To engrave so many plates—say 500—ES needed assistants, and indeed, two hands show in an ornamental leaf intended as a model for craftsmen [ 118 ]; ES' short, light strokes clothe the wild man with down, while the leaf curves with the long sweeps of Martin Schongauer's manner. Though Schongauer might not sign work while still an apprentice, he must have made many unsigned plates before maturing the style that appeared fully formed in all the engravings that he signed MS, in imitation of ES.

**118**
Design for craftsmen. Engraving, probably by ES and Martin Schongauer

**119** St. John the Baptist, the Church fathers, and symbols of the Evangelists. Engraving by ES, 1466

**120** Madonna. Engraving by ES, printed in white on blackened paper

After the painterly Master of the Playing Cards [ 115 ] had used the graver like a quill to create shadows with simple parallels, ES brought engraving back to its origins in the metal crafts. He decorated the garments of some of his figures with a metalworker's tiny punches [ 121 ], and he supplied silversmiths with the ornamental layout for a paten [ 119 ], though without the prescribed scenes of the Passion. He made things look like crinkled metal in a style organized exclusively for engraving with curves, flicks, dots, and crosshatching. His technical revolution was purified by Schongauer and then elaborated by Dürer into a basic grammar that all subsequent engravers had to learn.

However, no one continued ES' most singular innovation of hatching highlights instead of shadows for printing in white pigment on blackened paper [ 120 ]. He thus imitated manuscripts painted from about 1370 to 1470 in silver and gold on blackened vellum—and imitated them so clearly that all four surviving impressions of his Madonna were at one time catalogued as drawings. Round engravings recur after about 1460 for decorative applications. In Germany some served as playing

**121** Christ and Angels Dedicating Einsiedeln Monastery in the Year 948. Engraving by ES, 1466

**122** Guerino dit Meschino (shown upended). North Italian engraving, about 1500. Made on reused plate of 121

cards, while others were probably meant to be copied on metal patens, boxes, or mirror backs, or else painted on chests and window glass. In Florence many round engravings decorated box tops [ 89 ], while nielloed silver disks were inserted in metal objects.

ES, unlike Schongauer, engraved all kinds of subjects, producing up to six variations on popular images like the Annunciation. For the 500th anniversary of papal permission to the monastery of Einsiedeln near Zurich for granting the remission of sins to pilgrims, ES engraved the earliest copperplate pilgrim souvenirs in three sizes for three prices [121]. Each version varies the Virgin's miraculous statue, being as symbolic as the three first woodcuts of Venice [ 40–42 ]. Many ES prints must have been among the 130,000 mixed souvenirs (Zeichen) that Einsiedeln sold in two weeks of the 1466 jubilee. Some 30 years later a north Italian engraver shortened and scraped off ES' superannuated image to engrave the hero of a popular romance [ 122 ]. The copper must have been worked on both sides (like most surviving early plates) for if there had been a blank side, the Italian would have

saved himself trouble by using that. For the middling rich, who bought engravings as well as the cheaper woodcuts, ES designed knightly courtships, mostly out of doors where he did not have to contend with the perspective of a room. The briskest of his lovers [ 123 ] snuggle in the kind of medieval garden that had to be squeezed into some southward angle of a town wall or castle, where boards bank up a square of grass and violets, set with a potted shrub. ES' engravings were the first to be adapted all over Europe in paintings, embroideries, carvings, and metalwork. Individual details of his richest ornamental design [ 119 ] inspired more adaptations than any other Gothic engraving.

**123**
Lovers. Engraving by ES

**The Housebook Master and drypoint** The greatest of the unidentified printmakers gets his name from his drawings of medieval household gear and other subjects in a manuscript known as the *Housebook*. He used to be called the Master of the Amsterdam Cabinet, from the collection that treasures all but nine of his known prints. While he seems to have worked in Germany, he is Netherlandish in the modeling of his shadows [ 124 ] and the bizarre elegance of his skinny fig-

ures. He was possibly, perhaps probably, the Erhard Reuwich of Utrecht who illustrated the *Pilgrimage to the Holy Land* [ 43 ] in Mainz, and very likely the Speyer *Mirror* [ 22 ], with the same stylish quirks. But whether we have here three artistic cousins or one artist, the Housebook Master, like the earlier Master of the Playing Cards [ 115 ], certainly came to printmaking from a painter's studio and not from a metal workshop. He and Mantegna finally transformed printmaking by freeing

**124** Christ Falling beneath the Cross. Drypoint by the Housebook Master

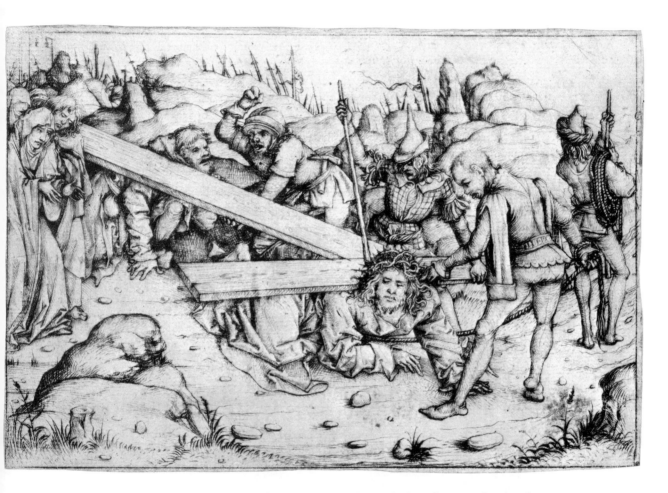

it from its origins in engraving metal and woodblocking cloth to bring it for good and all under the dominance of the painter.

For painterly purposes, the Housebook Master flouted the tidiness of professional metal practice by inventing drypoint. The stout drypoint needle [ 125 ] scratches the plate without removing substance (unlike the graver), simply deflecting metal up out of the grooves into flanking ridges [ 126 ]. These ragged ridges

**125** Drypointing Hands. Drypoint by Sir Francis Seymour Haden, 1877

**126** Drypoint line by Rembrandt, enlarged. The summits of the metal ridges were wiped to print white in the smudge of ink

catch a smudge of ink that prints a furry blur until about a dozen or even fewer printings wear the projections down and shrink the smudge to a mingy scratch. The Housebook Master inspired Dürer to make three drypoints [ 127 ]; these are among his rarest prints. Dürer made no more, partly because his silversmith father had conditioned him to neatness, partly because he had too shrewd a business head to invest much time in a process that yielded such meager returns. But a business

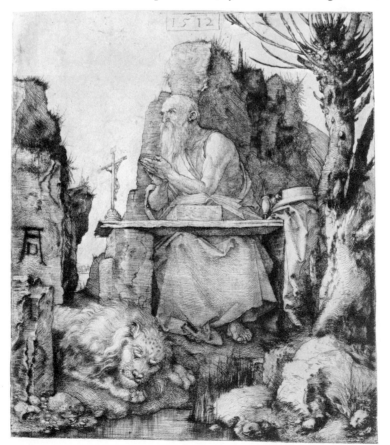

**127**
St. Jerome.
Drypoint by
Dürer, 1512

idiot like Rembrandt turned more and more to drypoint after he was about 40, because he could get effects without waiting for acid to bite, and because he had developed the command of hand to dominate the almost ungovernable scratching in so hard a metal as copper. Drypoint enabled him to accent his etchings [ 493 ] and to attack the copper directly [ 478 ] for the smoky majesty of his greatest paintings.

The Housebook Master and drypoint

Drypoint became commercially rewarding after the 1850s when copperplates could be electroplated with iron to reinforce the burr. Then Seymour Haden and Whistler in his Thames set [ 702 ] took advantage of this "whiff of steel" to launch drypoint in the so-called revival of etching in Britain. But back in the 1480s, the Housebook Master's plates (possibly of soft pewter) printed fewer impressions than those of any great artist. Only 31 of his 91 drypoints have survived in two to five impressions, while 60 are unique. Some 30 more of his lost prints (or drawings?) seem to have been copied by Israhel van Meckenem [ 139 ].

Rarity kept the Housebook Master's work private for 400 years until photogravure reproductions finally published it in 1893. Only then did we see his passionate vision that vibrated to the medieval world of the young [ 128 ], shaken between the extremes of rapture and early death [ 129 ]: cabined in the shuttered room without window glass and released into the jeweled endlessness of the cathedral, agitated by the days of processions and the days of beheadings.

**128**
Wrestling Peasants. Drypoint by the Housebook Master

**129**
Death and the Young Man. Drypoint by the Housebook Master

**Schongauer** Martin Schongauer is the first northern printmaker whose biography we know, and the first whose signed engravings have apparently all survived, even the rarest one existing in three impressions. He must have been born when engravings were first being printed, and he may have been apprenticed to ES [ 118 ], whose monogram suggested his own MS. Unlike ES, Schongauer never dated a print. Although ES engraved all kinds of subjects, Schongauer specialized in saints and the New Testament (107 prints) in preference to ornament and worldly life (eight prints).

His father was a silversmith in Augsburg, but Martin settled in Colmar on the upper Rhine, where he died just when Dürer, aged 19, was about to visit him on his student wanderings. His father's workshop must have trained him to an instinctive mastery of metal. After the first northern engravers had tentatively scratched, and ES had started to vary the strokes with method, Schongauer organized the basic rhythm of lines that all later engravings developed. Since his long strokes are the first to curve concentrically, he may have been the first to pivot his copperplate on a hard leather pillow, revolving the plate with his left hand against the graver, steadily held in his right. This active opposition plows out segments of circles with a regularity distinct from the caprices of the quill, pencil, or etching needle. Schongauer harmonized this ambidextrous geometry of sinuous sweeps with an exquisiteness that purified Gothic engraving to its last refinement of conscious simplicity. His reasoned delineation of shapes spread beyond the technique of engraving to the pen drawing of Ghirlandaio in Florence about 1490, and through him to his 15-year-old pupil Michelangelo.

Besides being the first virtuoso engraver, Schongauer also somehow learned to paint and draw at the center of northern art in Flanders, mastering so much of the grace of Rogier van der Weyden that Vasari thought him a Fleming. Flemish training enabled him to make the first prints that situate furniture convincingly in a room and people the depth with complex and expressive groups [ 130 ]. His Death of the Virgin was copied in some 40 paintings, carvings, and textiles, showing a special wonder at the boldly foreshortened bed and the intricate linking of the two kneeling apostles. Metalsmiths must have found useful ideas in the candlestick that Schongauer designed with the mastery of a man born in a metal shop. For the most exquisite prayer books, Tory of Paris [ 182 ] adopted Schongauer's splitting

130 The Death of the Virgin. Engraving by Martin Schongauer

*Schongauer*

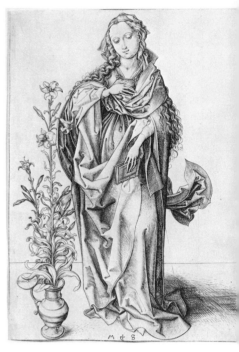

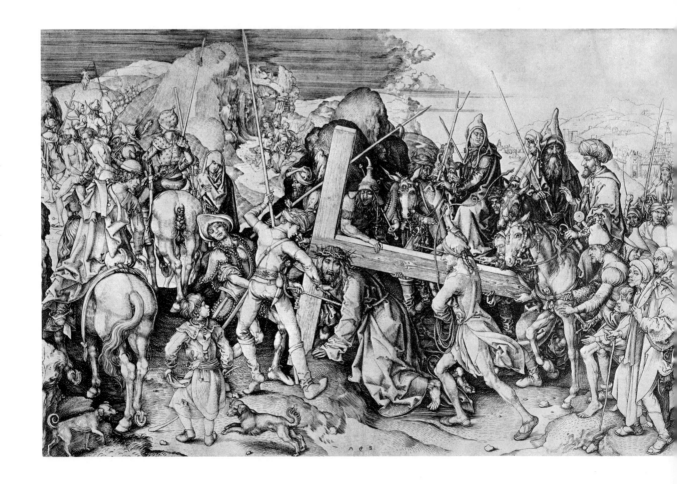

of a scene into two facing pages [ 131 ]. His Road to Calvary [ 132 ], one of the largest early northern copperplates, masses together more figures than any other Gothic print, and fuses them into a processional surge that inspired artists from Memling to Guido Reni.

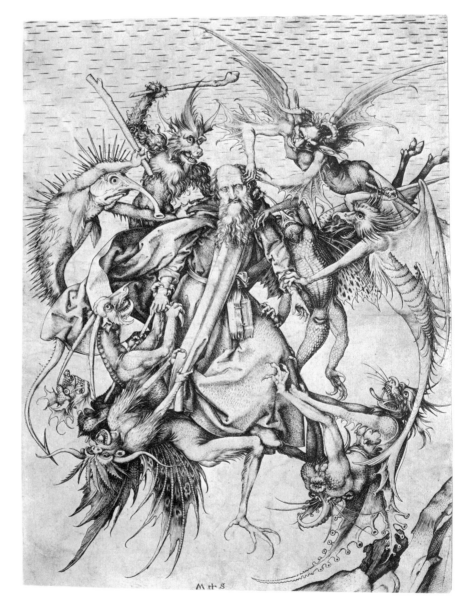

Schongauer's most formative print was his Bedeviling of Saint Anthony [ 133 ], which sums up the spooky drolleries that the late Middle Ages shaped into gargoyles and misericords and painted on the margins of books. Monsters patched together out of giblets from fish and poultry stalls here congregate in one engraving

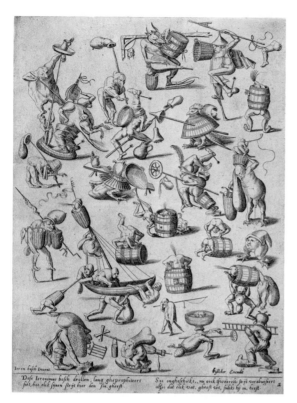

**134** Monsters. Engraving after Jerome Bosch

**135** Self-portrait with Demons. Lithograph by James Ensor, 1898

that spawned a whole category of art. Michelangelo copied this print when he was a boy, and developed its implications in his later grotesque drawings. Bosch [ 134 ] and the elder Brueghel hybridized its freaks all their lives, and Schongauer's monsters haunted artists as recent as James Ensor, who died in 1949 [ 135 ].

## Early Netherlandish engravers
The early Dutch and Flemish engravers, associating with northern Europe's first great painters, adapted the German engraver's technique to the painter's vision. The ablest early Flemish engraver signed his prints FVB. Since his style resembles the paintings of Memling in Bruges, VB may stand for "of Bruges" (van Brügge). FVB perfected his skill by copying eight of Schongauer's engravings with a darker blend of lights and shadows. He seems to have been one of the few early non-Italian engravers to copy paintings, and must himself have painted to be able to construct figures [ 136 ] more solidly than any Netherlandish engraver before Lucas of Leiden.

A Dutch engraver with more flourish than FVB often signed himself IAM Zwott, which is interpreted as IA, Master of Zwolle. To show that he also worked metal, he signed beside a metal drill, worked like a yo-yo by spinning it back and forth with a string. IA saw like a sculptor or a hammerer of metal when he engraved a silversmith's bright flanges on his armored figures [ 137 ], which much resemble the woodcuts in the *Chevalier Délibéré* [ 49 ]. He is the first engraver to display Dutch swagger, the vaulting exuberance of a people who successfully defend their independence and force the sea to keep its distance. The same victorious self-confidence was to alert the paintings of Dutch admirals and stadtholders, and to regulate the elegant uprightness of their houses.

*Early Netherlandish engravers*

**136**  St. Barbara. Engraving by FVB, Bruges (?), 1475–1500

**137**  St. George and the Dragon. Engraving by IAM of Zwolle, Holland 1475–1500

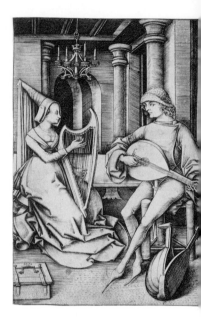

**138** The Engraver and His Wife. Engraving by Israhel van Meckenem, 1490s

**139** Lute and Harp Duet. Engraving by van Meckenem

## Van Meckenem

Israhel van Meckenem—the first engraver thought to be the son of an engraver—copied other men's work in practically every print except his self-portrait [ 138 ]. He copied 145 engravings by ES, and added his IM or Israhel to 41 more coppers that ES himself engraved. He seems to have engraved some 30 lost drawings or drypoints by the Housebook Master, including half a dozen of couples dancing or playing music [ 139 ]. He probably went to the bottom margin of a late medieval manuscript for his egalitarian drollery of hares roasting a hunter [ 140 ]. And for his personal memorial to himself and his wife, he adapted the paired conjugal portraits of Roman gravestones.

Israhel's wholesale expropriations accumulated a stock of over 600 copperplates, from which he sold so many impressions that he had repeatedly to retouch worn

**140** Hares Roasting a Hunter. Engraving by van Meckenem

areas, even though he did his best to make the engraving last by driving his graver heavy-handed. To this day much of his work can still be collected, though usually in tired impressions. As if all this printmaking were not enough, Israhel also made the earliest silver objects by a northern engraver. Such industrial mass production required assistants. Did his wife, Ida, help? (IM, or IVM could also stand for Ida van Meckenem.) If people are to collaborate smoothly, they must share a teachable, and therefore impersonal, routine. This subjection to efficiency accounts for the mechanical competence of Israhel's engravings, and—to be frank—of the numerical bulk of old copperplate prints wherever they came off the assembly lines that this brisk boss did so much to organize.

**141** St. Peter. Engraving by ES

**142** St. John the Evangelist. Engraving by ES

**Florentine engraving** twice succumbed to German engraving. In the 1440s the first German engravings changed the backgrounds of Florentine nielli from checkers or diapering, imitated from Parisian illuminations, to backgrounds of close hatching. The Florentines showed their dependence on German inventiveness by adopting the German oil ink and by combining two of ES' apostles [ 141, 142 ]

into a prophet seated on a homemade Renaissance throne [ 143 ]. This first importation of silversmiths' niggling, the so-called Florentine fine manner of engraving, cannot have pleased the Florentine painters, whose different example of the painter's way of drawing soon inspired broad-manner engraving [ 144 ]. For a decade or so, different shops must have practiced the silversmith's fine manner and the painter's broad manner.

Florentine painters drew with a silver wire on paper coated with fine white grit. They could hardly see what they were drawing until the silver trace oxidized into a moonstone image. The painter could erase nothing without scraping through the gritty coating onto the paper beneath. Thus forced to be both delicate and decided, Florentine painters outlined with crisp selectivity and shaded in close, straight parallels. Florentine engravers imitated such drawings so consistently that they often

**143** The Prophet Ezekiel. Fine-manner engraving, Florence, about 1470

**144** The Prophet Ezekiel. Broad-manner engraving in style of Botticelli, 1475–90

printed with an ink as gray as the silverpoint itself. The broad-manner engravers subordinated their unostentatious technique to grand pictorial effects in order to extend and popularize the work of painters. Collaborating in shops, they rarely signed their work. German engravers, on the contrary, showed that they, and not the painters, were the molding force by often initialing their work and by elaborating special quirks and strokes that suited the graver but would embarrass a pen or pencil. Thus, in the anonymous Florentine engravings, it is Baldovinetti and Filippo Lippi who give the considered clarity to the Life of Christ and the Virgin [ 92 ], and Botticelli who quickens an exquisite Triumph of Bacchus and Ariadne [ 145 ]. Vasari said that many Botticelli drawings were engraved, but all badly except for a Triumph of Savonarola, which is now lost.

In the 1490s, when Florentine engraving had perfected its personality, it was

**145** The Triumph of Bacchus and Ariadne, adapted from a Roman sarcophagus by a follower of Botticelli. Engraving, Florence, 1480s

disrupted—forever—by the impact of Dürer. In this second and last wave from Germany, Dürer's irresistible virtuosity deflected the feeble dependence of the first Florentine engraver who signed many prints, Cristofano Robetta (who also made the last noteworthy prints in Florence until the work of Callot and della Bella a century later). Robetta concluded the sweet grace of the early Florentine Renaissance as he imitated Filippino Lippi's febrile, mannered figures, often setting them against a landscape copied from Dürer's engravings [ 146 ]. Though Robetta copied northern landscapes, like his contemporary Giulio Campagnola in Venice [ 267 ], neither of them, unlike the fine-manner engravers, copied northern figures. By Robetta's time Mantegna, Pollaiuolo, Leonardo, and Michelangelo had perfected a supremacy of figure drawing that Italians taught to foreigners in contempt of foreign efforts. It thus caused a shock in 1522 when Pontormo frescoed the Passion from Dürer's big woodcuts. He was, however, only initiating the future practice of baroque painters like Rubens and Rembrandt, who stocked all kinds of prints to get ideas. By 1712 some painters relied so much on borrowing that the Dutch artist Gérard de Lairesse remarked: "They cannot start any subject—history, allegory, or mythology—without first raking together bits and pieces of prints, drawings, and figure studies, taking here an arm, there a leg, a face, a garment, a torso to jumble together into a patchwork."

**146**
The First Family. Engraving by Cristofano Robetta, Florence. Landscape copied from Dürer's Madonna with the Monkey, 265

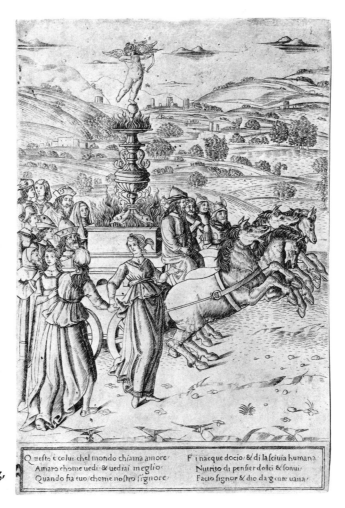

**147**
The Triumph of Love.
Broad-manner engraving,
Florence, 1470s

Queſto e colui chel mondo chiama amore
Amaro chome uedi & uedrai meglio
Quando fia tuo chome noſtro ſignore

Fi nacque docio & di laſciuia humana
Nutrito di penſier dolci & ſonui
Facto ſignor & dio da gente uana

**The Triumphs of Petrarch and Maximilian**  In the 1350s Petrarch
began his popular poems on the Triumphs of Love, Chastity, Death, Fame, Time,
and Divinity. A musician of rhetoric, but not an imagist like Dante, Petrarch sup-
plied practically nothing visual to illustrate. Nevertheless, in 1441 Matteo de Pasti
painted the Triumphs for the Medici, apparently in miniatures that are now lost.
What did he find to paint? His handiest models could have been the frequent pro-
cessions that the Medici staged to divert the fickle Florentines. Each of these street
pageants dramatized a religious or literary theme through elaborate floats on
wheels. (In northern medieval processions, priests carried images and relics in a
long file, varied now and then by buffoons.) Whether or not Matteo de Pasti
painted processional floats, they certainly represented Petrarch's Triumphs in the
earliest set of prints [ 147 ]. These six Florentine engravings solved a problem for

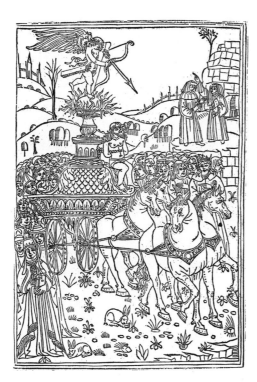

Venetian publishers, who adapted them in three distinct sets of woodcuts in 1488–
93 as the only illustrations for Petrarch's complete poems. The first two copyists
[ 148, 149 ] approximated the engravings with typical Venetian outlines, while the
third slavishly imitated even the Florentine broad-manner shading. At home in
Florence, however, a woodcutter completely redrew the floats (from an up-to-date
procession?) and departed entirely from any copperplate style into his own local
knife style of woodcut [ 150 ]. Thus, because an alert Venetian publisher helped
himself to ready copy for tacking some pretty pictures onto a text that offers noth-
ing to illustrate, other publishers of Petrarch's poems followed him for nearly 200
years, while Virgil, though evoking vivid tableaux [ 56 ], usually lacked pictures
altogether.

The sudden appearance of many illustrated Petrarchs after 1488 marked a finan-
cial crisis in book publishing. The earliest printers started by selling Latin gram-
mars to schoolboys, who wore them to shreds that were then reused for patching
bindings. The earliest surviving books were printed for priests and the next for
lawyers and humanists. The glutting of these markets by the late 1480s ruined
printers here and there. Accordingly, about 1490, forward-looking publishers
opened a new market by illustrating books to catch the general reader, the way the
Augsburg publishers had so successfully done in the 1470s and 1480s [ 34 ]. Thus,
in the 1490s, Venice, Florence, Milan, Paris, Nuremberg, Basel, Lübeck, and other
cities burst out with the first widespread crop of splendid woodcut illustrations.

Successive sets of illustrations to Petrarch's Triumphs kept so close to the look
of processional floats that they inspired designs of dream processions on other

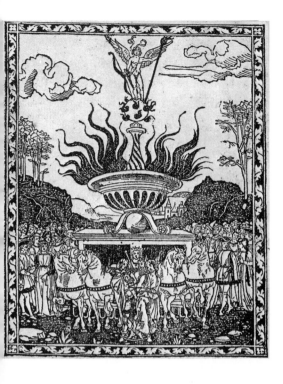

**148** (OPPOSITE PAGE, LEFT)
The Triumph of Love. Woodcut in Petrarch, *Trionfi*, Venice (Rizus), 1488

**149**
Woodcut in Petrarch, *Trionfi*, Venice (de Plasiis), 1492. From 1508 edition

**150** (LEFT)
Woodcut in Petrarch, *Trionfi*, Florence (Pacini), 1499

**151**
The Triumph of Maximilian I, Holy Roman Emperor. Woodcut by Dürer, Nuremberg, 1518

*The Triumphs of Petrarch and Maximilian*

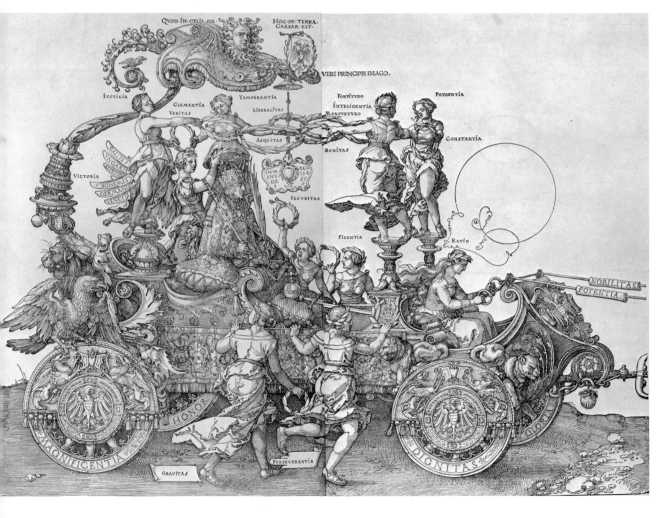

themes, and then actual pageants. The most sumptuous of the imaginary processions was drawn by Dürer in woodcuts for Emperor Maximilian's program of paper grandeur [ 151 ]. Thereafter real floats, costing whatever money was available, appeared in processions in Italy, Germany, and Flanders. Fewer appeared in France, where royal entries kept closer to the simplicity of medieval church processions. Venice, always the exception, walked relics around the Piazza and over foot bridges, but floated its grand pageants on the Grand Canal.

**Dante** as the oldest writer in any modern language who still molds thought, and the first modern classic to be printed in pocket format (1502), is the only supreme writer who fascinated a supreme artist. Vasari says that Botticelli's obsession with the *Divine Comedy* caused him "infinite disorders," and that he "*figuró lo Inferno.*" Botticelli's vehemence struggles through 19 rough engravings of the Inferno made for the first illustrated printing of the *Divine Comedy* in 1481. Four years before, the German Nicolaus Laurentii had successfully printed three full-page copper

engravings [ 152 ] in the first illustrated book published at Florence. But the Dante faced him with the harder problem of printing the text on a screw press while reserving 100 gaps in which to center 100 small copperplates for the rolling press. When he forgot a gap on the first page, he had to add the illustration below the text, where the binder usually cropped it. The printer managed to introduce copperplates into the text for the next two or three cantos in a few copies of the book, then printed the illustrations through Inferno 19 on separate slips of paper numbered for pasting in later, and gave up entirely on the 81 remaining illustrations. (He tactfully omitted all attempts at illustration in the vellum copy presented to the city fathers.) This botch practically stopped Florence from illustrating books for eight or nine years, until the city found its true style in the magical woodcuts [ 153 ] of the 1490s.

Some of the Dante engravings of 1481 show Dante and Virgil twice in the same picture, whose top and bottom edges overlap into the levels of hell above and below. Thus, the rebels against nature and art scratch off the rain of flames above Geryon, who pokes up his head from the ultimate abyss of Fraud [ 154 ]. These

**152**
Hell, adapted from Traini's fresco at Pisa, about 1350. Engraving in Antonio Bettini, *Monte Sancto di Dio*, Florence (Niccolo di Lorenzo della Magna), 1477

**153**
Woodcut in Antonio Bettini, *Monte Sancto di Dio*, Florence (Morgiani and Maganza), 1491

**154** (OPPOSITE PAGE, ABOVE)
Inferno 16: The Violent against
Nature. Engraving in Dante, *Divina
Commedia*, Florence (Niccolo di
Lorenzo della Magna), 1481

**155**
Quill drawing by Botticelli, 1492–97

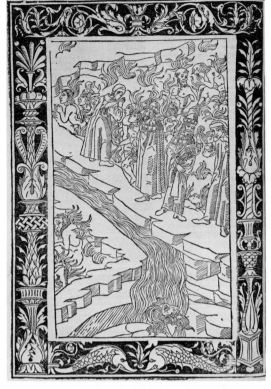

**156**
Woodcut in Dante, *Divina Commedia*,
Brescia (Boninis), 1487

engravings must therefore be snippets out of a panorama of the tiered funnel of
hell in an earlier medieval version [ 152 ]. Botticelli, in his late 20s or early 30s,
must have drawn or painted (Vasari's *figuró*) such a funnel, to which he returned
in middle age when starting his 100 exquisite vellum drawings for the elder Lorenzo
di Pier Francesco de' Medici [ 155 ].

Sometime between Botticelli's early overall view and his late vellum drawings,
the engraver of the 1481 Dante (Baccio Baldini?) must have prepared for his task
by excerpting 34 Inferno scenes from Botticelli's survey, which included bits above
and below some of his subjects. These excerpts, or copies of them, inspired the
Inferno cuts in three north Italian Dantes—two different but similar printings at
Venice in March and November 1491, and a handsome folio at Brescia in 1487
[ 156 ]. The Brescia cuts are framed in black and white ornament in the Milanese
style, and many of the Inferno illustrations are drawn with the open boldness of
a Milanese illustrator trained to Mantegna's rugged schemes for rocks and torsos.
The successful Brescia cuts sparkle more happily with type than the smoky Floren-
tine engravings, but the Brescia publisher evidently ran out of funds, for he
changed to a jacknife slasher for the Purgatorio (for which Botticelli had not yet
invented illustrations), and stopped all pictures after Paradiso I, stretching his 60
blocks with eight repeats. While adaptations allow a glimpse at Botticelli's early
Inferno picture, we have no clue at all to the even intenser intellect and passion that
Michelangelo must have packed into drawings on the wide margins of a Dante
that existed for two centuries and then disappeared at sea.

**157**
Savonarola Preaching in the Duomo. Woodcut in Savonarola, COMPENDIO DI REVELAZIONE, Florence (Pacini), 1496

**Savonarola** preached in the cathedral of Florence from 1490 to 1498 to crowds so tightly packed that he had to stretch a curtain to keep the men from ogling the women [ 157 ]. His voice echoed down that stony chasm with a command that rang in Michelangelo's ears for decades after Savonarola himself had vanished in flames. This Florentine uproar spread to the outside world and a future time when Savonarola printed his sermons with pictures so apt that he forced the papacy to counterattack. He published his brief, plain, eloquent tracts in pamphlets handy enough to pull out of a pocket while one waited for a ferry or a barber. The first and last leaves often display woodcuts to signal from a bookstall that the Frate had delivered a fresh blast. A generation later, Luther was to split Western Christendom with pamphlets that also fit any style of pocket, and also display distinctive woodcuts [ 300 ]. Luther's covers were either decorative borders or violent satires, whereas Savonarola's often reminded a man to contemplate his shortcomings.

Battle by the printed word driven home by the printed picture was then as portentous as broadcasting is now, being as difficult for censors to jam. And indeed, Savonarola in the white silence of his cell [ 158 ] looked and acted like a radio broadcaster—a voice in a closet persuading millions.

**158**
Savonarola Writing. Woodcut in Savonarola, DELLA SEMPLICITA DELLA Vita Christiana, Florence (Pacini), 1496

**Florentine woodcut illustration**   Savonarola's bonfires of vanities in 1497 must have consumed entire editions of Florentine stories and poems. Only three copies remain of a delicately saucy illustration to a love story written by a Renaissance pope [ 159 ]. Such lyric dalliance from the Holy Father would naturally have sparkled in a burning of worldly delights, but it is not so easy to explain the disappearance of early editions of the religious plays that Florence staged every Easter. Many of these *sacre rappresentationi* are known only in a 1555 reprint of 38 of them [ 160 ]. In this earliest gathering of miscellaneous plays ever published, each play opens with a cut of the angel who speaks the prologue, and then illustrates the action without showing any stage arrangements. At least one of these dramatic illustrations was copied from a little wood panel painted in Uccello's workshop, probably for a chest or cupboard.

**159**
Lovers. Woodcut in Aeneas Sylvius Piccolomini (Pope Pius II), *hystoria di due amanti*, Florence (Pacini), about 1495

**160**
Miracle play. Woodcut of 1490s in LIBRO DI RAPRESENTATIONI, Florence (dei Giunta), 1555

**161**
The Road to Calvary. Woodcut in *Epistole & Evangelii*, Florence (Morgiani and Maganza), 1495

**162** (BELOW, LEFT)
Doubting Thomas. Woodcut in *Epistole & Evangelii* (Morgiani and Maganza), 1495. From 1565 edition

**163**
Bronze statue by Andrea del Verrocchio at Or San Michele, Florence, 1478–80

The longest series of Florentine woodcuts continued in use until printing wore out the blocks. For some 80 years, while German families were studying the Bible in German, Florentine families studied homilies on the Gospels and the Epistles in Tuscan, arranged as they were read in church during the year and always reprinted with the same 140 woodcuts. The publishers claimed that they had illustrated the folio so generously "to delight the buyer's eye and to allow the senses to share in the consolation of the spirit." Since most Florentine woodcuts were made while Botticelli was hypnotizing the town, his windblown grace naturally sweeps through many of these figures [ 161 ], raising the mirage of a return to adolescence with a magic that hovers between tenderness and impertinence.

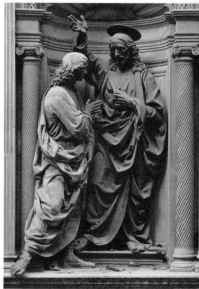

Although the great Florentine artists seem just around the corner, none ever drew on a woodblock the way the great Venetians and Germans did. In Florence the guild shops of anonymous woodcutters transposed the discoveries of the major artists into a uniform style of knifework on blocks as wide as a narrow column of type (four inches), and all similarly bordered. These domestic miniatures lie in a civilized proximity to the disturbances of genius. When a woodcut of Doubting Thomas [ 162 ] appeared, Verrocchio's bronze [ 163 ] had stood on the main street for over a decade, until Florentines could not imagine the miracle in the upper room taking place in any other way. The woodcut summarizes a monument the way some Athenian vase paintings summarize then familiar, now lost, Greek paintings and sculptures.

Florence did not start to illustrate books with woodcuts until 30 years after Germany, and 60 years after a Florentine inventory had listed "woodblocks for playing cards and saints." When at last, in 1490, the Florentines began to make up for lost time, they were so close to being beggared by wars and revolution that they had less than 15 years in which to make all the great illustrations they were ever to create. In contrast, Venice began a decade earlier, and kept quality for three centuries because the sea provided more dependably than banking, and the Venetian welfare state sedated civic unrest.

**Business books** took on a modern look at Florence in 1491/92 when the first illustrated arithmetic published the present form of long division and illustrated the handsigns that still signal numbers across noisy auctions [ 164, 165 ]. About

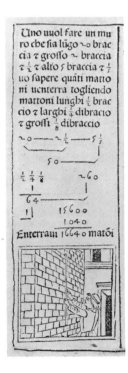

**164, 165**
Woodcuts in Filippo Calandri, *Aritmetica*, Florence (Morgiani and Maganza), 1491/92

three years later Venice published the first instructions for double-entry bookkeeping. Florence managed to be the second Italian commercial center after Venice, and the second producer of books, in spite of lying away from the sea and aside from great trade routes. The city based her power on training the intelligence of her citizens, with more free schooling in 1400 than she was to have in 1800. Her artists did not work for a court clique, but for hundreds of prosperous bankers and merchants who had an eye for a good thing, either in mortgages or Madonnas. The Florentine sense of industry and economy found pleasure in books of pocket size, and in the elegant sobriety of the first consistently uncolored woodcuts.

When American gold and silver shifted the base of Europe's economy from land to cash, the new liquid coinage made Antwerp the first great international money market. To cope with fraud in the circulation of many kinds of currency, Flemish money-changers pocketed booklets hardly bigger than a cigarette lighter, containing woodcuts of current coins [ 166 ] and statements of their values in guilders. Larger Flemish coin indices were printed tall and thin to shelve with ledgers.

**166**
Venetian coin, obverse and reverse. Woodcut in LES MONNOYES d'or & d'argent, Ghent (Lambert), 1544

**Lettering and writing**   The late Gothic letterers who deformed writing (sometimes to prevent forgery) or juggled letters out of men and animals [ 167 ] did not want to communicate so much as to decorate, the way Arabs decorated bowls and domes by swirling script. Germans, who clung to the semilegible Gothic black letter through the second World War, elaborated capitals in variations as labyrinthine as their musical variations [ 168 ]. To convolute this baroque B, the calligrapher said that he had "dipped his pen in his brains," scorning the mechanics who drafted Roman capitals with ruler and compass. Italians felt otherwise as they gazed at the clarity of the great Roman letters that their triumphal arches display to this day like posters for a perpetual election. The ancient Roman letterer had first painted the stone with a flat brush that swelled and tapered curves, and ended straight strokes by neatly spreading them in thornlike serifs. (Greek letters are uniformly narrow.) The carver then grooved the stone to weatherproof the message, the way the Egyptian relief carver weatherproofed paintings.

In the 1460s the archeologizing north Italians began to analyze the freehand antique capitals in rigid geometrical constructions, even as they began to codify Vitruvius' Roman shop practice of architecture in the rigid regulations of the five orders of columns. Ever since the first publication in 1509 of capital letters constructed in Leonardo da Vinci's circle at Milan [ 169 ], designers have labored to adjust hairbreadths in the matchsticks and washers of our printed letters without being free to reshape what must remain standard to be read without noticing. The lowercase letters you now are looking at derive from the script in which Charlemagne's scribes copied Latin classics about 800. When Renaissance scholars mistook these Carolingian manuscripts for autographs of Cicero's contemporaries, they adopted the script for lowercase letters to go with the truly antique stone-cut capitals. This hybrid fossilized when the two sorts of letters were printed together

**167** (ABOVE, LEFT)
Letter B. Engraving by ES

**168**
Letter B. Woodcut in Paul Franck,
*Schatzkammer allerhand Versalien
(Treasury of Capital Letters)*, Nuremberg
(Dietrichin), 1601

**169**
Letter R. Woodcut in Luca Pacioli, *Divina
proportione*, Venice (Pagano), 1509

**170**
Engraved title page from *The Little Work of
Ludovico of Vicenza for learning to write the
chancery hand,* Rome (Ludovico degli Arrighi,
called Vicentino), 1522

**171**
"Give others their due if you would enjoy your
own." Woodcut by Pedro Diaz Morante, Madrid,
about 1630

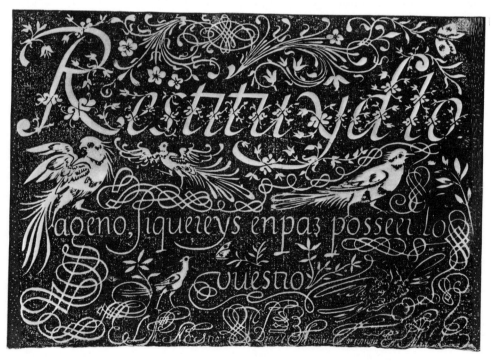

in Venice in the 1470s [ 211 ]. By then, Vatican scribes, perhaps following Venetian precedent, were beginning our modern handwriting by slanting and tying this book hand for swiftness and convenience. This new, elegant, compact lettering conquered Europe as *italic* when a papal scribe adapted it to cast type for printing the first, and instantly successful, pocket edition of a classic, the chubby little Virgil that Aldus published at Venice in 1502. Just 20 years later the same scribe published the chancery hand (*cancellaresca*) of the papal chancery itself in the first copybook for handwriting [ 170 ]. Many subsequent printed copybooks show how the fine Italian hand developed through the natural haste that saves lifting the pen off the paper by slurring more and more letters together.

Though Western handwriting can never depict character as forcibly as the Chinese script, the Spaniards at least made the chancery hand as decorative as—and more legible than—the Arabic flowed over their Moorish buildings [ 171 ]. Teutonic Europe showed its spirit again when a baroque Dutchman swung the tied Italian hand into a "strike" of swaggering illegibility [ 172 ]. Since publications of new hands did not immediately supersede old ones, the typical baroque penman wrote different hands for different uses, turning from a running chancery for the classics and polite correspondence to Gothic black letter for churchly texts and vernacular literature and to a crabbed, rapid "secretary" for accounts and inventories. A baroque painter, made aware through prints of many styles, seems like several artists when he draws—laboring over studies of anatomy, shading complete pictures of projects for submitting to patrons, jotting down ideas for compositions in a personal shorthand, or rendering pedantically for an engraver to copy without mistaking anything.

**172** "Vive la Plume." Engraving in Jan van de Velde, *Spieghel der Schryfkonste* (*Mirror of Calligraphy*), Amsterdam (Iansz), 1605

**Perspective**   After the antique world and the Middle Ages had seen objects singly and separately, the Renaissance began to embed things in a continuous matrix of space. Perhaps as early as 1424/25 some Tuscan painters and mathematicians correlated the artist's sensuous impressions with the scientist's intellectual analysis. Disciplines so distinct could parley in Renaissance Italy, where a man might still aspire to know something about everything. Scientists needed art to clarify the world's complexity, and artists needed science to form principles for analyzing appearances. With mathematical perspective a painter could depict objects in their "real" size within an imaginary framework stretching to the horizon. The artifice enabled a Florentine to engrave the first convincing print of a city as only a hawk could then see it. This four-foot-wide overflight was an assembly of six prints, of which a unique impression of one section [ 173 ] survived until World War II. (Big city views interested residents, who normally threw them away when dust had dimmed them after hanging on a wall.) The complete engraving of Florence was copied in a big woodcut (also unique), and was adapted in the *Nuremberg Chronicle.*

From 1483 to 99 perspective was elaborated as an end in itself in Milan by two Tuscans, Leonardo da Vinci and Fra Luca Pacioli, leading to Pacioli's publication of the first series of perspective renderings [ 174 ]. These puzzles stimulated Germans to contrive even more outlandish fantasies [ 175 ] as perspective grew into a game for astonishment. While Pacioli was still working on his book, the

Oftaedron Elevatum Vacuum.

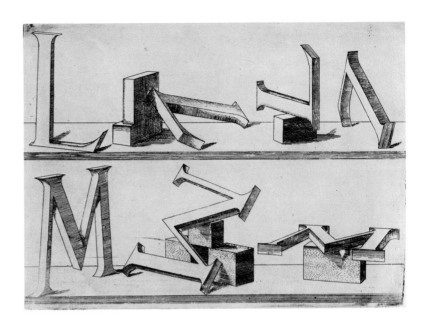

Tuscan discovery somehow reached Jean Pèlerin, a canon of the cathedral of Toul, who used it for the first clear manual of perspective drawing. The French genius for discovering charm at home inspired the most personal and endearing of all perspective illustrations. These are the first prints that present rooms that we might settle into as we explore the canon's wine cellar, his chapter house, his courtyard with an espaliered tree, and even his bedroom [ 176 ]. The very coziness of these

**173** (OPPOSITE PAGE)
Florence and Fiesole, from a set of six prints.
Engraving by Francesco Rosselli, Florence,
1482–92

**174** (ABOVE, LEFT)
Octahedron. Woodcut in Luca Pacioli, *Divina proportione*, Venice (Pagano), 1509

**175**
Etching in Hans Lencker, PERSPECTIVA LITERARIA, Nuremberg (Lencker), 1567

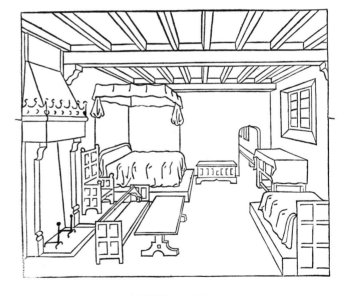

**176**
The Artist's Bedroom. Woodcut in Jean Pèlerin (Viator), *De Artificiali Perspectiva*, Toul (Jacobi), 1505

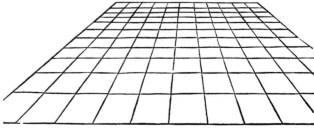

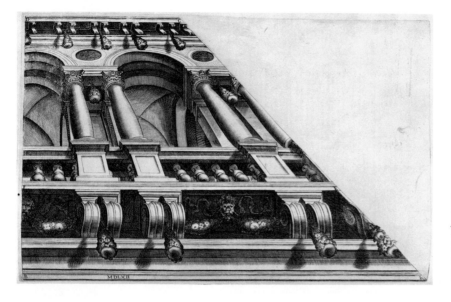

**177**
Design for a ceiling painting.
Engraving in Giacomo Barozzi
da Vignola, LE DVE REGOLE
DELLA PROSPETTIVA, Rome
(Zanetti), 1583

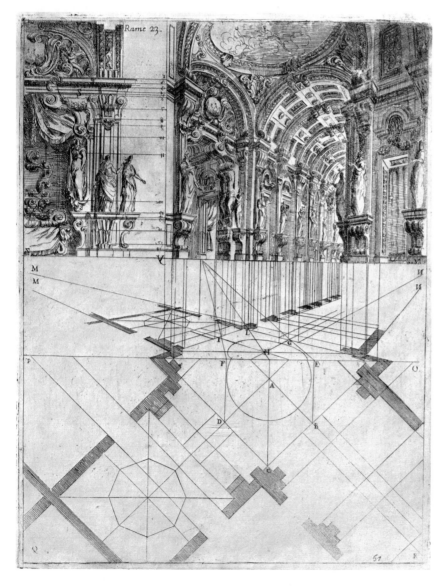

**178**
How to Draw a Backdrop.
Etching in Ferdinando Galli
Bibiena, L'ARCHITETTURA
CIVILE, Parma (Monti), 1711

woodcuts may have kept them from circulating as widely as the formal instructions given to a more pedantic age by the great baroque architect Vignola. This Roman's foreshortening of façades from a mole's-eye point of view [ 177 ] completed the lesson of Mantegna [ 196 ] by showing baroque painters how to open ceilings upward through an illusion of soaring colonnades into clouds and the toes of lolling gods.

The last original application of perspective to art came from the scenery designer Ferdinando Bibiena, who made small opera stages seem immense by painting backdrops with buildings seen at an angle, like ships driving at you, with their walls flying backward right and left into the wings [ 178 ]. After painters and architects had monopolized perspective for over three centuries, the French mathematician Gaspard Monge took it back in the 1790s to invent the descriptive geometry by which engineers are able to calculate spatial relations exactly enough to design the interchangeable parts of modern machinery.

# Maps

**Maps** About A.D. 100 in Alexandria, Claudius Ptolemy listed cities, rivers, and mountains by their latitude and longitude, and also drew maps that proved too complicated for copyists. In the 15th century his lists served Germans in Italy to found modern map-making. A German Benedictine, Master Nicolas, used these lists to construct maps that underlie the earliest engraved illustrations to Ptolemy, published in 1477 at Bologna, 1478 at Rome, and 1482 at Florence. The Bolognese and Florentine engravings were not reprinted, but the more informative Roman ones, which were the first to be started, went through four editions and were used by Columbus. They were printed in Rome by a German and were engraved, possibly by the engraver of the E series of "taroc" cards [ 16 ], under the supervision of Conrad Sweynheym of Mainz, who had introduced book printing into Italy in 1465. Applying his training in making matrices for casting type, Sweynheym stamped the copperplates with steel punches for the lettering and circles to locate towns [ 179 ]. Master Nicolas' geographical experience supplied the schemes for indicating rivers, mountains, and forests, and cleared the seas of fanciful monsters. The publication of three expensive sets of Italian engravings in five years shows the interest in geography that was soon to launch the voyages of discovery. After these first copperplates, maps were printed for 50 years in the cheaper woodcut, whose coarse detail sufficed to render the earth while it was still empty. But as surveyors added features to Europe, and as explorers doubled Ptolemy's old world with a new one, the need for finer detail turned Flemish map-makers to copperplate even before the Antwerp book illustrators took to engraving for esthetic reasons.

After edifying inland scholars, maps began to go to sea. Northward explorers found it hard to calculate polar distance and direction on early maps that distorted

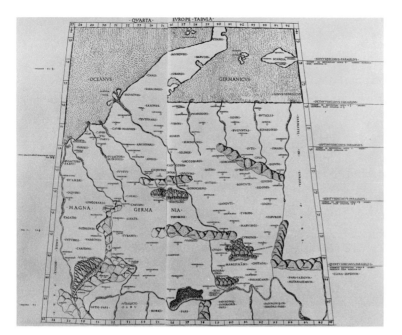

**179** Germany in the time of Caesar. Engraving in Ptolemy, *Cosmografia*, Rome (Buckinck), 1478

**180** The New World. Engraving by Gerard Mercator, Netherlands, mid-16th century

them by spreading apart the meridians where they actually converge. A practical solution was found by Gerard Mercator, a Fleming who combined enough skill of hand with knowledge of mathematics to be able to plot and engrave the first maps [ 180 ] whose presentation did not have to be essentially altered until our age of air travel. He founded the succession of map engravers in the seaports of Antwerp and Amsterdam who, from the 1530s until nearly 1700, expanded coastlines and lengthened rivers to keep pace with reports from explorers.

In the 1660s Louis XIV made map production a government concern, as it is almost everywhere today. The French then perfected the modern self-evident symbols, and indicated altitudes by contour lines. Old wall maps, like most big prints, have mostly perished. In 1554 Mercator engraved a six-sheet wall map of Europe, of which Plantin in Antwerp sold 868 impressions from 1558 to 76. One survives.

**Copyright and patronage**   Any Greek or Roman with pen, ink, papyrus, and patience was free to copy any text for sale. Printing introduced copyright (then called privilege), not to protect the author, but to protect the printer's unprecedented investment in a press, type, stacks of paper, and years of training.

The first recorded privilege conveyed absolute monopoly: in 1469, when the German John of Speyer proposed to inaugurate printing in Venice, the Senate

promised to exclude all other printers and all foreign books. Luckily, John's prompt death cleared the way for the competition that was to make the glory of the Venetian presses. Once the Senate realized the value of printing, they encouraged it wisely. In 1486 the Senate insured a worthy format for a history of Venice by granting a monopoly for the book to the author's chosen printer. Since few authors earned royalties until 1667, when Milton sold *Paradise Lost* for £10 with the promise of £5 more for each of the next two printings, penniless authors existed as they always had, by sinecures or by flattering the rich for handouts, the way Horace had lauded Maecenas until the name connoted any generous patron. Renaissance authors did not dissipate their praise throughout the text but saved it for dedicatory prefaces to be detached in case the patron proved stingy or died.

Long practice made a writer, not an artist, the first to dedicate a print to a patron. In 1515, when the German emperor's astronomer and historiographer, Johannes Stabius, mapped the constellations in two woodcuts whose star figures were drawn by Dürer, he left the useful Northern Hemisphere to sell itself unsponsored, but dedicated the Southern Hemisphere to the Cardinal of Salzburg [ 181 ]. Stabius protected himself, but not Dürer, with a ten-year privilege from his imperial patron.

In 1569 the French autocracy armed itself against the press by forbidding any book to appear without a privilege. This restriction was extended to prints in 1685. In the mid-16th century the religious wars wasted so much money that it probably did not pay to dedicate prints. Then, in 1569, Martino Rota engraved a dedication to the Prince of Savoy in the margin of his Last Judgment after Michelangelo, a practice that engravers continued until sales to the general public paid them more than patrons.

Private patronage, for all its uncertainties and humiliations, may have benefited an artist more than copyright laws, which define the plagiarism of words more easily than that of images. Marcantonio bought Dürer's prints in the Piazza at Venice to engrave some 60 copies of them [ 336 ]. When Dürer was in Venice in

**181**
The Southern Constellations.
Woodcut by Dürer, 1515

1506 he may have protested the copying of his AD, which cut into his sales of his originals, for some of Marcantonio's plagiarisms omit it. If these two non-Venetians quarreled, the Venetian Senate ignored it, though in 1521 it granted a copyright to a native for some otherwise unknown woodcut illustrations to the Pentateuch.

The first descriptive copyright for an artist's designs was granted in France in 1524 by Francis I to Geoffroy Tory, who had spent money to refashion the persistently Gothic Parisian books of hours by cutting metal relief blocks in imitation of Venetian woodcuts (*à l'italienne*) [ 251 ]. In 1527 and 29 he imitated the borders of insects and flowers (*à la moderne*) [ 182 ] that Flemings had been painting in prayer books since the 1480s [ 183 ]. For six years Tory's plagiarized illustrations and borders (*histoires et vignettes*) were not to be copied with backgrounds in white, gray, or red, nor to be reduced or enlarged, under a fine of 25 marcs. The edict must have been flouted, for in 1526 Tory obtained a privilege for his "illustrations, vignettes, friezes, borders, headpieces, and ornaments [*entrelacs*]" with the fine raised to 100 marcs. But the pirating of designs went merrily on, and today it riots among designers of furniture and dresses.

**182** The Angel of the Annunciation. Woodcut by Geoffroy Tory in *Horae ad usum Romanum*, Paris (Tory), 1529. From 1541 edition

**183** Prayer book of Cardinal Albrecht of Brandenburg. Border and initial painted by Simon Bening, Bruges or Ghent, before 1545

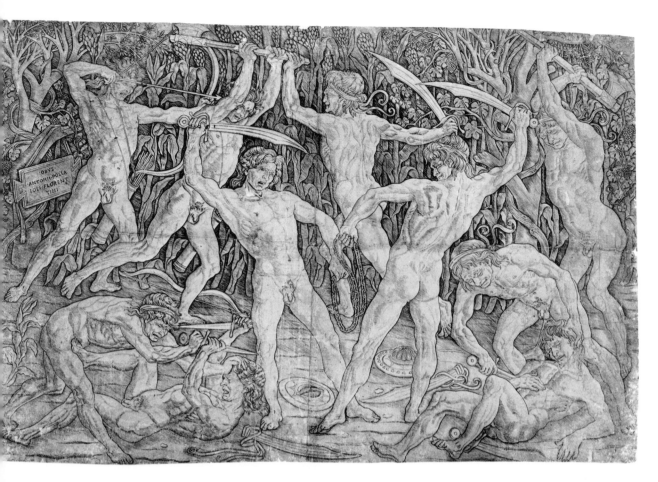

**184** The Battle of the Naked Men. Engraving by Antonio Pollaiuolo, Florence, late 1460s

## Anatomy in Florence

The first grandiose Florentine design to be printed, and the only print ever to be signed by a great Florentine artist, probably represents Titus Manlius Torquatus battling a Gaul for his torque, or gold collar, which marked him as a chieftain [ 184 ]. Against the somber wall of grapes and sorghum, the figures stand out as pale as in a monumental niello [ 113 ]. Vasari says that Pollaiuolo was the first artist to flay cadavers in order to paint and model the bones and muscles in the modern—that is, Renaissance—manner. Since he was a sculptor as well as a painter, Pollaiuolo may have modeled his skinned bodies in wax manikins, which he then bent into various positions and turned front and back to engrave these five men battling their mirror images. Some of the figures raise one arm as flayed bodies were made to do when suspended from a beam by the neck and one wrist to keep them from revolving while being studied all around. Mapping every single exposed muscle, Pollaiuolo engraved figures that Leonardo ridiculed as sacks of nuts [ 185 ]. But when Pollaiuolo was not instructing, but painting

**185**
The Battle of the Naked
Men (detail)

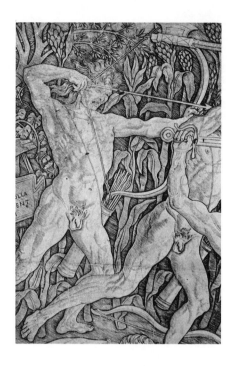

**186** Hercules and the Hydra. Painting by Pollaiuolo, Florence, about 1460

[ 186 ], he knew well enough how to bulge the pulling muscles furiously above the inactive rest. His ten men, reaching, stooping, stretching, and twisting, compress a whole course of artistic anatomy into one picture. This print changed art more than any other print ever made in Florence, by imposing the naturalistic study of muscle and bone through dissections just when Mantegna's engravings [ 187 ] revived the Roman sculptor's structural logic.

**Mantegna** established the painter's dominance over Italian printmaking with some 35 engravings in the style of his drawings. He must himself have engraved seven of them with his unique sculptural authority that develops stylistically through the Madonna of Humility [ 195 ], the two Bacchanals, the Battle of the Sea Gods, and the horizontal Entombment [ 190 ] to the Risen Christ [ 196 ]. Since part of the Sea Gods [ 187 ] was copied in a manuscript in the style of the 1460s, and other engravings of his inspired paintings and drawings of the early 70s, Mantegna must have been engraving by the 60s, when he was in his 30s. If so, his bold scale and large format could have started Pollaiuolo magnifying the niello style in his Battle of the Naked Men [ 184 ].

The two artists must have met when Mantegna visited Florence in 1466. Since both made drawings that other artists used, they may well have thought to invest their time on copperplates, whose many prints would earn them more dividends than the same effort spent on drawings. Both Pollaiuolo's Battle and Mantegna's engravings sold to painters who carelessly dripped paint on surviving impres-

**187**
The Battle of the Sea Gods.
Two engravings by Andrea
Mantegna

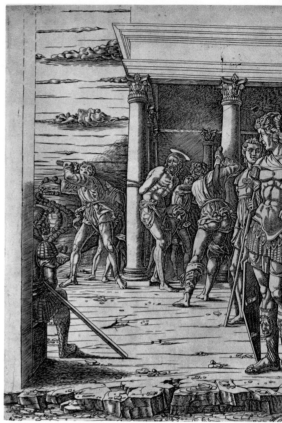

**188**  The Flagellation, with the pavement. Engraving after Mantegna

**189**  The Flagellation, without the pavement. Engraving after Mantegna

sions. Mantegna further invested money by hiring at least one professional en-
graver to copy his drawings. The earliest document proving that a painter had
commissioned engravings is an angry, disingenuous complaint from an otherwise
unknown Simone di Ardizoni of Reggio, "painter and engraver," who wrote in
1475 to Duke Lodovico Gonzaga that when he came to Mantua, Mantegna made
him "good and friendly offers." But when Simone's friend Zoan Andrea, "a Man-
tuan painter," lamented that he had been "robbed of prints, drawings, and medals,"
Simone, "out of pity," worked for him for four months "to remake the said prints."
On hearing this, "the devil [*lo indemoniato*] Andrea Mantegna" first threatened
them and then one night had both of them beaten and left for dead. When he then
accused Simone of sodomy, Simone fled to Verona "to complete the said prints."
What had angered Mantegna? Did Simone, a tramp who claimed to have "visited
40 cities," repay the "good and friendly offers" by engraving Mantegna's drawings
for Zoan Andrea? Were the stolen prints that Simone "remade" actually unauthor-
ized copies after Mantegna that Mantegna had seized as his rightful property?

190 The Entombment, horizontal plate. Engraving by Mantegna. Detail of early impression

191 Detail of late impression

Several of Mantegna's subjects were indeed engraved twice [ 188, 189 ], one version at least undoubtedly being by Simone di Ardizoni.

Mantegna forced his hired professional to unlearn his craft conventions in order to use the graver like a quill in a way that only a painter could have discovered by experimenting on his own. Where professionals worked the entire copper surface, Mantegna reserved ample blanks of air to absorb the energy that he compressed into the center. (The thrifty scrapbook collectors who later trimmed off what seemed to them waste paper left not a single impression to record the size of some of the copperplates.) By drawing with a graver to clear everything for mass and rhythm, Mantegna raised the craft of printmaking to an art as absolute as any. His rage at living too late to be an antique Roman drove him to timeless assaults on the imagination, expressed in the first prints that are not period pieces requiring historical explanation. His grandeur shows to the full in the rare early impressions that still wear the velvet of lines that granulate (how?) and mat into shadows [ 190 ]. Yet he designed so ruggedly that he kept his power even after the worn copper skinned the line [ 191 ].

The reproductive prints after Mantegna fail to show us whether the originals were frescoes, tempera paintings, some kind of drawings, or even relief sculptures, but they surpass most black and white photographs in distinguishing between

*Mantegna*   adjacent areas of paint of the same paleness or darkness [ 192, 193 ]. The clearly articulated engravings of the Magi sets the main group of the painting in a summary of the surroundings. By consciously encasing the finished study in a suggestion of preliminary sketching, Mantegna became the inventor of the "unfinished" work of art half a century before Michelangelo.

Mantegna was the only great painter who was more moved by sculpture than painting. He worked on several sculptural projects, and often painted figures as if they were carved in low relief. His interest must have started as a boy of 12 in Padua when Donatello, aged about 60, came there from Florence for a decade of sculpture. Mantegna adapted one of Donatello's favorite themes [ 194 ] for his earliest engravings [ 195 ], which in turn conveyed the group to Rembrandt for a total transformation two centuries later [ 490 ]. The north Italian pioneering in archeology inspired Donatello and Mantegna with a passion for the antique marbles that lucky spades were then unearthing. These were not the great Greek sculptures revealed to us when the British Museum bought the Parthenon marbles in 1816, but the ancient Roman copies of Greek originals. The Romans had imported plaster molds of famous statues for reproducing in marble with a simple contriv-

**192** The Adoration of the Magi. Painting by Mantegna, about 1464

**193** Engraving after Mantegna's painting

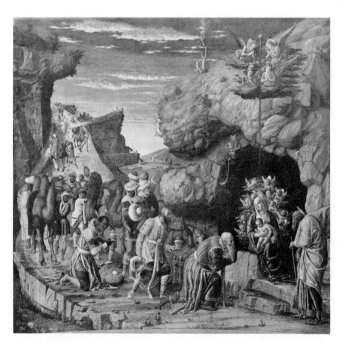

ance that located the points to which the carver cut down into the stone. Between the points, the freehand cutting tended to smooth over details and to simplify the anatomy into a grand balance as declamatory and as formal as an actor's mask. This solid geometry of the body, deduced from the box of the torso and its junction with arms and legs, became still clearer and more teachable in Mantegna's engravings. His prints launched the antique scheme into the mainstream of European art at about the same time that Pollaiuolo's Battle launched the study of the body from anatomical dissections. Mantegna's grand, ready-to-wear carapace descends through the mannerists, Veronese, Poussin, Boucher, Ingres, Canova, and Daumier, while Pollaiuolo's deeply probed interplay of bone, muscle, and flesh became the study of Leonardo, Michelangelo, Ribera, Géricault, Rodin, and Eakins. Both approaches held their own until about 1905 when the fauves in Paris began to distort anatomy for expressiveness.

Mantegna must have drawn antique sculptures in steep perspective as they lay on the ground or stood high in niches. An upward look at grandeur became his supreme stage effect, which he put into general circulation for baroque ceiling painters through his last engraving of the Risen Christ [ 196 ]. He had frescoed this

**194** The Madonna of Humility. Marble relief by Donatello

**195** Engraving by Mantegna in style of Donatello

**196** The Risen Christ between Sts. Andrew and Longinus. Engraving by Mantegna

Christ above the door of Sant' Andrea in Mantua, where Saint Andrew, as the city's patron, stood at the left, and the centurion Longinus earned a place at the right for having collected Christ's blood in a vial that was—and still is—the town's treasure. Mantegna did not engrave the finished fresco (now weathered and re-painted), but the underdrawing [ 197 ], hidden by his coloring until the plaster layers were peeled off in 1961. Being the first draftsman on copper, he chose to publish, not his colored painting, but his volumetric line.

While Mantegna's paintings had only a local effect until photographs made them known, his engravings were the first commanding Italian works of art to cross the Alps since the Roman emperors had deputized their bronze and marble likenesses to overawe the provinces. Mantegna's prints circulated widely until the 1520s, when the huge production of Marcantonio's Roman workshop superseded them as models of Italian composition and drawing of the nude. But the explosive authority of Mantegna's engravings has always moved and astonished great individuals like Dürer, Ribera, and Rembrandt. As late as 1892 Aubrey Beardsley died in a hotel room thumbtacked with facsimiles of all of them.

**197** The Risen Christ. Sinopia (preparatory drawing for fresco) by Mantegna

198 Old man's head. North Italian engraving after Leonardo da Vinci

199 The Laocoön group as monkeys. Woodcut by Niccolo Boldrini after Titian, about 1545

**200**
King Louis-Philippe Contemplating the Past, Present, and Future. Lithograph by Daumier in *La Caricature*, 1834

**Caricature**   Sir Thomas Browne wrote that "When men's faces are drawn with resemblance to some other animals, the Italians call it, to be drawn in caricature." *Caricare* means to charge selected features so as to bring out the latent animal whose nature shapes the man, according to the followers of Aristotle. For his scientific classifications, Leonardo da Vinci collected faces as impersonally as he might have collected striking butterflies. A perhaps leonine old man [ 198 ] was engraved after a lost Leonardo sketch, probably by one of the engravers trained by Mantegna to preserve the autographic individuality of a drawing. The malice that Greeks aimed at slaves and foreigners reappeared when Titian drew, not men resembling animals, but animals acting like men [ 199 ]. He was not belittling the Laocoön group [ 343 ], which he admired, but the Galenist anatomists who believed that ancient Romans and apes had had identical organs. ("If so, here is how your ancient heroes must have looked.")

Though Sir Thomas Browne had seen caricatures (possibly by Annibale Carracci) in Italy in the 1630s, in 1665 Bernini found that no Parisian had heard of the word or the idea: Bernini was the first to caricature noblemen instead of slaves and to cajole at least his Italian victims into sharing the joke. The French drew few caricatures until the 1820s, when the triumphing bourgeoisie pursued caricature until it became almost a French art. Daumier and his editor Philipon followed English precedent by using caricature as the most dreaded political attack [ 200 ]. The supreme caricaturists have been masters of the grand manner, like some of the late Greek sculptors and moderns such as Leonardo, Michelangelo, Bernini, and Daumier—all artists who explored the pitfalls that they must avoid if they were to make men look noble.

**Hawkers and walkers**   By the mid-1400s the northern interest in daily life had started north Italians making the first pictures of street criers, who may perhaps have bawled their wares and services more often in the complex Italian cities than in the more countrified German towns. The earliest print of a street crier [ 201 ] has some of the sturdy Virgilian elegance of peasants in Ferrarese paintings. It may be all that is left of a series that could have given Annibale Carracci the idea of drawing the hawkers and walkers of his native Bologna in the 1580s or 90s. Annibale's pen drawings have disappeared, but two sets of copies, etched after his death, record now forgotten aspects of city life and inspired imitations for two centuries. His picture peddler [ 202 ] is helping to dispose of the overproduction of paintings that occurred in Bologna in the late 1500s.

The liveliest set of cries of the 1700s was drawn by the sculptor Edmé Bouchar-

**201** Peasant with rabbit and brushes. Engraving, Ferrara or Padua, 1470s

**202** Paintings for Sale. Etching by Simon Guillain after Annibale Carracci, 1646

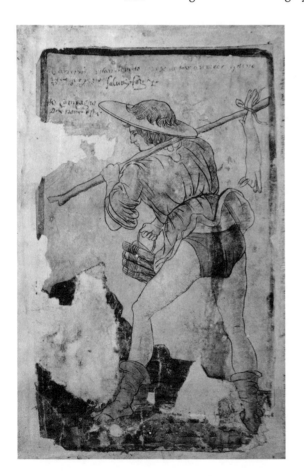

don. His trudging impresario shoulders a peepshow equipped with so-called *vues-d'optique* [ 203 ]. These were engraved by the hundred thousand in Paris and Augsburg with titles at the top in reverse to be read the right way around in a slanting mirror. Being of uniform size, dozens of *vues-d'optique*, glued end to end, made a ribbon of pictures that the peepshow operator cranked in for the customer, who peered through a large lens at city squares and palaces and celebrated battles sliding past the magic mirror to movie music from the barrel organ.

About 1810 Thomas Rowlandson etched a charming set of cries, one of which shows a London lass giving a letter and the glad eye to a brisk postman [ 204 ]. He serves the first postal system efficient enough to circulate illustrated periodicals to the mass of the population.

In Russia, four years after the Communist Manifesto had signaled a new respect

**203** Barrel organ and peep show. Etching after Edmé Bouchardon, 1737–42

**204** Postman. Etching by Thomas Rowlandson, about 1810

Bouchardon in.

*Lorgue de Barbarie*
*ou plustost d'Allemagne*

c. s.

POSTMAN.

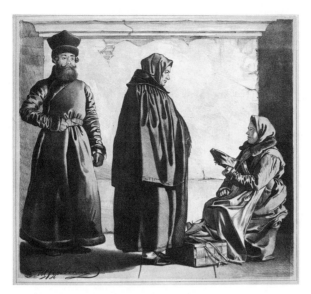

**205**
Shoe seller. Lithograph by
J. Szczodrowski in *Scenes of
Russian Life,* St. Petersburg, 1852

for the propertyless classes, ambulant workmen became the theme for some of the first sympathetic studies of the life of the poor [ 205 ].

During the centuries when street criers posed unconsciously for artists, some 300 sets of prints recorded the noisy life of Bologna, Rome, Venice, Paris, Vienna, London, Saint Petersburg, and New York. Art lost a vivid theme when modern city traffic crowded these itinerants off the pavements, and easier circulation brought customers to goods rather than goods to customers.

**Book covers** After Augsburg publishers industrialized book illustration in the 1470s, they started to catch the buyer's eye with covers printed on thin paper yellowed to look like expensive fresh leather. The central panel of one of these shows the so-called pomegranate pattern [ 206 ], suggesting that the leather bindings had in turn imitated cloth book covers of perishable Italian silks. After about 1490 Ferrarese and then Venetian binders sewed small books cheaply and prettily into stiff cardboard covers printed with classical ornament [ 207 ]. A block sometimes printed three panels—for front, back, and the spine between—but without lettering, so that the cover might serve for any octavo.

Venetian publishers sometimes printed plain catch titles in bold type on the outside of the first and last leaves to identify the book whichever way it lay on the shop counter. Such cover titles must have caught Dürer's eye on Venetian bookstalls, for he raised them to a high art in 1511 when he published his woodcut sets of the Apocalypse [ 208 ], the Great Passion, and the Life of the Virgin. No one has ever flourished Gothic letters with such illegible exultation as Dürer, who would have made the lordliest writing master of them all.

**206** (RIGHT)
Woodcut book cover on yellowed paper,
Augsburg (Schapff), after 1478

**207**
Woodcut book cover, Venice, about 1500

**208**
Woodcut by Dürer for Apocalypse, Nuremberg,
1511

**209** Woodcut book cover, white on green paper, Venice, 1792

**210** Printed cloth binding for Tennyson, *Enoch Arden*, London (Moxon), 1866

In the 1690s special printed covers were eclipsed for a time by papers printed in colored patterns [ 570 ] that could be cut to fit books of any size and brightened a shop counter like a flower bed. The old Venetian pasteboard covers reappeared as rococo masterpieces by the 1760s when they dressed the souvenir pamphlets that Venetian patricians presented to their guests at a wedding, the installation of a procurator of Saint Mark [ 209 ], or the ordination of a noble nun. Grandees who could no longer afford gilded morocco could still splurge with bright printing on blue or rose cardboard.

Publishers shipped books out of town in casks, unbound to fit the curve of the cask and to save weight. Over the counter, books were sold either bound or unbound, depending on the clientele. About 1640 Bosse's bookstall [ 462 ] displays only bound volumes to elegant Parisians. In 1658 Comenius' little woodcut [ 450 ] shows a more academic bookshop in Nuremberg. Here the public has access to books in sheets, individually wrapped and stacked flat. Each stack is identified by the book's title on a paper inserted between the packaged sheets. Guarded by the counter, the more expensive bound books are shelved upright, seemingly presenting their fore edges, where each volume's title would be inked. In London by the 1760s, so many books were offered folded and sewn for binding that booksellers identified them by pasting printed labels on the spine. But if a British dealer bound a set of books in leather, he wasted no money on gilt titles, but merely stamped the volume numbers to insure selling complete sets. Full information on the paper backs and paper covers was probably first printed on German almanacs in the late

1700s and appeared by 1818 in Paris. These bright-colored paper wrappers that usually repeat the title page [ 662 ] were thrown away when the purchaser had his book bound to his personal taste, as many Frenchmen still do.

Cloth bindings began to be mass-produced about 1770, when London wholesalers experimented with canvas, which, however, tended to sweat the glue. By 1825 cotton cloth, sized to prevent its absorbing the glue, was revolutionizing trade binding from a handicraft to a machine industry, much the way the spinning jenny had revolutionized weaving in the 1780s. In 1832 an English hot press began to emboss and gild trade bindings, making them too durable and pretty to discard like the plain old canvas ones. To keep fancy trade bindings fresh on the counter, publishers protected them with printed dust jackets that purchasers immediately discarded. The earliest surviving removable dust jacket seems to be a London one of 1833. Victorian ornamental buckram bindings [ 210 ] enticed Englishmen and Americans each autumn to buy gift annuals and slim volumes of verse as Christmas presents.

**Title page and frontispiece**   Run-of-the-mill medieval manuscripts open with a solid block of writing that starts with an *incipit:* "Here begins the book of . . ." and continues without wasting parchment into the first words of the text. Such manuscripts end with a *colophon:* "Finished writing by me, John Doe, at Paris, Ash Wednesday, 1400. Praise be to God." Until after 1500, printers followed this manuscript form with but one surviving exception in 1476. This was a title page so modern that it listed author, title, place of publication, printer-publisher, and date in Arabic numerals [ 211 ]. The surrounding frame is the first Venetian woodcut printed with metal type, and the earliest print of classical ornament [ 243 ].

**211**
Woodcut and metal-type title page from Regiomontanus, *Calendarium*, Venice (Pictor, Loslein, and Ratdolt), 1476

**212**
Woodcut frontispiece by
Erhard Reuwich in Bernhard
von Breydenbach, *Sanctae
Peregrinationes*, Mainz
(Reuwich), 1486

These unacceptable innovations began the career of three Germans from Augsburg, where books had been massively illustrated for five or six years. One of the three, Bernard Pictor (Painter), presumably drew and cut the architectural framework, despite its Italian look. (German printers left their taste at home when they took their skills abroad.) The inventive Erhard Ratdolt [ 74 ] probably selected and laid out the information even though he never afterward designed so prophetic a title page in all his subsequent 42 years of printing.

Many grand manuscripts in antiquity and the Middle Ages began with a full-page frontispiece showing the author at his desk. The first elaborate printed frontispiece alluding to the author was designed by the Dutch artist Erhard Reuwich for Breydenbach's *Pilgrimage to the Holy Land* [ 212 ]. The bejeweled lady (Jerusalem) dominates the arms of the author and his two traveling companions. Here, 20 years after the Dutch blockbooks [ 21 ] had introduced shading in parallel lines, Reuwich darkens his shadows by intersecting parallels in two directions to make a grid of crosshatching that complicated the knifework. Reuwich's invention of the allegorical frontispiece was combined with Ratdolt's layout for a title page in 1516 when

Holbein, aged 19, released the imagination of book designers by varying title borders for Swiss publishers. No artist ever invented so many different kinds of title pages: architectural frames with figures, storytelling landscapes, borders of running men and animals, and formal Italianate ornament. His Table of Cebes title border [ 213 ] unfolds the course of man's life in a kind of *Pilgrim's Progress* so picturesquely that he redrew it several times. His widely copied Cleopatra border [ 324 ] started a craze for perspective tricks that led to dizzy assemblages of scaffolding [ 361 ].

When book illustration turned from woodcut to copperplate, the great cost of engraving plus the double presswork usually constricted a book's decoration to an author portrait that could also be sold separately, or to a frontispiece that summarized the text in one gorgeous volley of allegory. For such frontispieces, Rubens perfected the full baroque treatment with figures as heroically round as sculpture [ 429 ]. Curiously enough, Bernini, the virtuoso stone carver, made his frontispieces look like drawings [ 214 ]. The most optical of sculptors, and a magician

**213** Woodcut title border (the picture of human life as described by Cebes) by Hans Holbein, Basel, 1522

**214** Engraved frontispiece after Gian Lorenzo Bernini in Gian Paolo Oliva, *Prediche*, Rome (Varese), 1664–80

with light on marble, Bernini teases the eye with his dog-eared paper that ruffles away in a mist. This witty artifice makes one regret that he condescended to design an engraving only when begged to do so by someone as important as a Jesuit general.

Every title page or frontispiece, according to the Dutch painter Gérard de Lairesse in 1707, absolutely had to include Fame blowing her trumpet. Further, "a frontispiece must 1: please the eye, 2: do credit to the author and the artist, 3: help to sell the book." Separately printed title pages served as posters.

After the title page had absorbed the visual delight of the whole baroque book, it dwindled to a margin of mean moldings in the cold dawn of the Age of Reason, and it has never since regained its glory.

## Milanese woodcuts

Today's Italian publishing, distributed by mechanized transport, centers in Milan, but when printing began, Milan's mule transport could not compete with Venice's water freight. The small editions of old Milanese books were still further reduced by destroying soldiers who kept sweeping down the high-

**215** Woodcut in *Libro de le Batale del Danese* (Ogier the Dane), Milan (Scinzenzeler), 1513

**216**
Christ Takes Leave of His Mother. Woodcut in Giovanni Pietro Ferraro, *Spechio de Anima*, Milan (Le Signerre), 1498

The Man of Sorrows.
Woodcut by Andrea
Solario

way of Lombardy. Milanese woodcuts often copy Venetian ones. The fewer origi-
nals strike the eye with their open drawing and their knifework, which is rougher
and bolder [ 215 ] than what the pressure of production developed in busier Venice
and Florence. Milan's first and greatest picture book is a *Mirror of the Soul*, show-
ing the life of Christ in 76 episodes, many of which are seldom depicted elsewhere.
The rare scene of Christ taking leave of his mother [ 216 ] could have suggested
Dürer's including it among the woodcuts of his Little Passion and Life of the Virgin.

These Milanese cuts are as plain and four-square as the paintings of Ambrogio
Borgognone, who had come home to Milan four years earlier. If, in fact, Borgognone
drew these illustrations, he may also have learned to cut them himself, for the
knifework improves toward the end, instead of worsening like the work of many
professional cutters in haste to be done with a long chore. The cuts show no effect
from Leonardo da Vinci, who had been in Milan for 15 years, but Leonardo's impact
is clear in a large woodcut (15 by 11 inches) by his younger contemporary, Andrea
Solario [ 217 ]. This print is known only in modern impressions from the chipped
and battered block. The ruin makes one regret that big prints and drawings have
always fared worse than little ones.

**Full tide in Venice**     Unlike Florence, with its terse frugality, Venice—*La Serenissima*—flaunted her opulence on expansive pages of ornament in folios sailing forth on ships that brought back paper for printing more folios. Her bulky missals for the use of Salisbury reached England by the fleet that touched at Southampton while making for Flanders each summer until 1532. Early Venetian presses published more books than all the rest of Italy together. Her printers risked few first editions but made the best editions of books that had proved popular elsewhere. Competition reduced the price of printing to one third of that at Rome. Then, in 1596, Pope Clement VII's Index of Prohibited Books suddenly enforced a censorship that collapsed the Venetian industry from 125 presses to 40, reducing the annual average of publications from about 75 to about 35, while the city's applications for copyright slipped from 24 in 1596 to seven in 1597.

But until 1596, Venice created taste for all Europe by modernizing classical ornament for its first splendid use in books [ 211 ] as in architecture. The sumptuous urbanity of her Herodotus border [ 218 ] of 1497 was copied in the first full Renais-

**218**
Woodcuts in Herodotus, *Historiae*, Venice (Gregoriis), 1494

**219**
Woodcuts in *Breviarium Trajectense*, Gouda (Fratres Collationis), 1508

sance decoration for a northern book [ 219 ]. The Venetian masterpiece, when reproduced photomechanically in the 1890s, started Englishmen and Americans designing books like it for the next 30 years. The border's bold flow of black and white encloses a vignette at the bottom. Such tiny, yet uncluttered vignettes had been appearing independently in Venetian books for ten years to become models for Holbein [ 328 ] and to set the scale for French books.

The little Herodotus picture, which may represent Hercules choosing between ease and effort, is one of the first of the Venetian pictorial riddles that abounded from the time of Giovanni Bellini in the 1490s until the Tiepolos of 300 years later. The compactness of the island city may have brought painters closer to poets than elsewhere, or the painters may have become more literary by illustrating so many books.

**Hypnerotomachia Poliphili**   Francesco Colonna wrote his freakish book, *The Strife of Love in a Dream,* for Renaissance snobs who excluded the vulgar by reserving knowledge as the arcane perquisite of a clique. In a practically impenetrable jargon of Latin, Greek, and Italian, he adapted the form of Dante's *Divine Comedy* to an allegorical dream in which Poliphilus (the lover of the antique City) wanders with Polia (the City herself) through minutely inventoried ruins and inscriptions. The author concocted "Egyptian" hieroglyphics by mixing symbols from Roman coins with actual instruments of sacrifice carved on the Temple of Vespasian in Rome [ 220 ]. The motto of the emperor Augustus, *semper festina lente* (always speed forward deliberately) appears as a circle for eternity, a dolphin for speed, and an anchor for deliberation [ 221 ]. The book's publisher, Aldus Manutius, made the dolphin and anchor famous by adopting it as his printer's mark two years later. In wider consequence, the *Hypnerotomachia,* Aldus' only richly illustrated publication, started grandees symbolizing their aspirations by combining an image and a motto in an emblem to represent them like a personal

220  Frieze from the Temple of Vespasian, Rome, dedicated A.D. 81

221  Emblem of Emperor Augustus. Woodcut in Francesco Colonna,
     HYPNEROTOMACHIA POLIPHILI, Venice (Aldus), 1499

222  Emblem of Cosimo de' Medici. Woodcut in Paolo Giovio, DIALOGO DELL'
     IMPRESE, Lyons (Roville), 1574

**223, 224** The dragon. Woodcut in HYPNEROTOMACHIA POLIPHILI, Venice (Aldus), 1499; woodcut in Discours du sonGE DE POLIPHILE, Paris (Kerver), 1546

trademark. Separately, the image or motto would only generally suggest a temperament; together, they strove to describe one individual only.

Such semisecret identifications obsessed the courts and academies of Europe until nearly 1800. Hundreds of manuals and dictionaries associated mottoes with images [ 222 ]; in 1588 emblems composed Pope Gregory XIII's entire biography; in 1640 the Jesuits featured emblems in a huge volume commemorating their order's centennial. The emblem became such an international expression that even the bare symbolic image without the motto (scales of justice, laurel wreath) signaled unmistakably from palace façades or the painted canvas of festival decorations. When the word spoke for the absent picture, it produced the poetry of intricate imagery that we call metaphysical if it is written in English.

The *Hypnerotomachia* woodcuts [ 223 ] look like a more accomplished work by the clean and elegant illustrator of the Venetian Ovid of 1497 [ 232 ], who was perhaps Benedetto Montagna. Such pure outlines were already becoming old-fashioned by 1499, when other woodcuts were being shaded. The illustrator's felicitous invention of solid black accents recurs rarely until they formed a style in the age of Aubrey Beardsley [ 707 ]. Aldus composed his choice illustrations in formations of type that end chapters in the shape of a V or an X. Type and illustration balance with the nearly inhuman perfection of a book elaborated by the precious for the few.

Inevitably, the *Hypnerotomachia* set the taste for private presses the world over, since it was published for a public so restricted that ten years after its appearance the backer still had unsold copies on his hands. At this sad juncture, the French invaders under Francis I seem to have discovered the book, for in 1545 the Aldine press reprinted it with most of the illustrations, though without bothering to shape the type, and in 1546 a French translation came out in Paris with woodcuts exqui-

sitely adapted to the French taste [ 224 ], perhaps by Jean Goujon. The Parisian printer also harmonized picture and type, and with such care that when he made some woodcut initials too dark, he canceled them by pasting lighter ones on top, as if to demonstrate that perfection demands pains in any age.

**Giorgione's twilight**   Just after 1500 Venetians began to dream of youths and maidens musing in the ambiguities of twilight. The painter of this idyllic dusk was Giorgione, and the printmaker was Giulio Campagnola, the only Italian between Mantegna and Marcantonio to engrave distinctively. This elaborately cultivated youth drew deceptive copies of drawings by masters, some of which are now probably hiding under grander attributions. In a signed print [ 267 ] he transposed a Mantegnesque figure and a landscape from Dürer into Giorgione's atmosphere of reverie and Virgilian adolescence. To blur the air, he extended the powdering of dots on the bodies of Dürer's Adam and Eve [ 278 ], stabbing the copper with swarms of specks that cluster or disperse to gather shapes out of the dusk [ 225 ]. He taught 18th-century English etchers to stipple reproductions of sentimental drawings [ 226 ], while the French marshaled the dots into lines to imitate chalk sketches [ 588 ].

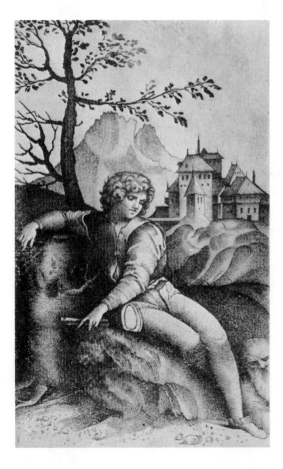

**225**
The Young Shepherd. Stipple engraving by Giulio Campagnola

**226**
Honora Sneyd. Stipple etching by Francesco Bartolozzi after T. H. Benwell, 1784

However, when Campagnola's contemporaries attempted such atmospheric effects in woodcut, their equipment failed them. Woodcutters had to approximate the dots by relief lines cut so close together that the minute pits soon clogged with ink specks from the printer's suede leather balls, and the wooden presses squeezed too feebly to force ink into the troughs between the ridges of the laid paper [ 227 ]. These drawbacks were not overcome until after 1800, when a smooth roller spread ink cleanly, and an iron press struck hard against the uniform thickness of machine-made paper [ 636 ].

**227**

The Annunciation. Woodcut in *Epistole et Evangelii*, Venice (Vitali), 1510

**Etching and aquatint**   When Gothic armor was decorated with oil paint, the bare steel around the paint often rusted down. Perhaps noticing this, armorers after 1400 began to decorate swords by scratching a wax coating with a design, and applying sal amoniac, vinegar, and vitriol for three or four days. Since these corrosives eroded grooves like those plowed by a graver, about 1500 Daniel Hopfer and his two sons, armor decorators in Augsburg, began to etch designs on flat iron plates for printing like engravings. Within 20 years their application of etching (from the Dutch *etsen,* to eat) had spread to Urs Graf in Switzerland, Altdorfer in Regensburg, Dürer in Nuremberg, and Parmigiano in Parma. About 1520 Lucas of Leiden used the modern metal, copper, for more delicate control [ 285 ]. But even the finest etched lines cannot blend into a continuous tone, for if they crowd too close together, the metal walls between the grooves break down, leaving a smoothness that catches no ink. Daniel Hopfer somehow pitted or rusted his iron plates enough to hold a light tone of ink [ 228 ], but the classic approximation of the continuous tone of watercolor wash—aquatint—was not invented until the 1650s in Amsterdam, where mezzotint was also being invented [ 511 ]. The inventor of

**228** Enlarged detail of etched decoration for armor, by Daniel Hopfer, 1520s. A protective coating was brushed on the highlights before the rest of the iron plate was corroded

**229** Oliver Cromwell. Aquatint by Jan van de Velde, after 1653

**230** Enlarged detail of rosin-grain aquatint by Delacroix

aquatint was a certain Jan van de Velde [ 229 ], whose process was then forgotten until Stapart's *Art de graver au pinceau* (1773), and J.-B. Le Prince's more popular *Découverte du procédé de graver au lavis* (1780) revolutionized etching by publishing recipes for aquatint.

Aquatint tone is etched either by dusting the bare copper with rosin, whose specks keep off the acid and become minute caps for microscopic peaks of metal, or else by coating the plate with a ground containing salt or sugar, whose grains admit acid to erode microscopic pits. Both methods roughen the copper to a sandpaper texture that catches ink in a continuous scattering [ 230 ]. Where the acid bites briefly, the tone prints light; where a deeper bite catches more ink, the area prints darker. Each separate tone prints like a hard-edged stratum of deposit, unlike

the hand-pricked stipple tones [ 225 ], which glide from light to dark. English etchers of views [ 376 ] elaborated aquatint to its utmost, and Goya used it more simply for dreams and drama [ 626 ]. In 1640–60, while aquatint and mezzotint [ 511 ] were being invented in Amsterdam, Castiglione in Genoa made one etching in what looks like soft ground—a technique that, like aquatint, was all but forgotten until after 1750.

### Gods and personifications

**Gods and personifications**  Though antique palace scrolls must have illustrated Ovid's graphic anecdotes, later scribes copied only the words. The loss of antique pictures hardly mattered so long as the Middle Ages, valuing symbol above historic fact, clothed Venus and Caesar in local skirts and jerkins. From about 1460 to 75 Ovid's *Metamorphoses* was rewritten to inculcate Christian morals (not always an easy conversion), with directions for dressing up burghers as gods. In the manuscript illustrations and their woodcut copies such local maskers go jolting in farm carts over the cobbles in a Flemish pageant [ 231 ].

Historical correctness began to matter when the Renaissance enthusiasm for archeology demanded to see the gods as antiquity had imagined them. A new age started in 1497 when a north Italian artist (Benedetto Montagna?) invented something like antique dress to illustrate Ovid with the first long series of mythological prints [ 232 ]. These 53 woodcuts supplied immediate copy for artists and artisans. North Italian pottery decorators used the illustrations with such a specialized experience in antique subjects that they aimed the fatal arrow correctly at Achilles'

**231**
Cybele. Woodcut in Ovid, *Methamorphose moralisie*, Bruges (Mansion), 1484

heel [ 233 ] instead of at his back. The still rather fanciful costumes of the Venetian Ovid satisfied the early Renaissance, but as people collected more prints to compare, they judged more critically. 74 years after the Ovid, and again in Venice, the first illustrated manual of mythology specified what the well-dressed god will, or will not, wear at home [ 234 ]. Cartari compiled his social guide to Olympus from antique descriptions, mostly of the outlandish idols that late Roman superstition rummaged from all over the empire. His often conflicting quotations resulted in

**232**
The Slaying of Achilles. Woodcut in Ovid, *Metamorphoses*, Venice (Bevilaqua), 1497. From 1501 edition

**233**
Majolica plate painted by Nicola Pellipario, Castel Durante, about 1520

**234**
Neptune and Ocean. Etching in Vincenzo Cartari, LE IMAGINI DE I DEI, Venice (Valgrisi), 1571

86 etchings that occasionally copy contemporary prints but never go back to the antique coins or sculptures.

Fantasies so wildly hybrid proved handy for poets and indispensable for painters, who copied details the way Beaux-Arts architects were to copy historic doorways and balconies. But though Cartari took care of gods and nymphs, he neglected the personifications increasingly needed by the learned art of mannerism and the baroque. How should an artist draw Pity—like a naked, newborn babe, striding the blast? What color should he use for Fame—painted full of tongues? After 1603 he could look up such matters in the first illustrated dictionary of 150 personifications [ 235 ], compiled by Cesare Ripa of Perugia "for the use of orators, preachers, poets, painters, sculptors, draftsmen, or any educated man, and convenient for planning decorations for weddings, funerals, and triumphs."

Since personifications, unlike the gods of antiquity, change as ideas change, Ripa's *Iconology* evolved through successive editions to German rococo elaborations [ 236 ] that the original author would never have recognized as his. Editions of Ripa are listed in every studio inventory until the French Revolution, along with Cartari's *Images of the Gods,* Vignola's *Five Orders of Architecture,* some book on

**235**
Beauty. Woodcut in
Cesare Ripa, NOVA
ICONOLOGIA, Padua
(Tozzi), 1618

**236**
Terror. Etching after Gott-
fried Eichler II in Cesare
Ripa, *Sinnbilder*, Augsburg
(Hertel), about 1760

perspective, and some version of Vesalius' *Anatomy*. About 1670 Ostade etched a painter who has propped one of these books open beside his easel to support his imagination the way his maulstick supports his hand [ 506 ].

## Illustrations for architects

Vitruvius, a minor Roman architect and engineer who worked under Augustus (27 B.C.–A.D. 14), compiled the only surviving ancient builder's manual by quoting from lost Greek treatises and by describing building methods out of his own practice. When the Renaissance studied his handbook and published it in 1486, it stopped the free experiments of medieval builders by imposing architectural laws that regulated the next four centuries. Italians printed his unillustrated manuscript without pictures until the fourth edition in 1511 started architectural illustrations in print. Ten years later the first translation into a modern language (Italian) drowned Vitruvius' text in an ocean of commentary flowing out of Leonardo da Vinci's discussions in Milan. The annotator surprisingly drew Milan Cathedral [ 237 ], on which he had worked as an architect,

**237**
Façade and section of Milan Cathedral. Woodcut by Cesare Cesariano in Vitruvius, *Architectura*, Como (da Ponte), 1521

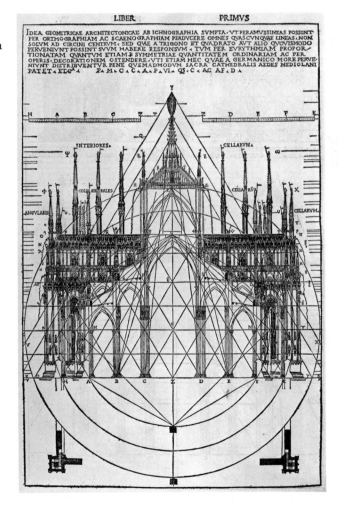

to show that the old "*Germanici architecti*" had proportioned their Gothic building by the same triangle, square, and circle that Renaissance theorists, elaborating on Greek and Roman architects, venerated as the perfect geometrical figures. These first printed renderings of an elaborate Gothic building helped to keep Gothic respectable in Italy until its revival in opera scenery shortly after 1700.

In 1537 Sebastiano Serlio, a Venetian architect who may have built even less than Vitruvius, started to issue the first architectural books ever illustrated by their author. He began by publishing Vitruvius' foundation of design, the five orders of columns and entablatures, and then proceeded to original projects [ 238 ]. When Francis I employed Serlio at Fontainebleau, he re-Romanized France by replanting classicism in what was to become its second home.

The canonical five orders were summarized in the simplest, and therefore most

**238** Two Shops under a Palace. Woodcut by Sebastiano Serlio in his REGOLE
GENERALI DI ARCHITETURA, Venice (Marcolini), 1537

**239** The Corinthian order. Engraving in Giacomo Barozzi da Vignola, REGOLA
DELLI CINQVE ORDINI D'ARCHITETTVRA, Rome (Vignola), 1562

**240** A country house. Woodcut in Andrea Palladio, *I Qvattro Libri Dell' Architettvra*,
Venice (Franceschi), 1570

used, rules of thumb by the severe Vignola, whose Roman church of the Gesú
became the model for many Jesuit churches in Europe and the Americas. Vignola
crystallized Vitruvius' rambling memoranda in diagrams with engraved captions
[ 239 ] so terse that even unlettered workmen could assemble the classical building
blocks—column, capital, entablature—in ways that could not avoid some conso-
nance and might achieve beauty. Musicians followed a later parallel course by
agreeing on sequences of keys, refrains, and recapitulations with which they could
compose speedily and at the very worst coherently. The countless adaptations of
Vignola's pictorial syllabus fixed columns to all formal façades until steel construc-
tion revolutionized proportions a while after musicians had abandoned their old
prearranged signals.

Gentlemen became their own architects when Palladio offered further guidance
to organize the classical units into harmonious exteriors and imaginative sequences
of spaces [ 240 ]. Palladio himself designed for the Venetian patricians who were
then settling newly drained marshes to enjoy the refined rustication praised by
Horace, Pliny, and Varro. Wherever men—Englishmen, Russians, or Virginians—
have dreamed of Horatian cultivation, they have turned to Palladio's designs for
their serene blend of beauty and use. He flanked his houses, for instance, with

TA: XV.

Die schöne Sinesische Pagode, vor dem Stätt-
lein Sinkicien in der Provinz Xantum gelegen.

La belle Pagode prés de la petite Ville de Sinkicien
dans la Province de Xantum.

**241**
A Chinese pagoda.
Etching in Johann
Bernhard Fischer
von Erlach, *Entwurff
Einer Historischen
Architectur*, Vienna
(Fischer), 1721. From
1725 edition, Leipzig

**242**
The Theseion. En-
graving in James
Stuart and Nicolas
Revett, *The Antiqvi-
ties Of Athens*, Lon-
don (Haberkorn),
1762–94

colonnades to embellish them, to walk under out of the sun and rain, and to store root vegetables and firewood.

In 1721 Fischer von Erlach, obsessed by the Germanic ambition for comprehensiveness, collected buildings from the whole world in the first general survey of architecture, gathered, according to the English translation, "from the most approv'd Historians, Original Medals, Remarkable Ruins, and Curious Authentick Designs" [ 241 ]. His 90 large engravings put Chinese pavilions in every park and supplied stage designers with exotic fancies but left historians still thinking that Greeks had copied Etruscans. This Italian partiality was set right when two Englishmen published the first measured renderings of Greek temples [ 242 ], starting a Greek revival that extended Doric porticoes from Saint Petersburg to Cincinnati. By 1850 so many books had illustrated historic masterpieces that 19th-century architects could imagine beauty only as the past rearranged, thus debarring themselves from originality except in problems to which the past hardly applied, such as warehouses, factories, and railway stations.

**Grotesque ornament**   About the time of Christ, the old-fashioned architect Vitruvius deplored that the traditional wall paintings of realistic landscapes and factual renderings of stonework had been supplanted by "monstrosities—pediments sprouting stalks that uphold half-figures with human, or even animal heads." This controversial modern style decorated Nero's Golden House in Rome [ 243 ]. When Nero died (A.D. 68) his newfangled extravaganza was razed to its basement vaults, on which a terrace was laid. By the later 1400s, breaks in the vaults allowed artists to slide down the debris into chambers known as *grotte*, where they copied the fanciful designs on the walls and ceilings, calling them *grotteschi*.

One grotesque scheme, the tall wall panels of balanced branches springing out of a central stalk, had already been adapted from other sources in a Venetian wood-

**243**
Painted vault in Golden House
of Nero, Rome, A.D. 64–68

244 (LEFT) Grotesque ornament. Engraving by Zoan Andrea after the Master of the Sforza Book of Hours, 1490s

245 Grotesque ornament. Engraving by Cornelis Bos, Antwerp, 1540s

246 Cleopatra. Etching by Jean Mignon after Luca Penni

cut of 1476 [ 211 ]. The example of the Golden House elaborated these vertical strips to decorate the side margins of manuscripts with panels that engravings [ 244 ] published for all to use. By 1519 the most generative version of the Golden House ceiling grotesques was frescoed under Raphael's direction at the Vatican in the Logge, a sort of upstairs verandah. Raphael varied Nero's reed gazebos to fit so many useful shapes that traveling artists sketched his frescoes more than the antique originals and engraved their own adaptations of them in Germany and France. There the framework of the grotesque replaced Gothic leaves as a habitat for the robust hybrid monsters that the north of Europe had been inventing during the 1000 years since the age of migrations. In Flanders the crossbred Gothic drolleries moved into cages that caught them like the stocks [ 245 ]. At Fontainebleau, the stucco modelers invented curving slabs where slim nudes exercise as in a jungle gym [ 246 ]. The slabs straightened into dizzy carpentry in French books on perspective [ 361 ]. Indeed, the French took such a liking to this mixture of structure and caprice, of logic and whim-wham, that they played with the grotesque until nearly 1900 and may still return to it some day.

## Books of hours

While Venetian folio missals were sailing to priests in faraway ports, Parisians printed handy little prayer books for families in and near France. These laymen's books of hours contained a calendar with doggerel verses for the labors of the months, often an anatomical man to show where to bleed a sufferer under each zodiac sign [ 84 ], readings from the Gospels, the seven canonical hours of prayer to the Virgin from matins to compline, special masses for the dead, and sometimes, for humbler traditionalists, prayers to local saints.

Surviving books of hours rarely agree exactly, since small dioceses often ordered only a few dozen copies, which printers made up by adding sheets of special prayers to a bulk printing of the standard parts of the book in the use of Rome. Many copies were printed on vellum to stand handling in daily reference. Carried to mass like hats and gloves that neighbors also discussed, prayer books changed fashions more sensitively than other French books. No one knows how many editions Paris printed from about 1480 to 1540, but some 1400 have survived, though often reduced to a single copy. The founder of the industry, Jean Dupré, was probably

**247** Metal cuts in the style of Jean Dupré in *ghetyden*, Antwerp ([Liesvelt]), 1496

**248** Woodcuts in *heures par le cōmendēt du roy*, Paris (Vérard), about 1490

printing prayer books before 1480; their existence can be inferred from blocks of copper nailed to wood that he reused in his missals of 1481, and from other cuts in his style that wandered out to Venice and Antwerp [ 247 ].

Most family prayer books fit the pocket, but some were tall and thin like tiny ledgers, and some exceptionally big *Grandes Heures Royales* [ 248 ] were printed after 1489 at the king's order for Antoine Vérard, the richest French publisher. His firmly outlined cuts avoided shading to facilitate printing them in the vellum presentation copies that were Vérard's specialty. He often copied his prayer-book cuts from the most elaborate of all the books of hours, printed in the 1490s by Philippe Pigouchet for Simon Vostre [ 249 ]. Horae borders agree with each text or illustration, to help slow readers find their places. Thus the Virgin's Dormition, Funeral, and Assumption surround her moment of triumph when her newborn son is adored by shepherds, who are labeled with the names they bore in miracle plays [ 249 ].

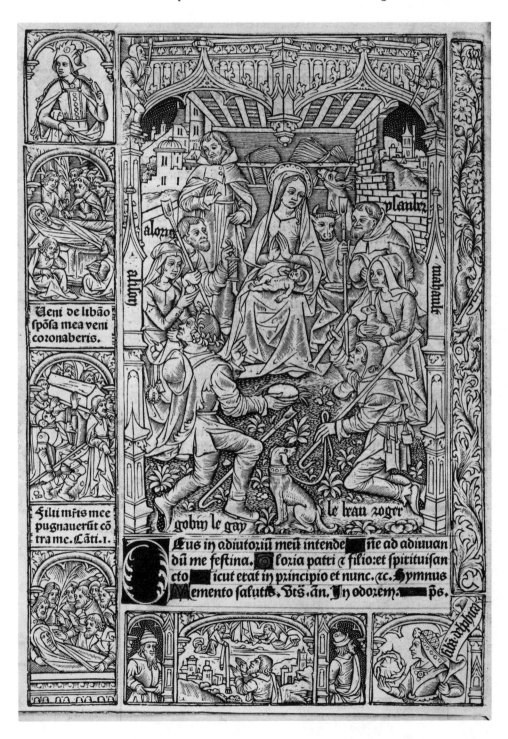

The few foreign imitators of such prayer books succeeded in rivaling the Parisian unity of taste only in Venice. There the printer de Sanctis, a cutter of saints' images, transposed the French layout into Italian Renaissance ornament so exquisite [ 250 ] that it captivated a traveling French designer, grammarian, and reformer of spelling, Geoffroy Tory. When Tory returned to Paris around 1518, he found the Parisian books of hours shaded even more muddily than Strassburg woodcuts [ 56 ]. He reintroduced clarity in 1525 by adapting the 30-year-old Venetian adaptation of Parisian prayer books [ 251 ] and combining the unshaded Venetian outlines with the black accents of the *Hypnerotomachia* [ 223 ], both long out of fashion in Venice itself. He thus killed the Gothic book in France by launching the Italianate balance that was henceforth to formalize French official art with the chill of perfect taste. During the next 15 years, Tory also adapted Flemish manuscript borders of fruits and flowers [ 182 ]. Tory replaced the old Gothic coziness by synthesizing impersonal elegance just when the circulation of prints was internationalizing art, and Rome was imposing uniformity on the Catholic world. The last graceful personal prayer book was Queen Elizabeth I's adaptation of the Parisian format to Anglican use in 1569 [ 252 ].

Ad sextam Versus.

Eus in adiutorium meū intende. R̃.D omine ad adiuuandū me feſtina. G loria patri, & filio,& ſpiritui ſancto. S icut erat in principio,& nunc,& ſemper,& in ſecuſa ſeculorum. Amen. Alleluia.    Hymnus.

F.iij.

**250** (OPPOSITE PAGE, LEFT)
The Annunciation. Woodcut in HORAE, Venice (de Sanctis), 1494

**251**
The Adoration of the Magi. Metal cut in HORAE, Paris (Tory), 1525

**252** Typesetter and printer. Metal cuts in *A Booke of Christian Prayers*, London (Day), 1569. From 1590 edition

Printing had begun to level the heterogeneous particularity of parish traditions even before the papal bull of 1571 formally purged prayer books of local idiosyncracies and stripped them to their present interchangeable austerity. The wholesale obsolescence of the old local prayer books created a sudden market that established the fortunes of the Plantin press in Antwerp through its monopoly of church books in Flanders and Spain, making it the busiest book factory before 1800.

**Royal progresses** At the end of the Middle Ages strong sovereigns centralized Burgundy, France, Spain, and England by absorbing feudal domains and provinces. While it was all very well for a supreme ruler to be crowned in some cathedral, people at large heard little about this and could be impressed only by seeing their new prince in the flesh. So each new sovereign had to tour his cities. In Flanders, the cities invested in elaborate street decorations for confronting their new ruler with pictures and inscriptions that bound him to respect their traditional rights and begged for new favors. As if to ratify such contracts by allegory, the city of Ghent in 1508 appropriated five guilders to print 300 copies of an illustrated record of the decorations that greeted the boy who would become Charles V. If this book was ever printed, it has vanished now. The first extant printed illustrations of such bluntly contractual decorations record Charles' reception into Bruges in 1515. The local presses in Bruges were too provincial to do honor to such an occa-

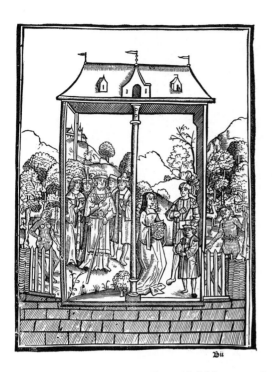

**253** Painted folding panels. Woodcut in Rémy Dupuy, *La tryumphante entrée de . . . Monsieur Charles*, Paris (Gourmont), 1515

**254** Gateway to tournament lists designed by Philibert Delorme. Woodcut by Jean Goujon in C'est l'ordre qui a este teNU A LA NOUVELLE ET JOYEUSE ENTREE . . . *Henry Deuzieme*, Paris (Roffet), 1549

sion, and the town hated Antwerp, the nearest great printing center, so the book was printed in Paris. Charles was 15—the age of reason—when he entered Bruges to inherit the first major installment of his far-flung empire. Pushing his way through thousands of torches in the April twilight, he saw broad canvas paintings like medieval altars being opened for him. (They were probably hinged to close in case of rain.) Each one balanced a scene from the Old Testament or Roman history with an event in the history of Bruges to warn the beginning emperor to be good to his city. In one painting [ 253 ], Joshua apportions the Promised Land on the left while Bruges is founded on the right, thus requesting Charles to restore the power that the city had lost to Antwerp when its harbor silted up.

Such frank demands and Gothic diptychs gave way to servility and Renaissance ornament 30-odd years later when the Valois kings tightened their grip on France and issued the first long series of publications for ostentation. When Henry II entered Paris in 1549, the sculptor Jean Goujon was paid 45 livres to draw the woodblocks of arches and set pieces that leading artists had designed. The arch shaped like an H for Henry looks huge in the cut [ 254 ] but was actually a mere 24 feet high.

Triumphal arches taller than their marble models in Rome could be built only by

an exceptionally rich city like Antwerp. Here, in the spring of 1635, when the brother of Philip IV of Spain sailed up the Scheldt as governor of Flanders, he saw the river banks and all Antwerp built up with canvas arches [ 255 ] whose scale is proven by some of the earliest surviving fragments of actual festival decorations, two life-size portraits from Rubens' studio [ 256 ]. Antwerp's painted splendors may have been the most enormous since Roman times, in complete contrast to Amsterdam's studied indifference when Queen Henrietta Maria came to beg for funds to finance Charles I's losing fight with the Roundheads. Why, one wonders,

**255** Arch of the Infante Ferdinand. Engraving after Rubens in POMPA INTROITUS FERDINANDI, Antwerp (van Tulden), 1642

**256** Philip IV of Spain. Painting by Rubens and assistants from a triumphal arch at Antwerp, 1635

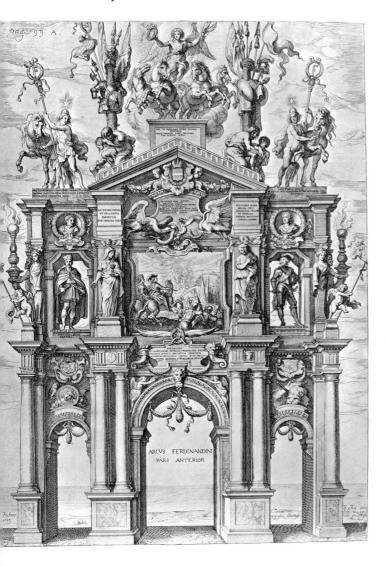

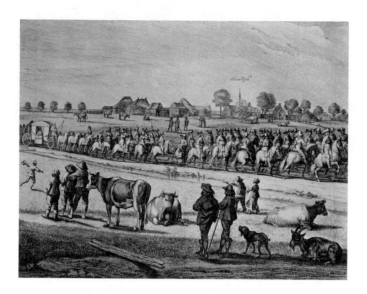

**257**
Henrietta Maria
Enters Amsterdam,
May 1642. Engraving
after Paul Potter

did the city choose to record its scanted courtesy by engraving [ 257 ] the queen's coach jolting past a reception committee of Dutch cows?

The great age of royal receptions closed with the French Revolution. In 1810, when Marie Louise traveled from Vienna to Paris to marry Napoleon, her correct and uninteresting triumphal arch was published, not in an imperial folio, but in the trade catalogue of a manufacturer of composition ornaments, where it figured as a testimonial that his decorations could stand the weather for over a year. Nowadays, when a chief of state impresses himself on the public more through radio and television than by traveling about in person, ceremonial entries mark only a few international visits of good will. The modest scale of today's setting goes back at least to 1844 when Louis-Philippe returned a visit from Queen Victoria to patch up political differences over Egypt [ 258 ]. Less upholstered railway carriages have served for similar talks in our time.

**258**
Louis-Philippe, Queen
Victoria, and Prince
Albert. Lithograph in
VOYAGE DE S.M.
LOUIS-PHILIPPE
A WINDSOR,
Paris (Pingret), 1846

**Dürer's four horsemen**    After the Black Death in the mid-1300s had killed about half of Europe, the survivors and their descendants for generations dreaded the Last Things predicted in the Apocalypse. Death's engulfment revived a very old cycle of about 50 pictures of the end of the world, which included the four terrible horsemen released by breaking the seals of pestilence, war, famine, and death. The vast Angers tapestries of the Apocalypse, woven in northern France after 1376, were designed from a manuscript tradition [ 259 ] then at least two centuries old. The Apocalypse cycle was published for everybody everywhere through many versions of a blockbook of woodcuts that centuries of experiment had refined to a serene assurance [ 260 ]. The momentum of this tradition made the Apocalypse the only book that New Testaments printed in Germanic dialects illustrated before about 1670. For pictures of the life of Christ, people looked instead at the blockbook *Bible of the Poor* [ 21 ], then at its typographic enlargement in the *Mirror of Man's Salvation* [ 22 ], and finally at the *Postils:* New Testament homilies arranged as they are read in churches during the year.

**259**
Painting in manuscript Apocalypse, Netherlands, 13th century

**260**
The Four Horsemen. Woodcut in blockbook Apocalypse, France or Flanders, early 15th century

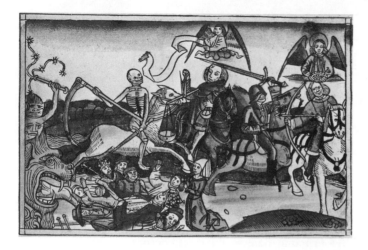

**261**
The Four Horsemen. **Hand-colored** woodcut in Bible in German, **Cologne** (von Unkel), about 1478. From **1483 edition**, Nuremberg

Pictures for the Old and New Testaments in German translations were fixed by the 123 woodcuts of the first richly illustrated Bible, printed at Cologne about 1478, probably for the Brothers of the Common Life. These woodcuts [ 261 ] transmitted a German manuscript tradition to the boy Dürer, who was about seven when they first appeared at Cologne and 12 when they were reprinted near his house in Nuremberg. They represented the Bible itself to him as they lodged in the center of his imagination like grains of sand to produce one pearl after another. Their very

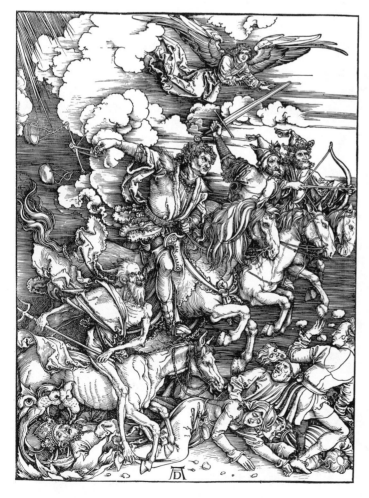

**262**
Woodcut by Dürer, about 1498

**263**
Woodcut by Hans Burgkmair in New Testament, translated by Luther, Augsburg (Otmar), 1523

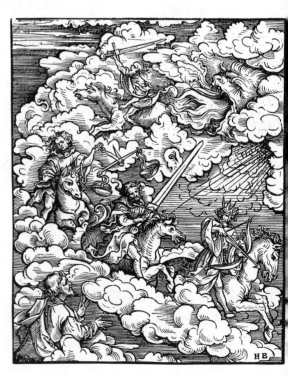

crudity encouraged him to improve upon them, when more accomplished models might have discouraged him. On them he based the 15 woodcuts of the Apocalypse that he published when he was 27 [ 262 ]. At 19 he had finished three years of learning to draw and cut woodblocks as an apprentice in Wolgemut's shop, Nuremberg's center for book illustration. When he was 22 or 23 he copied Mantegna's engravings [ 187 ] to acquire the grand manner of figure drawing, and the clear and forceful massing of forms. With the Gothic and Renaissance traditions thus funneling into him, he transfigured the hints of the crude Cologne cuts into the first pictures of violent action since the German Romanesque illustrations. His Apocalypse charges a symbol with experience. The first woodcuts initialed by a great artist, their fame made his AD the first artist's signature to be extensively faked. For us, his four horsemen exhaust a theme in the way Raphael exhausted the theme of the Madonna and Degas the ballet dancer.

Dürer's followers, dodging around him, harked back to the horsemen in the Cologne Bible because it illustrates the text more literally by stringing out the riders as the seals break them out one by one. A year after Luther published his translation of the New Testament, Burgkmair's civilized simplification of Dürer [ 263 ] cleared away clutter in an arrangement like the Cologne cut. Burgkmair had grown up in Augsburg imbibing an Italianism that Dürer, farther north, had to struggle toward all his life without ever absorbing some of its essentials. While the white heat of Dürer's imagination fused profusion into a masterpiece, creating the taste by which the future would enjoy him, Burgkmair floated more naturally in the mainstream of art. In 1534, when Luther got around to supervising illustrations for his translation of the whole Bible, he had Lucas Cranach II modernize the first three

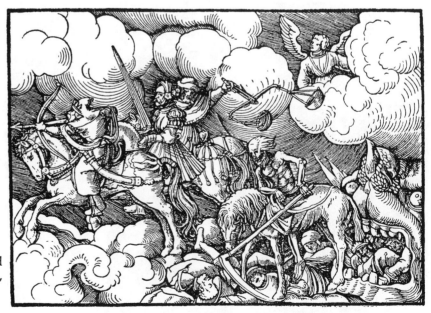

**264**
Woodcut by the Cranach
workshop in Bible, translated
by Luther, Wittenberg (Lufft),
1534

horsemen [ 264 ] into a Turk, a German knight, and a Jew. He let them trample on no crowned heads, for he did not forget that only princely protection had saved him from being burned at the stake.

**Dürer in Italy**   Although Dürer was not the greatest 16th-century artist, his personality lorded it over every 16th-century printmaker except Ugo da Carpi [ 347 ] and Parmigiano [ 350 ]. His restless investigations and his worldwide awareness make him enough of a puzzle without the smokescreen of incense from his German worshipers. Yet some traits stand out clear, such as his relentless economy of energy that produced so many elaborate creations in his 57 years, and his workmanlike practicality. When he was about 25 he standardized his prints in upright formats to fit economically on whole, half, or quarter sheets of paper that he marketed to all Europe. When he was 26 he dated his first print 1497, and when he was

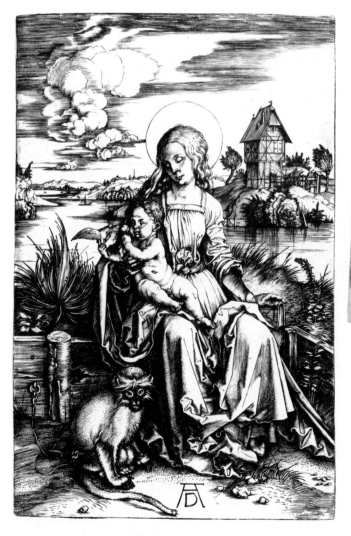

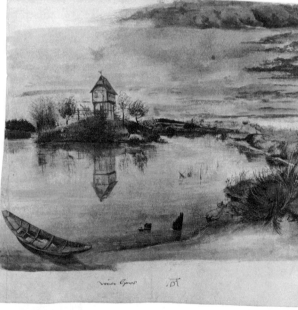

**265**
The Madonna with the Monkey. Engraving by Dürer, about 1498/99

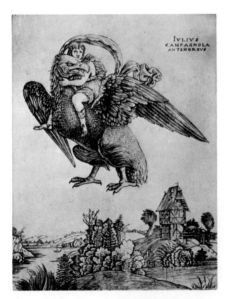 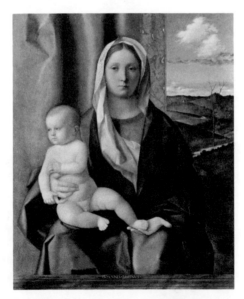

33 he began regularly to combine dates with his monogram AD as a pun on Anno Domini. He is thus the first printmaker whose development we can follow continuously. He is also the first artist from whom we have letters to a friend and a diary of travel expenses.

He visited Venice in his mid-20s and again in his mid-30s, taking from Italy more than any previous northern artist, and returning more. In Venice he saw Madonnas by Mantegna [ 193 ] and Giovanni Bellini, who do not hold a wizened homunculus like northern Virgins [ 47 ] but a boy whose ampler plumpness fits better with an adult. Between his two Venetian visits, Dürer engraved such an Italianate group [ 265 ] next to a monkey that he probably also met in Venice and against a background that he had noted at home in one of his earliest watercolors [ 266 ]. This half-timbered tower in a pond looked as exotic to Renaissance Italians as Chinese pagodas were to look to 18th-century Europeans. In Venice, Giulio Campagnola copied the whole setting of this wooden storehouse [ 267 ] as though it were a rare sketch brought home by a Venetian from an expedition to mainland meadows. In Florence the German half-timbering amused the fluid and receptive Robetta [ 146 ], searching for ready-made backgrounds to combine with figures copied from Filip-

**266** (OPPOSITE PAGE, RIGHT) The Gunpowder Magazine on the Weir, Nuremberg. Watercolor by Dürer, 1495–97

**267** (ABOVE, LEFT) Ganymede. Engraving by Giulio Campagnola, Venice, about 1500–1515

**268** The Madonna. Painting by Giovanni Bellini, about 1504

pino Lippi. Italians did not copy Dürer's Madonna and Child (Italianate though he may have thought them) the way the first Florentine engravers copied figures from ES [ 143 ]. The only great Italian to accept what Dürer had made of the Venetian figures was Giovanni Bellini, who smoothed Dürer's fussy complexities into the larger calm of Italy [ 268 ]. He obviously shared the Italian opinion that northern figures, especially nudes, were an Italian specialty misunderstood by barbarians. However, his Gothic resourcefulness in breaking the folds of drapery recommended his prints much later to Veronese and Guido Reni.

Dürer had more thoroughly absorbed the Italian vision in his last, and perhaps greatest Gothic dream of the Christian knight braving the Valley of the Shadow [ 269 ]. Only a supreme artist could have evoked so haunting an image out of a literary commonplace. Dürer copied the armor from his watercolor painted 15 years before of a middle-aged man loitering on a plow horse. This prosy notation took on drama in the engraving from the example of Verrocchio's bronze statue of Colleoni [ 270 ], which was being finished when Dürer first went to Venice. Both Verrocchio and Dürer modeled their stallions on the antique bronze horses of Saint Mark's. Dürer, who often worked at either end of his Gothic-Italian world, for

**269** (OPPOSITE PAGE) The Knight, Death, and the Devil. Engraving by Dürer, 1513

**270** Bartolommeo Colleoni. Plaster cast of bronze statue by Andrea Verrocchio, Venice, cast 1496

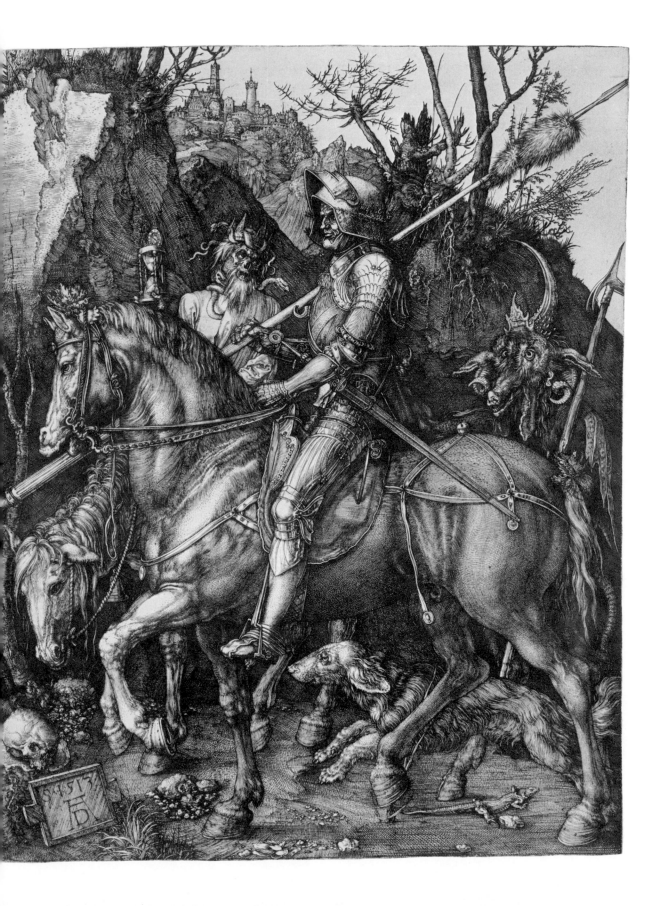

once brought both unforgettably together in this engraving. He had enriched his technique in the 15 years since the Madonna with the Monkey, when he was still following Schongauer's clear and simple structure. In the Knight, Death, and the Devil, his 70th work on copper, he elaborated strokes, flicks, and dots to distinguish steel, flesh, glass, and fur with textures as specified for specific purposes as the categories of brushstrokes in Chinese painters' manuals. Such wizardry discouraged all subsequent serious painters from ever attempting a real mastery of the graver, which now became the exclusive tool of specialists in reproducing other men's pictures. Dürer established and imposed the basic grammar of engraving, suffocating those close to him, but providing a guide for those lucky enough to live at some remove, like the Little Master engravers of the next generation [ 315 ].

## Dürer's print styles

Dürer mastered the techniques of woodcut, engraving, etching, and drypoint, invented modern watercolor, and drew in every medium except red chalk. By being the only artist so versatile, he completed the transformation, begun by Mantegna and the Housebook Master (Reuwich?), of entirely freeing printmaking from its craft origins. After Dürer, printmakers were trained by drawing, not by working in wood or metal, and all the different kinds of prints fused together under the leadership of painters. Dürer used all of his print techniques except drypoint (learned from the Housebook Master) over a stretch of seven years for four versions of Christ's Agony in the Garden, an image of isolation that must have moved a man forever struggling alone. He engraved his first dated version [ 271 ] when, at 37, he was beginning to dominate German art. His engraving style had already moved away from Schongauer's contrasts of dark hatching and white paper to a painter's allover tone, where shadows cling to silvery modulations emerging into the light. The contrapuntal graver constrained his hand to meditate and plot. Yet the ambiguous stance of Christ—neither quite standing nor quite kneeling—has a wild power that inspired El Greco a century later in what was possibly his last painting [ 272 ].

Though Dürer's engravings traveled far and wide, his woodcuts may have gone even farther, because more of them could be printed for less money. About 1509, or perhaps earlier, he began his most popular series of woodcuts, the Little Passion. The first try of the series may have been a version of the Agony in the Garden [ 273 ] that he rejected, evidently because it was cut in the sloppy way that he condemned as "bad woodcut work." Yet the original drawing must have charged the Christ, flat on his face, with the Gothic intensity that drove Dürer during his 20s in the Apocalypse [ 262 ]. When he published the Little Passion in 1511, he replaced this desperate image with a more tranquil one cut exactly to the personal quirks of his line [ 274 ]. This later design has the stateliness acquired by the em-

271 The Agony in the Garden. Engraving by Dürer, 1508

272 St. John Beholding the Wonders of the Apocalypse. Detail of painting by El Greco, 1610–14

273 The Agony in the Garden. Woodcut by Dürer, about 1509

274 Woodcut by Dürer in the Little Passion

**275** The Agony in the Garden. Quill drawing by Dürer, 1515

**276** Etching by Dürer, 1515

peror Maximilian's official artist after he began the imperial woodcuts that still enact the Hapsburg dream of glory.

Yet all his young energy returned to him once again in his 40s when he became the first great artist to experiment with the new medium of etching. He etched only six plates, probably because the acid bit the iron too raggedly to suit his demand for exact detail. But just because etching on iron prevented him from finishing minutely, it loosened all the free fury of his swiftest sketches. When he copied his impulsive pen drawing [ 275 ] onto the etching plate [ 276 ], he did not, like most artists, sober the emotion; he intensified it.

Dürer suits us best today when he dares his wildest arabesques, for he was the giddiest doodler in all art. His speed in scratching the etching plate set free the ecstasy that he rightly considered his rarest gift when he wrote that "what one artist sketches with a quill in a day may outdo what another will labor over for a year."

**Dürer's figures**   Dürer recalled that during his youth the Venetian painter and engraver Jacopo de' Barbari "showed me the figures of a man and a woman which he had drawn according to a canon of proportion. I would rather have seen what he meant than see a new kingdom." Actually Barbari confessed anatomical ignorance in the slack and mannered grace of his figures [ 277 ], but he teased Dürer into a lifelong search for a nonexistent formula. Had Dürer met Leonardo da Vinci instead of Jacopo de' Barbari, the Florentine would have shown him that Italian nudes achieved beauty by functioning like mechanisms of pivots and levers. Mantegna would have shown him the antique sculptor's structure of bulk that overrides details. But since copying Leonardo's drawings and Mantegna's engravings did not teach Dürer the logic of function and structure, and since he probably had a horror of watching the dissections that underlay most Italian figure drawing, he went to work in his own methodical way by measuring men, women, and children with calipers to plot their exact outlines [ 281 ]. In time he came to see outlines before he saw the form within, so that each separate thing explodes against its bounds, and the distinctness of details fragments the whole. His search for the ideal

**277**

Apollo and Diana. Engraving by Jacopo de' Barbari

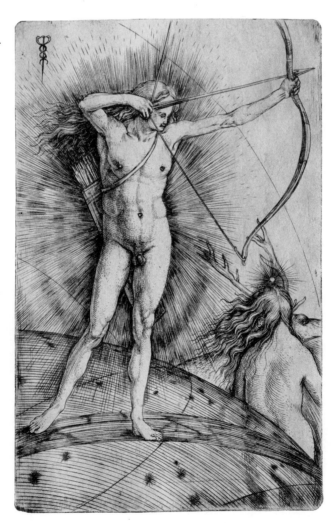

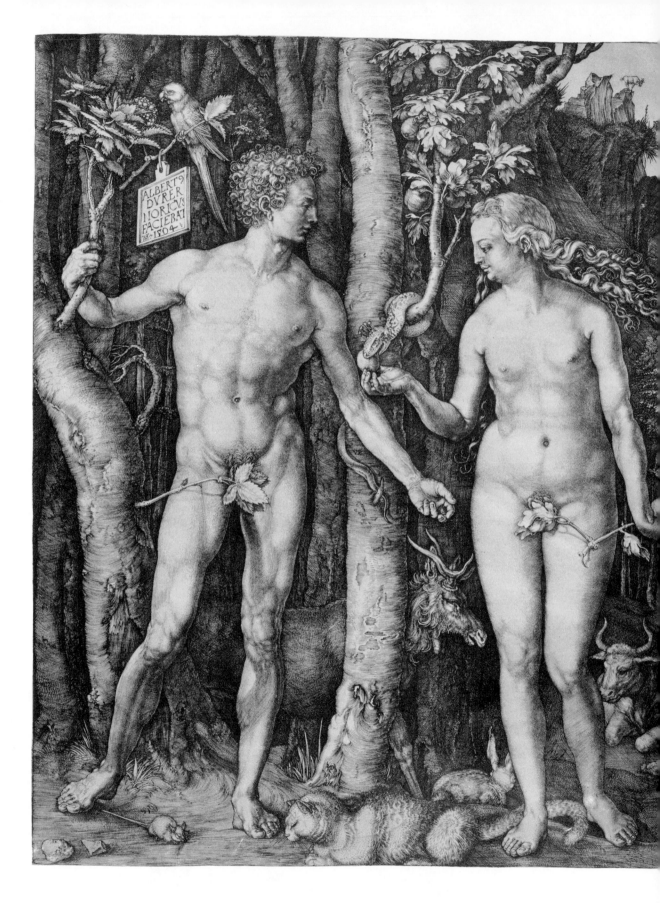

nude led him to engrave Adam and Eve, God's own personally made patterns of beauty [ 278 ]. He must have thought that here he could challenge the Italians at their own instructive specialty of figure drawing, for he signed this one print only with his full name and address, the way Pollaiuolo had signed his anatomical pattern sheet, the Battle of the Naked Men [ 184 ]. Adam's gesture and proportions recall the Apollo Belvedere [ 279 ], unearthed in Rome a quarter century before and already the supreme model of male beauty that it continued to be until about 1800. Since Dürer probably never saw Rome, he must have known the marble through a drawing of it glimpsed in northern Italy, or shown him by Jacopo de' Barbari. He engraved the Adam and Eve with such caution—one might say trepidation—that he finished the entire background before he got the courage to sneak up on the figures, around which he reserved an aura of blank to allow him to fatten them if need be [ 280 ]. He may have known the saying of Polycletus, that beauty depends on adjustments the thickness of a fingernail. Though Dürer modeled the flesh with a powdering of dots and flicks of a delicacy never seen before, however often attempted since, the engraving fails to satisfy because he was striving too tensely to achieve his masterpiece. Details steal the show, like the mouse playing by the cat's claws in the closing instant of the world's innocence.

**278** (OPPOSITE PAGE) Adam and Eve. Engraving by Dürer, 1504

**279** The Apollo Belvedere. Roman marble copy of Greek original

**280** Adam and Eve. Engraving by Dürer. Unfinished state

**281**
The well-proportioned man.
Woodcut by Dürer in *von
menschlicher Proportion*,
Nuremberg (Dürer), 1528.
From 1532 edition

As Dürer grew older, he studied human proportions more and more. His 30 years of researches appeared just after his death in a book with woodcuts of a startling pedantry [ 281 ]. His treatise became the first study in visual statistics, as he tabulated the proportions of 200 or 300 humans by measuring them in units of 1/600 of their height, as if to reach beauty through arithmetic. The involutions of his method gave it the authority of the arcane, and the dogmatism of his book did much to slacken the instinctive energy of the German Renaissance.

**Portrait engraving**   After Alexander the Great, rulers began to circulate their portraits on coins, where only gods had been before. The first sovereign to consider censoring printed portraits was Queen Elizabeth I, who, when she was 30, drafted an edict that she apparently never issued. Aware of her womanly presence, she decreed that copies of an official portrait by "some speciall coning payntor" should replace the "deformed" ones then being made by "paynting, graving and printing."

The first printed portrait of a living private individual was the profile of an author in a Milanese book of 1479. Italian books followed it with many portraits of artists and intellectuals. The intellectual began to be publicized in single-sheet prints when Cranach made three engravings of Luther in 1520/21 [ 299 ], and Dürer engraved Willibald Pirckheimer and the reformers Erasmus and Melanchthon [ 282 ] in 1524 to 26. Dürer had been making portraits ever since he drew

himself in a mirror as a boy of 13, and he may have cast his very longest influence through his six engraved portraits of men, one made just before he traveled to the Netherlands, the other five soon afterward. His study of Flemish painting and his realization of his own world importance combined to invest these last engravings with a haunting authority. In the best of them his overpowering personality felt inspired to cast a spell that engulfed his sitters, making every man hanker to be thus dramatized. These prints founded a profession of portrait engraving that became one of the best paid and most dependable specialties of printmaking until about 1900.

Dürer drew important and impatient people quickly by looking through a fixed eyehole to trace the outline on a pane of glass [ 283 ]. But to publish portraits profitably, the printmaker had to speed up production as well as preparation. This was

**282** Philip Melanchthon, aged 31. Engraving by Dürer, 1526

**283** A Drawing Machine. Woodcut by Dürer in *Underweysung der messung (A Course in Measurement)*, Nuremberg (Dürer), 1525

1526
VIVENTIS·POTVIT·DVRERIVS·ORA·PHILIPPI
MENTEM·NON·POTVIT·PINGERE·DOCTA
MANVS

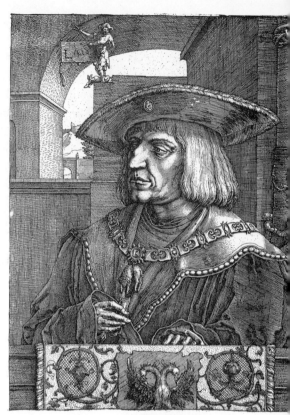

**284** Emperor Maximilian, aged 59. Woodcut by Dürer after a drawing made in June 1518

**285** Etching and engraving by Lucas of Leiden, 1520

accomplished when Lucas of Leiden copied Dürer's woodcut of Maximilian [ 284 ] to put a print [ 285 ] on sale while the emperor's death, in 1519, was still news. Lucas rapidly etched most of the picture, reserving the slow graver for the head and hands. By introducing copper instead of the usual iron, he managed to etch lines neat enough to blend with the engraved additions. This mixed technique was to become standard for reproductive copperplates. After about 1700, almost all so-called "engravings" are really etchings touched up with the graver to smooth over transitions.

Lucas' shortcut came in handy when the psychological imagination of the age of Shakespeare, Cervantes, Molière, and Racine produced perceptive portraits in quantity. The first exquisitely sensitive portrait engraver was Goltzius, who made a few big copperplates and more in locket size on silver. Although he engraved portraits only as a sideline, he attained an almost neurotic insight [ 286 ] that many artists tried to imitate but few could equal.

In Italy, the 76 woodcut heads in the 1568 edition of Vasari's *Lives of the Artists* prepared the way for the first specialist in portrait prints, Ottavio Leoni. This Knight of Malta drew all kinds of Romans in pastels from which he engraved 40

small coppers, mostly of writers and artists. An accomplished, truthful portraitist
when he began in middle age to engrave, he clustered dots like Barocci [ 436 ] to
model faces, and rendered lace and breezy hair with self-taught freshness [ 287 ].
He imitated Venetian and Florentine woodcut portraits by framing many of his
heads in ovals or octagons.

In Spain the example of Italy produced one portrait engraving that survives in
only one impression [ 288 ] but whose unprofessional graving packs enough ex-
pression to have founded a whole school of printmaking. Who but young Velázquez
could have achieved such painterly force? If he made other prints, they probably
vanished in the Madrid palace fire of 1734 that seems to have destroyed all but a
handful of his hundreds of drawings and oil sketches.

**286** (ABOVE, LEFT)
Hieronymus Scholier, aged 30. Engraving by
Hendrick Goltzius, 1583

**287**
Self-portrait, aged 51. Engraving by Ottavio
Leoni, 1625

**288**
Count-Duke of Olivares. Engraving, probably
by Velázquez

In France the earliest school of portrait specialists appeared about 1510. Even before there was a print-collecting public, Catherine de Medicis employed portraitists to draw her courtiers for herself and for presentation to other courts. Henry IV, like Queen Elizabeth I, issued a few official engraved portraits, and Louis XIV incorporated portrait engraving into his bureaucracy after about 1650 with huge souvenir broadsides (*thèses*) that listed the subjects a candidate for a law degree was prepared to discuss in his examination. The *thèse* often displayed a large engraving of some bigwig who could further a young man's career. The politics of patronage made the great portrait engravers of the age of Louis XIV waste their skill on faces of now forgotten lawyers and civil servants, with hardly a worthy engraving of any great French artist, musician, writer, or royal mistress.

Leoni's portrait formula came to France with Claude Mellan after Mellan had spent 12 years in Rome. There he learned to exaggerate Villamena's manner [ 409 ] in his own unique style of curving, swelling parallels without crosshatching, all sparkling as limpidly as sunlight under the water of an aquarium [ 289 ]. The tricki-

**289** Anna Maria Vaiani, painter and engraver, worked 1627–50. Engraving by Claude Mellan

**290**
Jean Loret, journalist, aged 63. Engraving by Robert Nanteuil, 1658

P.J. MARIETTE

*Conservateur général de la grande Chancellerie*
*Honoraire de l'Académie Royale de Peinture et Sculpture*
*né à Paris le 7 Mai 1694*

*Dessiné par C.N. Cochin*          *Gravé par Aug. de St Aubin 1765*

**291**
Pierre-Jean Mariette, the first
great connoisseur of prints and
drawings. Etching by Augustin
de Saint-Aubin after Charles-
Nicolas Cochin II, 1765

ness of his mannerism tempted him to engrave a broad head of Christ in one single spiral centered on the tip of the nose.

The greatest French portrait engraver was Nanteuil, who mastered everybody's technical advances and then subordinated his consummate skill to analyzing his sitters. By drawing in pastels like Leoni, he directed his eye away from line toward form and color in 216 engraved portraits that include 11 life-size heads of Louis XIV and 14 of Mazarin. Nothing could be more uniform than his plain frames, simple lighting, three-quarter poses, and fly-screen backgrounds ruled by assistants—and nothing short of life itself could vary more than his characters [ 290 ]. He clarified his art as unobtrusively as Racine, who was then polishing his alexandrines to a desperate delicacy.

Nanteuil's successors were not asked for psychological analysis by statesmen, who ordered full-length effigies in robes of office, treading on a baroque litter of professional paraphernalia. The psychological portrait returned when the Marquis de Marigny, Madame de Pompadour's brother, began to direct French official art after studying in Italy with C.-N. Cochin II. There Cochin, as successful an artist as lived in all the 18th century, had absorbed the recurrent classical taste for the profiles that he admired on Greek vases and antique coins, revived in Renaissance medals and paintings. In the Salon of 1750, Cochin exhibited some pencil profiles *à l'antique*, which pleased so generally that over 260 of his drawings were etched in the next 20 years [ 291 ]. His friendly shrewdness evokes the very voices of his fascinating contemporaries.

**292**
Thomas Jefferson, aged 62. Physiono-trace etching by Charles-B.-J. Févret de Saint-Mémin, 1805

A portraitist had merely to satisfy his sitter and the next of kin until "scientific" exactitude was required of him after 1775, when J. K. Lavater began to publish a classification (based on Aristotle) of men's characters as indicated by their facial characteristics. Lavater considered the profile to be the most revealing view. To draw profiles in machine-made facsimile, a cellist in the Versailles palace orchestra about 1784 invented the physionotrace: squinting through a surveyor's sight of crossed hairs, he followed the sitter's profile, thereby moving an attached pencil that traced the profile on paper. A pantograph then reduced this life-size outline mechanically to a small silhouette or copperplate etching. The physionotrace, by which even an amateur could achieve truthful likenesses, enabled refugees from the French Revolution to support themselves in the new United States [ 292 ]. This mechanized recording of profiles promoted a standard of accuracy that was not really met until photography became available in 1839. When photographic por-traits began to be printed in halftone and gravure, these reproductions deprived the printmaker of the dependable specialty that Dürer had created for him three centuries before.

### Burgkmair and the emperor    Hans Burgkmair, Dürer's junior by two years, lived in Augsburg, the international center for the Fugger Bank and imperial politics. Dürer, farther north in more Gothic Nuremberg, had to assault the Italian Renaissance as a grown man; Burgkmair grew naturally into its clarity. As a lad of 14, Burgkmair began to illustrate the church books that Ratdolt printed on his return to Augsburg, soon producing the first woodcut picture in black and three colors [ 76 ]. The relaxed grace that Burgkmair learned from Schongauer grew so Italianate that he must have followed Ratdolt's example by going to Italy. The only proofs of such a voyage are a typical Burgkmair woodcut [ 293 ] printed (belated-ly?) in a Venetian missal, and a cut of Death Killing the Lovers, with its gondola,

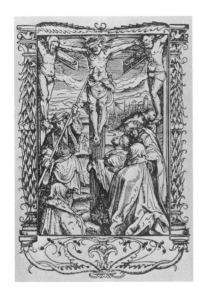

**293**
The Crucifixion. Woodcut by
Hans Burgkmair in *Missale
Aquileyense*, Venice (Pencius),
1517

**294**
Emperor Maximilian. Color
woodcut by Burgkmair, 1508

**295**
Death Killing the Lovers. Color
woodcut by Jost de Negker
after Burgkmair, 1510

Venetian chimneys, classical ornament, and Botticellian rush of figures stabilized
against a grid of architecture [ 295 ]. After having started and developed the Ger-
man method of color woodcut by printing black lines over color [ 294 ], Burgkmair
in 1510 printed the first dated analysis of a picture in three intensities of one color
[ 295 ], the method that Ugo da Carpi in Venice claimed as his own invention six
years later [ 347 ]. Had Ugo, before 1510, made color woodcuts that Burgkmair

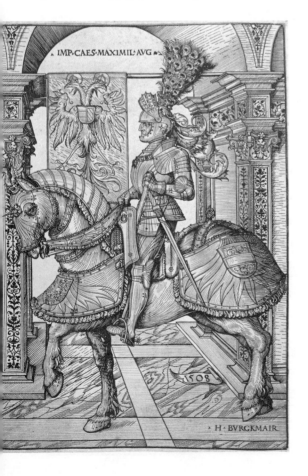

imitated? Or was Ugo stealing an invention that properly belongs to Burgkmair?

The three blocks of Burgkmair's Death Strangling the Lovers were cut by the Antwerper Jost de Negker, whose Augsburg woodcutting shop was Germany's best. Since Burgkmair also cut some of his own blocks (among them, certainly, the block that appeared in Venice with such un-Venetian cutting), he always spared the cutter the drudgery of crosshatching by shading in swelling parallels that are easy for the knife. The painterly richness of his black and white, and his urbane observation of people, made him an ideal illustrator for the various glorifications of the Hapsburgs that Emperor Maximilian dictated on his constant journeys—even while being rowed across Lake Constance. From about 1510 until Maximilian's death in 1519, Burgkmair drew nearly 300 woodcuts for this frustrated royal author, who revised the blocks by inserting plugs with changes in a vacillation that in the end left almost all of them unpublished.

**296** Noah, Emperor Maximilian's earliest ancestor. Woodcut by Burgkmair in *Genealogy of the Emperor Maximilian*, 1509–12

Burgkmair's first imperial assignment was the Hapsburg genealogy in over 90 cuts, starting with Noah [ 296 ]. Despite imperial nagging, he put grace and ease into the 121 illustrations to the emperor's political autobiography, in which Maximilian, the White King, represents himself as outwitting the statesmen of Europe, and instructing armorers, musicians, dancers, painters [ 297 ], and cooks in their several professions. After printing a few proofs, Maximilian characteristically abandoned what would have become the grandest book of the northern Renaissance. Luckily, practically all of the blocks have survived for modern reprints. Maximilian, despite his intricate hesitations, was astute enough to choose Burgkmair to present his private life to posterity, while employing the less malleable, more public art of Dürer for the woodcuts of his triumphal arch and imaginary processions [ 151 ]. The dream of grandeur that this impecunious emperor committed to mere paper has outlasted what many richer princes built in marble.

**297** Emperor Maximilian Instructs the Painter. Woodcut by Burgkmair in *Der Weisskunig*, 1514–16

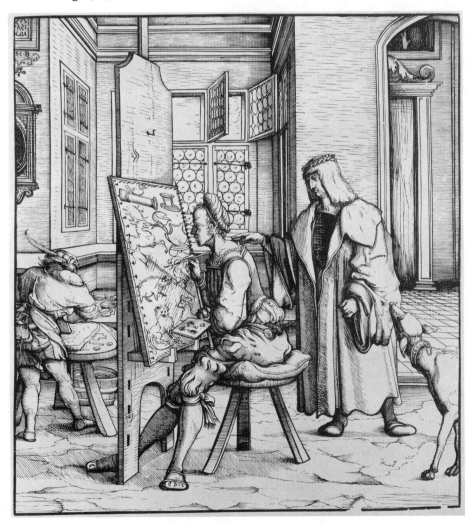

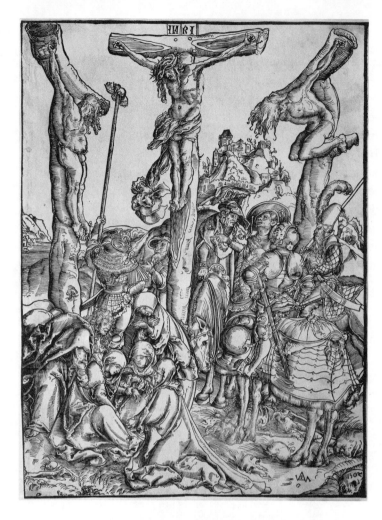

**298**
The Crucifixion. Woodcut by Lucas
Cranach I, 1502

**Cranach** Lucas Cranach was born a year after Dürer, some 50 miles north of him in a village now called Kronach. In Vienna, at about 30, he drew a few woodcuts [ 298 ] in a storm of agony that calmed down when, at 32, he settled for life as painter to the Duke of Saxony at Wittenberg. In that garrison of religious revolution during the first half century of the Reformation, Cranach painted and designed woodcuts, stained glass, weapons, and wall hangings until his mid-40s, when he gradually delegated his art to two sons and more than ten assistants. He also founded a pharmacy that his descendants ran for 300 years, and became burgomaster and the duke's political counselor and propagandist. Over 1000 paintings survive from his workshop, which perpetuated his style for 80 years until the death of Lucas II in 1586. Both father and son painted so rapidly that "before another could arrange his brushes and colors, and think what to do, they would have finished a picture." The two Lucas Cranachs invented Protestant allegory and recorded the founders of the Reformation in incisive, neurotic likenesses. Their painting shop dominated Germany while Dürer, a slow painter, made his money and his

fame through prints. Dürer's woodcuts furnished themes that Lucas I often embellished with curlicues.

The elder Cranach made the only lifelike portraits of his intimate friend Martin Luther [ 299 ], who chose him to supervise the printing press that helped to drive home the Protestant attack "by preaching and talking and singing and writing and drawing." Luther's inclusion of drawing contributed to make his press the papacy's most dreaded arsenal of opposition, as Cranach printed pamphlet after pamphlet in the pocket format that Savonarola had popularized for propaganda [ 157 ]. Peddlers slipped these pamphlets past Catholic censorship into towns, villages, and farms throughout Germany and beyond. Unlike the imaginative cuts on Savonarola's paper covers, the cuts by the Cranachs decorate Luther's tracts without illustrating their religious themes [ 300 ]. The Cranachs' sprightly ornaments were copied all over Germany as Luther's writings spread by piracies that imitated the original editions even to faking Wittenberg as the place of publication. Luther did not object to piracy—every printer's way of life—for, since he earned nothing by publishing, he lost nothing by piracy. He was, however, annoyed when Nuremberg printed a stolen manuscript before he could publish it himself. To protect his printers, he persuaded the Wittenberg town council to ask the Nuremberg printers

**299** Martin Luther as a Monk. Engraving by Cranach, 1520

**300** Woodcut by Cranach workshop in *The Gospels Translated into German and Explained by Martin Luther*, Wittenberg (Lotter), 1520

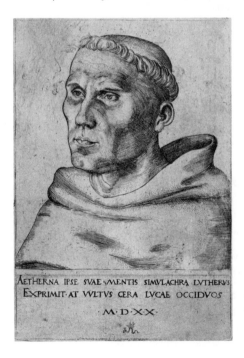

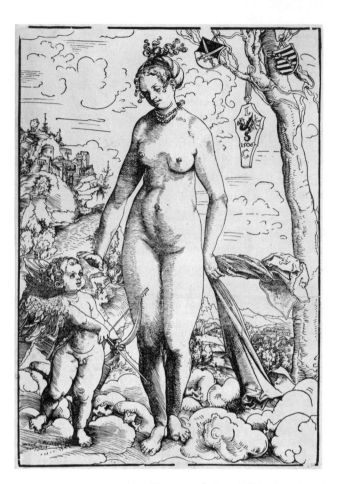

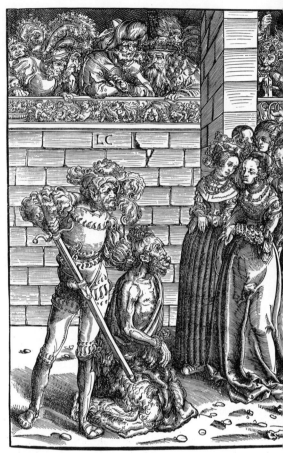

**301** Venus and Cupid. Woodcut by Cranach, 1506

**302** The Beheading of John the Baptist. Woodcut by Cranach

to hold off for seven or eight weeks until home editions could sell out, and *please* to read proof more carefully. At home his translation of the New Testament, the so-called September Bible of 1522, sold some 5000 copies in ten weeks despite the high price of two and a half guilders, and was reprinted 80 times in Germany and Switzerland during Luther's lifetime, thus establishing a literary language for all Germany. Like all northern New Testaments, it illustrated nothing but the Apocalypse [ 264 ], a decision that must have been Cranach's, since Luther cared little for Saint John's vision.

As the only German artist who ever influenced important decisions at court, Cranach played his part in a ceremonial world, ornate and sensuous. The kept minxes that he drew and painted as Venus all emphasize their nakedness by wearing necklaces and turbans that are stylish because absurd [ 301 ]. His knights and ladies carry off their eccentric accouterments with the assurance of provincial grandees. Their courtly callousness strikes a little shudder into the dank backyard

where the Baptist kneels under their idle eyes to receive the formality of a be-heading [ 302 ].

Cranach also pioneered in a color woodcut to imitate a German drawing in black line with white accents on tinted paper. His Saint Christopher [ 303 ] was first published as a complete black and white cut. The date, 1506, was then removed and the black block was imposed on a solid pale tint from another block in which accents were gouged to expose the white paper. Cranach thus refined the picture printing in colors that Ratdolt had started at Augsburg in 1487 [ 76 ], which differed in its whole intention from the flat areas of tone in the Italian chiaroscuros [ 492 ].

**303**
St. Christopher.
Color woodcut by
Cranach, dated 1506
in first state

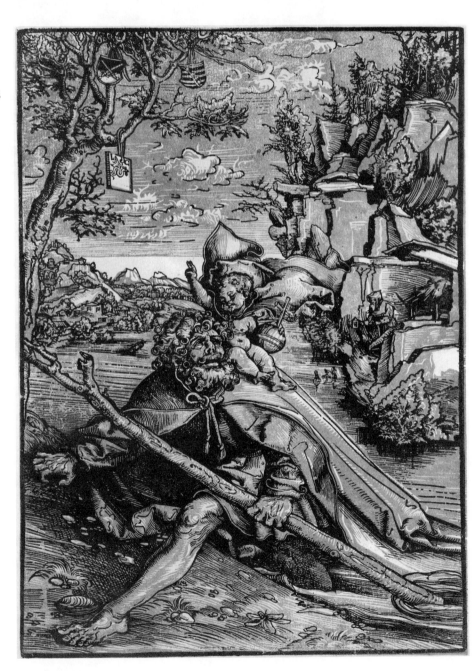

**304**
The Synagogue at Regensburg, destroyed 1519. Etching by Albrecht Altdorfer

**305**
The Virgin Seeking Her Son in the the Temple. Engraving by Altdorfer

**306**
The Resurrection. Woodcut by Altdorfer, 1512

**307** (OPPOSITE PAGE)
Danube Valley landscape. Etching by Altdorfer, about 1530

**Altdorfer**   Albrecht Altdorfer, who was about five years younger than Dürer, came only passingly under Dürer's influence after he had formed his own style of close engraving by copying Italian nielli [ 113 ]. In Regensburg, where shipping brought foreigners and fresh ideas to the head of navigation on the Danube, he founded a local school of art, much as Cranach did at Wittenberg. With something like Dürer's versatility, Altdorfer painted, drew in watercolor, and designed fortifications, municipal buildings, and silverware. He was the only German printmaker of Dürer's generation who worked more on copper than on wood, and who illustrated no books. He recorded the synagogue at Regensburg, at the time of its destruction, in an etching [ 304 ] that is the first print of an interior seen by a builder as a structure, not by a painter as a background for figures, or by a draftsman as linear perspective. It is the first print of a room that says "I was there." When, like all men of the Reformation, Altdorfer turned to the Bible, he went to episodes of intimacy and feminine tenderness, as when the Virgin searches the temple for her 12-year-old son [ 305 ]. These appealing little engravings, in a style based partly on Dürer and partly on Marcantonio's tranquil manner [ 339 ], domesticated the miniature format of Italian nielli to Germany and set the example for the German Little Masters [ 315 ].

In his slightly larger woodcuts, Altdorfer developed the delicate Venetian book illustrations of the 1480s and 90s [ 218 ] by adding shading. In his cut of the Resurrection [ 306 ], the oval radiance prints lighter than the Christ inside it, showing where the block was slightly hollowed so as to press less on the paper. Dürer had already lowered the tapering needlepoints of lines that project into wide blanks, where concentrated pressure would otherwise thicken them, but Altdorfer

**308** Silver cups. Etching by Altdorfer

**309** Silver drinking cup. Stipple engraving by Paul Flint, Nuremberg

seems to have been the first to lower a whole area to contrast gray with black, as Bewick was to do for wood engravings about 1800 [ 636 ].

Just after Giovanni Bellini and Giorgione had discovered landscape in Venice, Altdorfer became the first German landscapist. He etched the very first pure landscapes on copper [ 307 ] with the breeziness of his pen sketches and with the quill's open flow of line. The painters of the Danube school often followed him in subordinating figures to cliffs and sunny forests, and Hercules Seghers in Holland etched Altdorfer's moss-hung larches, which he never saw at home.

Altdorfer started another printmaking specialty when he etched silver-gilt goblets and spoons of Renaissance design [ 308 ]. Nuremberg silversmiths took the hint by engraving elaborate silver tableware by stabbing the copperplate with rows of dots [ 309 ]. This looks at first like Giulio Campagnola's stipple technique [ 225 ], but it actually comes from the silversmith's hammering with a sharp point to frost an area or to make a line twinkle. Germans and Frenchmen designed quantities of ostentatious silver platters and ewers that stored wealth for display on buffets—on which the less wealthy Italians arranged strikingly painted earthenware instead.

**Baldung and Weiditz**   Dürer was only the most forceful and versatile member of a generation of artists more rugged than any other Germans between 1550 and 1910. In this crop of geniuses, two Strassburgers, Hans Baldung and Hans Weiditz, shared a sense of the weird that was not to reappear in Western art until Goya, although it does occur among the Japanese.

Baldung achieved independence in spite of being Dürer's apprentice in an association that was still in force in 1521 when Dürer sold Baldung's prints on his trip to the Netherlands. In his woodcuts (but not in his paintings) Baldung was driven by the jangled agony of the German genius. More than any other Renaissance printmaker, he predicted the desperate introspection of the expressionists (like Grünewald in his paintings). It still shocks us across four centuries to see Baldung's Christ heaved up to heaven with his heels above his head in a nightmare somersault [ 310 ] that could have been imagined only by a solitary searcher of the Bible. Baldung discharged his most brutal stabs of Christian pathos in rough little cuts as summary as mosaics [ 311 ]. His lonely turmoil found refuge in the danger of the

**310**  The Ascension. Woodcut by Hans Baldung (called Grien)

**311**  Christ Buffeted. Woodcut by Baldung in Ulrich Pinder, *Speculum* PASSIONIS, Nuremberg (Pinder), 1507

**312** Wild Horses. Woodcut by Baldung, 1534

German forests, where horses—bringers of death in northern myths—still roamed wild [ 312 ].

A less lacerated but equally individual member of this great generation was Hans Weiditz, whose personal life has all but disappeared. Even his name was forgotten

**313** Framing a House. Woodcut by Hans Weiditz in Cicero, OFFICIA, Augsburg (Steyner), 1531

**314** The Harassed Spinster. Woodcut by Weiditz in Petrarch, *Das Glückbuch (The
Book of Chance)*, Augsburg (Grimm and Wirsung), 1532

until 1904, when the mention of "Hans Weyditz of Strassburg" as the illustrator
of the Brunfels Herbal [ 102 ] was connected with an Augsburg cut that is initialed
twice with HW above Hbb (for H. Beitidz? Or some woodcutter?). At Augsburg,
where Weiditz collaborated with Burgkmair, woodcuts in his style are dated 1518
and 1520, while more appeared later in Strassburg. Unluckily for Weiditz, the death
of a translator and the bankruptcy of his Augsburg publishers delayed the printing
of his two long series of woodcuts until he had left for Strassburg over ten years
later, when they were printed without supervision. The original publisher had
spared no expense to hire a virtuoso woodcutter (Jost de Negker?) who preserved
all the crispness of Weiditz' crinkles as they curl into half-shadows. But to find pic-
tures for the moral platitudes of Cicero and Petrarch, never illustrated before or
since, Weiditz was driven to search where Brueghel and Daumier were also to make
their discoveries: in happenings too close and familiar to be noticed by anyone
except a genius who can look at his home as though just arriving there. He saw that
the framing of a house [ 313 ] could show how mutual help builds friendships, and
an old spinster [ 314 ] can embody virtue acquired by working without thought of
reward. Weiditz, life's first gluttonous observer, poked into the marketplace, the
workshops, the schools, the countinghouses, the baths, and then ventured out into
the unseen fringe beyond, haunted by goblins and "those that lawless and incertain
thought imagine howling."

315 The Battle for the Banner. Engraving by Bartel Beham, 1528–30

**The German Little Masters** who succeeded Dürer engraved in the tiny format that Altdorfer [ 305 ] had imported from Italian nielli. Half a dozen printmakers tastefully epitomized the allover tone of Dürer's later engraving and Marcantonio's tranquility. The trend away from Dürer's exciting line toward Marcantonio's quiet tone was probably started by the best of the Little Masters, the short-lived Bartel Beham, who is said to have worked in Marcantonio's own studio. In Rome he evidently studied what every traveler could see without introductions — the antique marbles in courtyards and gardens, and the house fronts that Polidoro da Caldara had frescoed with friezes inspired by Raphael and Roman sarcophagi. Before rains washed away these processional ballets of nudes, they formed a Roman art in Germany and Switzerland [ 315 ]. The only Little Master who worked in northern Germany was Aldegrever, who was also the most mannered and stylishly bizarre [ 316 ]. All the Little Masters followed Marcantonio in engraving mythological scenes, roundly drawn nudes, and the kind of erotic subjects that appear whenever a great tradition breaks up, whether in late antiquity, the end of the Renaissance, or our own time. The Little Masters also engraved ornamental motifs for craftsmen to adapt in decorative works [ 317 ]. Indeed, they might have planned their whole production to furnish ideas for other artists, who copied their diminutive engravings wholesale, especially in the enamel workshops at Limoges. Several of these contrivers of exquisite miniatures, including Bartel Beham and his more prolific but duller brother, Hans Sebald Beham, lived violently enough to get themselves jailed and banished as subversive freethinkers.

**316**
Wedding Guests. Engraving by Heinrich Aldegrever, 1538

**317**
Putto and banderole. Engraving by Bartel Beham, 1520–22

**Figure-drawing books** Barbari's cryptic hints about human proportions badgered Dürer into muddled theorizing [ 281 ] that in turn badgered other German artists. Though they luckily could not write, they drew booklets of instructive woodcuts to raise themselves, as Dürer had done, from medieval artisans to Renaissance artists. Two of these booklets plagiarized the master's unpublished drawings. When Dürer died just before the appearance of his big book on human proportions, Hans Sebald Beham brought out a pamphlet of the horse in profile [ 318 ], pirated from studies that Dürer must have drawn from the bronze horses of Saint Mark's and their Renaissance adaptations. By later adding the human figure, Beham produced a self-help syllabus so practical that artists wore out edition after edition.

Ten years after Dürer's death another Nuremberger, Erhard Schön, adapted his drawing of elegantly disjointed manikins assembled out of stacks of boxes pivoting around a pliant axis [ 319 ]. Dürer probably took this cubist construction from lost drawings that Paolo Uccello or Piero della Francesca had made a century before. Schön's book transmitted the box scheme to Cambiaso [ 400 ] and Poussin, but not to 20th-century cubism, which came out of Cycladic and African sculpture and quite other theories.

318 Proportions of the horse. Woodcut by Hans Sebald Beham in *proporcion der Ross*, Nuremberg (Beham), 1528. From 1565 edition

319 Figure construction. Woodcut by Erhard Schön in *Underweissung der proportzion*, Nuremberg, 1538

**320**

Fanciful headdresses. Woodcut by Heinrich Vogtherr in *Kunstbüchlein*, Strassburg, 1538

**321**

Engraving by Giacomo Franco in Giacomo Franco and Jacopo Palma II, REGOLE PER IMPARAR A DISEGNAR, Venice (Sadeler), 1636

**322**

Engraving after Abraham Bloemart in *Artis Apelleae Liber*, Utrecht, before 1669

**323** (OPPOSITE PAGE)

Etching by Francesco Bartolozzi in Giovanni Battista Piazzetta, STUDJ DI PITTURA, Venice (Albrizzi), 1760

In the same year as Schön's book in Nuremberg, Vogtherr in Strassburg published the only German drawing book that escaped Dürer's dominance [ 320 ]. Instead of instructing systematically, Vogtherr compiled a medieval artist's model book of usable elements, saying that "out of brotherly love for artists burdened with wife and children, I am publishing a little gathering of exotic and difficult details full of fantasy and cogitation that will spare dull heads and will cheer and inspire artists of high understanding." His 31 pages of outlandish headdresses, hands, feet, and fantastic weapons classify spare parts to apply wherever an artist's invention might go blank.

Such attachable giblets were heaped like hospitable cold platters in some Italian drawing books [ 321 ]. Vasari was probably thinking of similar assortments when he wrote that "painters delude themselves if they center on perfecting a torso, an arm, or a leg with well-studied muscles, because a part of the work is not the whole."

The first wide range of models for figures draped and nude, heads, and animals, either in outline or shaded, was provided by Abraham Bloemart in 120 engravings [ 322 ]; these were still being used a century later by Boucher and his contemporaries. Dürer had included the proportions of the baby in his treatise as Leonardo da Vinci had planned to do in the book that he never pulled together. When the Counter-Reformation drafted squadrons of cupids for its campaign of blandishment, drawing books, like altars and ceilings, for years pullulated with pudgy hands, shy smiles, and tubby little rumps [ 323 ].

**Holbein** was the son and younger brother of skillful artists and grew into an inevitability of touch that looks effortless. While he was a boy in Augsburg, Burgkmair, 25 years older, was there blending Italianate harmonies into German art [ 293 ]. Holbein went to Basel at 18, fully trained, where he and his short-lived brother Ambrose drew woodcuts for the alert and learned publishers who were taking the initiative from war-torn Venice in printing for intellectual Europe. Though Holbein was anything but literary, being all eye and hand, he perfected a complete new ornamentation for books, from the title page through the decorative initials to the printer's mark at the end.

Title borders, invented in Venice [ 211 ], had appeared on many German pamphlets shortly after 1500. Holbein now made them sumptuous, humorous, or dramatic. His first, the often-copied Cleopatra border [ 324 ], is the first of many that bulk out from the page like a portico. (He drew it with the vanishing point at the left, to fit the right-hand page on which a title appears, forgetting that printing would reverse the image awkwardly.) Holbein totally reshaped the printer's mark [ 28 ], and gave meaning to the decorative initial letter by designing alphabets around a particular theme, such as cupids playing tag and leapfrog, skeletons attacking men, or peasants dancing, working, and making love. Finally, he invented symbolic initials to challenge the reader's learning with a guessing game. One guesses that he meant to illustrate omega with the giant Orion, though he actually drew the bard Arion [ 325 ].

**324** Cleopatra Committing Suicide and Dionysius of Syracuse Robbing Statues of Their Gold. Woodcut title border by Hans Holbein, Basel, 1523

**325**
Arion in the letter omega.
Woodcut by Holbein, 1538

**326**

Death and the Plowman. Woodcut by
Hans Franck Lützelburger after
Holbein in Les simulacres . . . DE LA
MORT, Lyons, 1538

**327**

Moses and Aaron Number the Men
of War. Woodcut in Bible, translated
by Nicoló Malermi, Venice (Bevila-
qua), 1490. From 1498 edition

**328**

Woodcut by Lützelburger after
Holbein in *Historiarum ueteris
INSTRUMENTI ICOnes (Old
Testament Pictures)*, Lyons
(Trechsel), 1538

Such handsomeness and wit affected the professional practice of printers, but
Holbein made his impact on the general public through two series of woodcuts that
he drew in Basel for a German publisher in Lyons. In his Dance of Death [ 326 ],
the skeletons do not mock at stock types as they do in the Gothic *Danse Macabre*
[ 54 ]; rather, they assault people like you and me in rooms and meadows where
you and I might drop.

Holbein's other set, 91 scenes from the Old Testament, was as famous at the
time. Here he turned for action to Baldung's stocky, driven men, and for orderliness
to the clear cuts in the first illustrated Bible in Italian [ 327 ], just as Dürer had
turned to the crude but forceful cuts in the first illustrated Bible in German [ 261 ].
But whereas Dürer chose subjects from the mystical and controversial New Testa-
ment, Holbein went to the historical facts of the Old. He transformed the Venetian
miniatures into monuments seen through the wrong end of an opera glass [ 328 ],
for he could design in the scale of hat jewels as aptly as he frescoed house fronts.

No preparatory drawing is known for any Holbein woodcut. With unbelievable assurance, he apparently attacked the wood directly. Fortunately, many of his Basel illustrations were cut by a fellow Augsburger, Hans Lützelburger, who surpassed even Jost de Negker in achieving exactitude in miniature. Lützelburger's death ended the ten-year collaboration when Holbein was about 29. He was sorely missed during Holbein's last 15 years in London, where some of the artist's grandest drawings on wood were slashed by provincial botchers [ 329 ].

**329**

Christ Exorcizing a Devil. Woodcut by Holbein in Thomas Cranmer, CATHECHISMUS, London (Lynne), 1548

**Lucas of Leiden** was probably the town's first engraver and was certainly the first engraver in the Netherlands to make an impact on the world at large. He formed his engraving style partly on that of IA of Zwolle [ 137 ] and even more on the worldwide example of Dürer, whose virtuosity he simplified, and whom he followed by signing his prints with his L and the date on a tablet. At 14 he engraved his first dated plate [ 330 ] with such mastery that the landscape was copied two years later in Rome when Marcantonio needed a background for figures from Michelangelo's cartoon of the Battle of Pisa [ 331 ]. When Lucas blended etching with engraving in his portrait of Maximilian [ 285 ], the saving in time revolutionized copperplate technique. Lucas' graver caressed the copper so delicately that the lighter lines wore thin before many bright impressions could be pulled. Yet this adolescent refinement of touch serves to render figures that bulk with the solid strength of old Dutch art in the Milkmaid [ 332 ], which became the model for hundreds of Dutch farm pictures and studies of cows' hides sagging from their skeletal

**330**
Mohammed and the
Monk Sergius. Engraving
by Lucas of Leiden, 1508

**331**
The Climbers, in The Bat-
tle of Pisa. Engraving by
Marcantonio Raimondi
after Michelangelo, 1510

**332**
The Milkmaid. Engraving
by Lucas of Leiden, 1510

supports. Curiously, Lucas had less effect through his woodcuts [ 333 ], in which he developed the bright side lighting that had first appeared in Netherlandish block books [ 21 ]. It is a pity that his big woodcuts are the rarest of his prints, for in them he drew with his finest control and animated figures as vividly as the Master of the Lübeck Bible [ 38 ].

Although Dutch art was ultimately to base itself on Lucas' robust welcome to everyday things, in his mid-life such endearing homeliness was banished as an embarrassing leftover from the dying Middle Ages. When all the north of Europe began drifting toward Italy, Lucas preceded the German Little Masters [ 315 ] in succumbing to the engraving style and the subject matter of Marcantonio, whose own engraving style Lucas' early work had helped to form. Thus the publication of prints, only some 80 years old, was already interchanging enough artistic ideas to homogenize styles. Along with all his compatriots, Lucas turned so far away from medieval homely frankness to reach out for the heroic generalizations of the antique that his last engravings [ 334 ] look as though they could not possibly be by the same man, or even come from the same country, as the Milkmaid. Italian Renaissance prints made an impact on the north of Europe so violent that Netherlanders needed a century of trips to Italy before they could absorb the onslaught of Italian art and finally range themselves with Lucas' youthful point of view. So Lucas of Leiden was Holland's last indigenous artist until the great age of Rembrandt—but only during his teens and early 20s.

**333**
Salome and the Head of John the Baptist.
Woodcut by Lucas of Leiden

**334**
Adam and Eve. Engraving by Lucas of Leiden

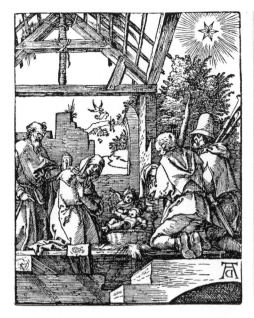
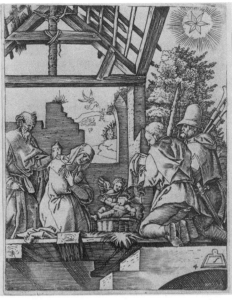

**335** The Adoration of the Shepherds. Woodcut by Dürer in the Little Passion

**336** Engraving by Marcantonio Raimondi after Dürer

**Marcantonio**   Printmaking changed about 1500 when painting changed from the daylit scenes of the 1400s to Leonardo's and Giorgione's umber forms dissolving in twilight [ 225 ]. Dürer helped to precipitate the crisis by engraving the first prints with a broad range of shadow and a convincing distinction of textures. From then on, people wearied of Mantegna's and Schongauer's equivalents for various kinds of quill drawings, or the imitations of silverpoint drawings in the Florentine broad manner [ 144 ]. Young painters studied less from drawings and more from plaster casts. When they used prints, they wanted the rounding light and shade of the new paintings. They found their printmaker in Marcantonio Raimondi. A man without genius but with receptive intelligence, he absorbed and harmonized trends as smoothly as Raphael himself. A hard worker, able teacher, and efficient organizer, he became the most widely imitated of all engravers anywhere, for he was as imitable as Dürer was inimitable. If Dürer created the new doctrine of printmaking, Marcantonio was the Saint Paul who gave it currency.

Young Marcantonio was apprenticed to Bologna's leading painter and medalist, Francesco Francia, for whom he engraved belt buckles and other niello trinkets in silver. He carried the dark color of niello into his earliest copper engravings. In 1505 in Venice, he systemized his first confused scratching by copying Dürer's engravings. He then let in still more air by the singular procedure of engraving copperplate copies after Dürer's woodcuts of the Life of the Virgin and the Little Passion [ 335, 336 ]. The breadth of the woodcut lines taught his graver to indicate

form without particularizing textures. Marcantonio thus clarified Dürer's discipline without corrupting his virtuosity. By then absorbing Lucas of Leiden's limpid unity, his line became so clear and so reasonable that it had but one function—to surround a shape without calling attention to itself.

On leaving Venice, Marcantonio stopped in Florence long enough to make one of the very few records of Michelangelo's grandest drawing, the huge cartoon of the Battle of Pisa [ 331 ], begun in 1504 and cut to pieces about 1512. In 1509/10 he established himself in Rome, where he perfected his taste by engraving after Raphael's drawings, sometimes reproducing a composition even before Raphael had readjusted the design on the wall. Reproduction is hardly the word for an en-

 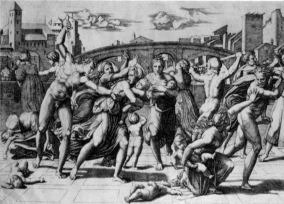

**337** The Massacre of the Innocents. Quill drawing by Raphael, pricked for transfer to copperplate

**338** Engraving by Marcantonio after Raphael

graver who had the ability to invent harmonious draperies for Raphael's nudes [ 337 ] and to blend his groups into landscapes adapted from Dürer and Lucas of Leiden [ 338 ]. The French accurately call this "interpretive engraving." For such pictorial translation, the engraver's weeks cost more than the designer's hours. (In 1747, for example, C.-N. Cochin II was paid 1250 livres for a drawing, and 4000 for engraving it.) All we know of Marcantonio's business arrangements is that he is said to have worked with Raphael's shop foreman.

Marcantonio's adaptation of northern engraving styles, and his northern backgrounds, made his prints more digestible for northern artists than Raphael's original drawings and paintings. Painters ever since have liked Marcantonio for his sacrificing showiness to pictorial essentials. Degas found in his engravings the consolation of a consummate calm. Marcantonio's Judgment of Paris [ 339 ], after a

lost Raphael drawing, has been copied or adapted in 34 or more works of art, of which the most notorious is Manet's Lunch on the Grass [ 340 ]. The French public who screamed at the girl's indecency would not have noticed her if her gentleman friends had stripped off their morning coats and gray trousers to join her in the everyday undress of Parnassus.

**339**
The Judgment of Paris.
Engraving by Marcantonio
after Raphael

**340**
Lunch on the Grass. Painting by Edouard Manet,
1861

**341** Venus and Mars. Engraving by Giovanni Jacopo Caraglio after a lost drawing by
Rosso Fiorentino for Pietro Aretino

**342** (OPPOSITE PAGE, LEFT) The Laocoön group as found in 1506. Engraving by Marco
Dente da Ravenna

**343** The Laocoön group as restored in 1533 by G. A. da Montorsoli. Engraving by
Charles-Clément Balvay Bervic, 1809

**Marcantonio's workshop**   Marcantonio synthesized the main printmaking styles of his time with a logic so teachable that his assistants could blend their engraving indistinguishably on one copperplate. His mostly anonymous crew composed the first internationally important engraver's shop and perfected a system of collaboration that spread uninterruptedly until about 1875, when reproductive printmaking began to give way to the cheaper and more accurate photomechanical processes [ 657 ]. In some 15 years the shop produced close on 1000 engravings after Raphael, Giulio Romano, Bandinelli, Peruzzi, and Andrea del Sarto, projecting the Italian Renaissance style into the rest of Europe by explosion. Antique sculpture also first became widely known when Marcantonio and his most prolific assistants, Agostino Veneziano and Marco Dente da Ravenna, followed the archeological enthusiasm of their native north of Italy by engraving statues fresh from the Roman earth.

The shop ran until the German and Spanish sack of Rome in 1527 killed one of the engravers and scattered the rest, sending the most individual member of the group, Giovanni Jacopo Caraglio [ 341 ], as far as Poland. These fleeing engravers carried with them the system of Marcantonio's organization to places where their style had already preceded them. The German Little Masters [ 315 ] took to Marcantonio's own manner, while the French preferred Caraglio's brilliant variation. All the engravings of the time, except some of Dürer's, record basic forms under a generalized illumination [ 342 ]. But as three centuries elaborated Marcantonio's system, reproductive engraving more and more specified exact particularities of surface and lighting [ 343 ]. The world adopted a photographic view well before photography arrived in 1839.

**Imitations of drawings**  Artists have always saved drawings that they could use, but nobody collected drawings as such until Vasari wrote about his pioneer collection in his *Lives of the Artists* (1550). The first extensive publication of old-master drawings was etched in the 1640s and 60s when Wenzel Hollar reproduced some of Lord Arundel's drawings (many now in Windsor Castle), including caricature heads by Leonardo da Vinci [ 344 ]. Hollar's fidelity to a past style gave the general public its first sight of Leonardo's art. His etchings were probably Goya's models for monks and witches in the Caprichos and were certainly Tenniel's for the Ugly Duchess in *Alice in Wonderland*. Leonardo's scientific drawings slept in Windsor and Milan until they took top place through photographic reproductions after 1898.

From the 1670s until nearly 1800 the most frequently reproduced draftsman was Guercino, who parted with few drawings during his lifetime, leaving his heirs to sell off sizable lots of them for almost a century. As soon as George III had acquired his long series, Bartolozzi started to copy them with supple skill [ 345 ] in the first publication of a single artist's drawings in a single collection. Various etchings after Guercino's drawings were in their turn copied in pen far and wide, to the confusion of collectors ever since.

Collectors in the 18th century began to copy their own treasures in etchings that record many lost masterpieces. The most skillful imitator of this sort was an Amsterdam amateur, Ploos van Amstel, who combined copperplate processes so deceptively that some of his prints have passed as drawings in practically every large collection. Ploos imitated the crumbling grain of chalk by coating paper with glue, powdering it when dry with metal filings, then pressing lines through the original drawing laid on top to stick the filings to the glue below. The design in filings was then pressed onto a grounded copperplate to open a stippling of dots in the ground

**345**
Four Putti. Etch-
ing by Francesco
Bartolozzi in
*Eighty-two Prints
... from Original
Drawings of
Guercino*, London
(Boydell),
1764–84

for etching [ 346 ]. His process was so complicated that Ploos once lost a whole
year's work by one foul biting.

The 18th-century imitations of drawings were the first prints that aimed at more
than copying other prints or indicating the general bulk of things, for they tried to
substitute printing on paper for handwork on paper. Today's photographic pro-
cesses can reproduce certain kinds of drawings and watercolors so convincingly
that the beholder enjoys the full experience of the original until he is told that he is
admiring a facsimile. Art museums, take note.

**344** (OPPOSITE PAGE)
The King and Queen of Tunis. Etching by Wenzel Hollar after
a drawing by Leonardo da Vinci in Lord Arundel's collection

**346**
Jan van Goyen. Crayon-manner etching by Cornelis Ploos
van Amstel after Van Dyck

**Color printing** always costs so much time and trouble to keep one color from intruding onto another that printers originally bothered with color only to avoid even more bothersome hand painting. In 1457 the first book with a printed date imitated the red and blue initials of manuscripts [ 26 ]. In 1487 Ratdolt printed the first imitation of a hand-colored woodcut [ 76 ]. Sometime after 1506 Cranach imitated a German color drawing [ 303 ]. But when Ugo da Carpi asked the Venetian Senate in 1516 for a privilege (patent) for "a new way of printing in light and dark [*a chiaro et scuro*], a new thing never done before," Germans had been elaborating color woodcuts for some ten years, and in 1510 Jost de Negker's cut of Burgkmair's Death Killing the Lovers [ 295 ] had already perfected the very method that Ugo da Carpi was to launch into Italy. In this method, probably invented by de Negker and claimed by Ugo da Carpi, the picture is analyzed into areas of highlights, middle tones, and darks for printing in several intensities of one color, starting with the palest. Any single tone [ 347 ] makes little sense separated from the assemblage [ 492 ]. These most Italian of prints sacrifice detail to clarify the mastering Italian passion for grandeur of design. They satisfied an Italian taste so basic that the Italians kept on making color woodcuts for centuries after the Germans had dropped them for linear black and white.

In 1633 a French painter and etcher, Francois Perrier, dimly imitated Italian chiaroscuros by printing an etched copperplate in black for the shadows and another in white for the highlights, both imposed on a medium tone of paper. Four years later Abraham Bosse obtained a patent for coloring "almanacs and wall calendars, *thèses*, posters, New Year's greetings, screens, fans, and holy pictures." After printing black outlines, he brightened them with painted watercolors, then shaded them by printing a second black plate over the watercolor. His modish nicknacks have left no trace except for the box labeled "Bosse's fans" in his print of the fashionable shops under the law courts [ 462 ].

In the 1770s (just when Japanese woodcuts had burst into full color) the European tone processes of mezzotint, aquatint, and stipple were printed in colors, usually after a plate had worn too much to print a brilliant black. The printer painted the plate in oil pigments with a dolly *(poupée)* of cloth rolled into a stump, which

**347**
The Death of Ananias. Dark block for chiaroscuro woodcut by Ugo da Carpi after Raphael, 1518

**348** (BELOW, LEFT)
Color mezzotint by Jacob Christoph le Blon in COLORITTO;
OR THE HARMONY OF COLOURING IN PAINTING *Reduced to* MECHANICAL PRACTICE, London (le Blon), about 1722

**349** The Tuileries. Color lithograph by Thomas Shotter Boys in *Picturesque Architecture in Paris, Ghent, Antwerp, Rouen*, London (Hullmandel), 1839

cannot help blurring adjoining colors into each other. Skies in landscapes were often inked in blue, and the ground in brown for finishing in watercolors on the paper.

In the meantime, modern color printing that approximates the density of oil paint became possible when Isaac Newton deduced from the spectrum that all colors are mixtures of red, blue, and yellow. He worked out his theory in the 1670s but did not publish it until 1704. By 1711 a wandering minor artist, J. C. Le Blon, was already superimposing the three primary colors from three mezzotint plates [ 348 ]. Though Le Blon muddied his picture by piling up ill-balanced opaque pigments, Newton's theory proved sound for today's four-color reproductions that scatter dots of red, blue, yellow, and black side by side for distance to blend in the eye. Faithful color reproduction demands a coordination of photographic filters and printer's inks that did not begin to balance precisely until about 1920.

Le Blon's premature mixture of the three primary colors soon gave way to printing any pigments that would blend like watercolors. In this more instinctive way, Viennese experiments in 1819 started lithographers building up remarkably truthful pictures by combining tints from up to 45 lithographic stones. England made the first handsome color lithographs [ 349 ], and then brightened children's books, Christmas cards, and labels for linens by combining colors from stones, woodblocks, and etched plates, teaching these complex processes to the rest of the world. Lithographers, thus highly trained, took on the early photomechanical color printing in a technological revolution that for once threw nobody out of work. Color occurred on prints in disconnected episodes: watercolors painted on Gothic woodcuts [ 30 ]; stenciled colors [ 65 ]; flat tones on chiaroscuro woodcuts [ 347 ]; colors dabbed on copper plates in the 1700s [ 348 ]; colors from lithographic stones [ 641 ]; and modern silk screen [ 743 ].

**Parmigiano**   While Marcantonio was perfecting reproductive engraving and Ugo da Carpi was evolving a new kind of color woodcut, the painter Parmigiano was making equally transforming discoveries. His obsession with alchemy—so strong that he finally gave up all his art for it—probably made him the first Italian to experiment with etching acid. He is certainly the first printmaker after 1500 who disregarded the complexities that Dürer imposed on engraving. Ignoring the graver, he used the etching needle like a quill skimming over paper to jot down pictorial ideas. (The engraver cannot work directly from nature as he twists and turns his plate against his burin, pushing along lines already traced.) After the first etchers had worked in line, which is easy to see on the copper, Parmigiano became the first etcher of shadows. To etch in shadows, he had to teach himself to predict his results from a negative, like a photographer, as his scratching opened lines of copper brighter than the surrounding ground. (An engraver judges shadows more readily by muscularly controlling the depth of bright grooves in equally bright metal.) Following Parmigiano, Italian painters have etched continuously to this day.

Parmigiano's most famous etching was the Entombment [ 350 ], which was copied by at least nine other etchers and must have gone to Toledo with El Greco, since he painted the same cylindrical heads, extended limbs, and confluence of impassioned gestures. Parmigiano is the first painter who is known to have hired a woodcutter to reproduce his drawings [ 351, 352 ]. This had unhappy consequences, for Vasari reports that "one morning while Parmigiano lay in bed, his woodcutter, Antonio da Trento, who was living with him, opened a strongbox, stole all his copperplates, woodblocks, and drawings, and must have gone to the devil for all that was ever heard from him." To reproduce the exquisite line of his draw-

**350** The Entombment. Etching by Parmigiano

**351** Circe Giving Her Drink to the Companions of Ulysses. Quill and wash drawing by Parmigiano

**352** Color woodcut by Antonio da Trento after Parmigiano

**353** Sts. Peter and Paul Healing Cripples. Etching by Parmigiano, combined with woodcut by Antonio da Trento

ings, Parmigiano introduced the German kind of color woodcut into Italy [ 352 ], based on a black-line block so complete that it can satisfy with or without a color block. He also first combined copperplate with woodcut in one print, etching a sort of composition sketch in outline for printing over a woodcut like an ink wash [ 353 ]. He did not repeat this middling successful experiment, but in the 1720s the combination reappeared in England and then in France for reproducing drawings.

Parmigiano's etchings and woodcuts won him more admirers in France than at home. In France his lithe elegance set the fashion for the 16th century and again for the 18th. In the 17th and 19th centuries Raphael dominated in the round-faced plumpness of Rubens and Renoir. Today, in the 20th, athletics and sparser eating have brought us back to Parmigiano's ideal, as any fashion magazine will show.

## The Fontainebleau school

The steadiest patron of artists for a millennium, the papacy, suddenly stopped payment in 1527 when the sack of Rome forced it to fight for its life. The next year Francis I, who had raided the French Church for a huge, irresponsible income, began to transform an old hunting lodge in the forest of Fontainebleau. When he died, 19 years later, a magical palace had arisen under the direction of homeless foreign virtuosi, mostly Italian refugees in their 20s and 30s.

The chief decorators were Francesco Primaticcio from Bologna, who worked from 1532, and Rosso, the violent Florentine, who came in 1530 and drank vitriol in 1540. They celebrated their escape from the restraining eye of their elders of the High Renaissance by standardizing the human form to an ideal—the *maniera*—of attenuations derived from late Roman sarcophagus reliefs and from Michelangelo and Parmigiano. With outrageous cunning, the Fontainebleau sculptors and painters twisted torsos and tapered limbs of arbitrary manikins for applying like sprays of acanthus as the most exciting of ornaments [ 354 ].

**354**
Medea Summons Her Dragon Chariot. Engraving by René Boyvin after Leonard Thiry in *Hystoria Iasonis*, Paris (Mauregard), 1563

**355** Sea Gods. Etching by Antonio Fantuzzi after Francesco Primaticcio, 1544

The cold but sexy choreography of their wall paintings and stucco decorations
first became known through slapdash copperplates dated 1543–47 and printed in
the palace itself. The press was probably started by Antonio Fantuzzi (possibly the
Antonio da Trento who stole Parmigiano's drawings), who coarsened Parmigiano's
etching manner to a rough and ready medium for copying anything [ 355 ]. The
press in the forest probably printed small editions, most of these prints being now
rare. Large editions (250 in one instance) were then published in Paris by Pierre
Millan and his almost indistinguishable successor, René Boyvin, who repeated
Fontainebleau designs (especially Rosso's) from the mid-1540s until nearly 1600
[ 356 ]. These more correct and available engravings, their neat, bright manner
derived from Caraglio [ 341 ], have inspired French official art ever since, as one
can see on any French banknote. At the time, the pitiless elegance of mannerism
offered an emotional refuge from the catastrophe of the sack of Rome, and later
from the agony of reciprocal Catholic and Protestant revenges during the Wars of
Religion. The shattered world regrouped its wreckage around absolutes—the abso-
lute dogmas of religion, the absolute prince, and the absolute standardization of the
human form. Fontainebleau, as the creation of an absolute monarch, displayed the
first insolently secular, one might almost say anticlerical, ostentation of Christian
times. Long after work had stopped and the palace was abandoned, its vision
spread in prints that enticed all Europe to emulate the libertine extravagance of its

356 Masquerade headdress. Engraving by René Boyvin after Rosso Fiorentino

357 Silver napkin box. Engraving by Boyvin after Rosso Fiorentino

painted and stuccoed walls, its sumptuous masquerades, and its silver sculpture that had already melted into coin [ 357 ]. As an art invented by exiles—decorative, exotic, rootless—the Fontainebleau style transplanted everywhere as readily as abstract art was to do in the 1920s.

**Duvet**   Decades after German and Italian engravers had organized their craft conventions, shops, and publishing channels, France had still produced no engraver known by name. Then, in 1520, Jean Duvet began to date prints at Dijon. Engraving started late and far from Paris, perhaps because of jealousy from Parisian guilds. Since France lacked a copperplate tradition, Duvet adapted figures from Mantegna, Dürer, Marcantonio, and others, scattering short, thick strokes so like those in Milanese engravings that some of his prints used to pass for Italian. His father had trained him to work in silver before he started to engrave, so he also, like the very first engravers, stuffed in details as thick as on embossed metal. Although he derived much from others, inspired no followers, and owes at least part of his originality to provincial ineptitude, he fascinates by his intense peculiarity. He dedi-

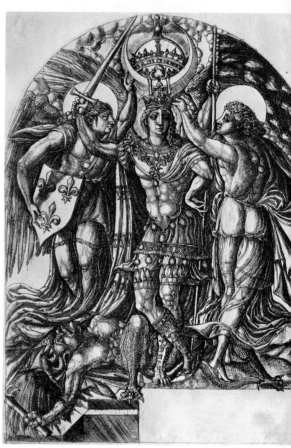

**358** The Woman Clothed with the Sun. Engraving by Jean Duvet in Apocalypse, Langres, 1546–56

**359** Henry II between France and Fame. Engraving by Duvet, about 1548

cated his 23 violent visions of the Apocalypse [ 358 ] to the king, whose coronation and love for Diane de Poitiers inspired allegories of equal strangeness [ 359 ].

Perhaps because he worked far away from the palaces that isolated the French court from French life, Duvet did not share the noncommittal detachment of the Fontainebleau mannerists but was gripped instead by the death struggle of Catholics and Protestants. The divisions of the age seem to have divided Duvet against himself, for he joined a fanatic Catholic fraternity in France, and then (unless Dijon produced two silversmiths called Jean Duvet) defected to the enemy at Geneva, where he proceeded to design coins, stained glass, and fortifications for the Calvinists.

**Cousin**    The art of Fontainebleau exhilarates partly because its components— Roman sarcophagi, Raphael, Michelangelo, Giulio Romano, and Parmigiano—all struggle against each other. The hybrid fused into a unity permanently French in

the sculptures of Jean Goujon and in the paintings, sculptures, and prints of Jean Cousin II, both of whom were captivated by Parmigiano's slender femininity. France adopted Parmigiano more wholeheartedly than Italy because his grace and seeming simplicity retrieved, for secular use, the smiling tenderness of French Gothic Virgins. Cousin was also the first Frenchman to etch [ 360 ] almost as fluidly as Parmigiano.

The most original invention at Fontainebleau had been the stucco frames that surrounded the wall paintings with supple figures twining in and out of cut and curled slabs [ 354 ]. These curving cages, easier to imitate than the dancers therein entwined, preceded the Fontainebleau style as it swept across Europe. Cousin, or his father, used the scheme to decorate a treatise on perspective with naked steeple-jacks scampering around a scaffolding [ 361 ]. Cousin parodied French logic by projecting his levitated acrobats from plan and elevation, as though he were drawing cubes or columns. Some years later, son or father published a treatise on drawing the figure by geometric projection. His ruler and compass failed, however, to establish coordinates for the flowing complexities of the body, just as Piero della Francesca had failed a century before.

**360** The Annunciation. Etching by Jean Cousin II

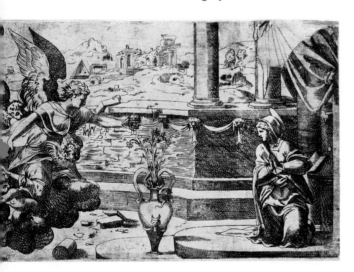

**361**
Woodcut frontispiece by Jean Cousin I, 1560

**Pleasure gardens**   When the French invaded Italy in 1494, they discovered country houses built for enjoyment instead of defense. Since the new cannon easily demolished any medieval fortifications, on coming home they Italianized their now useless keeps and castles, widening slit windows, opening dark courtyards, and expanding into gardens. The sudden transformation of so many great houses was recorded in the first architectural survey ever made of a whole country.

The recorder was J. A. Ducerceau, the first prolific designer to adapt Italian ornament to the French taste for elegance and precision. During 20 years of travel in wartime, he neatly and exactly etched nearly 150 plans and bird's-eye views of 30 mansions [ 362 ]. (Most of these mansions vanished after the French Revolution.) Ducerceau's folio changed architectural illustration from woodcut to copperplate and started a series of surveys that photography continues to this day. But he had little effect on builders, despite the particularity of his detail, for the French dropped this first Italianate mode when they saw a new harmony of house and garden that the Romans invented at Frascati in the 1590s [ 363 ]. There, a pupil of Michelangelo's sculptured the hillside, scooping out niches for cascades, slanting

**362** Château de Gaillon, Normandy, built 1500–1510. Etching by Jacques Androuet Ducerceau in LE PREMIER VOLUME *des plus excellents Bastiments de France*, Paris (Ducerceau), 1576–79

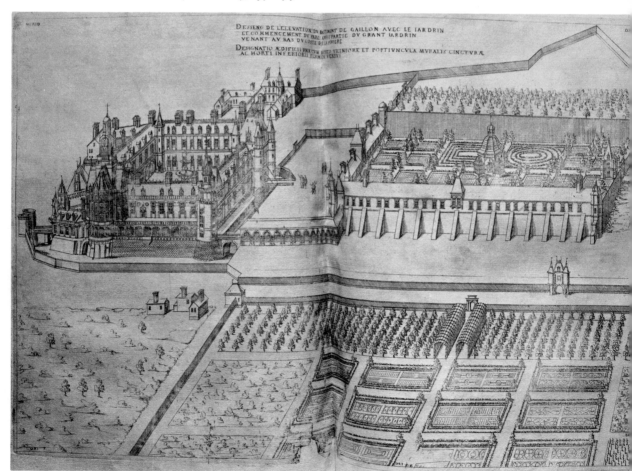

**363**
Villa Mondragone, Frascati, built
1613–20. Etching in Giovanni
Battista Falda, IL NUOVO
TEATRO DELLE FABRICHE
. . . DI ROMA, Rome (Rossi),
1665

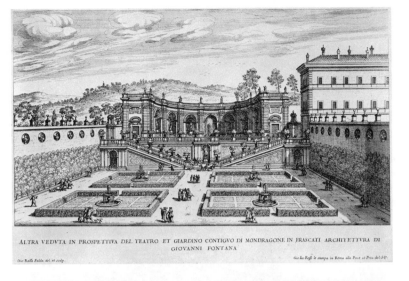

ALTRA VEDVTA IN PROSPETTIVA DEL TEATRO ET GIARDINO CONTIGVO DI MONDRAGONE IN FRASCATI ARCHITETTVRA DI
GIOVANNI FONTANA

Gio: Batta Falda del. et sculp.

Gio: Iac: Rossi le stampa in Roma alla Pace et Priu: del: S.P.

**364**
Vaux-le-Vicomte, Seine-et-Marne,
built 1656–61. Etching by Gabriel
Perelle

Veüe du Chasteau de Vaux le Vicomte du côté de l'Entrée.
A Paris, chez, N. Langlois rue St. Jacques a la victoire.   auec Priuil. du Roy.      fait par Perelle.

broad stairs to levels where clipped box and ilex swirled like marquetry, shapely in
leaf or snow. Hilltop reservoirs shot jets of water sparkling into the sunlight in
open-air galleries peopled with statues.

The French enlarged the Frascati scheme in the symmetrical stairs and grand
landings that once dropped from the château of Saint Germain-en-Laye to the
Seine far below. In 1650 Louis XIV's finance minister, Nicolas Fouquet, assembled
16,000 diggers for 11 years of leveling three villages at Vaux-le-Vicomte to make
the grandest garden [ 364 ] since those of the Caesars. When the jealous young
king imprisoned his minister and took over his group of artists in 1661, he extended
the Fouquet style to the broadest decoration ever spread over the earth. Though
Versailles's immensity was inimitable, engravings of its panoramic gardens in-
spired German princes to surround their new baroque palaces with symmetries
quite interminable enough.

**365** Pavilion of Harmony, Strangeness, and Delight, designed by Giuseppe Castiglione, S. J., Summer Palace, Peking, after 1747. Anonymous Chinese engraving

**366** The Serpentine, Chiswick Villa, near London, designed by Lord Burlington, about 1725. Engraving by John Donwell

In Peking the emperor Chien Lung emulated such prints with an exotic "europerie" at his Summer Palace, which he also had engraved in the European manner [ 365 ]. Ordinarily, the Chinese and Japanese do not make gardens into outdoor drawing rooms for the meeting of men and women, but plan them as intensively as paintings or poems by contracting the wide horizon to expand the beholder's mind.

France, and above all Italy, set models for a few gardens in England of a design geometric enough to extend horizontally the architecture of a house facade, but after about 1700 Englishmen began to prefer nature less methodized. While the English inventors of modern agriculture were improving the yield of their land, they also enhanced its beauty by reshaping woods and streams to make their windows frame views like Claude Lorrain paintings. A little before 1800, prints of English landscape gardens [ 366 ] furnished models for replacing many formal gardens on the Continent, as people read Rousseau on nature and could no longer pay to keep hedges clipped, gravel raked, and fountains spouting. Western man was beginning to realize that he was after all not the overlord of the universe.

**Eternal Rome** Germans in Rome printed the earliest pocket guides [ 367 ] for pilgrims, who hardly noticed works of art while touring the basilicas to pray for their souls. But when Renaissance classicism converted the north of Europe esthetically, northerners, seeking new artistic salvation at its classical source, wanted

**367**
St. Veronica's Veil Displayed from Old St. Peter's. Woodcut in *Indulgentie & reliquie Urbis rome*, Rome (Silber), about 1495

pictures to take home the way pilgrims took rosaries. Near Saint Peter's, the predictable tourist traffic supported bookshops that sold Marcantonio's engravings after Raphael and the antique until the sack of Rome in 1527.

By the 1540s enough visitors were returning to launch the first great print publisher, Antoine Lafrery. This expatriate Burgundian assembled the first large stock of miscellaneous copperplates by buying from Marcantonio's old stock and, beginning in 1544, commissioning new prints and copy prints from rivals. The Roman Calcografia Nazionale still prints from some of the copperplates that Lafrery included in 1573 in the earliest known catalogue of prints for sale, which lists 107 views of Rome. (The first general book catalogue grew out of the Frankfurt book fair in 1564.) So many tourists bought from Lafrery's offerings that he engraved a special folio title page for them, *The Mirror of Rome's Magnificence*. For the first time, a stay-at-home like Shakespeare could see Rome's freshly unearthed statues [ 342 ], its half-buried ruins, even its yet unfinished civic projects [ 368 ]. Some of Lafrery's engravings preserve all that we know of buildings that were cannibalized by baroque popes devouring everything in their haste to make modern Rome. Lafrery's selected buildings suited the Frenchmen who also studied Roman reconstructions by Serlio and Palladio in order to adapt the classical style to France.

**368** The Capitol, Rome, as planned by Michelangelo, 1560s. Engraving in Antoine Lafrery's SPECULUM ROMANAE MAGNIFICENTIAE, Rome 1544–77

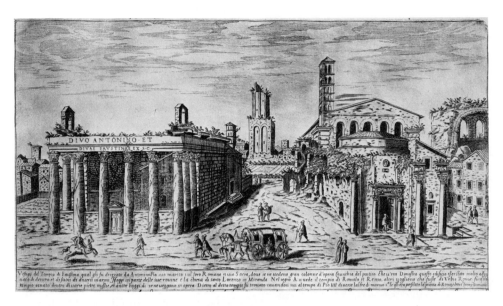

The first prints of buildings in groups that walk one through a city were etched in 1575 by another Frenchman [ 369 ]. Here is Montaigne's Rome of squalid earth engulfing the leafy ruins in a picturesque dilapidation that lured northern artists to perfect their art among broken masterpieces. A romantic young Dutchman like Breenbergh contemplated the collapse of grandeur in a twilight that dims the ruins humbled by weeds [ 370 ]. His pathos reduced Rome to less than what it really was.

**369** (ABOVE)
Temple of Antoninus and Faustina,
A.D. 141. Etching by Etienne Duperac
in I VESTIGI DELL' ANTICHITA
DI ROMA, Rome (Rossi), 1575

**370**
A Roman ruin. Etching by Bartholo-
meus Breenbergh, 1620–27

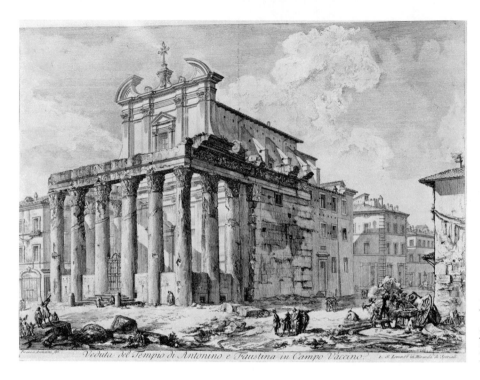

**371**
Temple of Antoninus
and Faustina. Etching
by Giovanni Battista
Piranesi, 1758

A century later Piranesi achieved the opposite by exploiting the devices of the
theatrical designer to twist the stark walls at an angle, and send them flying right,
left, and aloft [ 371 ]. He etched the Eternal City in its ideal state, when the popes
and their nephews had about ceased quarrying the ruins to make churches and
palaces, and archeologists had not yet begun stripping the rubble to expose the
misery of its minimal survival. Piranesi hypnotized the world with the spell of
Rome until 1839, when the process of photography was announced, and Rome
became the first city to be extensively scrutinized by the remorseless lens.

**372**
Calotype by William
Henry Fox Talbot,
1840s

The early photographers, who had not yet learned to make the camera lie as blandly as the brush, undid Piranesi's magic, just as photographers of royalty undid the court painter's flattery by exposing the tailor's wrinkles and bunches, while the ethnographical photographer ruined the myth of the noble savage with his rogues' gallery of paunches, knock knees, and dry dugs. Though the first photographers came to Rome with painters' and etchers' eyes for its impressiveness, they could not make their cameras register the awe that they themselves experienced. Yet, curiously, no one could now mistake the early Victorian photographs [ 372 ] for modern ones.

**373**
Fantastic Ruin. Etching by Jerome Cock in PRAECIPUA ALIQUOT ROMANAE ANTIQUITATIS RUINARUM MONUMENTA, Antwerp, 1551

## Printselling in Antwerp and London   Though print publishing began on a large scale in Rome by retailing souvenirs to pilgrims and tourists, it has usually prospered by wholesaling in centers of export. Since the print publisher had to judge foreign as well as local tastes, he was often a tourist who had stayed on, like Lafrery [ 368 ], or a traveled native.

In the 1550s the common market of the Spanish empire and the easy coinage of American silver and gold made Antwerp an ideal place for exporters of prints. Publishing centered there near the Exchange at the handsome house of the Four Winds, run by Jerome Cock, who had probably been in Rome when Lafrery was starting. Cock sold his own fantastic etchings of Roman ruins [ 373 ] for painters to copy in backgrounds, published engravings after Andrea del Sarto's already old-fash-

**374**
A Phaeton. Etching by
Rudolph Ackermann in
IMITATIONS OF
DRAWINGS OF
FASHIONABLE CAR-
RIAGES, London, 1791

**375** Kailasa Temple, Ellora, India, A.D. 725–75. Aquatint in R. M. Grindley, SCENERY,
COSTUMES AND ARCHITECTURE OF INDIA, London (Ackermann),
1826

ioned paintings, and imported an up-to-date Italian engraver. Though he published
such mannerist print designers as Floris and Heemskerck [ 417 ], we thank Cock
today for issuing over 60 engravings after Pieter Brueghel [ 425 ]. Cock stitched to-
gether engravings in sets of the four continents, the five senses, the seven virtues,
or the nine worthies, making unbound picture books that pleased the learned with
elegant Latin under the engravings, while the multitude understood the images
without reading. Cock's biblical subjects sailed as far as Mexico and Peru, where
Indians enlarged them in black and white frescoes on monastery walls.

Antwerp continued to publish important prints under Rubens [ 427 ], at which
point Amsterdam and then Paris began to compete. When the French Revolution
and Napoleon's wars gave London its chance to become the world's money market,
English wealth and the wartime ban on travel turned publishers to books of views
sumptuous enough to substitute for tours and cruises.

Blockade and embargo drove restless Englishmen to invent light, rugged car-
riages for the roads that John McAdam was experimentally paving with small
broken stones. Catering to these innovations, a young German carriage designer,
Rudolph Ackermann, drew, etched, and published a pamphlet of 12 "fashionable
carriages" in 1791 [ 374 ]. His success encouraged him to issue carriage designs
until 1825 and also to undertake over 60 folios of texts written around views of the
world [ 375 ], which in time familiarized the Regency Englishman more than any-
one else with the look of far places and directed his imagination to venture forth
for an empire.

Ackermann's glamorous aquatint plates were colored in his building in the Strand by refugees from the French Revolution. They sat at long tables, passing the sheets from hand to hand as each one brushed on a color. This meant coloring 107,000 prints for Ackermann's first big publication, the three-volume *Microcosm of London* in 1808–10 [ 604 ]. These prints did not have to be colored all at once, for the rolling press printed the copperplates gradually as the book sold, since the unit cost did not vary with number. Thus, worn *Microcosm* plates occur on paper watermarked with dates as late as the 1820s, even though bound with the original text, whose unit cost was greatly reduced by printing the 1000 copies in one press run.

Ackermann's salesroom [ 376 ], the first in London to be lighted with gas, looked like many printshops in England today. Here, in 1822, he imported the German vogue for gift annuals—those gracefully printed miscellanies of sugary verses and vapid pictures in stamped bindings like bonbon boxes that ladies collected until about 1840. On the new steel plates delicately etched illustrations could print perfectly to the very end of immense editions. Ackermann also invented the art magazine with the *Repository of Arts* (1809–28), which brought some 3000 subscribers about 1000 views of English interiors [ 376 ] and country houses, and 450 fashion plates, documented with swatches of actual fabrics.

**376** Ackermann's Gallery. Aquatint in THE *Repository* OF ARTS, LITERATURE, FASHIONS, MANUFACTURES, *& c.*, London (Ackermann), 1809

**377**
Design for black-on-white embroidery. Woodcut in Johann Schönsperger, *Ein New Modelbüch*, Zwickau (Schönsperger), 1524

**378**
Design for reticello. Woodcut in Matthia Pagano, *Ornamento per le belle virduose Donne*, Venice (Pagano), 1543. From 1554 edition

**379**
Lace design: "Steel wins more battles than gold, and piety makes a better life than riches." Etching by P. P. Tozzi in *Ghirlanda di sei vaghi Fiori*, Padua (Libreria di Giesu), 1604

**380**
Embroidery pattern for a man's sleeve. Etching by Andreas Bretschneider II in *New Modelbüch*, Leipzig (Gross), 1619

**For needle and bobbin**   In the 1520s publishers opened a new market by designing books for women. Their patterns for weaving, embroidery, and, eventually, lace sold so well that printers in Augsburg, Venice, and later Lyons, pirated each others' designs in booklets that mostly wore out from the pricking of the outlines to transfer them to cloth. The men who drew almost all these designs made them more complex as their publications trained home needlewomen to greater expertness. The one surviving copy of the earliest dated book indicates even earlier ones by calling itself *A New Pattern Book* [ 377 ]. Its branching leaves were meant to be woven or embroidered in black on linen collars and cuffs like those in Holbein portraits.

Venetians presently started to cut square openings in linen for darning patterns across the void *(reticello)*. This pre-lace was published, as usual, only after it had been in production. The woodcuts [ 378 ], partly in negative and partly in positive, required skill to interpret. Finally, around 1560, the cobweb of darning ventured forth "into the air" *(punto in aria)*, evolving lace of an intricacy that only copperplate could picture [ 379 ]. Engravings for lace terminate the printed designs for a technique that had at last become too complex for the amateur. Once professionals began to make lace for their living, they prevented patterns from being published for rivals to pirate.

Amateur embroiderers have always relied on professional designers. Some of the most ingenious early embroidery designs were shaped to collars, sleeves, and gloves

**381**  Pattern for silk caparison for a horse. Woodcut in Juan de Alcega, *Libro de
  Geometria pratica*, Madrid (Drouy), 1589

for home dressmaking [ 380 ]. In the 1500s dress patterns seem to have traveled from queen to queen by paper cutouts. Cutting patterns were first printed in Spain to help the professional tailor cut clothes for people and for horses [ 381 ] accurately and without waste. When the silk or velvet for a suit might cost a tailor's yearly earnings, he could not afford mistakes. To help him, Alcega printed a line about three quarters of an inch long as the standard inch of Castile for converting his patterns into the inches used in other places. His publication standardized the court styles of Madrid for Spaniards stationed in Naples, Brussels, or Lima as civil servants in the first empire on which the sun never set. Conformity mattered to the

Watteau fil. del.

Duhamel scul.

La belle Arsène méditant au Luxembourg : elle est en petite robe du matin avec un mantelet à la mode, et coeffée en négligé.

1. Pouf à la turque. 2. Gde Baigneuse à la Creole.

A Paris, chez Esnauts et Rapilly, rue S. Jacques, à la Ville de Coutances. N° 259. Avec Priv. du Roi.

subjects of a king who refused to receive a man until he appeared in Spanish dress.

The next tailors' cutting patterns were published at Paris in 1671 to further Louis XIV's ambition to impose French styles on the whole of the polite world. During the 1700s clothes conserved their basic cut while often changing their color and woven design. Prints published styles seen at court but did not begin to initiate new styles fresh from dressmakers until fashion magazines began in Paris a decade before the French Revolution [ 382 ]. Then one of the most coveted conquests of the new bourgeoisie was the right to dress in clothes that would look silly before they could wear out. This pushed the rich to race ahead of the poor with changes that professional designers now publish almost as soon as they invent them.

**Man's variety**   Ever since about 1500 B.C., when Queen Hatshepsut in Egypt had pictures carved of the tree houses and strange beasts of the Land of Puoni (South Arabia), people have wanted to see how men live far away. This curiosity led to the voyages of discovery, whose reports sharpened an appetite for more. Even as Columbus was returning from his first expedition, a huge world history appeared at Nuremberg with woodcuts of anthropophagi and men "whose heads do grow beneath their shoulders" [ 383 ]. Pictures of real men almost as strange began to come back with explorers of uncharted shores until Central and South Americans became so familiar by 1550 that masqueraders in Rouen dressed up as Brazilians to entertain the king on a visit.

Europeans were distracted from Americans when the Turks besieged Vienna in 1529 and kept threatening the city until the last, most frightening siege in 1683. People had already seen Turkish turbans in Schongauer's engravings, but now the

**383**

A prodigy. Woodcut in Hartmann Schedel's so-called *Nuremberg Chronicle*, Nuremberg (Koberger), 1493. This is the first book whose page layout has survived in preliminary sketches and in detailed drawings with a line count

**384** Suleiman the Magnificent Riding through the Ruins of the Hippodrome, Constantinople. Woodcut by Peter Coeck van Aelst in *Ces Moeurs et Fachons de faire des Turcz*, Antwerp, 1553

**385** (LEFT) Spanish peasant. Engraving by Enea Vico

**386** (OPPOSITE PAGE, LEFT) A Brazilian. Woodcut in François Deserpz, *Recueil de la Diversité des Habits*, Paris (Breton), 1562

**387** A Venetian bleaching her hair. Woodcut in Cesare Vecellio, *Habiti degli Antichi et Moderni*, Venice (Zenaro), 1590

first detailed prints of any strangers explored the manners and customs of the Turks as they were in 1533 [ 384 ]. This strip of woodcuts 16 feet long showed more about Turkish life than many Europeans knew about the lives of their neighbors.

As prints revealed the variety of the human family, neighbors from the next province, or even the next town, began to assume their place as subspecies in the great generic categories. In the 1550s the earliest series of costume prints of various peoples surveyed Europe and the Near East in some 100 Italian engravings [ 385 ]. Partly based on these engravings, the first costume book of the Old and New Worlds was issued in Paris in 1562 by an otherwise unknown man whose name was probably Després, misprinted Deserpz. He copied costumes from sketches by a French navy captain and a Portuguese traveler for a modest booklet that concentrates on Europe, with a supplement on South America [ 386 ].

The first pictorial encyclopedia of all mankind was published at Venice by a nephew of Titian, at a time when foreign costumes must have been everyday sights on the canals. Vecellio included antique Roman dress and pioneered in sociology by describing local customs with each of the 420 woodcuts that covered the then known world. The woodblocks, neatly cut by a German, note even finer differences as they approach home, distinguishing the dress of each city in Italy and each class and profession in Venice itself. One of the cuts [ 387 ] shows a Venetian girl bleaching her hair by spreading it over a wicker brim while she sits in the sun on one of the flat rooftops that Venetian women appropriated as their private living and reception rooms. Nowadays the magazines and newspapers that introduce everybody to everybody else have shamed many peoples out of their local traditions, imposing skirts and trousers from icebergs to jungles.

Le brefilien.

**388**
Design for a bed.
Woodcut by Peter
Flötner, Nuremberg,
1533

**Furniture designs** are worth printing wherever well-to-do people want to keep up with fashions created elsewhere. Nuremberg took advantage of its imperial status to issue the first printed furniture designs for less favored places. There Peter Flötner signed his cuts with his woodcutter's chisel and mallet, and even showed himself sitting on his bed with his leather apron and another mallet in his hand [ 388 ]. He probably derived his open, unshaded lines and his classical swags and niches from the *Hypnerotomachia* [ 223 ]. Beds were worth embellishing in Flötner's day when people lived among them in halls and parlors, where their curtains shut off a room within a room. In France, where Paris set fashion for the provinces, and an absolute monarch exacted more elaboration than a joiner could invent, the professional designer J. A. Ducerceau etched the most ostentatious furniture of the age. At Fontainebleau and the Louvre, the showpiece was the cabinet [ 389 ], whose doors disclosed a midget stage of mirrored niches and columns of ebony and agate. The real purpose of such doll palaces must have been to provide small talk for the intimate circle of French courtiers who scrutinized furniture so exactly that from about 1675 to 1789 they demanded and got the most elaborately designed and intricately contrived pieces ever made. This court furniture eventually supplied ideas to be simplified in the practical designs that Paris printed in summary etchings costing a fraction of the shaded engravings after paintings.

Prints played an odd part in the curiously individual style of the furniture designed at Antwerp in the 1580s [ 390 ]. Though Vredeman de Vries' designs were published in the greatest seaport of the time, Antwerp's ships spread them no farther than up the Rhine into Germany and across the Channel to England, while

**389**
A cabinet. Etching by Jacques
Androuet Ducerceau

Antwerp's overlords in Madrid, and all South America, continued to drape velvet over plain trestle tables. Old furniture purely in Vredeman's style is rare until after 1882, when his engravings, reproduced in photographic facsimiles, inspired beer-hall decorations in both hemispheres.

All the while that Italy was instructing the world through prints of architecture and figure drawing, the Italians printed no furniture designs, because each city preferred its own local style that it saw being made in open-front shops. It was almost 1700 before Rome at last brought out the only Italian furniture designs to be printed for nearly a century thereafter. Some Roman baroque sculptor such as

**390**
Towel rack. Engraving in Jan Vredeman de Vries, *Pourtraicts de Menuiserie*, Antwerp (P. Galle), 1588. From 1650 edition

In Roma nella Stamperia di Domenico de Rossi alla Pace con Privilegio

28

**391** A soldier's bedroom. Etching by Filippo Passarini in NUOVE INVENTIONI D'ORNAMENTI, Rome (Rossi), 1698

**392** (OPPOSITE PAGE, LEFT) Design for mirrors. Drawing for Thomas Chippendale, THE GENTLEMAN AND CABINET-MAKER'S DIRECTOR, London (Chippendale), 1754

Algardi must have invented this theatrical furniture of branches swirling around cupids and captives [ 391 ]. It caught on in Turin and in Austria but declaimed too operatically for France or England. Indeed, traditional English furniture excels in the exactly opposite virtues of durability, convenience, and the elegance of plainness. In 1754 England, North America, and India quickly adapted the first special publication of furniture designs, Chippendale's *Director*, whose third edition in 1762 added new designs and a French text to send it still further afield. It served Chippendale as a mail-order catalogue for his busy factory by being the first publication of furniture for the drawing room, dining room, bedroom, and library. His designers intermixed Gothic window tracery, Chinese fretwork, and French chair forms with rock and shell carving from Augsburg prints. He constructed soundly for all furniture meant to be shoved about but disregarded practicality in mirror frames [ 392 ], where he let the imported fad of rococo go madder than it did anywhere in its home on the Continent. The *Director* summed up and ended this English hybrid. Oddly enough, the only documented furniture from Chippendale's factory is in the classic style of Adam. Chippendale's contemporaries varied his designs to suit themselves, but when his style ceased to be current and colloquial, the early Victorians copied his engravings literally. After about 1870, manufacturers' trade catalogues [ 393 ], instead of books by designers, spread styles and documented their development.

**393**
A rattan chair. Wood engraving in catalogue of Wakefield Reed and Rattan Furniture Co., Wakefield, Massachusetts, about 1890

**Anatomy becomes a science**   Before 1543 classroom lists of the parts of the body illustrated anatomy vaguely, if at all, while Leonardo da Vinci and Michelangelo were basing their art on the most searching studies ever drawn of dissections. But since the anatomist could not draw and the artist lacked academic system, neither alone could produce a text useful to modern science.

While Renaissance artists habitually collaborated in workshops, as architects do today, scientists did not. True scientific collaboration between artist and anatomist began in the intellectual climate of Italy when the Flemish anatomist Andreas Vesalius, a full professor at Padua University while still in his 20s, worked with John Stephen of Calcar, a Flemish painter some 15 years older, who had formed his style on Titian. The anatomist had to explain to the artist just what to clarify in a given dissection in order to fit it into a general survey of the body. Then the artist had to find the angle and lighting that best emphasized the required features. Lastly—the test of awareness—the artist had to choose among the infinite alternatives for drawing any object just those lines that unmistakably describe the stressed aspects. The resulting picture had to look "real" and yet be as selective as a diagram.

In this difficult task of understanding, then of drawing so as to convey the understanding to others, John of Calcar almost attained the clarity of Leonardo da Vinci,

**394** Muscle Men. Woodcuts by John Stephen of Calcar in Andreas Vesalius, *de Humani corporis fabrica*, Basel (Oporinus), 1543

whose drawings he evidently knew. Leonardo's quill moves with a subtler flexi-
bility, but is no more explicit than the bold, flowing lines of the Vesalian woodcuts.
Here the muscle men [ 394 ] stand against a continuous landscape that links them
in tattered ballets of eight who face you and six who turn their backs, lining up like
the old frescoed *Danse Macabre* in Paris [ 54 ] that Vesalius certainly saw as a stu-
dent. But instead of the dried cadavers of the medieval *Danse Macabre*, as skinny
as wet cats or actual dissections, the Vesalian men flex their stripped biceps and
strut like champions in a Renaissance Dance of Life that proclaims the will to keep
going, come what may: the determination that distinguishes Western man from
the world of Buddhism. Though none stands exactly like any antique statue, all
have the robust Polyclitan proportions that Titian followed in his paintings. John
of Calcar's woodcuts used to be attributed to Titian, who indeed may have outlined
the poses and proportions for the anatomical artist to fill in. Titian's own finer line
and more Olympian assurance certainly swing through the superb Adam and Eve
[ 395 ] that Vesalius omitted from his biggest book, perhaps because he had had
nothing to do with planning them.

Previous illustrators had jumbled human bones like safety pins, but Calcar was
able to draw their complex perspective because Vesalius had recently invented the
articulated skeleton by stringing the bones together on stiff wires for flexing into

**395** Adam and Eve. Woodcuts, probably by Titian, in Vesalius, *Epitome*, Basel
(Oporinus), 1543

**396**
"The Weeping Magdalene."
Woodcut by John Stephen of
Calcar in *de Humani corporis
fabrica*

dramatic attitudes. Calcar's three skeletons include one wringing its hands with
passionate grace [ 396 ], usually known as the Weeping Magdalene, and a skeleton
contemplating a skull that could have suggested Hamlet's "Alas, poor Yorick."
Since their backgrounds do not connect, Calcar may have drawn these skeletons
before his muscle men.

This publication, prepared in Padua and nearby Venice, should have climaxed
the glorious line of Venetian scientific books. Instead, some rage, some feud, drove
Vesalius to pack his manuscript and more than 200 bulky woodblocks on mules
and leave Europe's printing capital for Basel, beyond the Alps. The answer to this
riddle perished when exasperation at his critics provoked Vesalius into burning his
papers a year after he published his book. Yet, whatever his academic rivals had to
disparage, artists at once adopted his anatomical compendium. Some still use it,
absolving themselves from the messy and expensive drudgery of dissecting.

The publication of these woodcuts in 1543 and the unveiling of Michelangelo's
Last Judgment in 1541 established the heavy-set Roman athlete in the art of the
baroque.

**Artists as block-cutters**  Hans Burgkmair stated that he cut some of his own blocks. Similar skills had also been mastered by Francesco Francia while he, as Bologna's mint master, sank dies for coins and, as the city's only able painter, trained Marcantonio in engraving and drawing. Francia certainly designed, and probably cut, the metal block of Saint Catherine of Bologna [ 397 ], who died when he was 13. Her face is as darkly and smoothly modeled as those that Francia painted for altars, but unlike his Madonnas, this face looks disconcertingly like a portrait. And it *is* a portrait of Saint Catherine herself, who for five centuries has held court as an ebonized mummy in a chapel as feminine as a boudoir [ 398 ]. She sits today in a gilded throne that replaces the Renaissance one in the metal cut, which was decorated like Francia's altar frames and could well have been designed by him. The faithful who continually kneel before Saint Catherine probably first bought Francia's likeness of her printed on a single sheet, the block being later trimmed off at the top to fit it into a booklet of her writings.

397  St. Catherine de' Vigri of Bologna. Metal cut, probably by Francesco Francia, in St. Catherine, *Libro deuoto della beata Chaterina*, Bologna (Benedictis), 1511

398  St. Catherine, 1413–63. Chapel of Santa Caterina, Bologna

Another versatile Italian artist, Domenico Beccafumi, had learned all about cutting designs into flat surfaces while he worked for nearly 30 years on the marble marquetry pictures in the cathedral pavement at Siena. Vasari says that this "*uomo capriciosissimo*, successful in everything, cut his own woodblocks," and with such originality that Vasari pasted one of the prints in his famous scrapbook of drawings. In his woodcuts [ 399 ], as in his pavement, this painter of twilight devised happy, bold ways to evoke figures out of the dusk, cutting ink-blot shadows like black inlays in white marble.

In the following generation there was one Italian draftsman whose straight, wide-apart lines seem made for easy woodcutting, somewhat the way van Gogh's solid colors seem made for four-color process reproduction. Luca Cambiaso, a sculptor as well as a painter, could readily have cut the block [ 400 ] for this brisk seduction drawn from one of his Genoese frescoes. He certainly brushed on the wash that so skillfully heightens the effect. He might naturally have wanted to reproduce his drawings, as Mantegna had done, since he seems to have been the first artist to give a large part of his effort to making drawings specifically for sale, taking quick advantage of the mode for collecting them that Vasari's *Lives of the Artists* had stimulated when Cambiaso was 23. Although his drawings were popular enough to be frequently faked, his woodcuts, oddly, are rare. His stylish block construction followed after Venetian book illustrations [ 401 ] by some other art-

**399**
St. Andrew or St. Philip. Woodcut by
Domenico Beccafumi

**400**
Woodcut washed with
ink, by or after Luca
Cambiaso from his
fresco of the Rape of
the Sabines, in Villa
Imperiali, Terralba,
1570s

**401**
Musical Intervals.
Woodcut in Lodovico
Fogliani, MUSICA
THEORICA, Venice
(de Sabio), 1529

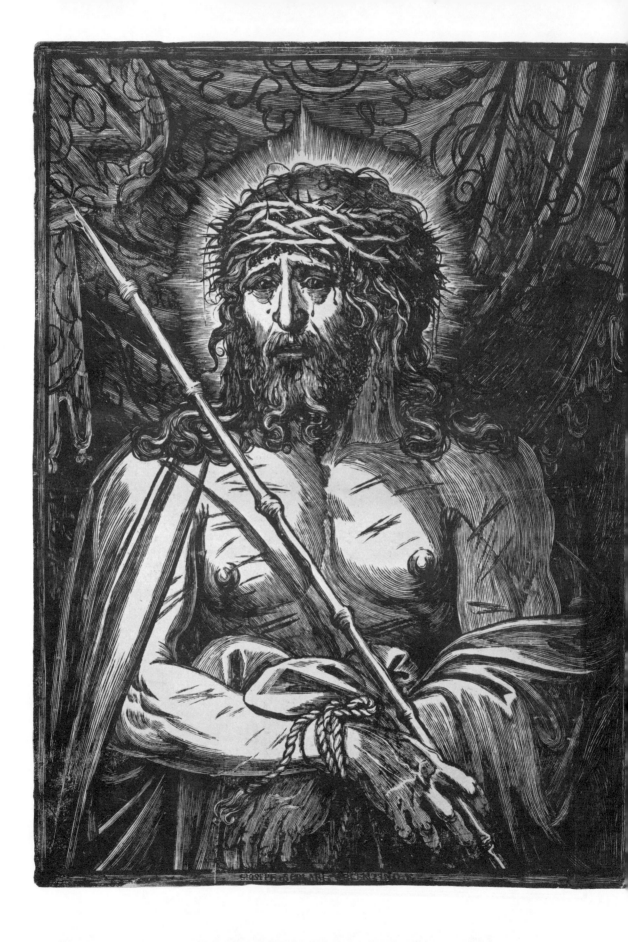

ist—surely a painter—who flowed lines continuously instead of sparking them with Cambiaso's discontinuous snaps. This Venetian probably drew quite differently when not simplifying for the woodcutter, who may well have been himself.

The airy openness of Cambiaso and his Venetian precursor is the opposite of the dark, painterly woodcuts of their contemporary Giuseppe Scolari [ 402 ], who seems to brush broad whites on solid black. Scolari drew his picture out of the dark by bundling white lines in close parallels, as though cut with the multiple tool of points like a rake that French and English wood engravers were to use in the 1920s. Like these recent wood engravers, Scolari imagined his pictures in terms of wood, not in terms of a pen or pencil transfer onto wood. Italian artists, unlike the French, fascinate by their unpredictability, now acting like their grandfathers, now like their great-grandsons.

**Titian**   After the lucid outline woodcuts of the 1480s and 90s, Venetian prints declined with the disasters that fell upon the Republic. In 1498 Vasco da Gama undercut her monopoly of Asian trade by sailing to India around the Cape of Good Hope, and in 1508 a league of her European enemies would have dismembered her had they not quarreled among themselves. Venetian discouragement shows in decades of sloppy book design and muddy little cuts in the mechanical routine imported from Strassburg [ 56 ]. But since book exports brought in money, the Senate in 1537 assured the quality of paper, at least, by decreeing that if ink were found to blot on the margins of any five leaves in any five copies taken at random from an edition, the entire edition must be burned in the Piazza.

While an edict might outlaw shabby materials, it took no less than Titian to raise the art of the book to its second, and perhaps greater, glory in Venice. He had begun to advertise his painting by drawing single-sheet woodcuts in 1508, when he was about 31, and he continued to publish them along with engravings [ 408 ] until his death 68 years later. He drew his greatest woodcut [ 403 ] on 12 blocks that compose a wall decoration four feet high by seven wide. While the blocks assemble into a sweeping unity, each one by itself delights with the shapes of the blank spaces between objects [ 404 ], active voids that Titian was the first Westerner to design as sensitively as the Chinese and Japanese. The inscription boasts that this paper tapestry was "drawn by Titian's immortal hand" and was cut by Domenico dalle Greche, of whom we know little except that he was not El Greco. Titian made the Greek woodcutter respect his reed pen line as exactly as a German cutter would have done in order to conduct the mass of energy that charges through the vast

**403** Pharaoh's Army Drowned in the Red Sea. Woodcut by Domenico dalle Greche after Titian, 1549

scale of this most imposing of all woodcuts. Only one book illustration is documented as Titian's: a sensitive profile of Ariosto, vouched for years later in a letter from the poet's nephew.

He put an even grander power into some of the most searching portrait prints made before Rembrandt's. These were published by his friend Francesco Marcolini, who led the resurgence of the Venetian book. Titian signed Aretino's portrait [ 405 ] all over with the descriptive lunge of his line. Only such a painter could have made a monument out of the little color-woodcut frontispiece to Aretino's poem to his mistress Angela Sirena [ 406 ]. Titian had every reason to grant a favor to Aretino, the blackmailer of princes and Europe's favorite bad boy, for his help in selling leftover paintings by praising them to sovereigns.

Titian's example gave space and movement to the smallest vignettes in Venetian books, even where he himself did not draw them [ 407 ]. These illustrations graced the reading of elegant and learned Europe, for whom Venice put together the first comfortable modern books—of a lightness and compactness that fits the hand, with a title page that tells you what title pages tell today, with numbered leaves, a table of contents, and an index—all in a type that you read without noticing. It was surely these easy and urbane Venetian editions that brought Italian romances to Shakespeare and Don Quixote.

**404**

Upper right-hand block of 403

**405**

Pietro Aretino. Woodcut by Titian in Anton Francesco Doni, I MONDI, Venice (Marcolini), 1552

**406**

Aretino and His Mistress. Chiaroscuro woodcut by Titian in Pietro Aretino, STANZE IN LODE DI MADONNA ANGELA SIRENA, Venice (Marcolini), 1537

**407**

Woodcut in Matteo Maria Boiardo, ORLANDO INNAMORATO, Venice (Scotto), 1545

**408**
Detail of The Martyrdom of St. Lawrence, engraving by Cornelis Cort after Titian's paintings of 1556 and 67

## Engraving standardized

Germans and Netherlanders invented almost all the print techniques and then elaborated them with the most determined polish. Line engraving evolved its intricate gratings through ES, Schongauer, Dürer, and Lucas of Leiden to Cornelis Cort. In Antwerp, while engraving for Jerome Cock's international publishing house of the Four Winds [ 373 ], young Cort made pen drawings that are often mistaken for Brueghel's. Then, in Italy during his 20s, he sent back drawings (probably his own) of Italian paintings for Cock to engrave, meanwhile teaching Italians his intelligent clarification of northern engraving. His style began to matter in 1565 when Titian lodged him in Venice to engrave paintings as advertisements for princely distribution. Titian did not hire an Italian of Marcantonio's then stagnant school, whose close and even graver work matches the mat colors of fresco, but instead sought out this Antwerper with a flashier line that could approximate the gleam and darkness of the new Venetian painting [ 408 ]. As usual, the painter retrained the engraver to subordinate tricks of skill to the grand articulation of design, and with such effect that Cort's later engravings were copied more often than anybody's except Dürer's.

After centering in Venice for about six years, Cort spent his remaining seven years in Rome, teaching the discipline of the Antwerp workshops as redirected by Titian. Goltzius [ 419 ] learned Cort's new style, perhaps by working directly under him. Another probable pupil, the native Roman Francesco Villamena, opened the spaces between the lines and flowed them in parallels that were later to be devel-

oped into a special style by Claude Mellan [ 289 ]. Villamena made the first heroic engravings of beggars [ 409 ], suggested perhaps by Ferrarese engravings [ 201 ] or by the studies that Annibale Carracci was then drawing of street criers [ 202 ]. Villamena thus introduced low-life subjects to Callot and the young Rembrandt.

Cort's greatest Italian follower was Agostino Carracci of Bologna, who was 21 when Cort died. Agostino's Italian taste simplified Cort's dependable system to make it easier to teach [ 410 ]. Agostino himself engraved so brilliantly that when he died the art world of Bologna splurged on a black and silver funeral elaborate enough to commemorate in a booklet with etchings by Guido Reni. It is noteworthy that Reni, Agostino's young admirer, did not imitate him by engraving, but followed Parmigiano by etching, like most Italian painters. Though Agostino Carracci could not prevent engraving from declining in Italy, he finally came into his own as a model when French printmakers began to specialize either in pure engraving with Nanteuil [ 290 ] or in the etched effect of engraving with Bosse [ 456 ]. Then Agostino emerged as the consulted old master.

**409** Roasted Chestnuts. Engraving by Francesco Villamena

**410** The Satyr's Amusement. Engraved by Agostino Carracci

**Last woodcut books**   For some time after the Antwerp engraving factories had turned Flemish book illustration to copperplate, good woodcut books still hung on in Germany and Switzerland, where they had been most glorious. The final out-burst of woodcut illustration escaped the commercialism of copperplate illustration because the Germans and Swiss still cut to preserve the draftsman's individual line. The Swiss Jost Amman shows himself cutting his own design [ 411 ] in his lively little survey of 132 crafts and trades that anticipates the great French *Encyclopédie* [ 449 ]. In Frankfurt and Nuremberg Amman drew, and sometimes cut, thousands of woodcuts that picture the thinking and doing of his age. To ease this swarming outflow, he simplified the cutting by crosshatching sparingly and openly. The woodcutter received no such mercy from a more individual Swiss artist born the same year as Amman.

411  The Woodcutter. Woodcut by Jost Amman in *Panoplia*, Frankfurt, 1568

**412**
St. John on Patmos.
Woodcut by Tobias
Stimmer in *Neue
Künstliche Figuren
Biblischer Historien*,
Basel (Gwarin), 1576

Tobias Stimmer drew fewer cuts than Amman because he mainly frescoed house-fronts in south Germany and painted portraits in oils and decorations on glass. His painting on glass accustomed him to reserving blanks for looking through the window, and his huge outdoor frescoes (now weathered away) trained him to design even a little woodblock massively. He framed his 170 Bible woodcuts [ 412 ] with a lavishness of decoration developed from Venetian title borders. Rubens said that these pre-baroque "jewels of art" had been his principal study when young. Stimmer rivaled engraving by crosshatching tones in his woodblock with a metal point or a quill as fine as a ballpoint pen. His minuteness ruined woodcut illustration financially by increasing the cutter's wages above copperplate illustration despite the slow, pure graver work usual in Stimmer's time and the double presswork: screw press for the type and rolling press for the plates.

By 1757, when etching speeded up "engraving," the French *Encyclopédie* stated that the amount of fine work done on copperplate in four or five days would require a month on wood. After about 1590 woodcut dwindled to chapbooks and to ornamental vignettes and initials that were cast in type metal and sold so generally at book fairs that commercial books looked alike everywhere.

**Jewelry designs** were published after the plundering of Central America glutted Europe with sudden gold that provided the first fluid coinage, the first lavish gold thread in tapestries, the first abundance of jewelry. Since jewelers toured from court to court with their knapsacks of tools, old jewelry is better described by its style of design than by its conjectured place of manufacture.

The earliest book of jewelry designs [ 413 ] was engraved in Paris after Catherine de Medicis had begun the long participation of women in politics. (She did not import a fashion from home, where Florentine portraits show few and simple jewels.) Boyvin's foursquare gold ornaments of a barbaric refinement were paid for

**413**
A pendant. Engraving by René Boyvin,
Paris, about 1600

**414**

A pendant and enamel rings. Engraving by Daniel Mignot, Augsburg, 1590s

**415**

Black enamel watch backs. Engraving by Etienne Carteron, France, 1615

**416**

"Aimer un Peu—Beaucoup—Passioné-ment—Pas du Tout." Enamel brooch. Watercolor by Eugène Grasset, Paris, before 1908

by the French kings' new privy purse that had paid for the similar stucco frames at Fontainebleau [ 246 ]. Although this assertive goldwork (all of it melted long ago) may have been exclusively French, the enamel and baroque pearl pendants of Flemish and German engravings [ 414 ] were made everywhere (and were even more eagerly faked after the 1830s). A useful pendant appeared in the 1530s when the German invention of the fusee shrank the timepiece small enough to hang on a girdle, where the conspicuous watchcase attracted with its bright enamel on black metal [ 415 ]. Enamel freed a fantasy of design that had to be given up after about 1650 when the taste for faceted gems restricted jewelry to minerals clumped together by invisible metal. Imagination revived around 1900 when art nouveau invited the designer to fit horn and moonstone into any shape and to flow enamels as he pleased [ 416 ].

## Northern mannerists

**Northern mannerists** After about 1510, trade with the Americas and the new route to India around Africa swung commerce away from Venice toward Antwerp. To supply prints to the Old World and the New, Antwerp organized the manufacture of engravings with an efficiency learned from Marcantonio's Roman workshop. Never before, or possibly since, did so many thousands of copperplates proliferate. The industry employed whole families of parents and children, some of whom later emigrated to Haarlem, Frankfurt, and Prague. Each dynasty of engravers shared a family style so totally that you cannot distinguish any one Galle, Wierix, Collaert, de Bry, or de Passe from another.

Most did not design their own prints but worked for a new class of artists who specialized in drawing for reproduction so tidily that engravers could copy them without uncertainty. Painters developed a similar exactness of drawing to impose their personal styles on assistants who helped them with big altarpieces and wall decorations. Medieval painters had sketched out work assignments more casually because each region shared a common style.

As Protestant Holland struggled with Catholic Belgium, Heemskerck in Haarlem dramatized every outrage in the Old Testament for Protestants who likened themselves to the Jews in bondage [ 417 ], while Spranger in Catholic Antwerp and

**417**

Judith and Holofernes. Etching
by Martin van Heemskerck

Prague proclaimed the resurgent Counter-Reformation with saints who declaim as turbulently as his gods and goddesses [ 418 ]. The prestige of a ten-year triumph in Italy, and then Hapsburg patronage, enabled Spranger to impose a sculptural swagger on the court theaters and pilgrimage churches of south Germany and Austria.

The virtuoso who ruled engraving was Hendrik Goltzius of Haarlem. As a baby, he had tumbled into a fire and cramped his right hand permanently shut. By being forced to draw with the large muscles of his arm and shoulder, the way the Chinese and Japanese control their brushes, he mastered a commanding swing of line. He based his engraving style on Cort [ 408 ]. His tapering curves intersect in lozenges that wrap like a fancy stocking around a wrestler's muscles [ 419 ], studied in Rome from Michelangelo and antique marbles. This style, known as line engrav-

**418** Mercury and Venus. Engraving after Bartholomeus Spranger

**419** The Farnese Hercules. Engraving by Hendrick Goltzius

420 The Shepherd. Line block for chiaroscuro woodcut by Goltzius

421 Galatea. Chiaroscuro woodcut by Goltzius

ing, prevailed for showpieces even after about 1875, when photographic processes began to supplant reproductive printmaking, and it survives today on dollar bills.

Goltzius was the last professional engraver who drew with the authority of a good painter and the last who invented many pictures for others to copy. His happy vigor triumphs in a few rare woodcut landscapes [ 420 ] that had little effect on anyone except Rembrandt. While so many followed Goltzius in engraving, nobody imitated his dashing color woodcuts [ 421 ]. He often printed these in tones of a single color, like the Italians, but with a black block that carries the main design, like the Germans. His exuberance in these joyous inventions sweeps all before him.

Heemskerck, Spranger, and Goltzius supplied ideas to Rubens, Rembrandt, and countless other painters. Their northern mannerism began to look artificial when romanticism discovered a rival artifice of sentimental intensities, but today it fascinates all over again as we realize that it is not enough for an artist to feel sincere; he must convince.

**Brueghel**    Pieter Brueghel was the only designer for the Antwerp print factories who developed into a painter with a sideline of drawing for printmakers. By working his way into the complexities of painting during the last 10 or 15 years of his life, he came to design prints with ever growing amplitude. Though he went, of course, to Italy, he was the first northerner who did not see it as a panorama of ruins or as a gallery of patterns for drawing heroic nudes. Italy was simply a landscape with buildings to which he traveled through breathtaking Alpine heights. He was the first artist who saw mountains, not as distant decorations or horrid obstacles, but as slouching beasts furred with forests and drowsing above immensities of air. He etched his vision in only one plate [ 422 ], sketching too individually to please at the time, but he drew other valley views for Antwerp engravers to copy. By rejecting the Italian heroic manner and returning to the Netherlandish past of Lucas of Leiden and Hieronymus Bosch, Brueghel must have made himself look comfortably old-fashioned [ 423 ]. He was, however, up to the minute in his

**422**  Rabbit Hunters. Etching by Pieter Brueghel the Elder

**423**
Summer. Engraving after
Brueghel, 1568

**424**
The Kermess at Hoboken.
Engraving after Brueghel

friendships with mathematicians and cartographers, from whom, perhaps, he got
his lofty view of man's brief swarming on this little planet spread out like a map.

Probably born in a village too small for most maps, Brueghel returned to country
festivals and junketings for the inspiration of some of his best pictures [ 424 ].
When he joined in a village wake or wedding, he dressed in peasant clothes, but
when he sketched, he drew as aristocratically as Ingres, and even more cleanly. He
did not draw figures like the Italians, as nudes inside drapery, but as though the

clothes and flesh had grown together through the habits of the social animal. Italian
art, however, showed him how to clear a figure for its dominant lunge, and Italian
heroics enabled him to draw a galleon in Antwerp's harbor standing to the wind
like an Alp in a snowstorm [ 425 ].

Antwerp's ships brought the American gold and silver that changed the basis of
wealth from land to money in a revolution that is still spreading disturbance in
South American haciendas. The strain of any such upheaval makes people like
Brueghel ask questions, while the authorities question the right of questioning.
He questioned the distribution of wealth in some of the first and acutest pictures
of social protest [ 426 ]. If he also drew satires of the religious persecutions that
Spanish imperialism inflicted at the end of his life, these were never engraved and
must have been among the subversive drawings that he prudently directed his wife,
as he lay dying, to burn. Yet Brueghel was much more than a satirist, for he was
the first artist who saw people as shaped by their habits and who discovered in-
tensity in the everyday. Both discoveries prepared the way for Rembrandt.

**425** (OPPOSITE PAGE) A Galleon and a Galley. Engraving after Brueghel

**426** Strongboxes Battling Piggy Banks. Engraving after Brueghel

**Rubens**  A couple of etchings show us how grandly Rubens might have made prints if he had not chosen to economize his time by hiring engravers. In his 40s, when he painted the ceiling for the Jesuit church in Antwerp, he recorded the oratorical grandeur of this first major commission (since burned) by etching the panel of Saint Catherine [ 427 ]. To retouch the copper, he needed an impression in the same direction as the plate. He got this by laying a fresh impression of his etching against a blank paper, and rolling both through a press to offset the damp printing onto the blank paper. He then penned alterations on the counterproof to guide his revisions on the copper. (Counterproofs, probably invented by Dürer, can also be made from drawings.)

During his last 30 years Rubens imitated Titian by repeating his popular paintings and by advertising them through reproductive prints that he marketed under copyrights from Brabant, Holland, and France. When he was 30 he hired his first engraver from a local workshop, only to find that the Antwerp routine of copying neat pen drawings unfitted engravers to render the heroic flow of his oil paintings. He then imported nearly a dozen Haarlem engravers trained by Goltzius to a more athletic line and more flashing contrasts, thus diverting the consequences of Goltzius' teaching from Holland to Belgium. By retraining the pupils of one man, Rubens united his engravers under one epoch-making style that liquified undulations from light to dark in an inspiring new splendor. He watched over their every motion, correcting their proofs in ink and opaque white, and copying some of his own paintings in tones of gray so that he, and not they, should decide on the black and white values. As he dismissed engraver after engraver, he drove the best one, Lucas Vorsterman, into a nervous breakdown, but managed by deliberate tyranny to impress his style on all of his assistants. Rubens had learned in Italy to dramatize the accepted ideas of his age with an art that is public and declamatory, and with a design so rugged that it survives execution by others.

About 1608 Rubens began to design many copperplate illustrations for the Plantin-Moretus press in Antwerp. Balthasar Moretus complained that "Rubens takes six months to mull over a title page, and works at it only on holidays." But no wonder. The press paid him in books worth only five to 20 guilders, as compared to the

**427** St. Catherine. Counterproof of etching by Peter Paul Rubens, with penned alterations by the artist

**428** Samson Killing the Lion that Breeds Bees. Quill drawing by Rubens

**429** Engraving after Rubens, title page for Urban VIII, *Poemata*, Antwerp (Plantin), 1634

**430** (OPPOSITE PAGE, BELOW) Drunken Silenus. Woodcut by Christoffel Jegher after Rubens

100 guilders a day at which he rated his painting. Rubens' title pages [ 428, 429 ] so exalted the baroque book in Antwerp that Parisians began to commission sumptuous printing there, while Flemish engravers often emigrated to Paris. Though copperplate rendered Rubens' forms convincingly, he, like Titian, conveyed a grander amplitude through woodcut [ 430 ]. Rubens' woodcuts are almost the last masterpieces in a medium that dwindled to ballad sheets and minor ornaments until Gauguin transformed it in 1894 [ 710 ]. Rubens sometimes drew in a cobweb of quill lines [ 431 ] that the woodcutter had to summarize in a structure simple enough for the knife to carve [ 432 ]. Since a woodcutter can remove lines, but cannot add them without drilling a hole and plugging it for new cutting, the cutter left plenty of marginal wood in proof impressions to be pared away as Rubens might direct.

**431** The Garden of Love. Detail of quill drawing by Rubens

**432** Detail of woodcut by Jegher after Rubens

P. P. Rub. delineau.
& excud.

*CVM PRIVILEGIIS.*

Christoffel Jegher. sculp.

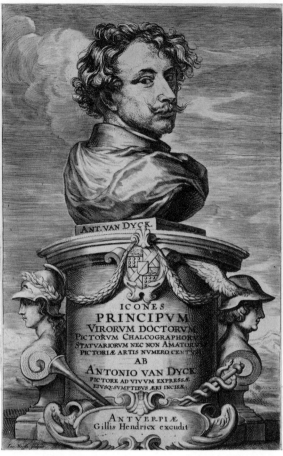

**433** Self-portrait. Etching by Sir Anthony Van Dyck

**434** Etching by Van Dyck, finished with engraving by Jacob Neeffs, title sheet from
ICONES (the *Iconography*), Antwerp, 1645

**Van Dyck** was 22 years younger than Rubens and was his most brilliant and
independent collaborator. During his 20s he spent six years in Italy, where he must
have been impressed by Italian publications of portraits of eminent men, for after
returning to Antwerp in 1626 he hired Rubens' crew of engravers to publish his
own portraits of artists and writers in prints of uniform format. He himself etched
over a dozen heads of his painter friends. With a painter's promptness, he opened
a ripple of lines on the copper, sprinkled them with dots for transitions in the man-
ner of Barocci [ 438 ], and etched with a single bite of the acid [ 433 ]. His spon-
taneity must have jarred the Flemish taste for engravings that darken the paper
out to the edges, for after pulling a few proofs of these supremely distinguished
heads, probably to give to friends, he let routine engravers make them salable by
finishing them—in every sense [ 434 ].

Van Dyck lived for success, not struggle. When he died at 42, his *Iconography*

**435**
Self-portrait. Etching by
James Abbott McNeil
Whistler

had reached 80 plates, to which his successors added 44. In 1851 the Louvre bought all the coppers, from which it still sells passable impressions pulled from electrotypes. After Van Dyck's etched states had been ignored by all of his contemporaries except Rembrandt, they slept until the 1850s or 60s when they dominated portraiture in the so-called revival of etching in England [ 435 ]. Etchers have studied Van Dyck ever since, for they can hope to approximate his brilliant directness, whereas nobody can hope to approach the complexity of Rembrandt's portraits.

**Barocci**   So long as the earth seemed but a shadow cast by heaven, the medieval artist found it simple to represent visions, but when science began to make the earth more real than heaven, the artist had to choose which world to emphasize. If a picture combined the ever more irreconcilable realms of the vision and the visionary, the artist might either demonstrate that the vision, though violating natural law, was really factual, by focusing a sharp light on every fold of cloth and

eyelash [ 436 ], or else he could suppress the thing seen to let the seer's expression suggest the invisible wonder [437 ].

In both these solutions Federigo Barocci of Urbino showed the way with the last pictures that move one to fumble toward a prayer. With only four etchings, he made more effect with fewer prints than anyone except Pollaiuolo [ 184 ]. He gave currency to three of his paintings by etching them with a black and white more colorful than their pink and blue. He discovered the most personal etching style of his generation by shooting free parallels over a contour line to soften an edge and by smudging transitions with a powdering of dots [ 438 ], perhaps suggested by Giulio Campagnola [ 225 ] or by Dürer's Adam and Eve [ 278 ]. These dotted modulations provided the basis for the style of Van Dyck [ 433 ], and then through Ottavio Leoni [ 287 ], for the French portrait engravers. Barocci in Urbino, like Cézanne in Aix, was one of the very few artists who, while isolated from the competition and criticism of art centers, beat a track for others to follow.

**436** St. Francis in the Chapel. Etching by Federigo Barocci, 1581

**437** St. Francis in Ecstasy. Etching by Barocci

**Twilight's gradual veil**    In Rome, about 1600, Caravaggio was painting large scenes with so-called cellar lighting and Adam Elsheimer from Frankfurt was painting small night landscapes and rooms. After both died in their 30s in 1610, their paintings directed European artists toward the mystery of shadows for the next century. Both painted long-sought effects of darkness in masterpieces that they could not equal in their occasional etchings. Caravaggio may have roughed out this tiny Denial of Saint Peter [ 439 ] to try the etching needle while visiting some printmaker. This print and another might help to attribute drawings to Caravaggio, by whom none have yet been identified. His two etchings did nothing to spread his art, which became known only when painters under his influence took his lighting and his composition to other lands.

Elsheimer approximated painting better than Caravaggio in a few rare pastorales from which Rembrandt and Claude Lorrain learned to submerge individual etched lines in a continuum of shade that blends nymphs into shrubbery [ 440 ]. The memorable darkness that recommended Elsheimer's exquisite little paintings [ 441 ] to Rubens and Rembrandt reached the general public through seven engravings by a Dutch friend, Count Hendrik Goudt. Goudt must have produced other, now unidentified, prints to have acquired the skill for engraving the longest black to white scale then known [ 442 ]. After engraving models for a new art of somberness, Goudt himself lapsed into the shadows, for he went mad. His prints after Elsheimer started printmakers on a technical search that led to the invention of mezzotint [ 511 ] and also to Rembrandt's dark masterpieces. Goudt's engraving of Tobias and the Angel was of course in Rembrandt's huge print collection, but it also reached him by a strange roundabout chain reaction. The engraving was adapted in etching by that moonstruck genius, Hercules Seghers, who was constantly absorbing other men's pictures into his own savage singularity. As Seghers enlarged the composition, he lightened night into dusk, which his etching needle could more easily cope with, and he inflated the figures into gods tramping down the deserted hills [ 443 ]. Some eight years after Seghers' death, when Rembrandt had acquired this copperplate along with much of Seghers' other work, he replaced Tobias and

**439** (OPPOSITE PAGE, LEFT)
St. Peter Denying Christ. Etching
by Michelangelo da Caravaggio

**440**
Nymph and Satyrs. Etching by
Adam Elsheimer

**441** (ABOVE)
Tobias and the Angel. Painting
by Elsheimer

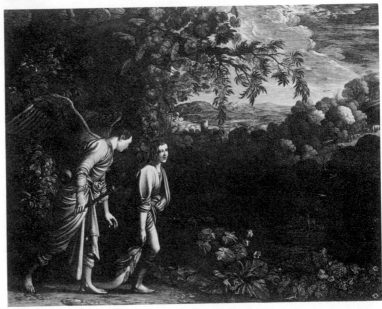

**442**
Engraving by Hendrick Goudt
after Elsheimer

**443**
Etching by Hercules Seghers
after Goudt

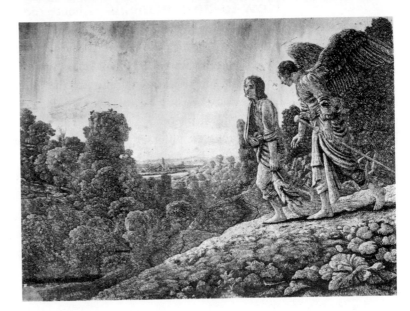

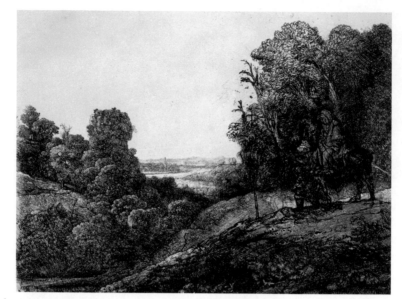

**444**
The Flight into
Egypt. Etching
by Seghers,
reworked with
drypoint by
Rembrandt,
1653

the angel with a diminished Holy Family fleeing into Egypt [ 444 ]. The furry dry-point of Rembrandt's substitutions segregates itself from Seghers' thorny etching, but it revives some of the shadowy mastery of Elsheimer's original painting. Dis-liking the arrogance of Seghers' conquering march, Rembrandt humbled the two around the Son of Man as they labor through the shadows of mortality. Like every artist confident of his originality, Rembrandt jumped his imagination off any handy springboard—another man's picture, a beggar glimpsed out of a window, or one of his own sketches. He cared nothing for his point of departure, everything for his point of arrival.

## How-to-do-it manuals
About 1100, at Essen, a monk called Theophilus described how to make the many kinds of things used by the Church. A medieval monk could instruct his monastic brethren by sharing shop practices, but when the guilds acquired power, they kept such things secret. It was not until 600 years later that the decline of the guilds allowed Chambers and then Diderot to assemble even more comprehensive technical encyclopedias. Meanwhile, though Renaissance guilds published nothing that could help a workman, the printing of Vitruvius [ 237 ] provided a literary model for a German physician to follow in writing the first detailed description of mining [ 105 ].

The earliest general account of metallurgy [ 445 ] was written by a Sienese archi-tect who worked in Italian and German foundries. Discounting prayers and magic, Biringuccio insisted on the exact weighing of ingredients and on cost accounting. In the same year as Biringuccio's book, the most sumptuous of all Renaissance in-structive manuals not only explained the use of the astrolabe (for taking the alti-

**445**

Welding a Cracked
Bell. Woodcut in
Vanoccio Biringuc-
cio, DE LA PIRO-
TECHNIA, Venice
(Roffinello), 1540

tude of stars) and the equatorium (for computing planetary positions) but provided
the actual instruments in revolving woodcuts [ 446 ]. These paper wheels (vol-
velles) were standardized by printing, which could not mark metal instruments
with absolute accuracy until the offset process made this possible after 1904. (Dur-
ing the 18th century London engraved the most nearly exact calibration on metal
sextants, rulers, and dials.)

At the opposite extreme of local interest, Amsterdam's municipal pride inspired
the first manual of fire fighting [ 447 ], showing how improved portable pumps shot

**446**

An astrolabe. Hand-
colored woodcut by
Michael Ostendorfer
in Peter Apianus,
*Astronomicum Cae-
sareum*, Ingolstadt
(Apianus), 1540

**447**

New and Old Fire Pumps in Amsterdam. Engraving in Jan van der Heide, SLANG-BRAND-SPUITEN, Amsterdam (Rieuwertsz), 1690

**448**

Printing press. Engraving in Joseph Moxon, MECHANICK EXERCISES, London (Moxon), 1678–83

**449** (OPPOSITE PAGE)

The Gobelins tapestry works. Engraving in *Encyclopédie*, Paris (Briasson and others), 1751–72

*Plate 4.*

canal water with new force into burning buildings. The brave Dutch fire crews and Amsterdam's concentric rings of canals prevented the city from burning down as London had in 1666. London recovered so rapidly from *its* fire that 12 years later it saw the first serial publication for home study, Joseph Moxon's *Mechanick Exercises, intended to be Monthly continued*. But the apprentice system probably discouraged young mechanics from studying on their own, for Moxon gave up after publishing the earliest instructions for smithing, woodworking, and printing [ 448 ]. (His very British promotion of self-education bore fruit long afterward in the trade schools that replaced apprenticeship during the Industrial Revolution, and his inspiration lives on in today's correspondence courses.)

In Britain, where primogeniture forced younger sons of great families into trade (many making more money there than the eldest son inherited), intellectuals interested themselves in mechanical problems. Various trades were described and illustrated in Ephraim Chambers' two-volume *Cyclopaedia of Arts and Sciences* (1728). When a French translation of Chambers was given to Denis Diderot for editing, the French playwright and critic enlarged the plan to include all the inventions, as well as the fresh ideas and philosophical doubts, of the age. His resulting 33-volume *Encyclopédie* was hounded by the censors during its 26 years of production, and with good reason, for it eroded traditions and rallied the forces that brought on the French Revolution. To prepare some 2885 engravings for the 12 volumes of plates, Diderot visited workshops [ 449 ], watched machines, had them taken apart, and even worked them himself. He was the first out-and-out man of letters not to look down his nose at mechanics. These fascinating illustrations created an interest that took concrete form in 1851 when the Crystal Palace in London assembled the arts and manufactures of all the world.

## Children's books

Book printing started with grammars to ram Latin into boys' heads. After about 1520 the new Protestant churches added catechisms [329] to direct the little Christian in his search for God. However, illustrations did not begin to be made especially for children until the 17th century began to explore the imagination. Then the children's book was invented by Jan Amos Comenius, a Czech exiled for his Protestantism when he was 32. While Comenius wandered in Protestant lands until his death nearly half a century later, his travels led him to hope that education might mitigate enough local bigotries to unite mankind. He believed, like the Jesuits, that as the twig is bent, the tree's inclined, but while the Jesuits confined the child in splints of discipline, Comenius proposed "to allure boys' attention with pictures that amusingly teach the chief things of the

### Bibliopolium.

### Der Buchladen.

**450**
The Bookshop. Woodcut in Jan Amos Comenius (Komensky), ORBIS SENSUALIUM PICTUS, Nuremberg (Endter), 1658

**451**
The Night before Christmas. Wood engraving by Ludwig Richter in *Neuer Strauss für's Haus*, Dresden (H. Richter), 1864

Weihnachtstraum.

**452**
Wood engraving by Winslow Homer in
EVENTFUL HISTORY OF THREE LITTLE
MICE, Boston (Libby), 1858

world." For little hands he made a book as little as an emblen book, with 304 wood-cuts that taught German children their Latin—and later other languages—by iden-tifying scenes and objects too familiar to be depicted elsewhere [ 450 ].

His book started an educational revolution that is still spreading. Protestant pub-lishers quickly discovered a market in children's books. In the early 1700s the *New England Primer* taught the alphabet with gloomy jingles that start "In *Adam's* fall we sinnéd all" and continue through "*Xerxes* did die and so must I." In 1762 Jean-Jacques Rousseau's *Emile* redirected education toward learning by doing, to de-velop the child's natural goodness through example. Though little Emile's books had no pictures, his bright response to sights and sounds started Catholics as well as Protestants illustrating books with the rewards and delights of being good [ 451 ]. These books that parents bought to quiet their children led naturally to books that children themselves might want to buy [ 452 ].

**Bellange**   French etching did not find its style in Paris but, through Callot and Bellange, in the border duchy of Lorraine, where a brilliant provincial court en-couraged artists shortly before and after 1600. Nancy, the capital, lies 200 to 500 miles from Paris, Antwerp, Amsterdam, and Vienna. Here travelers and soldiers from everywhere crisscrossed with ideas that converge in the exotic art of Jacques Bellange. He combined Barocci's dotted etching and Buontalenti's Florentine orna-ment with an all-out emotion that is German and an intricate feminine elegance that is French. The medley fuses in his vision of the Son sprawling between his

**453** Pietà. Etching by Jacques Bellange

**454** Hurdy-gurdy Player and Pilgrim from Compostela. Etching by Bellange

Mother's knees [ 453 ]. This frequent theme of the German late Middle Ages, which became rare in the balanced and reasonable early Renaissance, reappears in Bellange with a baroque luxury of pain. But however he refined his research in torture, this ambiguous aristocrat did not pose with Petrarch's pleasing melancholy, nor did he display, like Byron, the wound of a titled heart; he merely stated the violent facts of a suffering age. Bellange's blind beggars tussle with a frustrated fury that he observed with a lusciousness of disgust as one claws into a goiter as soft as an opened oyster [ 454 ]. His indolent, willowy women, with their silvery hysteria and their navels that indent through layers of silk and gauze, are the high-strung ancestors of Watteau's well-bred, nonchalant girls. Bellange, with Parmigiano and Correggio, invented the attitudes for the 18th century.

**Callot**  Jacques Callot, the first inventive international printmaker, culled something from everywhere and imparted something to all subsequent etching and engraving. His father was master of ceremonies to the Duke of Lorraine at Nancy

while this border land was being overrun by Protestant and Catholic soldiers attacking from east and west. When Jacques was about 15 he went to Rome to study engraving under pupils of Cort [ 408 ] for some three years, after which he worked for ten years in Florence. At 28 or so he settled at home in Nancy, making a few trips to Flanders and Paris. From a life of some 43 years, more than 2000 drawings survive, studying every stroke of over 1400 prints. Such strict application never tired a vivacity so inexhaustible that he could copy his most complex etchings on second coppers with no loss of freshness.

After he had learned the hack engraver's routine in Rome, he found his path in his early 20s when he started to etch in Florence. He then made two technical innovations that were to transform printmaking on copper. Abandoning the old, hard, waxy etcher's ground, which for a century had often flaked off and ruined work with foul biting, he adopted the lute-maker's tough varnish of mastic and linseed oil. When this new varnish turned etching into a predictable method of picture-making, he dared to elaborate a plate with the reasonable assurance that the acid would bite the metal only where he exposed it. Imagine his despair if foul biting had ruined his months of labor on the Fair at Impruneta [ 455 ], into which he had

**455** The Fair at Impruneta. Etching by Jacques Callot, 1620

**456**
The échoppe. Etching in
Abraham Bosse, TRAICTE DES
MANIERES DE GRAVER,
Paris (Bosse), 1645

packed 1138 people, 45 horses, 67 donkeys, and 137 dogs, marshaling this multitude between diagonal lanes of bare ground that avoid the older presentation of a crowd as a bumper crop of pumpkins. No one before had ever wagered so much work on the attack of the acid. Callot's second innovation was the *échoppe*, a steel cylinder honed to a slant at the end [ 456 ]. By twisting this slanted oval while drawing on the grounded copper, he started a line slim and then swelled it the way an engraved line swells. He swung his echoppe as freely as a quill in turning the contours of a figure. Callot also developed, though he probably did not invent, repeated biting to etch some lines briefly and lightly, while deepening and widening others by a longer immersion in the acid.

When young Callot arrived in Florence, his tourist's eye was struck by aspects of life that natives took for granted. In the public squares he looked up at comedians who pranced on platforms of loose boards and improvised ribaldries [ 457 ]. His pixilated vignettes of the commedia dell'arte—the only pictures that ever captured its wit—advertised it abroad and made it one of Italy's most applauded exportations. He also studied beggars and cripples more methodically than Dürer, Brueghel, or Villamena, composing a natural history of mendicants [ 458 ] that was consulted by Rembrandt and all the Dutch.

In 1621 the death of his grand-ducal patron forced this would-be Florentine to leave peaceful Tuscany for his birthplace in Nancy. He returned to random destructiveness—to the impersonal suffering of the Wars of Religion that seesawed back and forth across Lorraine, inflicting everyday lootings, beheadings, and hangings. He then etched his famous series, the Miseries of War [ 459 ], with lucidity, good manners, and the courtly indifference of one born to childhood sights of burn-

**457**
The Commedia dell' Arte in Florence. Etching by Callot
in BALLI DI SFESSANIA

**458**
A beggar. Etching by Callot

**459** Hanging. Etching by Callot in *Les* MISERES ET LES MAL-HEURS DE LA
GUERRE, Paris, 1633

**460** Louis XIII and Richelieu Break the English Blockade of the Isle de Ré near
La Rochelle. Etching by Callot, 1630

ing and butchering. From a loftier view of war, he etched overflights of three vast
campaigns—helicopter hoverings that incorporate the reality of a panorama in the
expanse of a map [ 460 ]. Callot discovered new subjects for art with new tech-
niques for presenting them.

**461** Etcher and engraver. Etching by Abraham Bosse, 1643

**Life in France**   While most of Callot's followers etched little views of France
and Italy, his pupil Abraham Bosse inherited the master's French relish for the
brook water of everyday living. Otherwise they differed, for Bosse, a Parisian of
Parisians, never budged from city business, while Callot risked international gypsy-
ing. After Callot gave his disciple a bottle of the new Italian varnish ground, Bosse
published the formula in his manual of etchings—translated into Dutch, German,
English, and Italian—that etchers used to speed the manufacture of copperplates
for withstanding the wear of huge editions until they turned to etching on steel in
the 1820s. Even while Rembrandt was discovering the unique magic of etching,
Bosse wrote that "the etcher's chief aim is to counterfeit engraving" and used Cal-
lot's echoppe [ 456 ] for quickly curving swells as geometric as the more laborious

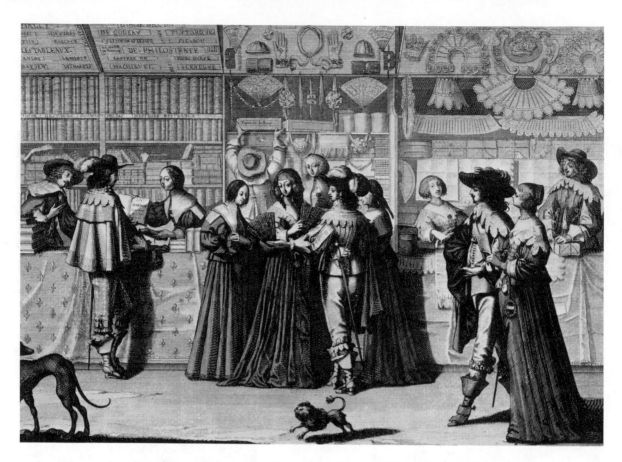

**462** Shops under the Law Courts, Paris. Etching by Bosse

and expensive graver. Bosse's book reduced the graver to a finishing tool for smoothing transitions in etchings, so that after about 1675 "engravings" differ from "etchings" in style, not technique. (Pure engraving did not return until the 1920s in Paris and then only for expressive open calligraphy [ 749 ].

Bosse, a Huguenot who battled the orthodox academies, made the first detailed prints of artisans. In his copperplate workshop [ 461 ] the etcher, left, holds a plate coated with ground through which he is scratching lines with an echoppe. He will erode these opened lines with acid from one of the bottles on the cabinet. He has already etched most of the design on the plate that the engraver, right, is grooving with a burin while pivoting the plate on a leather cushion stuffed with sand. The central screen stops the windows from reflecting on the plates. The engraver's window is "glazed" with oiled paper to diffuse the light on his uncovered metal. Both artisans display their work on the rear wall, where two monks and a gentleman consider purchases. The frames display paintings, or perhaps prints that are varnished rather than expensively glazed.

Bosse also shows us the work and leisure of the kind of down-to-earth Parisians who talk such tart good sense in Molière's comedies. His pictorial inventory of the

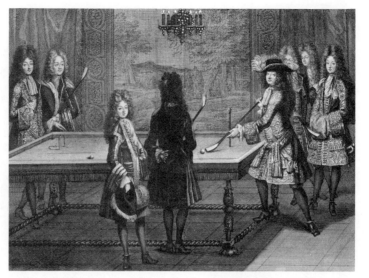

**463**
Louis XIV Playing
Billiards. Engraving
by Antoine Trouvain,
1694

smart shops under the law courts [ 462 ] illustrates the fashionable trifles that diarists mention, but nobody saved. Bosse recorded trivia so fascinatingly that Frenchmen have ever since made a specialty of intimate pictures that preserve more details of life in France than anywhere else. When one of Bosse's successors etched scenes of Versailles, he avoided state ceremonies for the cozy supper parties that Louis XIV, like a prosperous citizen, gave on three evenings a week to cousinly gatherings of the innermost court circle [ 463 ].

Separated from the official Italianate art of the French palaces, the French middle class made and bought pictures of family life that reached a quiet poetry in the prints after Chardin's paintings [ 464 ]. Prints continued to chronicle the triumph

**464**
The Governess. Engraving after
Jean-Baptiste-Siméon Chardin,
1739

**465** Flight. Color lithograph after Philippe-Jacques Linder

**466** Planning the Menu. Lithograph by Edouard Vuillard in H-J. Laroche, *Cuisine*, Paris (Arts et Métiers Graphiques), 1935

of the sometimes rowdy bourgeoisie under the Second Empire, when they questioned values and dared misconduct [ 465 ]. Daumier found Bosse's subject matter inexhaustible for original treatments that in turn inspired the impressionist painters. Everyday doings at home and on street corners still furnish the school of Paris with some of its happiest images [ 466 ]. The rest of us can only envy France's pictorial history, which stretches back through the Labors of the Months painted and printed in books of hours, and sculptured on Gothic cathedrals, to its origins in the mason's mallets and carpenter's adzes carved on Gallo-Roman tombstones.

**Dutch etchers before Rembrandt**  While regimented Antwerpers were engraving in factories, several Dutchmen in Haarlem etched with a stubborn individuality that cleared a way for Rembrandt. They gathered in Haarlem around the artistic activity centering on Heemskerck [ 417 ] and Goltzius [ 420 ]. Yet unlike these two, the others did not work for publishers but suited their own personal

467
The Brindle Cat. Drypoint by Jan
Vermeyen

tastes so much that most of their prints are now rare. Dutch etching began in earn-
est with Heemskerck and Vermeyen, both born at about the same time as etching
itself. Both used an open manner that probably influenced etchers at Fontaine-
bleau—Heemskerck for sets of Bible stories and Vermeyen for an original choice of
secular subjects bluffly drawn [ 467 ]. Heemskerck stayed in Haarlem, while Ver-
meyen soon wandered away to Spain and north Africa, an enigmatic adventurer
who founded no school. Goltzius passed his swagger on to Jacques de Gheyn II,
who sketched on copper with the freedom of Parmigiano. De Gheyn preceded Ru-
bens in learning from Titian's followers, the Bassanos, to naturalize the heroics of
Italian farmyard opulence in the Netherlands [ 468 ]. The etcher who initiated the

468
Farmyard. Etching by Jacques de
Gheyn II, 1603

classic orderliness of the Dutch 17th century was Buytewech. In a life of little more than 30 years, he formed artists around him by supplying them with drawings, most of which survive only in their etched copies. He himself etched figures with a Dutch flair for eccentric elegance [ 469 ] and landscapes with an almost Chinese calligraphy in the furrows of the fields and the windbreaks of trees like pressed seaweed. For the allegories that the age demanded, he discarded the quaintly bedizened personifications that had been current since Roman times—Victory, Africa, and the rest—and invented the symbolic landscape [ 470 ].

The astonishing genius among early Dutch etchers was Hercules Seghers, Rembrandt's only contemporary with force enough to make an impression on that master's maturity. Rembrandt reworked at least one of Seghers' plates for his own purposes [ 444 ] but does not seem to have used the technique that Seghers devised in solitary experiments. Unlike any contemporary, Seghers apparently penned lines on the bare copper with a water-soluble syrup. After coating the plate with etcher's ground, he soaked it in water to dissolve the syrup and expose the penned lines. Since some of these lines would etch too wide to catch ink, he pitted them with a granulating process like aquatint [ 229 ]. He sometimes printed on linen, apparently making offsets by pressing the cloth against a freshly printed etching on paper. He probably invented methods as individual as these to color his prints with horizon blue, ashes of roses, and verdigris. As he beat his desperate way, Seghers copied a Baldung woodcut or a recent Dutch print by absorbing it into his own

**470** Fire, from a set of the Four Elements. Etching by Jan van de Velde after Buytewech

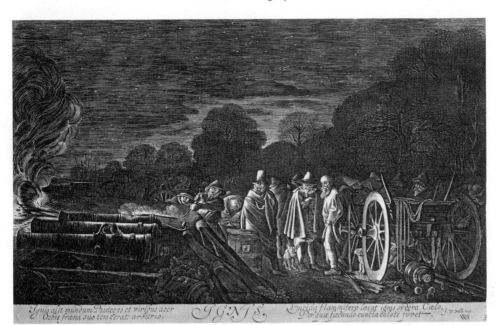

intensely personal style. His hallucinatory landscapes range from views of the flats of Holland, settled like a sediment under the deep sky, to ruins and lunar gullies [ 471 ], eroded, airless, abandoned—all etched with the crabbed scraggles of a man struggling to burst out of himself.

**471** Imaginary landscape. Etching by Seghers

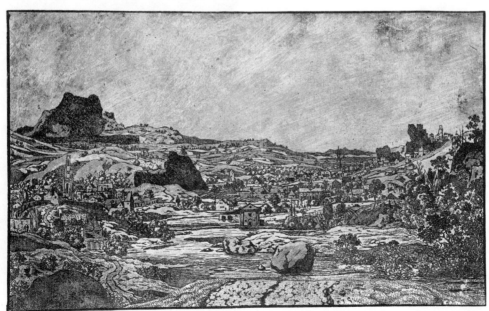

**472**
Self-portrait by Candlelight. Etching by
Rembrandt, 1630

**473** (BELOW, LEFT)
Baldassare Castiglione. Drawing by
Rembrandt, 1639, after painting by
Raphael, about 1515

**474**
"Ariosto." Painting by Titian, about 1512

**Rembrandt's portraits**  It is hard to describe the greatest painter of the
north and the greatest printmaker of them all, because Rembrandt is so many peo-
ple. Try to pigeonhole him anywhere, and he escapes. Call him a Dutchman, and
he shows a deeper understanding of the essentials of the Italian High Renaissance
than any northerner. Call him a master of shadows, and he draws a figure with
three or four lines. Call him spiritual, and he throws grossness at you.

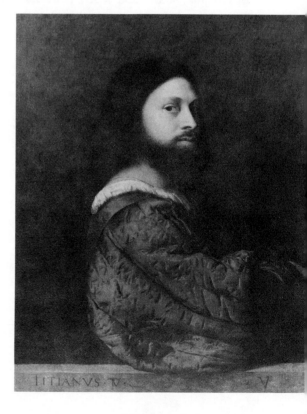

His various selves crowd his self-portraits. In his 20s he makes mouths at the looking glass to try out pity and fear [ 472 ], while the candle agitates shadows. At 33 he has married an heiress, Amsterdam society is queuing up to be painted, and he has just seen Raphael's portrait of Castiglione at a local auction [ 473 ]. The purchaser of the Raphael also shows him Titian's so-called Ariosto [ 474 ] with its Venetian pose that Raphael had assimilated for his Castiglione. Imposing the Venetian layout on its Roman adaptation, Rembrandt etches himself in a Renaissance aristocrat's wide sleeve, lounging on a parapet like the Ariosto and staring you down under a floppy beret like the author of *The Courtier* [ 475 ]. This is the one moment when he does not regard himself as merely his handiest model but wants to set himself on record as a pretty man. And if you were 33 and had just made a lot of money and a shrewd marriage, could you help indulging in a bit of physical vanity? Then Saskia slowly dies, Geertge goes mad. After nine years Hendrickje reestablishes order in the house and Rembrandt can again face himself in the mirror [ 476 ]. Now, at 42, what has become a potato face is mastered by those all-devouring eyes and that hand about to go exploring. Rembrandt's obses-

**475** Self-portrait Leaning on a Ledge. Etching by Rembrandt, 1639. Reproduced in reverse

**476** Self-portrait by a Window, Drawing. Etching by Rembrandt, 1648

sion with looking and drawing has finally fused the two acts into one reaction. He loses himself in looking until he becomes what he sees, whether he sees a gutted ox or Christ preaching, and he discharges his vision into a shorthand that instinctively nets all essentials. Becoming what he sees turns him into many things in succession and rescues him from good taste, which you demonstrate by rejections. This etching of 1648 starts the last long series of self-portraits that Rembrandt continued by painting himself in imperial loneliness.

We follow his etched portraits through his etchings of old friends who had helped him. He portrayed them with accessories that suggest their ways of life, quite unlike his paintings of strangers who came in off the street to sit empty-handed in the studio chair. When he was 41 he made his only full-length etched portrait of his steadfast friend Jan Six [ 477 ]. The young patrician, dressed with rich sobriety, stands in a handsome old room and reads what might be the draft of his latest poetic tragedy. The paper glows back at the face that Rembrandt worked and reworked with microscopic touches as the focus of a figure that makes its effect by its stance and setting. Rembrandt must have regarded this as his most important etched portrait; sketches for it survive in chalk, ink, and oils. About eight years later, toward the end of the series, he made his only portrait entirely in drypoint of the bailiff of the bankruptcy court [ 478 ]—toward which Rembrandt's business

**477**
Jan Six. Etching by Rembrandt, 1647

**478** (OPPOSITE PAGE)
Thomas Jacobsz Haringh (Old Haringh).
Drypoint by Rembrandt, 1655

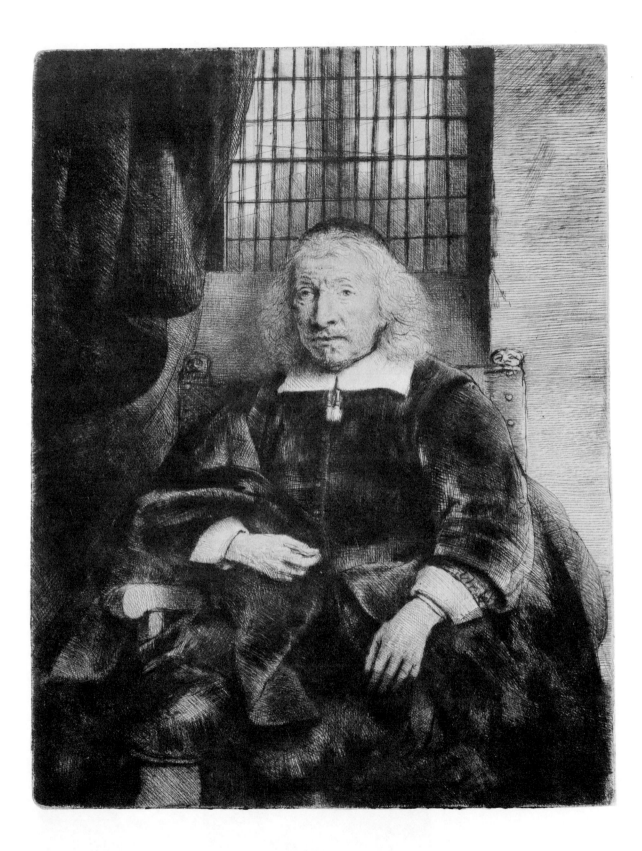

clumsiness was inevitably drawing him. The light from the thick windowpanes glows on the pale old face that has seen so many men in trouble, and now meditates on man's misfortunes. The flesh has worn to a lucid casing for the spirit. Here Rembrandt has left the rowdy force of his adolescence so far behind that it seems to come from another man in another country. No other artist ever traveled so long a road.

### Rembrandt's techniques

About a decade after Rembrandt's death, the Florentine critic Baldinucci marveled at "Reimbrond Vanrein's astonishing style of etching, which he originated and which has never been practiced before or since. With scratchings and scribblings and no outline, he achieved a rich and powerful light and shade, here totally black, and there baring the paper." This well describes the range of Rembrandt's effects. But by subordinating his skill to an imagination that developed more subtlety than any, he makes one forget that he was also the greatest copperplate technician. While most artists perfect a single manner, Rembrandt varied to suit each subject, now dropping a tried and proven way of working to revert to an earlier one, now inventing something new. Each fresh vision dictated

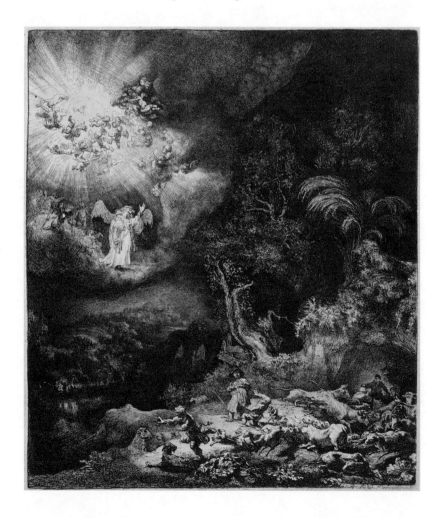

its own line and tone, the way each play dictated its own syntax and vocabulary to Shakespeare.

Rembrandt and Goya found release from insistent painting commissions by making prints that they could treat as they pleased while being challenged to juggle indirect manipulations for an always surprising outcome. Rembrandt must have started to etch in his late teens, for he was no novice at 22 when he signed and dated a plate, his needle, like a quill, already weaving lively lines. During his 20s he limbered his fingers by etching mostly full-length beggars and heads of himself and his household in about 150 little exercises—half his total etchings in number but far less than half in interest. At about 28 he began to mat lines thickly to rival painting with a black and white as striking as Goudt's engravings after Elsheimer [ 442 ]. Rembrandt's Annunciation to the Shepherds [ 479 ] is a brilliant melodrama of fugitives and stampeding cattle. The glory in the clouds (probably suggested by a translucent stage backdrop) spotlights the night.

After Rembrandt tired of making etching imitate painting and drawing, he used it to explore a third way of seeing. No brush or pencil could explode just like the single rough bite of acid (as economical as an etching by Manet) that suggests the silent shattering in the upper room [ 480 ]. Similar spontaneous jottings probably

**479** (OPPOSITE PAGE)
The Annunciation to the Shepherds.
Etching by Rembrandt, 1634

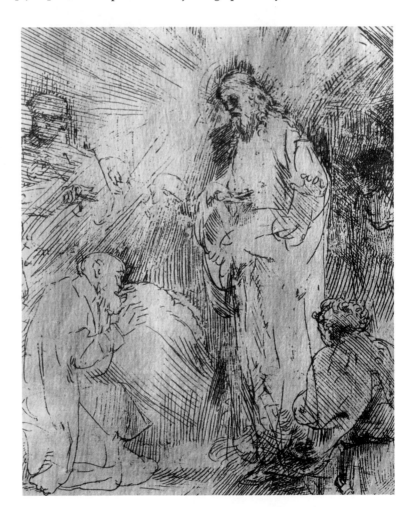

**480**
Doubting Thomas. Detail of etching
by Rembrandt, 1650

underlie the intricate rework on Rembrandt's later etchings. At one time he varied
a calm open etching [ 481 ] by painting ink on the copper itself [ 482 ]. Such print-
ings of tone could have prompted Castiglione to invent the monotype [ 527 ], in
which he painted the entire subject on an unworked copperplate and then printed

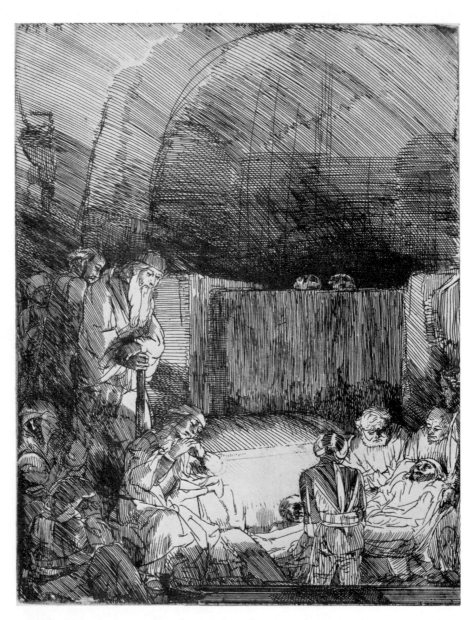

**481** The Entombment. Etching by Rembrandt, 1645. Clean-wiped impression of
first state

it as for an etching. Rembrandt usually reworked the copperplates of his late spontaneous etchings by using the graver unconventionally for medium tones and the drypoint needle for the blacks. In his early 40s he thus combined his range from outline etching to total shading by giving equal emphasis to the light and dark

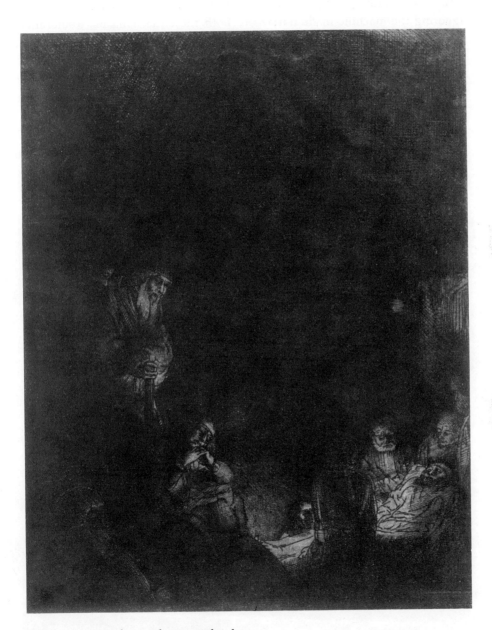

**482** Impression of second state with ink tone

halves of the Hundred Guilder Print [ 483 ], his bravura blend of etching, engraving, and drypoint, one of his most complex works in any medium. Christ beats his radiance at the haunted shadows, out of which the sick and ignorant grope their way toward his illumination. Drypoint creates this furnished and inhabited darkness in one of those modulations of deep tone that must have suggested the invention of mezzotint [ 511 ] and aquatint [ 229 ] in Amsterdam at this very time. Ignoring the machine-made flatness of both these mechanisms, Rembrandt preferred to develop his individual discoveries by etching more scenes of darkness than he painted.

After he was about 40, Rembrandt's impatience led him more and more to attack the copper muscularly with drypoint, slashing with an abruptness that still startles [ 484 ]. Since drypoint wears off in a few impressions, it is unfortunate that over 75 of Rembrandt's actual plates survive for reprintings until as late as 1906. These last, worn, reworked impressions show us less of Rembrandt's intentions than do good photomechanical facsimiles of early impressions.

**483** (OPPOSITE PAGE) Christ's Ministry (the Hundred Guilder Print). Etching by Rembrandt, 1640s

**484** Christ Presented to the People. Detail of etching by Rembrandt, 1655

**Rembrandt and the Bible** Rembrandt may never have read the entire Bible, but he meditated all his life on episodes in which the divine penetrates the everyday to surprise ordinary people in extraordinary relationships. He returned to the Bible more often than to any other subject and expressed his preoccupation most imaginatively in his etchings. Into his etchings he put as secret a part of himself as into his drawings, adding an effort for public presentation that makes them as effective as his paintings. He could throw himself into black and white, or brown and white, as wholeheartedly as into painting. Though he was not actually color blind, his paintings show that he cannot have distinguished colors as vividly as Vermeer or Monet. The comparative monochrome of his eyesight concentrated his vision on adjusting tones in a mystery of shade that his pen or needle expressed as ably as his brush.

Rembrandt's most ambitious picture in any medium is the Hundred Guilder Print [ 483 ], on whose 38 figures he must have etched for as many weeks as he painted on the 29 figures in the Night Watch, plus injecting a higher voltage of emotion. The etching sums up Christ's mission by showing him doing many things at once:

**485** Christ Presented to the People. Painting by Rembrandt, 1634

healing the sick, receiving little children, rebuking the Apostles, and answering the Pharisees.

Though no one but Rembrandt could have welded together such multiplicity, he achieved a more limpid fusion when he turned to single episodes. Two prints of Christ presented to the people show how 20 years of reflection deepened his insight into the Bible. When he was 28 he painted the subject in grays [ 485 ] for reproduc-

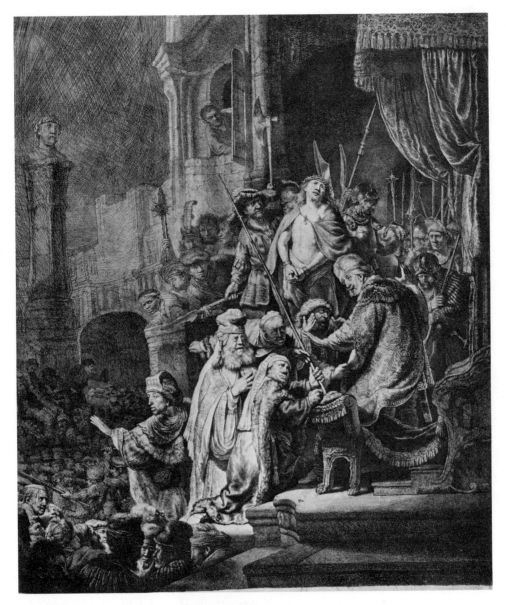

**486** Etching by and after Rembrandt, 1635/36

tion in a copperplate [ 486 ] that he copyrighted to emulate Rubens' profitable
advertisements during the previous 25 years. (Rembrandt, no businessman, gave
up copyrighting after two tries.) He or his assistants etched most of the early Christ
Presented before filling in the head and torso of Christ himself. He stands alone
outdoors, as Dutch prisoners did when they were being condemned to die, while,
in the darkness below, the scrimmage of his enemies cascades like a tragic car-

nival. Rembrandt later studied the Christ Presented that Lucas of Leiden had engraved over a century before [ 487 ], when medieval miracle plays were still being acted on platforms as wide as city squares. On such a platform Lucas lifted Christ and Pilate above the audience of the chief priests and the rabble, the way Greek actors were lifted above the chorus. (Saint John says that Christ was presented on the Gabbatha, actually the praetorium, which translators rendered as "the Pavement.") When Rembrandt was 49 he made a large drypoint [ 488 ] presenting Christ on a stage even loftier than Lucas' to separate still further the principal actors from the chorus. He interwove the rabble and the priests in a linkage more inventive than the cavalcade on the Parthenon. Their mere backs tell us how they feel toward each other and how they are reacting to the event that they and we are watching. By amalgamating intense individuals, Rembrandt perfected

**487**
Christ Presented to the People.
Engraving by Lucas of Leiden,
1510

**488** (OPPOSITE PAGE, ABOVE)
Etching by Rembrandt, 1655.
First state

**489**
Seventh state

the tradition of drawing crowds that was first published by Schongauer in his Road to Calvary [ 132 ]. Yet because the very fascination of this front row of spectators fences us off from the drama beyond, Rembrandt proceeded to rub out all but the two ends, expunging what alone would have made the fame of anyone else. An amateur artist hesitates to erase for fear he may do worse next time, but the professional shows his mastery by the ruthlessness of his sacrifices. Rembrandt's deletion—one of the boldest in all art—paid off, for it perfects the dualism of priests and rabble, Christ and Barrabas, godhead and mankind. He suddenly puts opera glasses to our eyes, pulling us into the void over the twin prison inlets to set us face to face with Christ and Pilate [ 489 ]. We now live inside the vision, oblivious to the calculations that went into its making, oblivious to the 20 years needed to get to the bottom of 200 or 300 words of reporting, oblivious even to the paper and the ink.

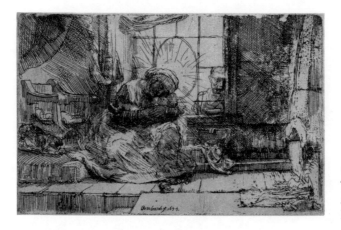

**490**
The Holy Family with
a Cat. Etching by
Rembrandt, 1654

**Rembrandt and Italy**   Rembrandt said that he had no time to travel to Italy with the other painters, and he was right, for Italy came to him in the Amsterdam salesrooms, transforming an ambitious yokel into a world-permeating mystery. In 1639 an auction displayed Raphael's best portrait, of Castiglione, long enough to show Rembrandt all that it had to teach him [ 473 ]. Such sales supplied him with the greatest collection of prints ever owned by any artist. Dozens of his purchases must survive in every large print collection, unidentifiable because he stored their images so completely in his eye that he never bothered to mark the paper as his property.

Mantegna's engravings inspired him long after other artists had abandoned them for Marcantonio and still later Italians. Although it is fairly easy to adapt and improve on characterless works of art, it takes a Rembrandt to digest anything so authoritative as a Mantegna, transforming his hieratic Mother of God [ 195 ], as symbolic as a sacred monogram carved in marble, into the human mother humming to her baby snug in a window nook [ 490 ]. The upward look that Mantegna uses to awe with the eminence of grandeur here turns into the small child's familiarity with the undersides of chairs and tables. Far from copying Mantegna's image, Rembrandt developed unsuspected implications in its canonized theme. Most expressive discoveries are made in old familiar subject matter, for the really original artist does not try to find a substitute for boy meets girl, but creates the illusion that no boy ever met a girl before.

Rembrandt also learned much from Raphael's impeccable command of layout. He studied reproductions of some of the ten huge cartoons that Raphael drew for tapestries to decorate the Sistine Chapel in the Vatican. When these vast drawings were unrolled in Brussels, they transformed tapestry weaving for four centuries. To reproduce such large, shaded, and rounded forms [ 491 ] the Flemish weavers had to give up their traditional flat patches of bright colors for somber tones curving into shadows. (Weavers coped with the new painting's broad volumes round-

**491** The Death of Ananias. Tapestry cartoon by Raphael, 1514–16

**492** Chiaroscuro woodcut by Ugo da Carpi after Raphael

ing into depth until Jean Lurçat in 1939 revived the old, bright, flat splashes.) Raphael's cartoons were translated more independently by Ugo da Carpi, whose color woodcuts simplified Raphael's design into basic areas of tone [ 492 ] that conveyed the flat pattern to Rembrandt [ 493 ]. Rembrandt's etching is reproduced

**493** Christ Preaching (La Petite Tombe). Etching by Rembrandt, about 1652. Reproduced in reverse

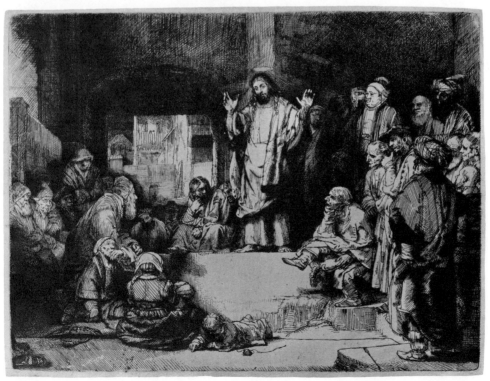

here in reverse, the way he drew it on the copper with one eye on the woodcut and a side glance at an engraving after a Raphael fresco for the attitude of Christ. Although he adapted the woodcut's spotting, he confused Raphael's precise placing of people on the floor, so that you cannot plot so clear a ground plan of the etching as you can of the woodcut. Rembrandt masked such ambiguities of position by blending figures in a thickness of air that makes his pictures more "real" than the Italian architectural construction. He pulls you into a circle of listeners so possessed by Christ's utterance that nobody thinks of looking at his face. This portrait of a voice was made a few years after the supreme showpiece, the Hundred Guilder Print [ 483 ]. On this return to the theme of Christ's ministry, Rembrandt had learned from Raphael to concentrate his drama with a simplification that looks inevitable.

**494** Nude Man Reclining. Etching by Rembrandt, 1646

**Rembrandt's figures**  No matter how many kinds of things Rembrandt drew, he never deserted that pivot of Western art, the human being. Unlike Michelangelo, obsessed by the muscular young man, Rembrandt, being an endless person, studied all ages and all conditions. As he developed he saw people as he saw everything else, in ever more subtle and complex relationships. He first etched small heads, then small figures in simple poses, sometimes tentatively grouped. Whereas most painters draw nudes when young, he etched almost all of his when he was 40 to 55. His male models were certainly apprentices, who were everywhere expected to pose on warm days if they stripped passably [ 494 ]. Although Rembrandt painted two anatomical demonstrations, no drawings of dissections by him now

**495**
Bathers. Etching by Rembrandt, 1651

survive. The engineering of bone and muscle (Leonardo's passion) probably interested him as little as the engineering of buildings. Provided a gesture or a vault looked convincing, it did not bother him if the arm was too short or the dome would collapse if built.

The optical age of the baroque had no more optical painter than Rembrandt. While he was etching his last great landscapes, he took a copperplate to a swimming hole to sketch the bathers in the open air [ 495 ]. He saw them like Cézanne [ 719 ], as bodies fractured in dappled shade or obliterated in sunlight. No such etching occurs again until the 1880s in France. From this noonday glimpse, Rembrandt could plunge deep into Giorgione's twilight for the so-called Negress Lying Down [ 496 ], in a Venetian dusk compacted as thick as aspic with a skill that he

**496** "Negress Lying Down." Etching by Rembrandt, 1658

**497**
Abraham Sacrificing Isaac. Etching by Rembrandt, 1655

**498** (OPPOSITE PAGE, LEFT)
The Presentation "in the dark manner." Detail of etching by Rembrandt, 1654 Rembrandt, 1654

**499**
Christ Presented to the People. Detail of drypoint by Rembrandt, 1655

alone commanded. It is hard enough to draw a thing to look round, but next to impossible to embed it in a shallow, yet palpable, deposit of air. To print the magic of such drypoint, Rembrandt wiped the copperplate with a touch almost as rare as the etching itself and printed it on Oriental papers that absorbed all the warm ink into their creamy softness. The woman lies in counterswings of hip and shoulder like the Venus that Velázquez was then painting in Madrid, also under Venetian influence.

Italian prints showed Rembrandt how to entwine Abraham, Isaac, and the angel [ 497 ] in a human column as intricately linked as Giovanni Bologna's marble Rape of the Sabines, published in 1584 through three woodcuts. Rembrandt's expressive invention was to cover the boy's face so that the shivering of his ribs makes us also suffer the gooseflesh of martyrdom. Thus a veteran actor conveys the pang of a crisis by turning his back on the audience.

Rembrandt's mastery of figure drawing appears most vividly in enlargements of details so tiny that he must have drawn them under a magnifying glass. This painter of wall-size dramas could also work like a gem engraver on heads that would not cover your thumbnail. On any scale it would be hard to find a face more expressive than old Simeon's at the temple when he holds the Christ child in his arms and says: "Lord, now lettest thou thy servant depart in peace according to thy word, for mine eyes have seen thy salvation" [ 498 ]. When Rembrandt scratched

hairlines through the etching ground, he had to calculate just how much the ragged bite of the acid would thicken them. He shaded behind the two heads with the tapering straight lines of the graver. The next year he achieved equal character in as small a head that he incised into the hard metal itself with the jerky, slipping, stiff drypoint needle [ 499 ]. Arresting as these details are when enlarged and isolated, they project even more drama in their setting, where, unlike Dürer's ostentatious particularities, Rembrandt's details blend like musicians in an orchestra pulling together for an overmastering effect.

## Rembrandt's landscapes   In two bursts, during his late 30s and mid-40s, Rembrandt etched some 24 landscapes that influenced etchers after they were reproduced by photogravure in the 1860s and 70s. His view of Amsterdam [ 500 ] may be the earliest of the group, since it seems the most factual. Yet it is so far from

500
Amsterdam. Etching by Rembrandt, about 1640

being a postcard record that Rembrandt deleted one church tower and etched the
rest as he saw them on the horizon, thus making them print in reverse order. He
suggested the depth that he strove for in all picture-making without resorting to
the traditional framing uprights, like stage wings, to push back the center. Instead,
the Dutch bogs dictated the horizontal foreground of rough sedges, the most insis-
tent foreground in all his etched landscapes, that stretches a starting line from
which the marsh river winds deep in.

About five years later Rembrandt subtly varied the old stage-wing layout in the
Omval, a spit of land on the Amstel [ 501 ]. With an art concealing art, he spaced
milestones horizonward from the tree so close that it overruns a third of the pic-
ture, balancing the black stump to make a gate opening in to the back of the man
who stares out across the rowboat to the diminishing windmills. The eye travels

**501** The Omval. Etching by Rembrandt, 1645

over lines patterned for surprise after surprise. The summer sky is clear, as Rembrandt always etched it except in visions of unstable weather.

In the more sensitive of his two stormy landscapes [ 502 ] the coming squall generates energy on the left where gusts tousle trees, ruffling a restless surface over a stolid substructure. Rightward, the blast dissipates in lesser contrasts, dying out in a sunny, still orchard. The foreground posts and hedge drive into the oncoming wind. All these intricate and possibly instinctive calculations manage to look "real" in this glimpse of a passing turbulence that Rembrandt developed in his studio like a photographer bringing out a latent image.

Even when Rembrandt left the sky blank, he still saw it as an ocean of air cresting over the sediment of Holland, the way it appears in a view of Rhenen [ 503 ] once attributed to Seghers. This print must have inspired one of Rembrandt's most

502 Trees, Farm Buildings, and Tower. Etching by Rembrandt, about 1650

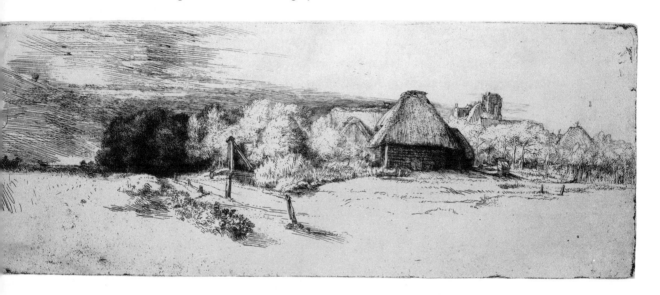

original landscapes [ 504 ], known as the Goldweigher's Field because it was formerly thought to represent the estate of a Receiver General near Amsterdam. It is the only landscape in all art that wheels under the drive of invisible wind around a pivot on the horizon, as level lands seem to wheel when watched from a fast train. Only Rembrandt could have perceived such a turning from the crawl of a horse or coach. Since the tufts of drypoint to right and left are needed to push back the horizon and to revolve the plain, this print must be seen in one of the few early impressions before the burr wore down.

During Rembrandt's mid-40s, human beings crowded out pure landscape as a subject for etching, forcing him to seek scenery that would merge with large fore

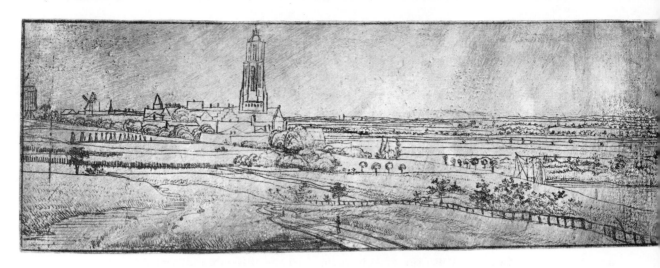

**503** Rhenen. Etching by Hercules Seghers or Jan Reuscher

ground figures. The Dutch flats—the only landscape that he habitually walked in—ebbed too fast behind a figure, abandoning it to rise solitarily into the sky. This problem led him to rework the Seghers plate of Tobias and the Angel [ 443, 444 ], where hills such as he rarely or never saw support and surround most of the bodies. He reduced Seghers' giants to the modest Holy Family to try blending people into nature. Though his inserted drypoint segregates itself from the original etching, his experiment at least showed that sizable figures can be made to sink into a landscape if it is hilly. Feeling that steeper and more interesting hills would do even better, Rembrandt went to drawings and woodcuts that Titian and Domenico Campagnola had made when they ferried from Venice and were surprised by the abruptness of uplands. A year or so after he had reworked the Seghers plate, he dreamed a high bluff in the Venetian manner, topped it with an ominous lodge and a dumpy

**504** The Goldweigher's Field (actually Haarlem). Etching by Rembrandt, 1651

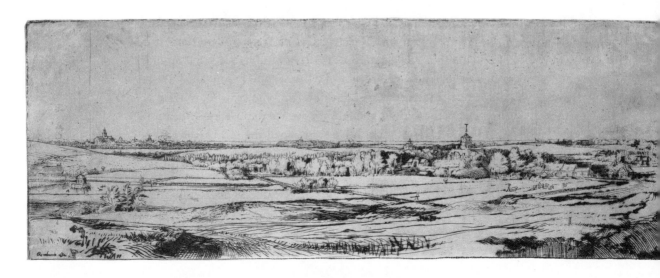

abbey [ 505 ], and linked this backdrop to old Saint Jerome in the foreground through the diagonal lion, who stares into the distance like the man in the middle of the Omval. If it is possible to guess whatever flashed an artist's magical first glimpse, this lion provided the lucky spark that ignited the whole vision. Observing the feline S-curve, Rembrandt then crossed it with the slanting tree and the spill of rock to make a huge X. He next started the procession into depth with the lion's tail—light against dark—that pulls the wraith of a hermit backward in a diagonal prowl traveling toward the lion's head—dark against light—where the secret eyes glare across the valley with enough of an expulsion to clear an upward blank into the far hill. Rembrandt unified these intuitions and recalls by spotting a light that is impossible yet inevitable; dream—nothing but dream—yet more deeply experienced than anything your window shows you. More than any other artist (Picasso included), Rembrandt compromised neither with verisimilitude nor with its enemy, the distortions of his imperious individuality, but grasped both together in a tension trembling with life.

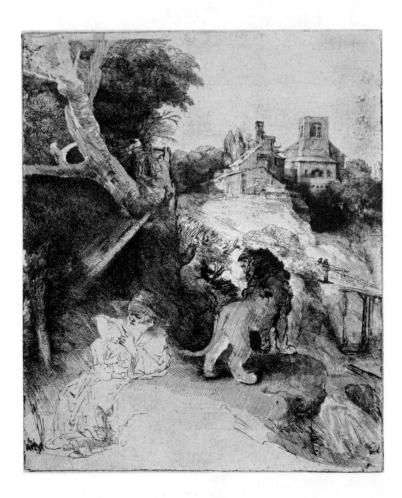

**505**
St. Jerome in an Italian Landscape. Etching and drypoint by Rembrandt, about 1653

**506**
The Painter. Etching
by Adriaen van
Ostade, 1667

## Rembrandt's contemporaries

Rembrandt illuminated a whole genera-
tion of artists who fluoresced—some more, some less—in his brilliance. Many bene-
fited from seeing how painting and printmaking quickened his vision by alternating
tools and problems. Rembrandt's youthful etchings served as models for his con-
temporaries, but as he grew older, he became inimitable. His early hold on his time
appears in the work of Ostade, who lived all his life in Haarlem, was taught by
Frans Hals, and yet etched like Rembrandt before Rembrandt began to use dry-
point. Ostade etched from his mid-30s until after the master's death without show-

**507**
The Bull. Etching by
Paul Potter, 1650

**508** The Traveler. Etching by Jacob Ruisdael

ing that he ever saw the late Rembrandt etchings that we prize most. Avoiding religious subjects, Ostade depicted beggars, peasants, and artisans. His painter [ 506 ] glances from the plaster muscle man on the shelf to the open book of emblems or personifications beside his easel, the two sources of the baroque artist's erudition in anatomy and allegory. Ostade's command of the difficulties of rendering full shadow is apparent only in the early states of his etchings before his coppers, like Rembrandt's, were reworked during two centuries of reprinting.

Paul Potter's etchings, like Ostade's, were prized in the 18th century. Potter and many other Dutch etchers of farm animals took their hint from Lucas of Leiden's Milkmaid [ 332 ]. Before Potter died at 29, he had founded the Dutch animal school with his clear and determined studies of cows, sculpturally defining their hard pelts, wet snouts, and pendulousness slung under a ramshackle scaffolding of bones [ 507 ].

Potter's followers were mostly Dutch, but Jacob Ruisdael's dozen etchings [ 508 ] set the style for many 18th- and 19th-century artists, especially in Norwich and Barbizon. Though he etched in his later 20s, the melancholy of his old age already announces itself in the crabbed scratching that has more character than any landscape etchings except Rembrandt's and Seghers'.

**509** The Resurrection of Lazarus. Etching by Jan Lievens

**510** Man in Armchair. Woodcut by Lievens

While Ruisdael and Ostade knew Rembrandt's art more than his person, Jan Lievens began by sitting beside Rembrandt to draw the same model in the same pose. Lievens, only a year younger, was not a pupil but an associate, with more taste and suavity than Rembrandt himself then possessed [ 509 ]. In his late 20s Lievens went for six years to Antwerp, where he fell in with local custom by engraving instead of etching. Christoffel Jegher, who was there cutting woodblocks for Rubens [ 430 ], may have started Lievens making the only woodcuts of the Rembrandt circle [ 510 ]. Lievens must have cut his own blocks to achieve such splintery spontaneity and the first rendering in woodcut of textures like wood and velvet. His experiment in a new medium energized a fluctuating talent with a force of personality that did not reappear in woodcutting until Blake's Virgil illustrations of 1821 [ 610 ].

**Mezzotint**   To print shadows as subtle as those in 17th-century painting required the wizardry of a Rembrandt. Even to approximate them, an engraver had to be as skillful as Goudt [ 442 ]. Then the discovery of mezzotint—"halftone"—suddenly opened the full range from black to white to any dullard. Its fuzzy tone without line excludes personal "handwriting" but aptly matches the gradations of oil paintings, making mezzotint the one print process that takes its character exclusively from painting. The process was invented by a half-German, half-Spanish soldier, Ludwig von Siegen, who experimented in Amsterdam while Rembrandt was discovering how to etch shadows trailing behind figures. By 1642 von Siegen was rolling a spiky roulette over copper wherever he wanted a roughness to catch a tone of ink, which amounts to a localized mezzotint [ 511 ].

In 1657 another soldier, Prince Rupert of the Palatinate, perfected von Siegen's invention by rocking a curved saw edge to roughen an entire plate with prickles like a file that catch ink in an allover black [ 512 ]. To make highlights, he then scraped off some of the prickles with a knife and burnished the copper smooth. If he happened to scrape any part too light, he redarkened it by roughing it again. Since the plate was roughened by an apprentice, whose drudgery was cheap to hire,

**511**  The Margravine of Hesse. Mezzotint by Ludwig von Siegen, 1643

**512**  The Standard-bearer. Mezzotint by Prince Rupert, 1658

The Duchess of Bedford.
Mezzotint by Samuel William
Reynolds after John Hoppner,
1803

**514** (OPPOSITE PAGE, ABOVE)
The Drop Forge. Mezzotint by
Richard Earlom after Joseph
Wright of Derby, 1778

the mezzotinter achieved full black and white faster than any other printmaker. The speed of the scraping more than compensated for the small number of good impressions that could be printed from the fast-wearing prickles. In 1660 Prince Rupert took mezzotint to the court of his first cousin, Charles II of England, where the court painter, Godfrey Kneller, promoted it to fill the gap left by the provinciality of English engraving. English painting, often darker than Continental painting, proved ideal for the imported process.

The "dark manner" became famous as the "English manner" when mezzotint rose with the rise of Sir Joshua Reynolds, who, on returning from Italy in 1753, began to give it the breadth of effect that painters always give to printmaking. When English mezzotints decorated a room as effectively as small paintings, all Europe and North America bought English "fancy subjects" as well as portraits of writers, painters, and solid, handsome gentry. English portraits demonstrated that a lady could look like a lady just as she is [ 513 ], without dressing her up as Flora or Diana, and contemporary events could be portrayed in perukes as solemnly as in togas. Baroque drama was running out of imagination. The coming factual view of the world produced some of the most fascinating "fancy pieces" in mezzotints after paintings by Wright of Derby, the first important English painter who refused to move to London. His pictures of scientific experiments and mill machinery made him the pictorial prophet of the Industrial Revolution [ 514 ]. Just before the inven-

tion of photography rivaled some of the effects of mezzotint with instant ease, David Lucas, a farmhand, learned printmaking at age 19 and became the most painterly of all mezzotinters. In his 30s he scraped some 40 landscapes after paintings by Constable, working on the steel plates that had been introduced in 1823 to

**515** Noon. Mezzotint by David Lucas after John Constable, 1830

yield more impressions than copper. Lucas submitted as many as 13 trial proofs for Constable to correct with black lead and white paint until the plate finally captured the sparkle of raindrops in a sunny breeze [ 515 ]. Though Constable said that "Lucas showed me to the public without my faults," these glimpses of fresh weather, too small for ornamenting a wall, were ignored in the excitement over photography. They cost Constable £700 and left Lucas to die in the poorhouse.

**516**
The Christ of
Caprarola. Etching by
Annibale Carracci, 1597

## Central Italian etchers

Shortly before 1600, Italian etching—both for the connoisseur and for the folk peddler—gravitated to Bologna, where the three Carracci—two brothers and a cousin—found time to make prints while painting with a blend of Florentine drawing and Venetian color. Agostino Carracci [ 410 ] engraved too much to belong to Parmigiano's tradition of painter-etchers. His brother Annibale, the strongest painter of the three, was also the strongest etcher [ 516 ]. He taught his command of form and large design to Guido Reni, who joined the Carracci's Academy and inherited their leadership in Bologna. Many of Reni's followers also made pretty, open-line etchings of Madonnas, Holy Families, and cupids, inspired by a piety whose undoubted sincerity escapes us today. These little devotional images are saved from sentimentality by the healthy Italian love for any young mother and her child [ 517 ]. Such popular prints, rather than Bolognese paintings, carried the sweet and intimate aspect of the Italian baroque into France and Spain, prolonging its grace into the 18th century.

Near Bologna, Guercino sketched only twice on copper [ 518 ], but with all the flow and spirit of the quill drawings that brought him his greatest fame after his

death released them to the world. He luckily etched with the young, full-blown abandon that he was persuaded to repress for conformity to academic taste. The most violent Italian painter-etcher was Pietro Testa. Like many Tuscans, Testa settled in Rome—not, however, for papal money but for his interest in archeology. He reconstructed paroxysms of antique brutality [ 519 ] with details as exactly documented as Mantegna's or Piranesi's. But poor Testa, lacking Piranesi's productive drive to live, drowned himself in the Tiber.

**517**
Madonna. Etching by Guido Reni

**518**
St. Anthony of
Padua. Etching by
Guercino

**519**
Achilles Drags the
Body of Hector
around the Walls of
Troy. Etching by
Pietro Testa

**520** Death's Victory. Etching by Stefano della Bella

**521** Cartouche. Etching by della Bella

Meanwhile, Florence produced the most exported Italian etcher of the age in
Stefano della Bella, who was 11 when Callot left there to go home to Nancy. Della
Bella learned from Callot's pupils to etch with French precision and mordancy
[ 520 ] and to be a specialist etcher instead of a painter who etched on the side, like
many Italians. He was also the first influential printmaker who did not cater to
piety; of his over 1000 plates, only 28 were made on religious themes for the French
market. Della Bella's etching took on a richer tone from Rembrandt when he spent
the decade of his 30s in Paris. There, where he had more followers than at home, he
passed on his picturesque command of ornament [ 521 ] to Lepautre [ 538 ]. Callot
and della Bella were the first to etch their personal fantasies as offerings for collec-
tors' portfolios. (A decade or so later, Poussin became the first painter to work less
on specific commissions than on his own for possible sale.) The print, traditionally
a recipient of prayers and a go-between of information, thus also became an esthetic
commodity, as it now is exclusively. Della Bella was the last artistic creator in Flor-
ence until Giovanni Fattori [ 682 ] in the 1860s. In fact, after the death of Cara-
vaggio in 1609, Italian painters and printmakers innovated less than Bernini and
Borromini did in their sculpture and architecture. Italy had by then trained Nether-
landers, Frenchmen, and Spaniards to explore fresh ways in drawing, painting, and
printmaking.

**Italy and Rembrandt**  In the 1600s Italy's traditional centers of painting turned to innovating in other fields—Venice creating dramatic music, Padua and Bologna exploring physiology, and Florence, through Galileo, founding modern physics. But in Naples and Genoa, weaker artistic traditions left natives open to foreign influences. Caravaggio's months in Naples in 1607/08 helped to darken Neapolitan painting in a dramatic manner that a Spanish follower brought to Valencia, there forming José Ribera as a Caravaggist even before he settled in Naples at the age of 28.

In Naples, Spain had dominated so long that Ribera continued to live among Spaniards who satirized each other and cut Olympus down to their own size. His irreverent Silenus [ 522 ] appeared the year when Rembrandt's first dated etching began his experiments toward the dramatic contrasts of black and white that Ribera had already achieved. With a control of form that harks back to Mantegna, Ribera modeled shadows around a glare of light as though he wielded a brush instead of a needle. Although he etched as powerfully as any of Rembrandt's contemporaries, his etchings have remained unpopular because of the harsh particularity of his satyrs—all bone and tendon—his blown-up drunkards, and his dried-out old men. As his legacy to students, Ribera etched studies of heads in one of the few vigorously drawn manuals of drawing [ 523 ].

**522**  Silenus. Etching by José Ribera, 1628

**523**  Drawing exercise. Etching by Ribera

Ribera's most independent pupil was a native Neapolitan, Salvator Rosa. As the last Italian artist who aspired to the Renaissance ideal of the universal man, Rosa painted, etched, wrote poems and plays, acted, and made scenery in his private theater. He invented the romantic landscape of crags and gullies as stage sets for hermits, brigands, and violent heroes [ 524 ]. He set attitudes for French and English romantics in 1775 to 1825 through his most imitated works in any medium—a drawing book in 62 etchings of volatile soldiers who brag, strut with spears, and plunge their heads into their desperate hands [ 525 ].

After Rembrandt absorbed Ribera's demonstration of painterly etching, the results returned to Italy through Benedetto Castiglione [ 526 ], Rembrandt's junior by ten years, who grew up in Genoa while Van Dyck was there painting the first vast portraits with palatial backgrounds. Castiglione's asps, skulls, broken columns, and toppled urns assembled the paraphernalia of evanescence for G. B. Tiepolo and the whole 18th century. He may never have seen a painting by Rembrandt,

**524**
Jason Slaying the Dragon.
Etching by Salvator Rosa

**525**
Two soldiers. Etching in Salvator Rosa,
*Ludentis Otii* (*A Player's Pastime*), Rome,
1660–72

**526** (OPPOSITE PAGE)
The Artist's Genius. Etching by Benedetto
Castiglione, 1648

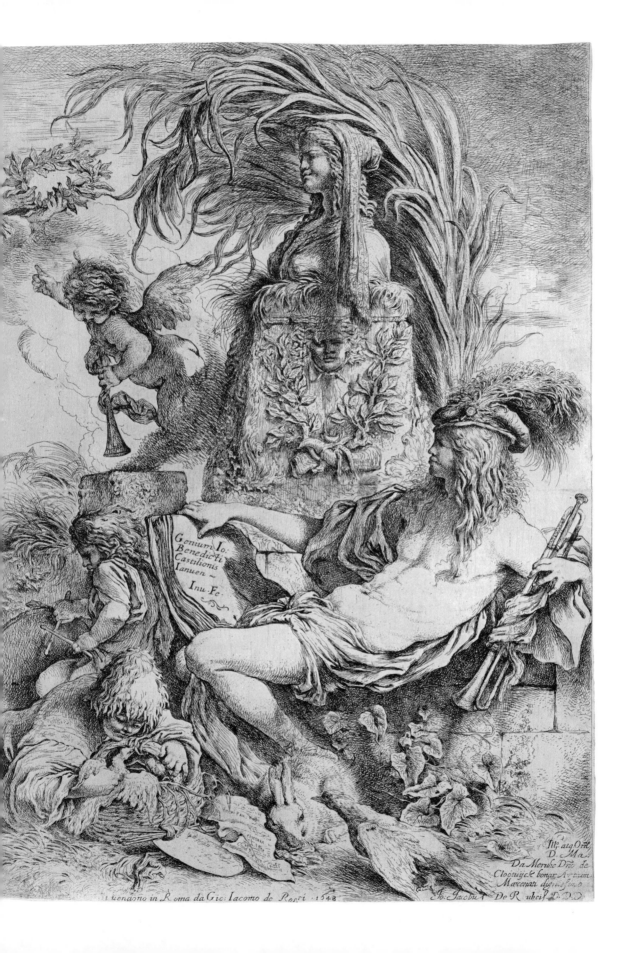

Genium Io:
Benedicti
Castilionis
Ianuen ~

Inu·Fe·

Illmo atq Ornẽ
D· Ma
Da Meruhe Dño de
Clootuijck bonar Artium
Maecenati dignissimo
Iho· Iacobus De Rubeis D·D·D·

in Regno in Roma da Gio: Iacomo de Rossi · 1648 ·

but he was the first artist outside the Netherlands to adopt Rembrandt's early etching manner of scribbled shadows. The heavy film of ink that Rembrandt partly wiped off some of his plates [ 482 ] may have given Castiglione the idea of doing the same thing on an unscratched surface, thus discovering Italy's only technical invention in printmaking, the monotype, made by painting a picture in printer's ink or painter's colors on a nonabsorbent surface such as copper or varnished cardboard, then printing it in a rolling press like an etching. Since one printing licks most of the ink off the smooth surface, leaving too thin a film for a good second printing, this offset painting is called a monotype [ 527 ]. Although it sacrifices duplicability, the printmaker's most profitable asset, the monotype (like the mezzotint) is easy to work in either direction, from white to black by painting with ink or from black to white by wiping some off again. The informality of the monotype's dab-and-wipe disgusted specialist printmakers, and even the convenience of its directness failed to attract painters after Castiglione until Degas made over 400 monotypes [ 685 ], many of which, like some of Castiglione's, served as bases to be worked over in colors.

**528**
The Spanish Ambassador
in the Piazza Barberini,
Rome, 1637. Etching by
Claude Lorrain

**Landscape**   In China and Japan men have long seen themselves as the companions of the carp, the deer, the pine, the snow. Ten centuries ago the Chinese were already painting landscapes in which man appeared, if at all, as a momentary speck to witness time flowing with the river and life melting in the mists. But Western man, heir to the egocentric Greeks and Hebrews, at first relegated landscape to decoration on Roman walls and then to backgrounds in medieval paintings.

Landscape was humanized into importance as Arcadia by Claude Lorrain, born Claude Gelée in Lorraine, some 15 miles from Nancy. There, in his late 20s, Callot started him etching, putting tools in his hands without imposing a point of view. Yet something of Callot's zest for everyday doings carried over to Claude when he arrived in Rome and etched the Spanish ambassador with a corporal's guard rambling past a plaster statue of the newly elected German emperor [ 528 ]. Once Claude had settled in Rome he found it to be his spiritual home, as so many have done. Neglecting the ruins that puzzled more educated visitors, Claude followed his village boy's instinct by dwelling from dawn to dusk in the hills and pastures of the Campagna, sketching them with sepia washes as exactly graded as a Chinese

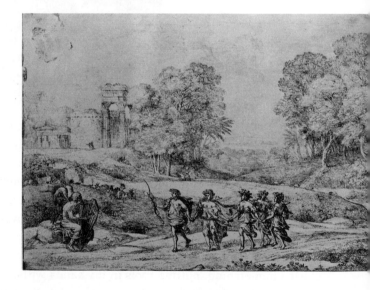

**530** (ABOVE)
Sunset. Etching by Claude,
1634

**529**
Apollo Leading the Dance of
the Seasons. Etching by
Claude Lorrain

painter's, and etching the flocks, shepherds, and thickets [ 529 ] in a tangle of lines
learned from Elsheimer's little prints [ 440 ]. He hardly varied this manner in the
etchings that he dated from his 30th to his 63rd year. Claude was also the first
etcher and painter to look square into the eye of the sunset, past dissolving spars
and columns [ 530 ]. Though French painters neglected Claude's native woodnotes
for Poussin's reasoned coherence, he made posterity see the Campagna through his

eyes until nearly 1900. He inspired a school of pastoral etchers in Holland, and 18th-century England expressed its veneration for him in manuals for drawing landscape.

Such printed manuals taught British naval officers to record harbor mouths and landfalls, and soldiers to sketch fields and hills clearly enough to help a commander plan a battle. England's good roads encouraged travel in coaches, from which the passengers studied the scenery or even sketched it on pocketable pads while changing horses. The local dampness kept watercolors moist long enough for a painter to finish his landscape at leisure, and after the 1750s a watercolorist could lay a perfectly even wash of sky on the new English wove paper instead of contending with the old laid paper that streaked color in parallel troughs. These circumstances encouraged the publication of more landscape drawing books in England than elsewhere. The most original was that by Alexander Cozens, who roughed out the masses of an imaginary scene by brushing "with swiftest hand" on crumpled paper. His random "blots" remind us today of Chinese brush paintings, which Cozens probably never saw. He aquatinted these "blots" [ 531 ] for students to place under translucent paper as suggestions for drawing finished pictures.

Highly practical imaginary landscapes were published by the landscape gardener Humphrey Repton, who would sketch the view from a house as it was and then hinge on a flap to show how he could make it look if supplied with funds [ 532 ]. Funds that were massive even by English standards enabled the Duke of Devonshire to transform a landscape on the grandest scale in the 1830s when he sodded over the village that had clustered by his doors at Chatsworth in order to surround his Italianized palace with a solitude as sweeping as Claude Lorrain's Campagna. As far as the duke could look, he thereafter saw nothing to disturb the mood of Claude's drawings, of which he owned the largest collection.

531 A blot landscape. Aquatint in Alexander Cozens, *A New Method of Assisting the Invention in Drawing Original Compositions of Landscape,* London, 1784/85

532 A park before and after improvement. Aquatint in Humphrey Repton, SKETCHES AND HINTS ON LANDSCAPE GARDENING, London (Boydell), 1794

**Art exhibitions** In 1483 the first exhibition catalogue listed and illustrated the relics displayed annually at Bamberg Cathedral. In 1495 the printer used some of the Bamberg cuts to represent quite different reliquaries at Würzburg. This economy really did not matter, since early catalogue illustrations always modernized the reliquaries so as not to embarrass the priesthood by advertising Romanesque hand-me-downs. In 1502 Vienna printed an exhibition catalogue that showed how relics were displayed to pilgrims outside the great shrine of Saint Stephen [ 533 ]. A row of priests, each one bearing a reliquary, halted in unison from window to window in the treasure tower. At such displays pilgrims held out little convex mirrors to soak up the saintly emanations for use at home. (In 1438 Gutenberg had contracted to cast such mirrors for pilgrims to Aix-la-Chapelle.)

The first prints of a private collection were made after Lord Arundel (1585–1646)

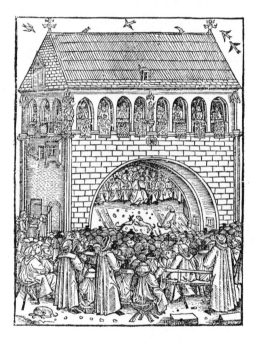

**533**
Exhibition of relics at St. Stephen's Cathedral, Vienna. Woodcut in *das Heyligtumb in Wienn (Relics in Vienna).* Vienna (Winterburger), 1502

**534** (OPPOSITE PAGE, ABOVE)
Gallery in the Palace of the Netherlands, Brussels. Engraving in David Teniers the Younger, THEATRE DES PEIN-TURES . . . DE L'ARCHIDUC, Brussels, 1660

**535**
François Girardon's sculpture collection. Engraving after Gilles-Marie Oppenord, about 1700–1715

had assembled the first great English connoisseur's cabinet during his travels as a diplomat. He commissioned his household artist, Wenzel Hollar, to etch over 100 of his antique marbles, pieces of silver, paintings, and Leonardo drawings [ 344 ]. If he planned to publish these as a catalogue of his collection, he was thwarted by his political misfortunes. The first great catalogue of a secular collection was issued instead by the Hapsburg archduke Leopold William while he was governing the Netherlands in 1646–56. 246 of his paintings were engraved individually, with their dimensions and a description in French, German, Spanish, and Latin, to proclaim the archduke's princeliness throughout the multilingual Hapsburg domains. The book also shows how the paintings crowded the old palace at Brussels from

floor to ceiling [ 534 ], the way they hung in every gallery until after 1900, when they began to be strung in a single line to thin out the growing museum crowds.

The first representations of an artist's collection fill six wide engravings with the sculptures that François Girardon, Louis XIV's busiest sculptor, bought out of his large earnings and installed beside models of his own works [ 535 ]. The juxtaposition shows us which Roman statues and Michelangelo marbles influenced French official art and how they were adapted. (The imaginary arrangement was invented by Gilles Oppenord, the most baroque of French decorators.)

When painters began to work more on their own initiative than on order, they organized exhibitions to sell their offerings. In 18th-century Venice they hung or stood their unframed, turpentine-smelling canvases outdoors in the square of San Rocco. In Paris and London the rains forced canvases indoors for formal showings at the Louvre and Somerset House. Prints provide pictorial inventories of some of these exhibitions from the first Paris Salon in 1699 until newspaper reports substituted inadequately after 1800. The camera began to record exhibitions when the Ingres-Delacroix show was photographed in place in 1855. On the unusually lofty walls of Somerset House [ 536 ], Reynolds and Lawrence commandeered the midheight for full-length portraits that they calculated to look their best when seen from below, using the formula that Rubens discovered at Genoa in 1606. In 1851 the first worldwide exhibition of contemporary art was made known through many illustrated publications and gorgeous color prints [ 537 ]. The Crystal Palace directly inspired the scope, arrangement, and catalogues of the Victoria and Albert Museum, all of which in turn guided many museums in the United States.

**536** George III and His Family Viewing the Royal Academy Exhibition at Somerset House. Engraving, 1789

**537** (OPPOSITE PAGE, ABOVE) Hiram Powers' Greek Slave at the Crystal Palace, Hyde Park, 1851. Color print in mixed processes by George Baxter

## Interior decoration

Medieval and early Renaissance rooms would have looked bare to us. So long as courts shifted from palace to palace, they packed up tapestries to clothe cold stone or brick quickly and a little sturdy furniture that often folded or knocked apart to load on mules. The more local and sedentary Italian princes at least unified the bare uncurtained rooms by getting the best painters to fresco the walls. But when Louis XIV decided to keep his nobles under his eye by making Versailles the only place worth getting invited to, he elaborated a harmony of decoration down to the last curtain tassel and flower bed. Charles Lebrun invented the required sumptuousness out of antique Roman architectural sculpture with a splendor that Jean Lepautre published to the world through 2350 etchings [ 538 ]. Lepautre etched the first corpus of interior decoration with a swift,

**538**
Project for a state apartment. Etching by Jean Lepautre

**539** Project for a night clock. Etching in Johann Jacob Schübler, *Wercke*, Augsburg (Wolff), 1728–32

**540** Apartment for Count Bielenski, probably at Nancy. Etching after Juste-Aurèle Meissonnier, 1723–35

colorful assurance learned from della Bella. These French prints showed erudite German princes how to display their collections of shells, porcelains, and scientific gadgets [ 539 ]. When Louis XIV's last great designer, Daniel Marot, emigrated to The Hague along with other Huguenots, French 17th-century decoration developed its final, elegant verticality in Holland, Louis XIV's most envied neighbor.

In France itself, the style broke abruptly in 1715 when the gloomy old king's death released the court. The younger courtiers fled to Paris to build themselves snug houses in the cosier Regency manner. The new, intimate rooms doubled their apparent depth through mirrors over the focus of talk, the fireplace. For a witty unity, Oudry's illustrations to Lafontaine [ 98 ] might be carved on the paneling or

**541** The Earl of Derby's drawing room, Grosvenor Square, London. Etching in Robert Adam, THE WORKS IN ARCHITECTURE, London (Elmsly), 1778

woven in the upholstery. The now independent courtiers drew ideas from the earliest sumptuous book on interior decoration [ 540 ], which illustrated andirons, tables, tureens, even snuffboxes and sword guards, in the style of the wall decorations.

Then, in the 1760s, Englishmen returning from the Grand Tour began to satisfy their nostalgia for Hadrian's Villa and Nero's Golden House by commissioning Robert Adam to resurface their Tudor halls with painted plaster lozenges and hexagons mirrored in the design of the carpet. Since Adam had little antique furniture to imitate, he matched the authentic Roman wall treatments by inventing furniture with square, tapered legs and a revival of marquetry. His scheme of classical quotations restricted everything except the old-master paintings to one decade and one taste. Adam's huge folio on interior decoration—the first in England—also influenced the Continent. In France in the 1770s his engravings [ 541 ] and the fashion for English simplicity went to make the Louis XVI style (then called *antique*) an alternative to the continuing rococo (then called *pittoresque* or *moderne*).

When Piranesi's designs further Romanized this "antique" style for showiness and declamation, it served Napoleon to legitimize his seizure of power by dressing

**542** The Library at Malmaison. Etching in Charles Percier and Pierre Fontaine, RECUEIL DE DECORATIONS INTERIEURES, Paris, 1812

**543** Kaiser Franz II's bedroom at Laxenburg. Lithograph in *Bildliche Darstellung von Laxenburg*, Vienna, about 1826

up in the toga of the Caesars. It is no accident that Napoleonic rooms impose with a theatrical autocracy that freezes out irreverence. The emperor's official designers presented this grandeur as though it were engraved on ice [ 542 ]. Such mastery of decoration exhausts the collaborating imagination with perfection that no work of expressive art can ever attain. The revolutions that followed Napoleon's downfall frightened the surviving aristocrats into Gothic Revival retreats [ 543 ] where they could imagine themselves back in the safety of their supposed origins during the Crusades.

As historical ages began to evoke emotional attitudes, the 19th century revived different styles to express different functions—Gothic for churches, Medicean Renaissance for clubs and banks, Louis XIV for municipal buildings, and Roman for law courts. An architect varied styles the way a character actor varies dialects. A shared architectural idiom suitable for all occasions appeared only in the 1920s when the Bauhaus in Weimar invented an international style.

**Stage scenery**   An Italian in France published the first illustrated treatise on stage scenery, showing an indoor platform set with lath and canvas "houses" [ 544 ] like those previously built on outdoor platforms for miracle plays. The action volleyed like a tennis ball, between opposite "houses" close to the audience, as it must have done in the original production of *Romeo and Juliet*. In Serlio's curtainless

**544**

Stage set for tragedy. Woodcut by Sebastiano Serlio in SECOND LIVRE DE PERSPECTIVE, Paris (Barbé), 1545

**545**

Ballet of the Four Continents. Etching by Stefano della Bella in G. A. Moniglia, IL MONDO FESTEGGIANTE, Florence (Stamperia di S.A.S.), 1661

palace hall the light shone equally on actors and audience, with the stage slightly brighter from candles wavering behind lens-shaped bottles of white or red wine.

A century later the Medici staged spectacles in the first outdoor secular theater of modern times, shaped like a Greek theater. The uphill slope of the Boboli Gardens was scooped out into an arena where educated horses paced in wide pavanes surrounded by the court, under cover at the rear of the Pitti Palace, and the rain-resistant populace in the bleachers [ 545 ]. The action advanced and withdrew as it was to do in the illusory depth of perspective scenery. Della Bella's etching appeared in one of those prestige publications that a prince sent to other princes to

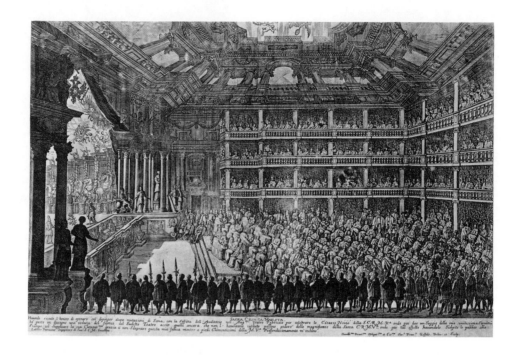

**546** The court theater, Vienna. Engraving after Lodovico Burnacini in Francesco Sbarra, IL POMO D'ORO, Vienna (Cosmerovius), 1668

advertise his magnificence. It must have impressed Louis XIV, then 23, for three years later he staged his own horse ballet and opera in his raw new gardens at Versailles. Lavish as his six-day spectacle was, it probably cost less than the fortunes spent by the Austrian monarchy to awe the discordant peoples of their domains.

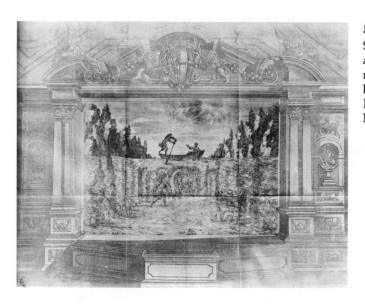

**547**
Scrim stage set. Etching after Francesco Santurini in Pietro Paolo Bissari, FEDRA INCORONATA, Munich (Jekelin), 1662

In Vienna one Italian opera, *The Golden Apple* [ 546 ], required 22 total transformations operated by gigantic wooden machines that dispelled a temple into clouds and sea, then gathered these into a Roman triumph complete with a lion chariot and captive kings.

In Munich (the other great home of northern opera) illusions like the fish-eye view of men rowing behind a scrim [ 547 ] required that the auditorium be darkened by snuffing candles or by hoisting the chandelier through a hole in the ceiling. But, as in the old, bright palace hall, the side walls of the auditorium still continued onto the stage in a wide corridor or mall until about 1700, when the Bibiena family of theater designers began to distinguish the stage from the baroque house by scenery of a contrasting style, such as Gothic, and by painting the backdrop with buildings that either point at you like an oncoming ship, or narrow back into a corner, or else combine both schemes in an X of intersecting colonnades [ 548 ]. This imaginative geometry opened even the tiniest stage to a vastness of dreams for the prince (who paid the bill) seated in the central box where the perspective lines converged. The eight busy Bibienas advertised their skill from 1690 to 1790 by publishing many of the sumptuous theatrical books that imposed Italian opera scenery on all Europe. With a deftness now lost, they could paint a balustrade plunging outward by diminishing the balusters as evenly as beads. Other stage designers might vary effects with more poetry and freedom, but none could draw so exactly for reproduction in striking engravings.

Scenery made its effect by line, not color, so long as candlelight yellowed everything, and footlights threw up a smoke screen of tallow smuts. (Old theaters stank

**548** Stage set by Giuseppe Galli Bibiena. Engraving in ARCHITETTURE E
PROSPETTIVE, Augsburg (Pfeffel), 1740

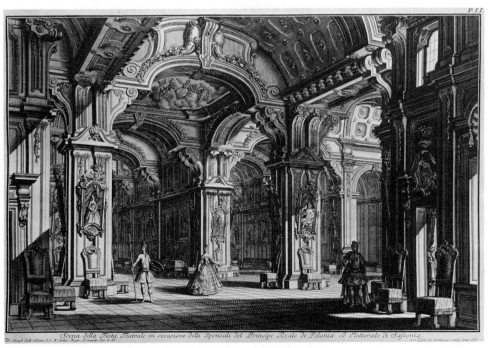

**549** Stage set for Mozart's *The Magic Flute,* Berlin, 1816. Hand-colored aquatint after Karl Friedrich Schinkel

like the roasting of rancid mutton.) An audience could begin to see bright colors after Paris in the 1780s introduced the six-candle-power smokeless lamp with a glass chimney, and especially after 1817 when clean gaslight began to brighten and dim London stages. The first great designer to use full color was Schinkel [ 549 ], who worked in Berlin when Napoleon's wars had beggared Germany. Like his fore-runners on the baroque stage, he painted on canvas the dream palaces that he could not construct in stone. Unhampered by the need for permanence, the cost of marble, the delays of masons, and the whims or deaths of patrons, Schinkel and all the old stage designers evoked visions of exotic styles and daring designs that sometimes shaped real buildings. Yet it is a pity that the great stage sets mostly decorated dramas of mythological twaddle. The masters of modern drama who wrote from 1575 to 1675 wished no visual intervention to distract their audiences from sharing a passion. Molière asked for nothing but some actors and three chairs.

**The copyrighted picture story**   Before the 1730s England produced illustrations for books and crude broadsides but no single-sheet prints other than maps, views, and a few portraits. To protect this weak effort imported prints had to pay a varying customs duty that for a time levied sixpence per print—often thrice

the price at home—while France, confident of a superior production, admitted prints for a mere 100 sous per hundredweight. Britain, having reduced court patronage by being the first modern country to tame its kings, had left engravers at the mercy of unscrupulous publishers. If an engraver ventured to publish on his own, anybody could legally undersell him with cut-rate copies.

The British writer, at least, had protected himself from piracy by the very first general copyright act in 1709, when William Hogarth, who was to protect the engraver, was still a 12-year-old apprentice learning to engrave flourishes and coats of arms on silver tankards and salvers. He, like Daumier, was the son of a thwarted author. Both Hogarth and Daumier more or less taught themselves to draw and paint the dramas that their fathers had tried to write. Hogarth said, "I treat my subject as a dramatic writer; my picture is my stage, and men and women my players" [ 550–555 ]. When he was 34 he painted the first of his "modern moral subjects"—The Harlot's Progress. He regarded the paintings as mere preliminaries, for he said that he planned to live "by small sums from many by means of prints which I could Engrave from my Picture myself." He cannily did not bother with "great correct-

**550–555** Marriage à la Mode. Engravings after William Hogarth, London, 1745

*The copyrighted
picture story*

ness in drawing or fine Engraving, which would set the price out of reach of those
for whome they were cheifly intended." He at least delayed copyists by soliciting
subscriptions for The Harlot's Progress while he was still engraving it, taking in
1240 guineas for as many sets of the prints, whereas he realized only 84 guineas
when he auctioned the six original oil paintings. His print sales after publication
must have suffered from the eight pirated copies of the series. This first original
story told in pictures for "reading" succeeded because it pictured Defoe's middle-
class moralizing with rooms, clothes, and gestures as exactly observed as in Bosse's
sets of prints of the Parisian middle class [ 462 ]. The Harlot was soon staged as a
pantomime and as a ballad opera, and it inspired English novelists to describe tell-
ing details of manners, dress, and settings. But if Hogarth's prints were to continue
to earn him dividends, he had to stop the piracies, so he—a fighter in every inch of
his five foot three—persuaded Parliament to enact the first copyright for "Design-
ers, Engravers, Etchers, &c." The first prints so protected for 14 years were Ho-
garth's series of The Rake's Progress, inscribed "Publish'd ye. 25 June, 1735.
According to Act of Parliament." Until 1911 commercially published English prints
continued to bear their exact date of publication, as American prints (but no others)
did after 1831. The pictorial copyright act did for Hogarth what the writer's act had
done for Defoe and Dr. Johnson: it enabled him to work independently. Not only
did Hogarth not need to slave for a publisher or flatter a patron, he was free to

express himself about any class of people without fear of censorship—England having been the first country to abolish most kinds of censorship shortly before Hogarth was born. France, on the contrary, would not trust an engraver to own a press, even for proving his copperplates, from 1586 to 1734, and required prints to be marked A.P.D.R. (*Avec Privilège du Roy*) from 1685 to 1790, to certify that the printmaker had deposited a stipulated number of impressions and secured authorization to publish. British liberties developed Hogarth into the first British artist to make an impression on the Continent, where his picture stories set the style for some French engravings and furnished themes for writers in French and German. The British freedom of the press was the envy, or the dread, of outsiders for a century before it spread to other peoples.

## Trade catalogues

While advertising must be as old as walls, its great extension began with printing. The first dated typography advertised indulgences for sale at Mainz in 1453. Printers soon pushed their own product with little handbills and then with book catalogues. No one knows when or where advertisements were first illustrated, but by about 1650 a wrapper for pins or playing cards commonly displayed the swinging sign that identified a shop before houses were numbered. After about 1700 smart London shops gave out trade cards (as matchbooks are given today) that were often engraved with some of the merchandise to make a one-page catalogue [ 556 ]. In Paris the royally subsidized porcelain and tapestry

**556**
Trade card for metalwares.
Engraving, London

**557** Sugar basin in catalogue of Sheffield plate. Engraving, 1780s

**558** Sconces, drawer pulls, and sabots. Engraving in brassware catalogue, Birmingham, about 1790

factories issued no trade cards, while lesser firms needed only a few for the intimate cliques of courtiers and financiers. Italy advertised even less, since local craftsmen worked for neighbors. But by the mid-1700s the Sheffield and Birmingham metal factories and the Staffordshire potteries began to manufacture so much more than they could sell locally that they started to advertise through the first illustrated trade catalogues in book form. These were not given to customers but to middlemen. The middlemen erased the manufacturer's name, lest their clients order direct from the factory, and identified the illustrations in languages that show British trade pushing even farther afield than the British Empire.

Illustrations show the plated silverware [ 557 ] that Sheffield began to manufacture in the 1740s and perfected in the 1760s by fusing two thin plates of silver to a thick core of copper and then rolling this sandwich in a thin sheet to be shaped with classic simplicity. The illustrations look as though they had been engraved by the factory hands who engraved decorations on the actual silver pieces. Birmingham specialized in brassware as well as saws, sextants, and tin shower baths. Its catalogue [ 558 ] sold brass drawer pulls and furniture mounts to France, where they were chased, gilded, and applied to French furniture.

In Germany the long-established iron foundries began about 1800 to advertise stoves and neoclassic decorative castings. The Nuremberg cottage industry of toy-

making varied its 18th-century line of dolls and dollhouses with toy carpenter shops, microscopes, magic cabinets, and electric machines [ 559 ] for children of up-to-date parents who had read Rousseau on learning by doing. German toy catalogues captured and held the export trade until 1914.

Furniture was hard to advertise in catalogues so long as the mass-produced pieces were as universally standardized as Windsor chairs, and the better pieces were made to individual order. But in the 1830s the bandsaw, based on a British patent of 1808, was developed in the United States for the mass production of furniture composed of ponderous softwood scrolls veneered with mahogany. Factories could keep busy only by the pictorial advertising of their latest designs [ 560 ].

The United States, as the first large custom-free territory with a not quite impossible postal system, encouraged factories to sell directly to customers through innumerable mail-order catalogues. A Yankee specialty—the light carriage, springy

**559** Mechanical and electrical toys. Etching in G. H. Bestelmeier, *Magazin von verschiedenen Kunst- und andern nützlichen Sachen (Storehouse of various Contrivances and other useful Things)*, Nuremberg, 1803

**560**
Veneered furniture. Lithograph, New York, 1833

with American hickory and ash, rugged with hugging, machine-cut joints—was distributed via catalogues [ 561 ] as far as South America and India. The success of mail orders produced a middleman who stocked hundreds and then thousands of articles when Montgomery Ward in Chicago in 1872 sent out the first general list of the various things that a family might need in a village or on a farm. Montgomery Ward and Sears Roebuck unintentionally developed their catalogues into illustrated encyclopedias of social history.

NOS. 7 and 8, BREWSTER TOP BUGGY.

**561**
Brewster Top Buggy. Woodcut engraving, about 1890

**18th-century books**   The 18th century perfected a fresh, seductive format for books subsidized by wealthy patrons for wealthy bibliophiles. These books were not meant to be read but rather to be admired two facing pages at a time. In 1719 Claude Gillot, Watteau's teacher, diminished Louis XIV's royal folio format into a neat block of type and picture [ 562 ]. Gillot was the next French printmaker after Callot to see wit and grace in the everyday and to keep pace with comedians. In Venice the invention of the rococo book completed four centuries of collaboration between Venetian artists and publishers. Borders as elaborate as those in old Parisian prayer books [ 249 ] surrounded gratulatory odes in the souvenir pamphlets that Venetian grandees gave to guests at family ceremonies [ 563 ]. The last of many Venetian books to be imitated outside Venice was a massive folio of Tasso that took years to prepare. Though each canto begins with the old baroque full-page copperplate, it ends with a new kind of vignette of figures sporting on an airy island [ 564 ]. But since Piazzetta's witty vignettes were dwarfed by the monumental page, the French, about 15 years later, scaled down the Venetian scheme to

FABLE CINQUIESME.

*Homere & le Sourd.*

A MONSEIGNEUR LE DUC DE NOAILLES.

Noailles, toi qui fais le métier de Heros,
Comme on le sçavoit faire à Rome & dans
    l'Attique,
Qui connois l'usage Heroïque
De l'action & du repos;
Moderne Scipion, propre à faire un Terence,
Qui même dans les champs de Mars,

Q q

**562**

Etching by Claude Gillot in Antoine Lamotte-Houdar, FABLES NOUVELLES, Paris (Dupuis), 1719

**563**

Etching by Francesco Bartolozzi, title page for LA REGGIA DI CALIPSO, Venice, about 1763

**564**

Etching after Giovanni Battista Piazzetta in Tasso, GERUSALEMME LIBERATA, Venice (Albrizzi), 1745

**FABLES NOUVELLES.** 121

Par le Destin il est abandonné;
C'est un trône vacant, si j'en crois l'apparence.
De notre globe infortuné
Deux étourdis ont toujours l'intendance :
Aussi va-t-il, comme il est gouverné.

**565**
Etching after Clément-Pierre
Marillier in Claude-Joseph Dorat,
FABLES NOUVELLES, Paris
(Monory), 1773

cupids lolling on capriciously evaporating cloudlets [ 565 ], harmonizing picture,
type, and paper with a delicacy better calculated to amuse the exacting idlers of the
age. The paper, "singing" through the ink, sets the brilliant key. C.-N. Cochin noted
that "vignettes must be etched, not engraved, to keep the spontaneity of a sketch,
which engraved finishing destroys." Though some Parisian book illustrators spe-
cialized in designing and others in etching, each could do the other's work well
enough for any number to collaborate as one. This unity of effort so impressed alert
amateurs that they began to bind preliminary drawings with the engravings to
make de luxe copies.

## Rococo and classicism in Germany
After the Thirty Years' War end-
ed in 1648, half a century of silence settled on the ruins of Germany. When initia-
tive finally returned, a new kind of pilgrimage church arose in south Germany and
Austria at ancient abbeys and on the sites of peasant visions in the fields. The new
builders explored the rococo with a rapture of release from the Vitruvian regula-
tions imposed ever since the end of the flamboyant Gothic. From about 1730 to
1750 churches rivaled heaven with the seraphic intoxication of white light sliding

566 St. Florian, Protector against Fires. Etching by Franz Anton Maulpertsch, Vienna, 1780–96

567 Winter, from a set of the four seasons. Etching by Jeremias Wachsmuth, Augsburg

from unseen sources across plaster sculpture tinted in shrimp pink, salad green, gilt, and silver.

Architecture's new mystery of brilliance surpassed the efforts of all Germanic painters except one—Maulpertsch of Vienna, who also used his experience of the Tiepolos' etching to make a few bold and subtle prints as bonuses issued yearly by a mutual benefit society [ 566 ]. Germany did not invent the rococo—indeed, where and by whom was it invented?—but Augsburg took the lead in disseminating the style through sets of four or six etched designs stitched together with a loop of linen thread [ 567 ]. Augsburg motifs spread south into Italian ceilings, west to Portuguese choir stalls, and north to Chippendale mirrors, for the Augsburg publishers marketed their ornament prints as efficiently as their ancestors had marketed the first mass production of woodcut books in 1470 to 90 [ 33 ].

In contrast to these south German factories, Prussia had but one printmaker of note, Daniel Chodowiecki, who painted French gallantries on enamel nicknacks

**568**
The Drawing Lesson. Etching by Daniel Chodo-
wiecki in ALMANACH GÉNÉALOGIQUE,
Berlin, 1781

until he was about 30, when he taught himself to etch, perhaps by studying prints
after Chardin [ 464 ]. He then etched over 2000 tiny, truthful glimpses of burghers
in placid little Berlin during the Age of Reason. He was also the German specialist
for illustrating pocket almanacs on subjects like men's hobbies, women's occupa-
tions [ 568 ], or the life of Frederick the Great.

## Wallpaper

**Wallpaper**    The earliest wallpaper found on a wall shows a silk-weave pattern
of pomegranates, printed in black on the back of a London proclamation of 1509.
This was discovered in England, where most wallpapers printed before 1750 have
survived. The prevalence of middling wealth allowed Englishmen to cheer their
rooms with paper, while Continentals had either tapestries or nothing. Early English
black and white wallpapers [ 569 ] imitated woven designs and the blackwork
then being embroidered in every household. From about 1690 to 1800 papers with
miniature designs for covering walls, lining drawers, or binding pamphlets became
a specialty of Augsburg, Germany's busiest producer of all decorative arts. To imi-
tate the gleam of the embossed and gilded leather wall coverings that Germany and
the Netherlands imported from Spain, the Augsburgers cut thick relief plates of
copper and heated them to emboss brass foil on single sheets of colored paper
[ 570 ].

By 1700 England was gluing together 12 squares of blank paper, each about 22
by 35 inches, for printing in rolls that were easier to paste on a wall than the Ger-
man single sheets. The British rolls received the main color from a woodblock
smacked with a mallet, other colors then being added to the basic design from sten-
cils that cheap child labor could center on the woodcut basis. In 1748 a British am-
bassador to Louis XV changed the style and production of French wallpaper by

decorating his Paris salon with British blue flock paper. Although the French gov-
ernment levied 20 livres import duty per hundredweight on British flock paper (as
against a mere 100 sous for British engravings), the French imported it until stopped
in 1755 by the Seven Years' War. In the 1760s a Parisian manufacturer, Jean-Bap-
tiste Réveillon, hired court designers of tapestries and silks to adapt their inven-
tions to the most subtle and vivid wallpaper that had yet been produced [ 571 ]. His

**569** Woodcut wallpaper with Tudor and Beaufort badges, England, 1558–1603

**570** Gold print on red paper by Joseph Friedrich Leopold, Augsburg, 1700–1727

**571** Taste. Blue and white wallpaper by
J.-B. Réveillon, Paris, before 1789

**572**
Gardens of Baga-
telle. Wallpaper,
Paris, about 1800

**573**
Captain Cook's
Voyages. Wall-
paper by Joseph
Dufour, Macon,
1806, in Ham
House, Peabody,
Massachusetts

papers invaded England, and their success gave him such grand airs as a deputy to the Etats Généraux that the French Revolution began by sacking and burning his factory 11 weeks before it stormed the Bastille.

But in Edinburgh an event had already occurred that was to change French wallpapers even more than Réveillon's designs. There, in 1788, the first panorama was exhibited in a kind of silo 25 feet across, painted with a view of Edinburgh itself. This started a craze for building panoramas 100 or more feet in diameter that wrapped the beholder in a painting of a famous town or a recent battle. After war in 1793 prevented Englishmen from introducing panoramas into France, the American Robert Fulton obtained a license to build one in Paris. When lack of funds forced him to cede his license, other impresarios built two in what is still called the Passage des Panoramas, showing the 1793 siege of Toulon and the monuments of Paris. Immediately an enterprising factory produced a sort of home version in a scenic wallpaper of the Gardens of Bagatelle [ 572 ].

Scenic papers came into their own in 1804 with a panorama 20 strips wide of Captain Cook's voyages in the Pacific [ 573 ]. Families bought the paper with a printed description "so that, without leaving his home, a man can transport himself into the presence of the strange peoples he has read about, and a mother can instruct her bright little girl in history, geography, and botany." The foreground of exotic trees pushed back the distance, as in the painted panoramas, and also served to frame doors and windows. These largest of all woodcuts required thousands of enormous blocks for the many tints and colors and a constant humidity to print correct register on the long stretches of paper. Most of the scenic wallpapers produced in Paris and Alsace from 1800 to 1835 have survived in the United States where wooden houses kept them dry, and conservative taste cherished them long after they bored Europe. They were priced out of existence after 1829 when endless strips of the new machine-made paper fed the first steam-driven presses for printing repeat designs at the rate of 18,000 yards a day. In 1933 England alone printed enough wallpaper to girdle the earth some 30 times.

**On cloth, china, and enamel**   In 1751/52 Irishmen invented, and Englishmen developed, picture printing to revolutionize the decoration of cloth, chinaware, and enameled copper. For centuries Europeans had block-printed cloth with oil stains that washed out. These became particularly unsatisfactory when they had to compete with Indian cottons hand painted in washable dyes.

From 1676 to 78 in London and Amsterdam various mordants were thickened into pastes for block-printing to produce fast reds, browns, and purples at one dip into a brew of madder roots. Additional fast colors might then be hand painted on the cloth with fluid dyes. At about this time some engravings of maps and *thèses*

were printed on satin in printer's ink. Attempts to print fast colors from engravings failed because the metal grooves did not retain the fluid dyes. Then, in 1752, Francis Nixon, a Dublin engraver, made dyes viscous enough to print engravings on linen and cotton. This led to a production of washable pictures on cloth, three to six feet tall and as intricate as the most laborious embroidery [ 574 ]. Moving to London, Nixon made a sensation with a public accustomed to cloth block-printed in simple repeats about one foot tall. A Scot, Thomas Bell, speeded up the decoration of cloth by printing it from relief rollers in 1783 and from engraved rollers in 1790.

The most productive of the early printers on cloth was a German, Christoph Phillip Oberkampf, who started block-printing in 1760 at Jouy near the gates of Versailles and in 1770 added a copperplate press. His cloth was not cheap, for the eight yards then needed for a dress could cost up to 240 livres, while the same length of black satin cost only 40 livres in 1787. Nevertheless, by 1805 he was employing three full-time designers, five copperplate engravers, 40 woodblock cutters, and

**574**
Shepherds among
Ruins. Engraving
printed on cotton by
Robert Jones, Old
Ford, London, 1761

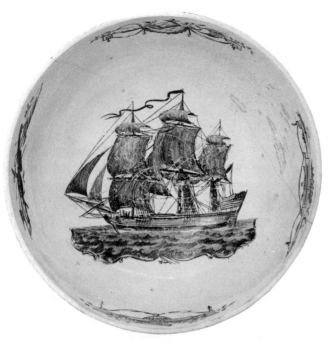

**575**
The *Constitution*.
Engraving printed on
glazed earthenware,
Liverpool, after 1797

175 printers in a total staff of 1322 employees. His factory flourished until soldiers of the Allies plundered it in 1805 and Oberkampf died.

Intricate and inexpensive decoration began on chinaware and enameled copper at about the same time it began on cloth. In 1751 John Brooks, an Irish mezzotinter, applied in Birmingham for a patent on "an art entirely new, and of his own invention" for "printing upon enamel and china from engraved, etched, and mezzotinto plates, and from cuttings in wood and mettle, impressions of History, Portraits, Landskips, Foliages, Coats of Arms, Cyphers, Letters, and other Devices." In 1754/55 Brooks reapplied for his patent from Battersea. His invention was brilliantly simple. A woodblock, copperplate, or in time a lithographic stone was printed in pure oil on thin paper or a flexible gelatin sheet, from which the oiled design was offset onto enamel or glazed china. When finely powdered enamel color was dusted on, it stuck to the oiled areas and slid off the bare glaze. A brief firing melted the enamel dust into the glaze. Suddenly anybody could afford snuffboxes, teacups, and dishes ornamented with the fine detail previously reserved for rich men's porcelains. The demand for the new transfer-printed wares was such that Commons was told in 1759 that "30 or 40 Frenchmen and Germans are constantly employed in drawing and designing" at Birmingham alone. Even greater production began at Liverpool when the kilns loaded directly onto ships to export cream-colored earthenware with black-printed American patriotic designs for the new United States [ 575 ]. (The ships returned with copper ore from Cuba.)

The English Industrial Revolution thus extended picture printing to household things as well as to newspaper illustration [ 638 ] and color lithographs [ 641 ]. These applications all presupposed the factory system, which differs from cottage industries not by numbers of hands but by the need for expensive machines and expert supervision.

**Venetian and Roman printmakers** In Venice a century of pictorial stagnation ended in the early 1700s with the emergence of her last great painters, who also schooled Europe in etching. Since Venetian etchers either worked with painters, or were painters themselves, they experimented without regard for copperplate craft conventions.

The most radical innovator was Antonio Canal, better known as Canaletto. After his father had taught him to paint the perspective of stage scenery with rapid accuracy in his early 20s, Canaletto went to Rome and learned picturesque composition from Pannini's arrangements of ruins. Somewhere he studied Dutch street scenes in which burghers saunter, gossip, and cheapen fish. He was 44 when he dated one of his 30 etchings, published by the British consul at Venice. British tourists brought this set of prints to England before Canaletto traveled there when he was about 50 for the first of two visits. He etched in long, clean, trembling lines that twinkle like moist sunlight on water, and he shaped his leisurely figures as if he had exactly dripped them with treacle [ 576 ]. No detail disturbs the gentlemanly composure of a simplicity too difficult, too personal, to found a school.

576 Tower near Mestre. Etching by Canaletto

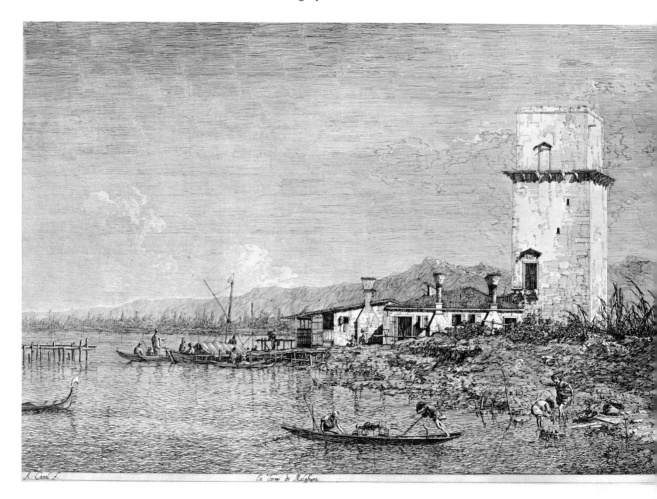

The most imitated Venetian etcher, especially in France, was Giovanni Domenico Tiepolo, Giovanni Battista's eldest son, who used his father's sparkling, idiosyncratic scribbles [ 581 ] to freshen standard crosshatching into something new, yet adaptable. Domenico's Venetian painter's training in atmospheric landscape and the grouping of figures served him to etch 27 episodes of the Holy Family's Flight into Egypt [ 577 ]. So many variations would not have been possible with a hieratic subject like the Nativity or the Crucifixion. Domenico also developed variations on other themes in witty, modish albums of ink drawings for Venetians cooped up in houses too constricted by canals for hanging big pictures. Photographic reproductions have made these series of drawings into today's high fashion, but Domenico Tiepolo impressed his contemporaries during his late teens to his early 30s when he advertised the family fresco team by etching 116 of his father's decorations, reanimating all the sunny grandeur of this last recklessly aristocratic art [ 578 ].

Venetian etching could also adapt itself to darkness to match the bloom of Piazzetta's charcoal smudges, for which Pitteri etched in parallels like Mellan's engraved sweeps [ 289 ], but blended his etched lines into broad tones by knotting

**577**  The Flight into Egypt. Etching by Giovanni Domenico Tiepolo, 1750–52

**578**
Glory and Honor. Etching by G. D. Tiepolo after a ceiling painted by Giovanni Battista Tiepolo

**579** St. John the Evangelist. Etching by Giovanni Marco Pitteri after Giovanni Battista Piazzetta

**580** The Madonna of the Grand Duke. Engraving by Raphael Morghen after Raphael, 1823–26

them with threaded specks in some secret of technique [ 579 ]. These ragged lines deepened into even more dramatic shadows when enlarged by Piranesi.

Venice's living collaboration of painters and etchers made for a sparkle that was rare in Rome, where tourists demanded prints of old paintings, old statues, and old buildings. With no painters on hand to prod them, Roman reproductive printmakers unthinkingly elaborated their technique into the ponderous, engine-turned engravings of Victorian parlors. After an engraver had copied a Raphael painting in a laborious wash drawing, and then had studied his tired transcription during months of pushing his graver, he had long forgotten Raphael's poetic essence [ 580 ]. The empty competence and expensive drudgery of most later reproductive engravings made the world yawn at Raphael until good photographic reproductions revealed his reasoned and sensuous nobility.

**581**
Scherzo di fantasia. Etching
by G. B. Tiepolo

## G. B. Tiepolo and Piranesi
In his happy, busy 75 years, Giovanni Battista Tiepolo revived the glory of Italian fresco painting, brushed thousands of sketches, and still found moments to etch some 25 coppers with a magical dash that stimulated Piranesi, Fragonard, and Goya. Tiepolo in turn had formed his unvarying etching style on Castiglione's Rembrandtesque, chopped-straw scribbles [526], also taking over the romantic stage properties of broken urns, goatish satyrs, asps, and skulls. But while Castiglione submerged time's trash heap in twilight, Tiepolo turned necromancy into wit with sunlight from his airy brushwork [581].

Tiepolo's and Castiglione's etchings were mainly what started Piranesi on his career. As youngsters both Canaletto and Piranesi had learned to render architecture promptly and convincingly by painting scenery for Venetian opera houses.

**582** A Prison. Etching by Giovanni Battista Piranesi from INVENZIONI CAPRIC
DI CARCERI

**583**
Tomb of Cecilia
Metella under con-
struction. Etching by
Piranesi in ANTI-
CHITA ROMANE,
Rome, 1756

While working for the theater, Piranesi etched 14 dream prisons [ 582 ] in free
sweeps of shadow as translucent as sepia wash. Dramatist though he was, the the-
ater was not to be his world, for he had absorbed from his engineering father and
uncle a north Italian passion for archeology that drove him to discover his true
home in Rome. From his settling there in his late 20s until his death 50 years later,
he raised the old Roman craft of view-making to such fame that he came to embody
Rome itself for the world at large more than any other individual except the pope.
In nearly 1000 etchings he enlarged Pitteri's ragged parallel lines [ 579 ] for biting
his copperplates in metal troughs so rugged that he could calculate his profits on
printing 4000 impressions from each plate. To simplify sales, he etched his address
and his modest early price of 2½ paoli under the title of each view. He used his
stage painter's skill with the *scena per angolo* [ 548 ] of buildings twisted askew to
push Roman structures to the top and sides of the picture in a hallucinating gran-
deur of action [ 371 ]. The walls tower above a modern infestation of human
degenerates who flutter like moths strayed into the daylight. When Rome's weed-
shrouded remains began to fascinate him the way cadavers fascinate an anatomist,
he presented them with all the apparatus of anatomical exposition. His atlases of
sections and reconstructions cut down to the foundations, probed joints for build-
ing methods and postulated how Romans might have hoisted their magnified stone
blocks [ 583 ].

As he studied and collected ancient marbles, he began to adapt their carved orna-

**584**
A mantelpiece.
Etching by
Piranesi in
DIVERSE
MANIERE
D'ADORNARE
I CAMMINI,
Rome (Salomoni),
1769

ment to designing mantelpieces, clocks, and sedan chairs in etchings that prepared the climate for the Empire style. He was also the first designer to use Egyptian details, standing Pharaohs on their heads [ 584 ] as high-handedly as Borromini, a century before, had upended obelisks onto their points to flank Roman doorways.

Piranesi's passion for a Rome that never was saved him from getting lost in the nit-picking of print techniques and made him one of the rare print specialists who achieved drama and grandeur without the clarifying discipline of painting. He was actually so far from being a painter that he drew his on-the-spot notes in precise proportion, but purposely bare and dry enough to reserve for his etching needle the painter's excitement of inventing shadows on crumbling brick and ravaged marble. Etchings so obsessive imposed a super-Roman scale on the architectural imagination that was to create our law courts, museums, and railroad terminals.

**Watteau and Boucher** inspired 18th-century Europe through more prints than any other painters of their time. Watteau drew and painted so compulsively during his 37 consumptive years that he had time to etch only ten coppers [ 585 ]. His dash and lightness, which delighted when he sketched, so flouted the craft conventions of reproductive printmaking when he etched that, after printing a few trial proofs, his etchings, like Van Dyck's, were "finished" by professional engravers. He saw few of his works engraved by others, but after he died, the most avid collector of his works, Jean de Julienne, had 622 of his drawings and paintings reproduced on copper. This pioneer attempt to illustrate an artist's complete work led in the long run to today's comprehensive monographs on individual artists, and in its immediate effect it started all Europe imitating Watteau's poetic scenes of lovers in neglected gardens. However, Watteau cast his most haunting spell with the anything but poetic subject of a shop sign showing half a dozen rich people haggling for luxuries [ 586 ]. Here he outdid his great Dutch model, Terborch, in the tension between a commonplace deal and its lyrical presentation.

**585**
Figure de mode. Etching by
Jean-Antoine Watteau, 1709–10

**586**
Gersaint's shop sign, painted 1721.
Etching after Watteau, 1732

L'ENSEIGNE

**587** Etching by François Boucher after a drawing by Watteau, 1727–31

**588** Stipple etching by Gilles Demarteau after Boucher

To finance the publication for over 15 years out of his own pocket, Julienne had to sell subjects as they were finished. This glutting of the market forced him finally to remainder most of the 100 sets and shortened the vogue for Watteau. The 40 artists in his employ, nearly all the printmakers of France, speeded the work by blending the tried copperplate formulas for reproducing paintings: Bosse's for architecture, Cort's for clouds, Barocci's for faces, and the new Venetian school's for general swiftness of attack. By developing quick etching at the expense of slow engraving, they introduced painters to etching as a sideline, and started professional printmakers etching forcibly enough to sparkle through the finishing with the graver.

Julienne began his publication with the comparatively straightforward problem of reproducing 351 of the magically deft figure drawings that Watteau stored up to group and regroup in his paintings. 103 of these drawings were etched by François Boucher as he turned 20 [ 587 ]. Watteau's red chalk strokes, impeccably accented with black, limbered Boucher's etching needle as it crisply imitated them, and the

**589** Fishing with a Cormorant. Etching after Boucher, 1740s

**590** Venus Giving Vulcan's Arms to her Son Aeneas. Etching after Boucher's painting of 1747

exercise brilliantly liberated his drawing pencil. With over twice Watteau's working time, Boucher etched some 180 original copperplates, while his paintings and drawings were copied for 50 years in nearly 1300 prints that permeated European art from the day when he became known by winning a prize at the age of 20. His etchings after Watteau helped to propagate such a taste for reproductions of drawings that when his own drawings began to sell, 266 of them were etched in stipple substitutes by Gilles Demarteau [ 588 ]. These were printed in red ink to look like red chalk drawings for framing as little pictures to hang in the small blank spaces of elaborately decorated paneling.

Boucher's most original inventions were decorative, especially in the fashionable style of chinoiserie, to which he was introduced by having etched 12 Figures Chinoises by Watteau. The 18th century was fascinated by a mostly imaginary Cathay, with a court etiquette more ancient and elaborate than its own, and a practical morality unembittered by the wrangling of priests. Chinoiserie decorations tended to be finicky and improbable, except when Boucher drew Celestials with a generous scale and a dreamlike humanity [ 589 ]. His French common sense and the drive of his sensuality also made him the last painter to present the gods of Olympus in pulsing flesh and blood [ 590 ].

## Etching in France and Switzerland

French 18th-century printmakers deferred to copperplate conventions when they etched the groundwork for formal official prints that imitated engraving, but when they did not have to finish with the graver, they etched almost as spontaneously as the Venetians. One of the most intelligent French etchers was the younger C.-N. Cochin, who was appointed Louis XV's illustrator of festivities when he was 20 and became the darling portraitist of the intellectuals [ 291 ]. Like most 18th-century Frenchmen, he freezes in the togas of Roman tableaux but is witty and acute when at home with his friends in the royal drawing school on the one day a year when a woman posed for three hours [ 591 ]. The silent intensity of such student competitions trained 18th-century French artists to their almost interchangeable command of hand.

Cochin was born in a dynasty of artists as interrelated as the old nobility, whose

**591** Mlle Clairon posing for the first *tête d'expression* competition at the Académie, Paris, 1759. Etching by Charles-Nicolas Cochin II

inbreeding also characterizes a family like the Saint-Aubins. A Saint-Aubin who designed embroidery was himself the son of another embroiderer, and in turn became the father of four artists. His eldest son, Charles-Germain de Saint-Aubin, styled himself "embroiderer of the King's coats, waistcoats, and breeches," and said, "I have drawn 40,000 designs for embroiderers, weavers, and lacemakers, all of which have vanished, as I myself will vanish." A dozen of his decorative inventions survive today in a set of etched monograms concocted out of flowers, stalactites, and stars [ 592 ]. His ravishing etchings of the daily life of butterflies [ 593 ] are trifles that achieve the aim of the age by taking to the air as they made light of the needed effort. The most successful son, Augustin, was received into the Académie, designed skillful vignettes for countless books, and etched over 500 profiles in the style introduced by Cochin. But perhaps just because Augustin swam com-

592 LS in a monogram for embroidery. Etching after Charles-Germain de Saint-Aubin, 1770

593 The Butterfly at Her Toilet Table. Etching by C.-G. de Saint-Aubin in *Papillonneries Humaines*

**594** The Journalists' Coffeehouse. Etching by Gabriel-Jacques de Saint-Aubin, 1752

**595** Self-portrait. Soft-ground etching by Jean-Etienne Liotard

pliantly with the current of his time, he seems to us to have less personality than his embroiderer brother and much less than the fascinating Gabriel, the elder brother who shamed the family with lifelong failure. After poor Gabriel thrice missed a scholarship for Rome in his late 20s, he lived alone in horrifying disorder while he mooned around town sketching anything and everything. On the wide margins of catalogues for auctions and the biennial Salons he drew thumbnail notations that document the exhibited works of art for us today. In occasional little etchings that then seemed as amateurish as Watteau's, Gabriel preserved the freshest and gauziest visions of old Paris: its theaters, its public gardens, its art exhibitions, and its coffeehouses [ 594 ]. The city's jostle inspired him with a verve that nevertheless deserted even him when he strained after the high style of allegory.

The Parisian punishment of deviations from "good taste" did not frighten Switzerland. There the pastellist Liotard, after five years in Istanbul and elsewhere, dared put a major effort into big etched family portraits in which he explored the mysterious tone made by pressing cloth into a soft etching ground [ 595 ]. These works from beyond the range of Parisian dictates have still not been properly valued for their large vision and delicate adjustment of light.

**The estampe galante**  Under Louis XIV official engravings ceremonially glorified the king's buildings, his battles, his courtiers, and his person. The next century shifted to the pleasures of the individual, and especially to the ruses and obstacles that could complicate love sufficiently to fill life's vacancy. While rooms in England were hung with mezzotints of prominent English people and of dairy-maids and lusty stable lads, French salons were decorated with engravings of *galanterie*, meaning urbane pleasures. French printmakers elaborated the *estampe galante* with that harmony of skills which made the 18th century unique. One man drew the picture, a second etched most of the copper [ 596 ], a third smoothed the transitions with a graver [ 597 ], a fourth designed the decorative border, and a fifth engrossed the lettering—all collaborating toward what looks like one man's inspiration. Admiration for the teamwork is tempered only by a slight disappoint-ment at the leveling of personalities. Contemporary collectors preferred the state after the graver had refined the details but before the lettering had been added (*avant la lettre.*) The preliminary etched state, whose raggedness catches some per-sonal brilliance, learned from the Venetians, was not put on sale because, as the

596  Le Carquois Epuisé (The Exhausted Quiver), after Pierre Antoine Baudouin, 1765. Preliminary etched state by Nicolas de Launay

597  Finished with engraving by de Launay, but before lettering, 1775

**598**  L'Armoire. Etching by Jean Honoré Fragonard, 1778

Académie Royale said in 1761, its "lack of finish might damage the artist's reputation." At this time the woodcutter Papillon dismissed etching as "a sketcher's amusement."

The briskest contriver of gallant escapades was Fragonard, the Frenchman who also came closest to the Tiepolos' happy largeness of design. During his 20s and early 30s in Venice and elsewhere in Italy, he miniaturized G. B. Tiepolo's etching style to record Italian paintings, at the same time training his hand through penciling swift copies of baroque ceiling decorations. The great Italians energized his art with a dash that substitutes adequately for passion [ 598 ].

The circumstantial observer of aristocratic manners, Moreau le jeune, fitted the theme of gallantry into two series of engravings, later called *Le Monument du Costume,* designed, as if in anticipation of the guillotine, "to document the manners and dress of the French in the 18th century." The first series matures a young married

**599** Les Adieux. Engraving by de Launay after Moreau le jeune in LE MONUMENT DU COSTUME, Paris (Neuwied), 1776

*The estampe galante*

**600** La Paix du Ménage, after Jean-Baptiste Greuze. Preliminary etching by Moreau le jeune, finished with engraving by P.-C. Ingouf, 1765/66

woman from her first pregnancy through her pastimes and flirtations [ 599 ] to her apotheosis in the court splendor of plumes and diamonds. The second series follows the day of a young aristocrat from his being dressed and frizzed to his midnight supper party, and then contrasts these vanities with the "true happiness" of a farmer's family on the 12th plate. Though Moreau was the son of a wigmaker, he showed himself as conversant with the rooms and the bearing of the aristocracy as if he had been born one of the wealthy, curled darlings that he depicted.

At the end of the century, when Rousseau was piqueing surfeited appetites with the surprise of simplicity, Greuze brought love into family life [ 600 ] with the young mother nursing her baby, the erring daughter coming home for paternal pardon, or a family music lesson.

The carefree *estampe galante* perished in the French Revolution, along with the sweetness of life that Talleyrand regretted losing. Only one artist, Prud'hon, was

able to carry the seductiveness of the old monarchy across to the hard heroics of the Empire. But love had suffered a sea change. Fashionable people were now seen at church, and sunlight filtered into drawing rooms through stained glass. To tingle agreeably, sensuality now had to spice itself with sacrilege in the mutual swooning of meaty monks and depilated nudes [ 601 ]. The blurring of the romantic penumbra taxed the last formal refinement of sophisticated engraving, just when the new invention of lithography was being perfected to get such effects more spontaneously.

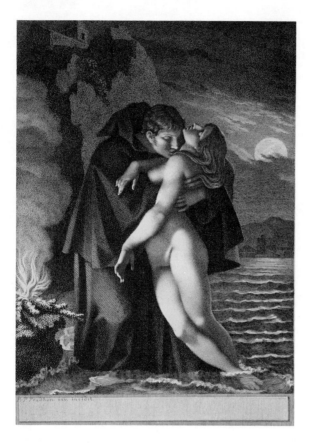

**601**
Phrosine and Mélidore.
Engraving by Pierre Paul
Prud'hon in Gentil Bernard,
OEUVRES, Paris (Didot),
1797

**Rowlandson and Debucourt** Rowlandson was William Blake's exact contemporary but in life and character so exactly Blake's opposite that the antithesis discredits the "spirit of an age" as a convenient fiction. While Blake's fame grew slowly inside the English-speaking world, Rowlandson quickly affected the Continent almost as decisively as Hogarth had. When Rowlandson's father lost his money in the silk trade, the boy was brought up by a French aunt, who sent him to the Royal Academy drawing school at 15. The British neglect of figure drawing may have been remedied by a visit to Paris, for somehow he became the only English-

man of his time to draw the figure with the accurate ease of the French. He wrote little except his signature on thousands of watercolors, which show that he traveled in Great Britain, France, and the Netherlands. He exhibited watercolors only when he was 18 to 30, after which his work began to coarsen, probably because he played cards with other sporting bloods instead of looking at the work of other artists. His art shows absolutely no effect from the innovations of Turner, who astonished England with his first big painting 27 years before Rowlandson died. During his 50

**602**  Tally Ho. Etching by Thomas Rowlandson, 1785

BRITTANNIA ROUSED,
OR THE COALITION MONSTERS DESTROYED

**603**  Satire against Charles James Fox and Lord North. Etching by Rowlandson, 1784

working years Rowlandson often multiplied watercolors in replicas made by counterproofing [ 427 ] the preliminary drawing, and it was said that he "etched as much copper as would sheathe the British navy." His dashing evocations of hunting [ 602 ] and boxing revealed the classic style for the great British specialty of sporting prints, into which he put more spirit than any specialist who followed him because he played with them for diversion instead of turning them out as a daily chore. Many of his etchings (but not his watercolors) satirize politicians [ 603 ] with a license that Philipon fought to introduce into France in the 1830s [ 659 ].

**604**
Copying Old Masters at the British Institution. Aquatint by Pugin and Rowlandson in THE MICRO-COSM OF LONDON, London (Ackermann), 1808–10

**605** (OPPOSITE PAGE, ABOVE)
Vauxhall Gardens. Aquatint after Rowlandson, 1785

To publish his caricatures while they still would sell as news, Rowlandson etched in rapid open lines for one deep bite of the acid. He then watercolored the first proof as a model to send upstairs in the publishing house of Rudolph Ackermann in the Strand, where French refugees copied the colors on the whole edition of prints. When he did not have to rush, he clothed his elegant, lively lines with the tone of aquatint [ 229 ] to supplement the finishing watercolor. The price, usually a shilling, often appears on the plate itself, and there is sometimes the notice that prints may be "lent out for the evening." Thus Rowlandson snuggled into the heart of the country jollity that Englishmen lost after the "dark Satanic mills" began to dirty the air. Even London retained some village greenery and leisure when he etched it in one of the most human surveys of a great city. For the 104 views of the *Microcosm of London,* he fitted figures into architectural backgrounds drawn by a French refugee, Augustus Pugin [ 604 ].

Rowlandson's French experience probably fitted him to collaborate with Pugin as smoothly as any artistic team in Paris. Before France and England stopped trading (1793 to 1812), Rowlandson repaid his debt to French art by setting a model for French prints of the Directoire in his breezy familiar etchings of the highjinks of fishmongers and countesses, bullyboys and tarts. Only seven years after the motley line-up of his Vauxhall Gardens [ 605 ], a similar carnival of impertinent fashion plates appeared in Paris in the masterpiece of Debucourt [ 606 ], who elaborated the Parisian technique of color printing until it needed no additional hand painting to complete the effect.

**606** La Promenade Publique. Mixed intaglio media by Philibert-Louis Debucourt, 1792

**English romantics**  In England, as in Germany [ 632 ], romantic artists retreated from the beginnings of modern industry into solitudes where they invoked a religious spirit outside the established churches. Romantic art was everywhere literary, but particularly so in England, where many artists wrote. These author-artists, with slight art schooling, rebelled against the increasing 18th-century dominance of dexterity over personality.

Henry Fuseli preached the gospel in Zürich until he came to London at the age of 22. Here, supporting himself by writing about art, he began seriously to draw and paint. He made a few soft-ground etchings by coating a copperplate with fat, laying a drawing face up on it, and pressing the drawn lines with a stylus to stick the fat to the back of the paper. Acid then bit the copper in charcoal-like lines that cannot be retouched unobtrusively [ 607 ]. Coarse cloth pressed onto the fatty coating makes a continuous tone [ 595 ]. Soft-ground etching, Castiglione's forgotten invention, disappeared when lithography reached similar effects more directly.

The renegade clergyman's satanic satires affected his deeply religious, but anti-clerical contemporary, William Blake. When Blake, at 14, began a seven-year apprenticeship with an engraver, he was set to copying medieval tombs in Westminster Abbey until he drew clothed figures so willowy that they can hardly lift the liquid weight of their draperies. He studied anatomy from engravings that must have included plunging muscle men from Michelangelo's Last Judgment. During his remaining 50 years, he wrote lyrics that everybody remembers and then impenetrable cosmic twaddle. As his writing worsened, his drawing improved, so that the best of the writer rarely collaborated with the best of the painter. While poverty

**607**
Witch and Mandrake. Soft-ground etching by Henry Fuseli

**608** "Pity, like a naked, newborn babe, striding the blast." "Illuminated fresco" by
William Blake, 1795

forced him to engrave potboilers as drably as the next hack, he privately devised
highly personal methods for his imaginative prints. He made "illuminated fres-
coes" by painting outlines on varnished cardboard, offsetting them onto paper
through a rolling press, and finishing the picture with watercolor [ 608 ]. Rowland-
son had already started this technique with red chalk, which may have reached
Blake by roundabout report. He had a more unusual instructor for the books of
illustrated poems—his "illuminated printing"—that he published from his early 30s
to his mid-60s, so unsuccessfully that he found few purchasers for the *Songs of
Innocence* at five shillings and *America* at 10/6. For these he followed instructions
received in a dream from his dead brother, who probably told him to write and
draw with etching ground on varnished paper, press these lines onto a metal plate,
and let acid erode the metal around them. Lines etched in such low relief would be
hard to ink without inking the barely lowered background. Blake very probably
pressed the relief plates against ink spread on a smooth sheet of metal. Like the
Chinese and Japanese, who paint as they write and write as they paint, Blake in
his own way charged his line with energy enough to flow from word to picture and

**609**

Hand-colored relief etching by Blake, 1794, title page for *The Book of Urizen*

**610**

An Eclogue. Wood engraving by Blake in R. J. Thornton, VIRGIL ADAPTED FOR SCHOOLS, London (M'Gowan), 1821

**611**

Sleeping Shepherd. Etching by Samuel Palmer, 1857

back again [ 609 ]. Since copybooks taught him to draw as well as to write, he flourished figures like seaweed into any pattern imagined with his impeccable instinct for layout. Although Blake's relief etchings are the oldest now known, a perhaps more workable recipe for relief etching was described about 1504 by Leonardo da Vinci. While Blake was working on his last illuminated book, he engraved 17 boxwood blocks for a classroom edition of Virgil's *Eclogues* [ 610 ]. These dusky evocations of dream so shocked the schoolmaster-editor that he allowed them to appear (somewhat cut down) only at the insistence of Sir Thomas Lawrence and other painters.

Blake's art had to wait for a wide public until his whirlpool swirling resurfaced in art nouveau. Being more the poet's painter than the artist's, this supreme painter-poet is revered only as far as English is spoken. Though he taught no pupils, he fascinated a band of disciples. In his last years he hypnotized a boy of 19, Samuel Palmer, who was starting to paint some of the most poetic of English watercolors. When Palmer translated Virgil's *Eclogues*, he etched 17 coppers [ 611 ] in whose haunted shadows, he said "a thousand little luminous eyes peer through."

**Early lithography**  Lithography—from the Greek for *stone drawing* or *writing*—is the only major art-print process whose invention was described by its inventor. It *could* have been invented as long ago as woodcut, for it requires nothing but grease, water, paper, and fine limestone. While it should ideally have arrived in time to multiply the drawings of Michelangelo's contemporaries, it actually coincided aptly with the romantic cult of genius that preferred a master's autograph sketch, no matter how slight, to a formal work carried out by assistants. In the 1790s, in Munich, young Alois Senefelder was too poor to pay for publishing his amateurish plays and songs, or even to buy copper for etching them himself. Instead, he wrote in grease on paper, pressed the greasy lines onto limestone, soaked it with water, and applied greasy printer's ink that stuck to the stone only where the first grease had marked, being rejected where the stone had absorbed water. A sheet of paper pressed against the stone accepted the inked markings. To write in liquid grease, Senefelder filed a piece of steel clock spring into a pen, thus ultimately initiating the British steel pen industry. He patented his "chemical printing" at Munich in 1799. In 1800 he sought a patent in London, where the process was introduced through an album of lithographs by prominent artists. The Philadelphian president of the Royal Academy, Benjamin West, started the series in 1801 with the earliest dated lithograph by any artist who is still remembered [ 612 ].

Lithography immediately succeeded as a parlor game. In an age when persons of quality learned drawing as inevitably as they learned writing, an alert hostess provided stones for her dinner guests to sketch lithographs as souvenirs. By 1805 the Orléans family was enlivening its exile at Twickenham by drawing family pro-

**612** "He is not here, for he is risen." Pen lithograph by Benjamin West in *Specimens of Polyautography*, London (Vollweiler), 1801–07

**613** Adelaïde d'Orléans. Lithograph by her brother, Duc de Montpensier, 1806

files [ 613 ]. Commercially, however, lithography failed during the 20 years of Napoleon's wars and their aftermath. Then, in 1819, expert Parisian painters attracted enough vigorous draftsmen to put lithography on a par with engraving, while a Philadelphia magazine published the first lithographic illustration outside Europe. The Orient started about 1837 when a British press in Delhi made possible the wide publication of writings in the swinging Indian and Persian scripts. Then all the world began to draw on stone.

When lithography achieved its first artistic success in England, British aquatinters, who had recently perfected their skill, tried to quash the upstart process with a heavy import duty on the uniquely apt Munich stones. But British (and American) lithography was more seriously hurt when it was snubbed as a cheap makeshift for reproductive aquatint and engraving. Ruskin spoke for the English-speaking world in 1857 when he said "Let no lithographic work come into your house if you can help it." The leading landscapists—Girtin, Turner, and Constable—never worked on stone, though they occasionally etched; and Lawrence waited until his last weeks before beginning his only lithograph.

The professional lithographers and aquatinters both specialized in illustrating books of views, where aquatint gave way to the less expensive lithograph in the 1840s, and the lithograph gave way to the still cheaper wood engraving and photograph in the 1860s. In Paris, English lithographs with the romantic trappings of Walter Scott and Byron inspired the hugest view publication of them all—Baron Taylor's 20-volume *Voyages Pittoresques dans l'ancienne France* [ 614 ]. In England about half of the views explored foreign lands, while the many series of French views mostly confined themselves to France. English lithographs followed aquatints by being kept thin for possible watercoloring, while French lithographs were drawn with the density and vigor of oil paintings.

In 1839 the first completely successful color lithographs in Boys' *Picturesque Architecture* [ 349 ] entailed an exact registering of areas and a complex blending of tones that frightened painters away from color work until 1899, when Vuillard's colored lines allowed free overlappings [ 720 ]. British specialists developed color lithography for linen labels, children's books, and posters. Similarly, the United States used lithography for billheads, cigar-box lids, and popular prints. In New York even Currier & Ives felt that they had to advertise their lithographs as "engravings." Germans also used lithography for copying, but with unexpected results

**614**
Rue du Gros-Horloge, Evreux. Lithograph by Richard Parkes Bonington in Baron Taylor. VOYAGES PITTORESQUES DANS L'ANCIENNE FRANCE, Paris (Didot and others), 1820–78

when they reproduced Maximilian's unfinished prayer book. The emperor had adapted the layout of Parisian prayer books [ 249 ] by surrounding a text printed in 1513 with fanciful quill drawings by Dürer, Cranach, Baldung, and others. This half-finished book slept until some of Dürer's borders were traced on thin transfer paper and lithographed in 1808 [ 615 ]. The delayed publication detonated a three-century time bomb. It gave Goethe his first sight of the "divine hilarity" that danced in Dürer when he went exploring with a quill, and it set a style for German book illustration for the next half century [ 616 ].

**615** Drawing by Dürer in the prayer book of Emperor Maximilian. Lithograph by Nepomuk Strixner in *Albrecht Dürers Christlich-Mytologische Handzeichnungen,* Munich, 1808

**616** Etching by Adolph Menzel in DIE DICHTER *des deutschen Volkes,* Berlin (Hoffmann), 1848

**Géricault and Delacroix**　By taking on all the technical cookery, the lithographic printer frees the artist to concentrate on his simple, exasperatingly difficult specialty—drawing. Unlike other printmakers, the lithographer, like the woodcut designer, draws directly in black what will print in black. Since lithographs *are* drawings, they vary as spontaneously as drawings and more than any other kind of print. Realizing all this, French painters used lithography rather than etching for their immediate reactions to life and events, and they created more great lithographs than everybody else put together.

**617**　Boxers. Lithograph by Théodore Géricault, 1818

The first major artist to work consistently in the new medium was Géricault, who produced about 80 lithographs in the last six years of his short, angry life. He was the first French artist to be fascinated by England, then recently discovered by refugees from the French Revolution. An anonymous English etching of a boxing match between an Englishman and a Negro in 1811 must have inspired his lithograph of 1818 [ 617 ], drawn before Frenchmen began to box. At the left a spectator reclines

**618**

Entrance to the
Adelphi Wharf, Lon-
don. Lithograph by
Géricault, 1821

like an antique river god as if to mark the modern revival of the Greek ideal of sport
as a test of naked agility and courage, supplanting the medieval ideal of a chivalric
pageant in armor. Géricault, Rowlandson, and Goya celebrated the boxer or the
bullfighter as these former village rowdies were becoming national heroes.

During the two years that Géricault starved in London, he wrote "I have aban-
doned the buskin and Holy Writ to dwell in the stable." England so impressed him
with the only serious school of horse portraiture that he adapted its allover density
to stone [ 618 ] in the first powerful lithographs of contemporary life. But these
darkest and most rebellious of Géricault's prints did not sell in England and were
not exported to France, so that when he died at 33, he had hardly affected litho-
graphic practice.

It was Delacroix who gave lithography his prestige as the heroic visionary who
single-handedly stormed—and sometimes captured—the passionate grandeur of
Titian and Tintoretto. He was 25, and drawing pale, dry caricatures on stone, when
Goya's bullfight lithographs [ 631 ] appeared in Bordeaux to provide the flashing
shadows of his maturity. Three years later Delacroix started the great French
production of luxurious books with lithographs by painters when he illustrated
Goethe's *Faust* [ 619 ]. He was not so much inspired by Goethe's "uninteresting"
poem as by a stage production that he saw in London in 1825. Goethe, however,
thought that "M. Delacroix's quick sketches—somewhat rough, but spirited . . .
outdid my own imagining." Like many pioneer publications, the *Faust* lost money—
so much money that Delacroix could never again induce a publisher to sponsor his

lithographs on literary themes. Thus no text accompanies his longest series, the 16 lithographs for *Hamlet*, on which he worked for 15 years. He studied Hamlet's hands from a woman's to feminize him in the moonstruck hysteria of the romantic theater [ 620 ]. France, with Delacroix's *Hamlet* and young Théodore Chassériau's contemporary, and rival, etchings of *Othello* [ 621 ], succeeded better than England in illustrating Shakespeare. Is this because artists feel they can supply something to a translation that has cut away Shakespeare's poetry to expose his action,

**619**
Lithograph by Eugène Delacroix in Goethe, FAUST,
Paris (Motte), 1828

**620**
"I am thy father's spirit." Lithograph by Delacroix for
*Hamlet*, 1843

**621**
Othello. Etching by Théodore Chassériau, 1844

**622** Horse and Tiger. Lithograph by Eugène Delacroix, 1828

**623** The Blacksmith. Aquatint by Delacroix, 1833

whereas in English his imagery makes scenery impertinent and overwhelms illustration? Both these Shakespeare illustrations sold as badly as the *Faust*, being ignored like most truly original book illustrations, all the way from the *Hypnerotomachia* [ 223 ] to Vollard's publications.

When Delacroix starts from a source more visual than verbal, as in his heroic grappling of animals fighting to the death [ 622 ], he does indeed tap the energy that he admired in the baroque and the High Renaissance. His technical scrutiny of Goya's Caprichos, acquired by copying some of them in pen and then in aquatint, bore fruit when he used the same format and the same dramatic division of light and shade for his own magnificent aquatint of a torso glimmering above embers and hot iron [ 623 ].

**Goya**   After the 18th century had refined a few themes to the point of exhaustion, the old way of art collapsed with the old way of life—in downfalls that cleared a road for new starts. At this moment for the unexpected the first tremendous personality of the coming age arose in Spain, where no great artist had appeared during more than a century of French and Italian importations.

Francisco Goya was born in the tough, barren Spanish northeast. After some provincial art lessons, he looked at baroque paintings in Italy, then settled in Madrid

in his late 20s shortly after Giovanni Battista Tiepolo had died there in 1770. The etchings of both Tiepolos inspired Goya to advertise his own work by etching one of his tapestry cartoons in the elder Tiepolo's translucent blend of parallel scribbles. Goya maintained this manner for the rest of his life, gradually enriching it through the study of Rembrandt. In the pure Venetian style he etched 16 of the king's Velázquez paintings [ 624 ] in the first publication of the then little known Spanish royal collection. Having the run of the palace started the young painter on his lifelong study of Velázquez, whose greatest (though posthumous) pupil he became.

He painted tapestry cartoons and then portraits until an illness deafened him and shocked his very Spanish communicativeness into his only year of apathy. Had he died then—at 46 (nine years older than Raphael at his death)—Goya would now be forgotten by all except specialists in decadent Spanish painting. A sudden buzzing silence locked him into his boyhood, haunted by village ghosts and goblins. When he recovered enough to work again, he learned the newly popularized technique of aquatint [ 229 ] to overlay his 18th-century line with the lights and shadows of romanticism. Out of this emotional crisis and technical exploration there emerged a new individual who burst on the world in 1799 when, at 53, he published the first long set of prints ever made in Spain, the 80 Caprichos.

Since Madrid had no printshop (Paris had 30), he put his bound etchings on sale

**624**
Aesop. Etching by Francisco de Goya, 1778, after painting by Velázquez

*Sacada y grаvada del Quadro original, de D. Diego Velazquez, que existe en el R. Palacio de Madrid, por D. Fran.ᶜᵒ Goya Pintor, año de 1778. 1.º Representa à Esopo el Fabulador de la estatura natural.*

in the perfume and liquor shop under the rooms where he lived. After four years only 27 sets had sold for an ounce of gold each. As an old man Goya recalled that foreigners had bought more than Spaniards, but the only sales record is of four sets bought by a Spanish patron. In 1803 he obtained a pension for his son by ceding the 80 coppers and 240 sets of impressions to the royal printing office. Their 1850 catalogue was remaindering the leftovers with such poor success that it omitted Goya from its list of Spain's six great printmakers. The word *capricho* refers to the goat *(cabra)* who scorns the huddle of sheep on the valley floor to browse dangerously on the cliffs. Goya's Caprichos comment outwardly on the hobbles of ignorance in Spain's medievalism, then being revealed by new ideas from France and England, but they really disturb because they confront us with whatever it is that visits you and me in our sleep [ 625 ].

These etchings were the first Spanish works of art to strike the world outside Spain. Delacroix copied some and French lithographers reproduced others, while Goya's paintings stayed put except for a few lent to the Louvre during the 1840s. The Caprichos have always been Goya's most popular works in any medium, though they are as miniatures to murals compared with the incomplete second set of fantasies that he etched 15 or 20 years later. He called these biggest of his aqua-

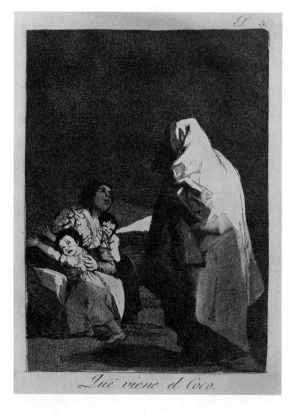

**625**
The Bogeyman is Coming. Aquatint from CAPRICHOS DE GOYA

**626** (OPPOSITE PAGE)
Fear. Aquatint by Goya from *Los Disparates*

tints Disparates, for which the nearest English word might be Incongruities. This time he explored to the outer boundaries of dream, discovering sights that haunt like Rembrandt's [ 626 ].

War upset Goya's life as profoundly as deafness had done, when on the night of May 2/3, 1808, Madrid rebelled against Napoleon's easy invasion. By early summer Spaniards everywhere had thrown themselves into a resistance that grew ever more desperate for six years, until they drove the last Frenchman back across the Pyrenees. The face-to-face killings around rocks and in doorways, the dismembering reprisals, the famine that sank on thousands—all these excitements and agonies came into focus in Goya's eye. Since he must have heard accounts of more than he actually saw, vision overpowered fact, freeing him to transmute experience into art with the erudition of the Italian baroque.

Hostilities meant few painting commissions to distract him from etching the 80 Disasters of War, so named in analogy with Callot's Miseries of War when they were first published 35 years after Goya died. Obsessed by the fighting, by the 20,000 who starved to death all around him in Madrid, Goya reworked these etchings more persistently than any others. War shortages forced him to make do with ill-beaten coppers and to cut up two of his own etchings to use the backs. Poor

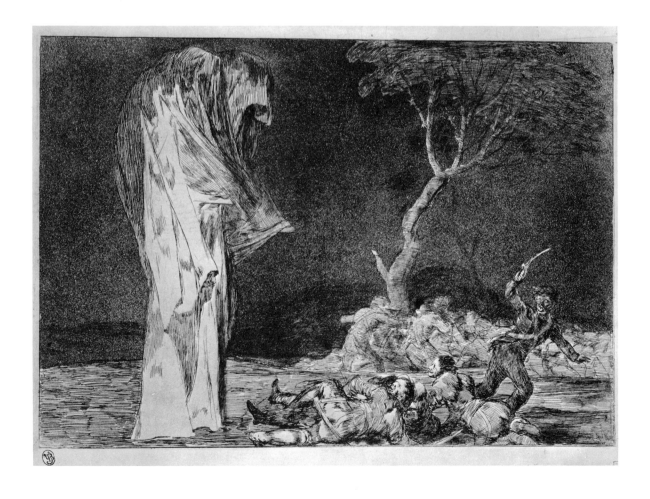

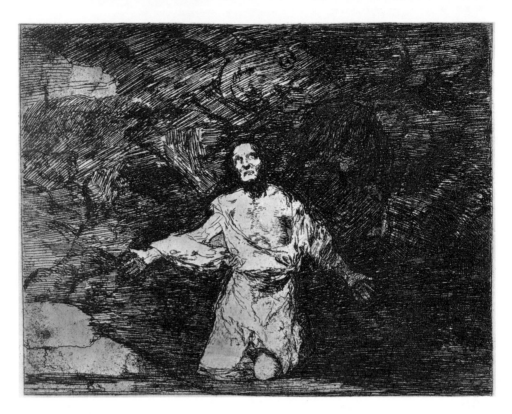

**627** Forebodings of Doom. Aquatint by Goya from *Los Desastres de la Guerra*

**628** Not Even for Women. Aquatint by Goya from *Los Desastres . . .*

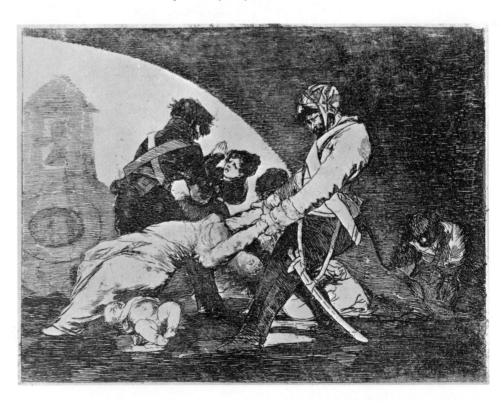

varnish ground admitted acid for spots of foul biting. Though few prints sold as people scrounged for crusts, Goya let nothing stop him from imagining pictures that stab, because he was above making propaganda for Spain or against France, and because he faced war with the individualist passion of a Spanish Christian. The series opens with a man flinging out his arms [ 627 ] in a supplication that Goya repeated in a painting of Christ's Agony in the Garden. The impression shown here was printed after some 50 years in storage had tarnished the copper, muddying the shadows and graying the highlights. The Disasters grip the heart in any state, but the rare wartime impressions, pulled while the coppers were still bright [ 628 ], reveal a grace, a seductiveness of the flesh, that Goya retained from his 18th-century youth. His good manners drive home war's final horror—its uselessness.

After the six years of anguish ended in 1814, Goya relaxed with a fanciful historical sequence of bullfights in 33 aquatints. Although now, by 1816, Madrid had a printshop, these first great sporting prints seem to have sold almost as badly as the Caprichos. Goya persistently spent on printmaking what he earned by portrait painting, even going to the expense of importing English copperplates for his bullfights. Few artists since Tintoretto have been able to launch figures securely into the air [ 629 ]; here Goya made good his claim that a painter should observe a man falling off a roof exactly enough to go home and draw him. In some of his bullfights he deployed figures against blank paper as decoratively as Utamaro [ 697 ], his contemporary, as though a global tide of taste carried entirely disconnected artists to the same point at the same time.

**629** The Lightness and Dexterity of Juanito Apiñani. Aquatint by Goya from *Arte de lidiar los Toros*

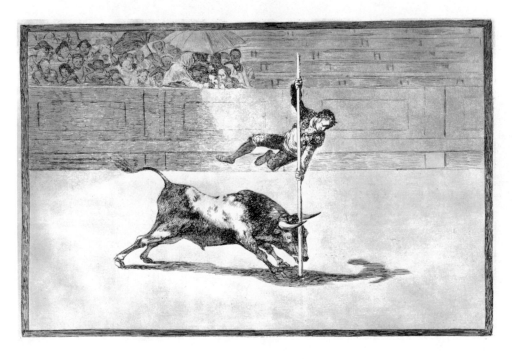

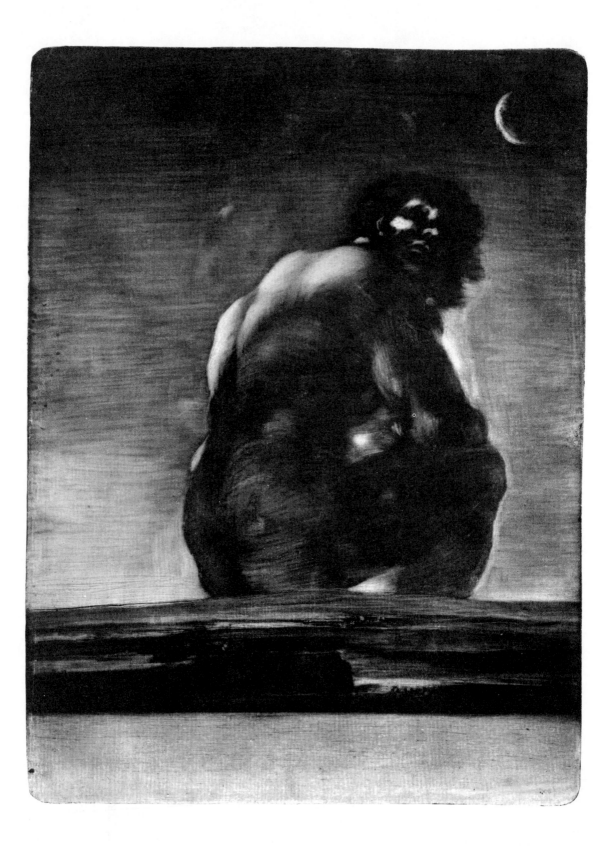

With experience gained from the tragedy of the Disasters and the exquisite deliberation of the Bullfights, Goya shaped his simplest and grandest print, the Giant [ 630 ], in the attitude of the bruised Greek bronze boxer that he remembered from his youth in Rome. Relying on consummate skill, he dared to aquatint an allover black on a copperplate and then scrape out the highlights as though it were a mezzotint. He needed a surer hand than a mezzotinter's, since, if he scraped a part too light, he could not darken it again. The Giant is the last work of art from a civilized country that projects an unreason, a bone-marrow terror, like an African mask, or any other sacred object shaped by the dread of God.

When the Inquisition returned to Spain with the Bourbon kings, Goya, aged 78, joined distinguished political exiles in Bordeaux. There, late in 1825, he drew four big lithographs of bullfights [ 631 ]. He propped his stone on an easel like a canvas, grayed it all over, then crayoned the darks and scraped out the lights. Half blind, he used a magnifying glass but really relied, like a pianist, on the experience stored in his muscles. He, who was about 75 when he first tried his hand at casual transfer lithographs in Madrid, was 79 when he achieved the first great works of art on stone—the first that combine the freedom of a sketch with a black and white as rich, as rounded as the impasto of a painting. The artist formed in the age of Boucher had explored until he had made himself the contemporary of his grandchildren. Like Dürer, he began in one world and ended in another. But while Dürer refashioned himself in the likeness of an art that already existed, Goya groped his way into the central drift to come.

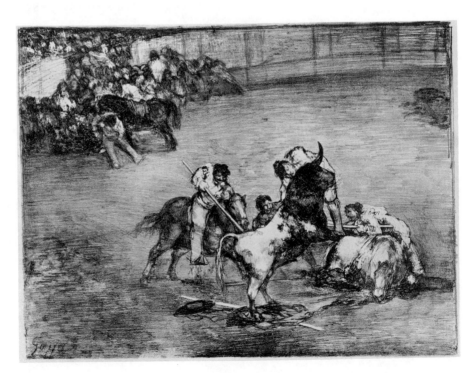

**630** (OPPOSITE PAGE)
The Giant. Scraped
aquatint by Goya

**631**
Bravo Toro. Lithograph by Goya, 1825

632 The Spider Web. Woodcut by Caspar David Friedrich

633 Frederick the Great on Campaign. Wood engraving by Adolf Menzel in Franz Kugler, *Geschichte Friedrichs des Grossen*, Leipzig (Weber), 1840–42

## 19th-century Germans

After 1800 German printmaking shifted from its ancient centers in Ulm, Augsburg, and Nuremberg to the Bavarian capital at Munich and the Prussian capital at Berlin, while Düsseldorf taught painting to Russians and Americans. The emotionalism of the German Middle Ages and the baroque, ice-bound under the Age of Reason, now resurged in romanticism's shivering touch of the undiscovered when the magical landscapist, Caspar David Friedrich, drew a few evocative woodblocks that his brother cut [ 632 ]. The widespread nostalgia for the past produced pictures that shaped the political future. In France, devotional images of Napoleon I prepared the electorate for Napoleon III. In 1840 the 500 illustrations in a French history of Napoleon immediately started Adolf Menzel in Berlin drawing 400 cuts [ 633 ] for a history of Frederick the Great that was to become a symbol for rallying German nationalism under Bismarck. Menzel's pencil point drew with crackling exactitude on end-grain boxwood blocks that he sent to Paris for engraving. When the Parisians slashed them arbitrarily, he trained Germans to cut in facsimile. Lest these exquisite blocks split in the press, they were printed from electrotypes made in the newly invented process for casting

Aber schon mit viel Vergnügen
Sehen sie die Bretzeln liegen.

surfaces exactly. In the course of illustrating the book, Menzel learned to draw the first accurately costumed pictures of the past that convince like snapshots. The wire line of his eerie realism had little effect on the tough traditions of the French, but in England it eventually formed the illustrators of the late 1800s [ 691 ].

German prints influenced an even wider world when Wilhelm Busch invented, or at least perfected, the comic strip in 1859 to 71 for the Munich weekly *Fliegende Blätter*. His verse captions condensed a wit too idiosyncratic to translate [ 634 ], but his pictorial form was appearing in France by the 1890s, and his roly-poly bad boys, Max and Moritz, were naturalized in America as the Katzenjammer Kids. When Gertrude Stein showed this American comic strip to Picasso, it pointed the way to his grand manner of impudence.

**Banknotes**   Promissory notes often substituted for coin when coin was scarce or inconvenient to carry. In 1790 the bankrupt French government replaced metal with paper money called *assignats,* which were mortgages assigning newly nationalized abbeys and châteaux to speculators who mostly quarried these architectural masterpieces for their timber and stone. Assignats were then issued as legal tender for billions of paper francs made by pulping ancient archives and libraries—which accounts for the scarcity of old French books. Since France's papermakers were soldiering, Louis-Nicolas Robert thought to replace them in 1798 by inventing

IN THE TURRET.

Parrot gun aboard a
monitor. Steel en-
graving by Bureau
of Engraving, Wash-
ington, D.C., for use
on bond certificates
and banknotes

today's machine that extrudes an endless ribbon of paper felted on a revolving loop of woven mesh. In 1790 the first issue of 400,000,000 assignats was prepared by hiring the then destitute Augustin de Saint-Aubin to slave for five or six months of repeating the profile of Louis XVI on 202 copperplates. If these plates were ever used, they have left no trace in today's French and American currency collections of assignats made, like Chinese banknotes, by the quicker, though more easily imitable, process of relief printing.

Since not even Saint-Aubin's hand could copy in absolute facsimile, forged assignats would have had to be checked against 202 originals. Machinery for absolutely identical repetition was described in 1806 in Massachusetts by Jacob Perkins after he discovered how to caseharden an engraved block of soft steel without damaging the engraving. A soft steel roller then passed over the hardened block with enough pressure to force the soft steel down into the grooves in the hardened block. Casehardened in turn, the roller repeated its design any number of times by pressing its ridges into a large printing plate of copper or soft steel. Perkins also combined gears and cams to engrave interplays of swirls too intricate to copy by hand, as can be seen today on any dollar bill. These innovations, America's main technical contributions to printmaking, enabled American engravers to supply the world with banknotes and bond certificates [ 635 ]. In 1840 the British used Perkins' processes to invent the postage stamp—the miniature print that is published in the largest of all editions and exposes a country's taste to global criticism.

**A quarter turn of the wood**   For a millennium woodblocks were carved into planks with the wood fibers running parallel to the picture surface. For white areas the knife had to labor by slicing from the sides into the center. After 1700 Englishmen and Frenchmen unhandily tried these plank-cutting knives on the end

grain of boxwood and pear, while Englishmen illustrated chapbooks and broadsides with type-metal blocks cut in relief with the copperplate graver. About 1780 Thomas Bewick, a copperplate engraver in Newcastle, combined both methods by turning his metalwork graver onto the end grain of boxwood. In the upstanding fibers he plowed white lines as readily as he had plowed black lines in copper. Parallel grooves in the end grain make two white lines with a wall between for printing a black line [ 636 ] that will not break down, though knife thin, because the fibers row up as strong as the pickets in a fence. When cleanly inked with the English glue roller (patented in 1818) and printed on the ever smoother machine-made papers, wood began to rival copper for minuteness of detail in pictures easy to combine with type for printing both at one run of the press. The first wood-engraved facsimiles of drawings [ 637 ] reproduced the handwriting of the line even more exactly than Lützelburger was able to reproduce Holbein's drawings on plank blocks [ 328 ]. By pushing out into pen or pencil lines that remain exposed, the graver can cling to a drawing more closely than the old knife that was pulled back over lines that it partly hid.

**636** Wood engraving by Thomas Bewick in WATER BIRDS, Newcastle (Walker), 1804

The quarter turn of the wood and the endless ribbon of machine paper released more pictures in a century than man had made in all his previous history. The pictorial deluge started in periodicals, which still print the bulk of illustrations. Englishmen anxious for news of Napoleon bought such unprecedented numbers of newspapers that the London *Times* in 1814 installed two steam-driven cylinder presses for printing 2200 sheets an hour.

**637**
Wood engraving by Thomas Stothard in Samuel Rogers, THE PLEASURES OF MEMORY, London (Cadell and Davies), 1810

Lieut. Drummond's Light.

**638** A limelight for lighthouses. Wood engraving in *The Penny Magazine*, London, 1840

**639** A Sharp-shooter on Picket Duty. Wood engraving after Winslow Homer in *Harper's Weekly*, New York, 1862

As subscribers became more demanding, wood engraving was used to create pictorial journalism. *The Penny Magazine* led off in 1832 by publishing pictures of news events, works of art, and the latest inventions [ 638 ]. So many people hungered to see the world that in a year *The Penny Magazine*'s steam presses were printing 200,000 copies. The new readership—or lookership—started *Punch* in 1841, *The Illustrated London News* in 1842, *L'Illustration* and *Die Illustrierte Zeitung* in 1843, and *Harper's Weekly* in 1857.

About 1840 England found a way to prepare large illustrations quickly. A draftsman drew on an assembly of boxwood blocks bolted together. The blocks were then distributed to a team of engravers who worked the separated pieces almost to the edges. After the blocks had been bolted together again, a master engraver finished the joins for printing while the subject was still news [ 639 ]. Pictures of last week's events ousted the huge, old, deliberately elaborated historical oil paintings, just as television may now oust newspaper illustrations of yesterday's events. Even though no newspaper seems to have illustrated Emperor Maximilian's execution in 1867, people had already grown so used to seeing news events quickly that hardly anybody looked at Manet's heroic painting of the firing squad when he exhibited it in New York and Boston 12 years after the shooting. The painter afterward cut up his canvas in disgust. (The next newsworthy subject painted by a major artist—Picasso's Guernica in 1937—succeeded because it did not rival a photograph by repre-

senting but commented with a vision.) News pictures began to appear in mere hours after 1897 when presses were so exactly machined that *The New York Tribune* curved a halftone plate around a cylinder for high-speed printing.

As wood engraving, and then the photomechanical processes, spread to all peoples who had presses, cheap books and periodicals multiplied detailed instructive pictures in an international outburst of popular education. Wood engraving thus helped to shift Europe, the Americas, and Japan from the apprenticeship system to trade schools and correspondence courses, from muscle power to steam power, from fortunes in land to fortunes in industry, from the trial and error of the natural philosophers to the 19th-century master discovery of the technique of invention. We now struggle with the consequences of this cascade of change.

**Posters**    The earliest dated pieces of Gutenberg's typography (1454), were little posters advertising the sale of indulgences to finance the rescue of Constantinople, captured by the Turk the year before. The pictorial posters—pictures meant to be seen by people who did not mean to see them—did not start until the 1830s, when Parisian publishers began to advertise their illustrated books with large black and white lithographs drawn by the book's illustrator [ 640 ]. When French advertising spread outdoors to infest walls with scare headlines on garish papers, Baudelaire

**640**
Lithograph poster
by J. J. Grandville,
Paris, 1842

641 Color lithograph poster by Jules Chéret, Paris, 1892

642 Color lithograph poster by Pierre Bonnard, 1894

lamented that Paris had been spattered by a vomit of posters. Imaginative pictures returned in 1866 when Jules Chéret advertised theaters, music halls, cigarettes, and champagne with about 1000 outdoor posters, at first in three colors and after 1888 in four, drawn on stones that became taller than a man by 1890. He achieved dash by using spatter (*crachis*) in ragged patches and by propelling the action of the picture into the lettering [ 641 ]. From 1889 to 91 French technical abilities began to matter artistically when Bonnard [ 642 ] initiated Vuillard [ 720 ] and Lautrec [ 709 ] into color lithography by way of the poster. For a decade these three painters experimented on the cylindrical billboards of Paris more daringly, promptly, and publicly than in the Salon des Indépendents. The painters' posters of the 1890s so altered all printmaking with their impact of size, design, and color that few printmakers have been content to return altogether to the earlier meditative little monochrome scaled to the collector's portfolio.

**Girtin and Turner**   In 1802, at 27, Thomas Girtin died of tuberculosis, like so many promising people whose young doom darkened the romantic outlook. Most of his magical watercolors have browned except where a surrounding mat has preserved a rim of their brilliance, and his most ambitious painting, a circular panorama of London, eventually disappeared into Russia. In his last year he went to Paris to export this London panorama and to paint Paris for a panorama at home. Since eight years of war with Britain had made Frenchmen suspicious of Englishmen, Girtin sketched inside a closed cab, probably tracing an image cast onto his paper by a lens and a mirror. At home again in his final months, and too ill to paint his second panorama, he transferred his Paris sketches deftly and boldly onto 20 soft-ground etchings. Death left him just days enough to watercolor some proofs [ 643 ] as guides for aquatinting the coppers. These plates and much of the edition perished in a fire 14 years later.

Girtin's achievement received its sincerest tribute from Turner. "If Tom Girtin had lived," he said, "I'd be starving." Unlike Girtin, Turner enjoyed success for all of his 76 years. He trained by making factual views of English places and by mastering the devices of all the great landscapists since Claude Lorrain. As Claude had authenticated each of his paintings by drawing it in a book, his *Liber Veritatis*, so

**643**  Vue du Pont Neuf et de l'Hôtel de la Monnaie. Hand-colored soft-ground etching by Thomas Girtin, 1802

Turner began, when he was 32, to publish his *Liber Studiorum* in a series of issues, each presenting five landscapes that cover the range of his virtuosity [ 644 ]. He etched the outlines himself with the tine of a broken steel fork and usually hired mezzotinters to fill in the shading. He found his ideal medium for publication after

**644** Spenser's *Faerie Queene*. Etching by Joseph Mallord William Turner in LIBER STUDIORUM, London, 1811

1823, when steel plates enabled etchers to achieve a vaporous translucence that nevertheless stood up to many printings. Turner had then begun his final style of mist and flame [ 645 ] that was to show Monet how to distill opals.

**645** Loch Coriskin. Etching on steel (so-called "steel engraving") after Turner in Walter Scott, LORD OF THE ISLES, London, 1834

**Folk prints**   Just as ancient court clothes congealed into church vestments and folk costumes, so artistic styles, when deprived of dynamic patronage, flattened and stiffened into folk art. Folk prints were practically the only kind ever made in the fossil worlds of Hinduism and Byzantine orthodoxy. Greek shrines sold pilgrims engravings in which Byzantine figures often clash with rococo borders [ 646 ]. El Greco used such prints when he painted Mount Sinai as three twisted cones. Although religious subjects also predominate in Russian prints, some achieve a lyric swing [ 647 ] that inspired Russian painters up to Chagall. Russian art his-

646  New Russian monastery on Mt. Athos. Etching, 1849

647  Sirin Sings of the Paradise of the Faithful. Lithograph copy of Russian engraving in Rovinski, *Russian Fairy Tales*, St. Petersburg, 1881

torians, anxious to assert native Russian inventiveness above foreign importations, were among the first people to collect and catalogue their folk prints.

Italy, before 1800, generated too much creativeness to allow the stagnation that petrifies into folk art, though there were a few religious woodcuts, and Bologna issued fairly expensive copperplate illustrations of proverbs, allegories, and news events. A Roman continuous strip shows the outbreak of a plague in 1656 through

30. *Cerusico, Medico, e Confes. sporchi. 31. Carrette, e Profumatori sporchi, che profumano le Case, et abrusciano le robaccie. 32. Carretta di Profu
le robbe, che mandano allo spurgo. 35. Carretoni, che portano uia le dette robbe.*

**648** Rome's Last Great Plague. Detail of etching, Rome, 1656

the burning of infected belongings [ 648 ] to the end where cadavers drop from the island hospital into barges for burial in the fields. This ribbon of events foreshadows both pictorial journalism and the comic strip.

In France a slight bettering of the roads during the 18th century deployed the Parisian printing industry into the provinces, where peddlers hawked romances of chivalry illustrated at Troyes with battered Gothic woodcuts conserved for remembering peasants. The most active of the new folk presses appeared in the Vosges mountains at the shrine of Epinal, where, as in nearby Germany, pilgrims bought souvenir woodcuts. Epinal peddlers distributed saints and Virgins to old-fashioned countryfolk while the French Revolution banned the church, and equally pious

**649** The Month of May. Lithograph by Pellerin et Cie, Epinal, 1850s

**650** John Bishop and Thomas Williams, Murderers. Wood engraving, London, 1831

BISHOP'S
# HOUSE OF MURDER,
*Situated in a Dismal Lane in Nova Scotia Gardens, Bethnal Green.*

The Murderers are represented carrying the Body of their Victim, the unfortunate FRANCES PIGBURN, at Midnight, whom they first stupified with Laudanum, and then suffocated in a Well.

House No. 2 the Witness WOODCOCK'S—No. 3 BISHOP and WILLIAMS, the House of Murder. This House has no front Door, the Victims being led in at a side Gate.

*(Price Two-pence.)*

images of Napoleon when the Bourbon Restoration banned memories of the Empire. Epinal cut costs by changing from woodcut to lithography about 1850 [ 649 ], then to photomechanical line blocks in the 1890s. Their stenciled coloring of yellow, green, and bright raspberry pink was adapted by Gauguin in his search for the "primitive." Since about 1914 Epinal has sold paper dolls and cutout Eiffel towers to children and reprints of old blocks to sentimentalists. The French pieties did not cross the Channel into England, where Georgian and early Victorian broadsides shocked with the Hogarthian gusto of their hangings and murders [ 650 ].

Folk prints were produced in small shops for local, or at most national, tastes, until the New York firm of N. Currier, later Currier & Ives, lithographed 4300 subjects from 1835 to 1907 for distribution to all the Americas and seaboard Europe. The firm's professional lithographers copied all kinds of prints, paintings, and commissioned sketches but never permitted a painter to draw his own design on stone. Their copyists' prim outlines, as skinned as early Gothic woodcuts, were meant to be completed by women watercoloring them at home. (In the 1880s a few of the firm's color lithographs were printed by an outside press.) The home colorists were paid a dollar for painting 12 large folio lithographs (22 by 28 inches), which sold for $1.50 to $3 each. The small prints (16 by 20 inches) wholesaled for six cents each to retail for 20 cents. These two standard sizes facilitated filing and shipping as well as rotating prints in showroom frames. Currier & Ives offered their sales agents "elegant and saleable Pictures—Juvenile, Domestic, Love Scenes, Kittens and Puppies, Ladies' Heads, Catholic Religious, Patriotic, Landscapes, Vessels, Comic, School Awards and Drawing Studies, Flowers and Fruit, Motto Cards, Horses, Family Registers, Memory Pieces and miscellaneous in great Variety." About 500 of these now appeal to our nostalgia for a vanished land where the adventurous could still drive westward into a larger freedom [ 651 ].

**651**
Snowbound. Lithograph by Currier and Ives, New York, 1871

**652** Mexican Newspapers Satirized as *Calaveras* on a Broadside for All Saint's Day. Metal cut by Guadalupe Posada, Mexico, 1889–95

The other early printmaking country in the Americas, Mexico, led the New World by a good century. Mexican work lacked interest until the upheavals resulting in the Revolution of 1910–20 also released the only vivid personality among popular printmakers, a self-taught Indian, Guadalupe Posada. This heir to the sanguinary promptness of the Aztecs modernized their lurid humor in ballad sheets of throat cutting and the firing squad and Halloween broadsides of skeletal highjinks [ 652 ]. He reproduced his pen drawings in line blocks that he retouched with the graver and printed on green, orange, or vermilion pulp paper for newsstands, peddlers, and night watchmen reminding their patrons to pay them. Though these flysheets perished like all such ephemera, many of the zinc blocks have survived for reprinting by Mexican artists who have drawn strength from the Indian's breakneck plunge into violence.

**Photography**   All hand processes for printing images could have been invented as soon as there was paper, but photography depended on advances in chemistry and optics that did not arrive until around 1800. In January 1839 Fox Talbot announced his negative-positive process in London, and in August Daguerre announced the daguerreotype in Paris. Daguerre captured the headlines because his precise directions started the world making his exquisitely sharp, brilliant, and permanent pictures on silvered metal [ 653 ]. Although Fox Talbot took second place because he only hinted at his paper-negative process (the calotype), hedged it

with patents, and produced blurry images that darkened [ 654 ], he nevertheless opened the future by making a negative that prints as many identical images as a copperplate or a woodblock.

After about 1850 every historic face lives for us through photographs, not through the artistic bias of painted portraits. Though the camera has never eliminated portrait painting, it robbed painters of their most predictable livelihood, thus creating the type of the beggarly artist. But photographs also helped artists by providing the handiest note pads. Thus, Degas based portraits on daguerreotypes, Daumier wrote his publishers for photographs to help him with architectural backgrounds, and Vuillard deduced some of his wittiest pictures from his fuzzy family snapshots.

Painters also experimented with photography for its own sake, just as their predecessors had done with etching and lithography. In Edinburgh, in 1843, when the landscapist David Octavius Hill undertook to paint the mass resignation of 300 clergymen from the Church of Scotland, he appealed for help in so many portraits

**653** Chief Justice Lemuel Shaw. Daguerreotype by Southworth and Hawes, Boston, 1851

**654**
Lacock Abbey. Calotype by William Henry Fox Talbot, 1839/40

Mrs Rigby.

to a 22-year-old chemist, Robert Adamson, who had been making calotypes with Fox Talbot's new paper negatives. Together they photographed the dissenting clergymen before they scattered to their parishes and then proceeded to pose all kinds of prominent or picturesque men and women on Hill's doorstep during glimpses of the Scottish sun [ 655 ]. In five summers they made some 1400 calotypes in the manner of Terborch's and Raeburn's paintings. The exposure of about three minutes allowed sitters the leisure to settle through passing expressions into their sum total of character. After being shown a few times, this first long series of artistic photographs slept in family albums until 1912, when Alfred Stieglitz' mag-

**655** (OPPOSITE PAGE) Mrs. Rigby. Calotype by David Octavius Hill, 1843–48

**656** Gallego Flour Mill, Richmond, Virginia. Photograph by Mathew Brady, 1865

azine *Camera Work* published brilliant photogravures made directly from the paper negatives in a revelation that transformed serious portrait photography.

While the average handmade picture interests us less and less as it ages, even the average photograph accumulates fascination by having put a fly in amber, fossilized an instant, coffined a gesture. After a century, the American Civil War can still disquiet us, because it is the first convulsion that the camera recorded in detail. Mathew Brady's thousands of photographs occasionally, perhaps accidentally, achieve distinction [ 656 ] but were little seen at the time because they caught no action and could be published only through laborious wood-engraved copies.

Reproductive engravers did not begin to lose their jobs to photomechanical reproductions until the 1880s, even though primitive photoetchings had actually

**657** Cardinal d'Amboise. Contact photogravure by Nicéphore Niepce, 1826

**658** The Virgin's Funeral, relief on Notre-Dame Cathedral, Paris. Photogravure by H.-L. Fizeau in EXCURSIONS DAGUERRIENNES, Paris (Lerebours), 1841–43

preceded lens photography through photoprinting by direct contact [ 657 ], the method used by today's copying machines. In 1841 the silver plate of a daguerreotype was etched deeply enough to print like an aquatint for the first photomechanical reproduction in any book or magazine [ 658 ]. At last a text could illustrate the brush and chisel marks that distinguish one artist's work from another's, an original from a copy. Art history, which had started as the history of artists, could now become the history of works of art. In the beginning this information could reach only a few, for the first soft silver photogravures wore quickly from printing. But the search was on for a durable relief plate to print cheaply along with type in huge editions for everybody. By 1885 F. E. Ives of Philadelphia had perfected the halftone screen, which fragments an image into larger and smaller pinheads on a metal plate, as in the illustrations printed here. The swarm of dots fuses into a continuous tone. Printing them required the development of exactly accurate presses and smooth papers.

As halftone reproductions supplanted hand engraving by being cheaper, more detailed, and more accurate, they enabled the scientist to study individual specimens instead of species, and they turned the dilettante of art into an art historian by showing him works without any copyist's misinterpretations. Copyist draftsmen, who had always been the majority, were reduced to drawing for the anatomist and the biologist what the camera could not select.

**Daumier** Honoré-Victorin Daumier was born in Marseilles during the turmoil of Napoleon's wars. His father, a picture framer who wrote poems and historical tragedies, went north to the literary life of Paris, and there the eight-year-old boy followed soon after Waterloo. In Paris small Daumier earned his keep as a "gutter jumper," or lawyer's messenger, serving writs on the shopkeepers and artisans who were to be his lifelong models. A little instruction in drawing, lithography, and sculpture started him making catchpenny prints for the lithographic presses that sprang up all around his home after lithography suddenly began to pay. He was then 11. In the lithographs of his teens he imitated the insipid prettiness of the day's popular printmakers. He found his real style, and his first real teachers, by studying the reasoned structure of sculptures by Michelangelo and the ancient Romans in the Louvre. (In his studio a cast of a relief on Trajan's Column for years imposed its grand volumes and its gesture of command.)

Just before his 24th birthday, Daumier published the first of about 100 lithographs in *La Caricature*, a weekly that for a year and a half had been importing British freedom of the press into France. Its intransigent editor, Charles Philipon, waged what he called Philipon's war against King Louis-Philippe by organizing the first systematic offensive of verbal satire driven home by even more stinging pictures. Daumier's first substantial assignment was to caricature reactionary deputies in lithographs for which Philipon invented mocking coats of arms [ 659 ]. Since a known cartoonist might not sketch in the Chamber of Deputies, Daumier studied his victims from the visitors' gallery, and modeled their heads [ 660 ] at home with

CH. DE LAM....

659 Charles de Lameth. Lithograph by Honoré Daumier in *La Caricature*, Paris, 1832

660 Painted clay by Daumier, 1832

the semidivine memory that he had developed by scrutinizing sculpture in the Louvre. All his life when he searched for a shape, rather than draw it on paper, he felt for it in a lump of clay—and then, with a squandering parsimony, he would knead up each little masterpiece to model the next one. His sculptor's instinct guided him to draw each hand, each head, as a logical structure, even where it rounded into darkness. This solidity in shadows is one thing that distinguishes his genuine paintings from the many forgeries. His approach to lithography through sculpture saved him from that prissy fussing with technique that makes the work of printmaking specialists so glossy when new and so quick to age.

Louis-Philippe was lampooned as a pear in issues of *La Caricature* [ 200 ], which the Citizen King set up on chairs for a good private laugh. His ministers, less amused, sent Daumier to cool off for six months in jail. The magazine collected a war chest by issuing monthly lithographs at one franc per number in a series called *L'Association Mensuelle*. This included Daumier's five largest lithographs, ending with one that magnetized such crowds at the shop window that the police seized the stone and what they could find of the edition. Daumier had drawn the moonlit corpses of a poor family senselessly shot by riot squads three blocks from his home. He may have actually witnessed the massacre, but he needed three months to

**661** Rue Transnonain, 15 April 1834. Lithograph by Daumier in *L'Association Mensuelle*, Paris

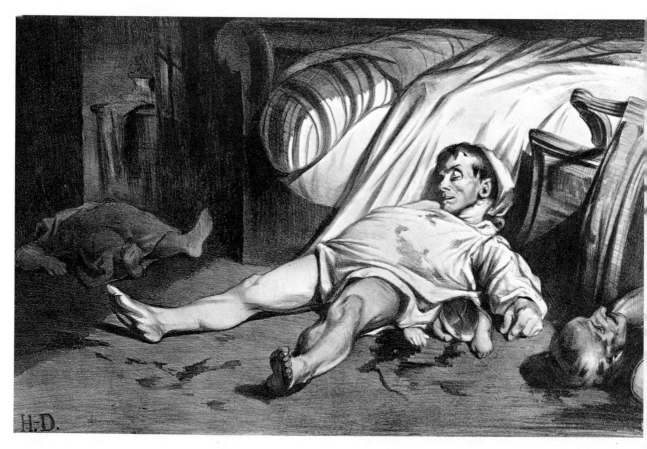

**662**
Wood engraving by Daumier, 1841

organize haphazard ghastliness into a dramatic unity [ 661 ]. At 26 he had achieved a masterpiece ("trivial and terrible," said Baudelaire) that he was not to surpass until his 6os. The Rue Transnonain added to the commotion that scared the censors into stopping *La Caricature* in August 1835, along with about 30 other periodicals. British freedom of the press had not long survived the Channel crossing.

Two years before the end of *La Caricature*, Philipon had foresightedly started a daily in which social satire predominated over politics. He named this new periodical *Le Charivari*, after the serenade of pots and pans hooted at the windows of unpopular people. Each day brought forth a single sheet folded once to make four pages. A typographic press printed text on pages one, two, and four, after which a lithograhic press added a full-page illustration on page three. *Le Charivari*, which gave the British *Punch* its subtitle, survived for over a century by venturing to satirize politics only when the government was weak, meanwhile floating along on social banter. Social satire thrives where different kinds of people live as neighbors and criticize each other, as they have been doing in France ever since the French Revolution divided party against party, Frenchman against Frenchman. (In French, collaboration is a dishonorable word.)

Daumier's endless human inventiveness overflowed from his *Charivari* lithographs into almost 1000 little boxwood blocks on which he sketched Parisian types. Many of these illustrated 21 of the booklets called *Physiologies*, of which some 200 appeared in 1841/42, depicting the lawyer, the concierge [ 662 ], the saunterer, and so on in squibs that tickled the middle class, now finally in command. On the smooth boxwood Daumier's steel pen molded sculptural solids with scribbles whirled up as spontaneously as though drawn with eyes closed.

*Charivari* was to keep Daumier from quite starving for all but eight or ten of his remaining 43 years. When he was 31 he contracted to supply 100 to 200 lithographs a year for 50 francs ($10) a stone. Then, when he was 35, of an age to expect a raise, *Charivari* cut his pay to 40 francs a stone. Daumier roused himself by studying Rubens' Kermess in the Louvre for an infusion of baroque energy rebounding from dancer to dancer. Thus invigorated, he swung back into political battle as soon as the revolution of 1848 relaxed censorship. When the future Napoleon III again muzzled the press in 1851, Daumier fell back on social satire with a mastery of baroque declamation [ 663 ] absorbed from Rubens. His watercolors and lithographs began to dramatize the gestures of mountebanks, actors, and their audiences as well as the mixture of the real and the feigned in the drama of the courtroom, discharging energy in the falcon glance, the writhing lip, the wide arc of the arm [ 664 ]. No wonder such a great stage technician as Sarah Bernhardt collected Daumier's complete prints. His new heroic figures, antique in the grandeur of their volume, scorn the whims of fashion to grow a kind of loose elephant hide of their own. The classical reference ever expanding in the back of his eye created dignity where Baudelaire hoped for it in the art of his time: in trousers and a plug hat. But figures so timeless, so oblivious to chic, could not but embarrass a Parisian periodical, so when Daumier was 52 *Charivari* dismissed him.

Thus freed, Daumier buried himself in the slums for three years while he struggled to support himself and his wife by peddling his paintings and watercolors at

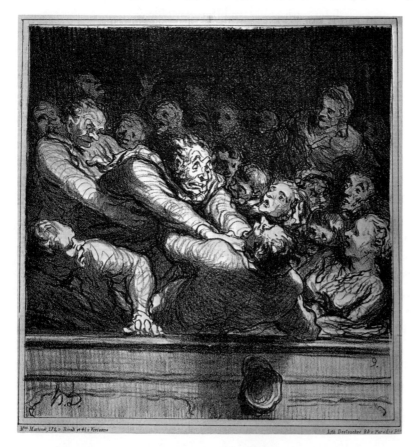

**663**

A Literary Discussion in the Second Balcony. Lithograph by Daumier in *Le Charivari*, Paris, 1864

the modest prices of his stones. He intended his watercolors—in vain—for people with more sensitivity than the mass public of his lithographs. Accustomed to the intimate scale of a sheet of paper, and set at ease by the cheapness of water paints, he made his watercolors into the most subtle and the most vehement of all his works.

In December 1863 *Charivari* took him back with a hollow-hearted editorial welcome, but still at the reduced pay of 40 francs a stone. Daumier returned to a newspaper whose increased circulation forced the lithographic printers to jam through his stones too hastily to print the pearly grays and saturated blacks of his early shading. He countered by evolving a manner too rugged for any printer to ruin, a manner that he also used in painting. He roughed out the masses by smudging the stone here and there (or by brushing tones on his canvas), on top of which he drew lines wherever planes change direction, thus displaying his construction on top instead of burying it underneath. Too frugal to waste crayons by sharpening them, he turned their haphazard facets to the one that would give a particular stroke its force. Like a Chinese painter, he held his mental image until the clearing of his inner eye freed a few final lines—lines that, like an actor's makeup, carry surprisingly far. The backgrounds of vague rows of city windows, or a tree or two, keep their distance in sun and air behind the actors, at the same time laying a subtle track to speed the lunge of the action.

At about 60 the blurring of Daumier's eyesight forced him to draw with open

**664**
"I have proved beyond the shadow of a doubt that my client was deceived by his wife." Lithograph by Daumier in *Le Charivari*, 1864

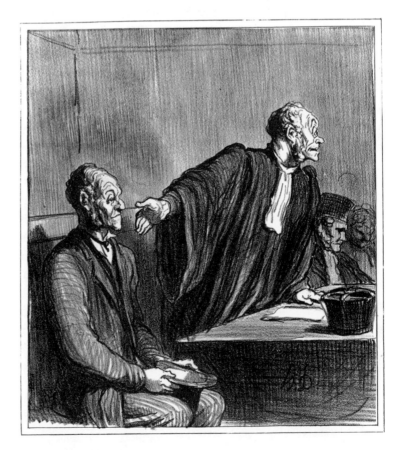

**665**
Conciliatory Attitude of the
Moderates. Gillotype by Daumier
in *Le Charivari*, 1871

**666** (OPPOSITE PAGE, LEFT)
Autumn: "The password?" Time:
"Fraternity and artillery." Litho-
graph by Daumier in *Le Charivari*,
1867

**667**
Council of War. Lithograph by
Daumier, 1872

distinctness, like so many aging artists, but this inevitable elimination of nonessen-
tials served him well in July 1870, when *Charivari* cut costs by eliminating its
sheet-fed, hand-inked lithographic press in favor of a relief plate for printing the
picture along with the text. In this 1850 invention by Firmin Gillot, a fresh impres-
sion of a lithograph was pressed against a zinc plate to offset the greasy ink onto
the metal. Dusted rosin stuck to the grease, causing haphazard dots of metal to
stand up in relief when acid ate down the unprotected metal around them. The
gillotype granulates the grays in a grit that disintegrates any drawing short of
heroic [ 665 ].

The darkening of Daumier's eyes awakened the cutting insight of his imagina-
tion. He saw the doom of the Second Empire drawing on with Greek inevitability
and pictured it in terms of antique tragedy [ 666 ] or as a timeless nightmare that
shocked the censors into prohibiting his most terrible visions [ 667 ]. He tore at his
late lithographs with a shorthand raging like rags in a hurricane—the last great
passionate outburst of baroque expressiveness as he scrutinized French politics
with such grim, inextinguishable hope that his cartoons symbolize any crisis any-
where. Feeling his time run out, he stormed against having to labor over newspaper
illustration, his "pushcart" that prevented him from painting. Actually, we may be
the gainers, for the expense of canvas and the nobility of painting intimidated him
into reiterating a few themes that he brushed in and abandoned. But on the familiar
stone the brute recklessness of his pursuit for novelties to amuse Parisians once or
twice a week, year in and year out, drove him to discover for French painters from
Manet to Vuillard what to paint and how to arrange it on canvas in scenes too close

to see: the café, the theater, the shop, the bus, and the railroads that were then spreading everywhere [ 668 ]. Today he would draw the airport, the escalator, and the television studio. To dislocate the commonplace into drama he sliced rooms with

**668**
"Some People Actually Travel for Pleasure in Winter." Lithograph by Daumier in *Le Charivari*, 1864. Inscribed proof

walls and turned stage scenery wrong side out [ 669 ], as only Hokusai had done before him, but as Degas and his followers would do afterward [ 670 ]. His 4000 lithographs, appearing in editions of up to 3500, amount to more than all the lithographs that all the painters of the world have drawn on stone. This one-time buffoon of the bourgeoisie now emerges as his century's spy of art, the only artist to range over the total complexity of that complex age. He was also one of the few great artists who was a great and lovable man. Forain summed him up: "He was not like the rest of us. He was generous."

**669** (ABOVE)
A Queen Prepares for Her Great Speech. Lithograph by Daumier in *Le Charivari*, 1856

**670**
Backstage. Painting by Edgar Degas, about 1890

**Lami and Gavarni**  When French emigrés in England ended their 20-year exile in 1815, they returned to their family châteaux with the English habit of country living. This passing anglomania was drawn by Eugène Lami with Moreau le jeune's circumstantial detail in outline lithographs [ 671 ] that were watercolored like Rowlandson etchings [ 604 ]. As soon as the restored noblesse got the money to reassemble in Paris, Lami made evocative watercolors of their salons for reproduction in delicate steel engravings. His prints carried his art to England, where Lami himself followed in 1826 and again from 1848 to 52 to paint Queen Victoria's balls and levees. Some decades of exchange visits had already brought French and English artists closer together than they had been since about 1400. Géricault had stayed in London in 1820–22, while Bonington was living in France, and in 1824 the Paris Salon showed Constable's Hay Wain.

England transformed one French visitor, Sulpice Chevalier, better known by the name that he adopted in his early 20s after visiting an amphitheater of cliffs in the Pyrenees called the Cirque de Gavarni. Under this romantic name, Gavarni incongruously started his output of 2700 lithographs with sprightly fashion plates. When he was 29 he began to explore the wiles of women for *Le Charivari* in the

671  Reading from Victor Hugo. Watercolored lithograph by Eugène Lami in *La Vie de Château*, 1833

*Mon adoré dis-moi ton petit nom.*

**672** "Darling boy, tell me your name." Lithograph by Gavarni, 1841

**673** Thomas Vireloque. Lithograph by Gavarni, 1850s

lorettes—those pretty little careless girls who played with the carefree young men in the *vie de Bohème* that Gavarni invented [ 672 ]. As he shaped his figures directly on the stone with no preliminary sketch, he said that they dictated their own witty Parisian captions. When Gavarni was 43 he went to London for four years, where, surprisingly, he refused to paint Queen Victoria in order to study the slum dwellers that the Industrial Revolution had stunted into a sub-breed. On returning to Paris this former man about town shut himself up alone to draw the companions of his youth in their bitter decrepitude [ 673 ]. Henry James said of Gavarni's contradictions that he was "either basely graceful or touchingly miserable."

**Artists' colonies**  Under the old French monarchy a few connoisseurs bought or commissioned work directly from artists. After the Revolution, when the new bourgeois prospered enough to buy from art galleries, some painters let dealers represent them while they themselves retired to the country. The first famous artist's colony was founded in the 1820s at Barbizon, near a picturesque chaos of boulders in the forest of Fontainebleau. The villagers lived with the simplicity that

**674**
Turning Sods.
Etching by Jean-
François Millet

Rousseau had idealized, and the fields looked like the Constable landscapes that had made a sensation among French painters. The political disturbances of 1848 drove Millet to Barbizon for his remaining 27 years. This peasant from the Channel coast painted and etched the inland sowers and reapers [ 674 ] with the force of truth in revolt against the theatricality of official art. He drew on copper with masterful directness but cared so little for brushing bubbles off a copperplate in acid that he let others bite and print his plates. The massiveness of his figures makes him a pre-cubist, like Corot, who was then painting buildings as blocks and cylinders.

Corot lived off and on at Barbizon. He started to etch in his 70s, when artists usually give up such eye-taxing work, but he mostly used a semiphotographic process described by T. H. Fielding in his *Art of Engraving* (1841). Learning the method in Belgium in 1853, Corot made about 65 of these *clichés verre*, painting a sheet of glass and scratching lines in the paint as he might on a grounded copperplate. He then placed the glass on photographic paper that darkened where the opened lines admitted sunlight [ 675 ]. Millet, Daubigny, and many other French painters used this simple and effective technique from 1853 to 75.

**675**
The Dreamer.
Glass print by
Jean-Baptiste-
Camille Corot,
1854

**676**
The Houseboat. Etching
by Charles-Francois
Daubigny, 1861

In 1860 Daubigny popularized a second artists' colony at Auvers-sur-Oise, where he was followed by Pissarro, Cézanne, and van Gogh. One of Daubigny's most charming works in any medium was a series of little etchings of the cozy, lazy Oise drifting past his houseboat [ 676 ].

**Late French romantics**   Romantic art exploded to a mass public in 1861 when Doré's big woodblocks for Dante's *Inferno* [ 677 ] were duplicated in electrotype shells that were printed under the sharp running pressure of cylinder presses for simultaneous publications in Paris, Berlin, Barcelona, Saint Petersburg, Stockholm, London, and Haarlem. Out of his facility for grotesque humor and gaslight

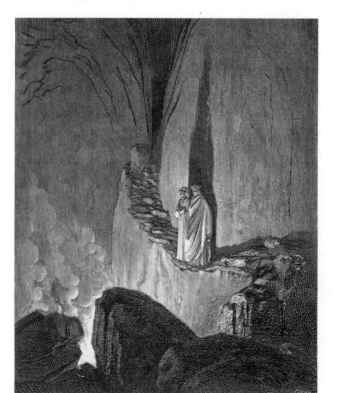

**677**
The Punishment of Evil
Counselors. Wood engrav-
ing by Gustave Doré in
Dante, THE VISION OF
HELL, London (Cassell),
1865

**678** (OPPOSITE PAGE)
The Flight into Egypt.
Lithograph by Rodolphe
Bresdin

melodrama, Doré invented some 10,000 illustrations for books and magazines, between painting canvases as vast as stage backdrops. To save the time it would have taken to draw in line, he often painted boxwood blocks with tones of ink and opaque white for engravers to interpret by inventing lines and dots. This tint engraving was refined by Americans in the 1880s and 90s just when halftone reproductions were eliminating handwork from all illustrations.

While Doré was hypnotizing the widest public ever captured by a major illustrator, a tramp, Rodolphe Bresdin, dreamed obscurely and obsessively of a haunted house, a battle wavering in twilight, and the Flight into Egypt [ 678 ], all of which he etched or drew on stone with the meticulous reiteration of the mad. In 1863, in Bordeaux, Bresdin taught his mastery of black and white to a pensive young

**679**
Daylight. Lithograph by Odilon Redon
in SONGES, 1891

**680** (BELOW)
The Dead Bullfighter. Etching by
Edouard Manet, 1864

painter, Odilon Redon, who at 23 had rejected classroom art schooling to learn architectural rendering. Thus trained, Redon painted and lithographed his reveries by putting, as he said, "the logic of the visible world at the service of the invisible" [ 679 ] Although he keyed his paintings to the brilliance of zinnias, he based his drawings and lithographs on the one incorruptible color—black. Redon kept such a workmanlike hold on his brushes and crayons that his pictures convey their mood even to people who have not read the poems that inspired them.

## Manet and Fattori   Two of the boldest 19th-century etchers offended their

contemporaries by disregarding the copperplate conventions of their time. Manet, who began etching and lithography about 1860, made most of his prints during his 30s. He started, like Goya, by etching paintings of Velázquez' time with Goya's

**681** "The pallid bust of Pallas." Lithograph by Manet in Edgar Allan Poe,
LE CORBEAU, Paris (Lesclide), 1875

**682** Noon in Tuscany. Etching by Giovanni Fattori

starry grain of aquatint. He then etched such paintings of his own as had attracted
attention, so exactly matching them on the copper that he probably copied reverse
photographs of his canvases reduced to the size of his plates [ 680 ]. Manet dog-
gedly reworked his etchings, reiterating some subjects on as many as four plates
before he achieved the look of spontaneity. He rarely forgot his great Spanish
model when etching, but lithography freed him for experiments that his publisher
called "detestable." His last five lithographs illustrate Poe's *The Raven* [ 681 ] with
an eeriness as sensitive as Mallarmé's translation of the text. The book's commer-
cial failure discouraged artist and poet from proceeding to *The Bells*. Almost no
Frenchman, and few Americans, bought the folio-size *Raven* at 25 francs ($5) or
Manet's much smaller etchings at two francs (40 cents) each.

When Manet died in 1883, his elder contemporary in Florence, Giovanni Fattori,
was just starting the etchings that he continued until his death in 1908. Fattori, the
strongest Italian impressionist, adapted G. B. Tiepolo's happy helterskelter to
sharper contrasts [ 682 ]. Where Tiepolo had suffused the lucky sunshine of the
18th century, poor struggling Fattori etched the harsh solitude of August noon,
contracting shadows on Tuscan rocks and dust. After he had raggedly bitten each
cheap zinc plate, he proved the effect on a random scrap of paper, then threw it all
aside for the next try. Luckily his plates, like Manet's, survived unworn for post-
humous printings.

**Degas and Cassatt**   Degas learned from quattrocento Tuscans to color lucidly and draw clearly, from Japanese woodcuts to spot pictures in patterns never imagined by Giotto or Raphael, from Ingres to control distortions of line, and from Daumier to spy from ambush for the gesture that sparks drama into somebody crossing a street, listening to music, or ironing a shirt. Degas explored more media than any artist between Dürer and Picasso. With intelligence and passion he investigated painting, pastel, sculpture, and all the varieties of drawing and printmaking, including photography, which he started when his eyes were dimming at the end. A beginner in photography, but not an amateur, he took advantage of the latest lenses and emulsions to master a medium that, like the piano, any child can use to some effect but only the strong can bend to their will. He was the first photographer to see that multiple exposures [ 683 ] might serve picture-making as usefully as reflections in plate glass. [ 684 ].

Most of his photographs seem to have disappeared when his heirs cleaned out his studio for auctioning. His other prints are also rare, since he pulled only enough impressions to check his progress through as many as 20 retouches on the copperplate. He combined etching with an aquatint of grains as sparkling as Goya's [ 684 ] to flatten the world like Japanese prints. He concentrated his printmaking from 1874 to 93 on making more monotypes than anyone since Castiglione, the inventor of the process [ 527 ]. Though he painted a few exquisitely finished pictures on the copper [ 685 ], he smudged most of his 400 monotypes as preliminary suggestions, like the "blots" that Alexander Cozens had streaked to inspire landscape drawings

683  Multiple exposure photograph by Edgar Degas

**684**
Mary Cassatt in the
Louvre. Aquatint by
Degas, about 1880

*Degas
and
Cassatt*

**685**
In the Firelight.
Monotype by Degas,
about 1880–90

**686**
The Jet Earring. Monotype by Degas

[ 531 ]. Degas's cloudy tones [ 686 ] served to fuse the precise lines of color that he usually laid upon them, and thus to blend his classic draftsmanship into the broad masses of the impressionists, who rarely or never drew. He applied his monotype technique to the stone of his lithograph of the *Ambassadeurs* nightclub [ 687 ], which he darkened all over to scrape out the grays and the highlights, as Goya had

**687**
Mlle Bécat Singing at Les Ambassadeurs. Lithograph by Degas, about 1875

**688**
The Letter. Color aquatint by
Mary Cassatt, 1891

done with his big bullfights [ 631 ]. His gaslight globes may have been suggested
by Harunobu's Plum Blossoms by Lantern Light [ 696 ], a rare instance of possible
linkage between a specific Japanese print and a specific work by one of the many
Western painters inspired by a general Japanese way of seeing.

Degas shared his admiration for Japanese prints with his only outstanding dis-
ciple, Mary Cassatt. This Philadelphian from a family as conservative as his own
had spent half her girlhood in France, where she settled permanently when she was
21. After mastering the academic discipline of painting, she broke away from it so
effectively when she was 33 that Degas invited her to show with the impressionists.
In 1891, after she and Degas had gone together to an exhibition of Japanese prints,
she consciously applied the elegance of Utamaro to the intimacies of her dressing
room, her writing desk [ 688 ], her tea table, and the nursery of her baby nieces.
Through these color aquatints, as well as her etchings and drypoints, Mary Cassatt
became one of the very few women to discover a new vision in the abstract me-
dium of printmaking. Her originality lay in seeing women and children as only a
woman—indeed a lady—can see them, and in drawing her delicate insight with a
supple strength that Degas thought possible only in a man.

## Illustration in the English-speaking 1860s    In Victorian London
artists and writers collaborated even more closely than in 16th-century Venice or
18th-century Paris. Although literature distracted many of the Pre-Raphaelite
painters (like Russian painters) from exploring form, color, and composition as
fruitfully as the 19th-century French, the English drew book illustration with ex-
quisite fitness, and with a liveliness that deserted them when they invented their

**689** (ABOVE, LEFT)
Sir Galahad. Wood engraving by Dante
Gabriel Rossetti in Tennyson, POEMS,
London (Moxon), 1857

**690**
Wood engraving by Sir John Millais in
Anthony Trollope, THE SMALL HOUSE
AT ALLINGTON in *The Cornhill Maga-
zine*, London, 1863

**691**
Dropping the Pilot (Kaiser Wilhelm II and
Bismarck). Wood engraving by Sir John
Tenniel in *Punch*, 1890

own subjects in single-sheet prints. The intimate precision of wood engraving suited the Pre-Raphaelite exactness better than canvas, while black and white eliminated their garish coloring. They took up illustration just when printers had solved the mechanics of the modern book with the steam press that squeezed woodblocks hard against the even thickness of machine-made paper. The finest lines yet printed from relief blocks blended with type equally lean to make a new harmony in Tennyson's *Poems* of 1857, illustrated by Sir John Millais, Dante Gabriel Rossetti [ 689 ], and others. These artists maddened and nearly bankrupted the publisher, but the book set the style for the next decade. Tennyson, sensitive to music but not to pictures, disliked the illustrations for departing from his details, but they embody his poems for us today. On the other hand, Millais fitted his illustrations to Trollope's novels [ 690 ] so intuitively that when Trollope reviewed his characters, he saw them as Millais had drawn them. Even Blake achieved no such fusion of word and picture when he wrote and drew his *Songs of Innocence*.

Many masterpieces of the 1860s illustrate potboilers turned out to fill the new weekly magazines that proliferated for the 19th century's largest leisure class with the widest interests. Politically astute Britain commented on her world connections through pictures as reasoned as editorials [ 691 ] when *Punch's* illustrators developed a dry, wiry drawing out of Menzel's illustrations for Frederick the Great [ 633 ]. British periodicals also popularized the views of foreign lands that had had an aristocratic success in the age of aquatint [ 375 ]. Such graphic reporting took on a lurid grandeur when Arthur Boyd Houghton turned from illustrating the Arabian Nights to discovering activities as weird in the United States [ 692 ].

**692**
Barber's Saloon, New York. Wood engraving by Arthur Boyd Houghton in *The Graphic*, London, 1870

**693**
Lumbering in Winter. Wood engraving after Winslow Homer in *Every Saturday*, New York, 1871

Illustration in London magazines, and in books that were often published simultaneously on both sides of the Atlantic, injected British style into American practice, while British painting remained local. The illustrating style of the 1860s, arriving just as the United States were tearing apart in the Civil War, had its first effect in war reporting for newspapers [ 639 ] and then in the gift books that began to appear after 1865. The best American illustrator in the style of the 60s, Winslow Homer, had started in his teens by decorating song sheets for a Boston lithographer, practically teaching himself to draw and paint. His painting broadened the pattern of his illustrating [ 693 ], and his illustrating directed his eye into the life around him and away from the genteel withdrawal that enervated many American artists.

From about 1860 to 1900 more poems and stories in English were printed with illustrations than ever before or since. After 1900 news reporting and technical books multiplied their photographic documentation while imaginative illustration dwindled until today's novel has no pictures inside its lurid dust wrapper, and a book of poems lacks even that.

**Light from the East**  In China, where printing started, historians of the printing of texts have ignored the printing of pictures, as philologists do everywhere. In Japan, historians of picture printing have had to contend with dating prints of actors and prostitutes by their obscure biographies, and to puzzling out the identities of artists who changed their names each time they changed their enthusiasms. (Hokusai signed with 31 or more names.)

Color printing came to the Orient from Europe. Saint Francis Xavier may have brought chiaroscuro woodcuts with him when he landed in Japan in 1549. A Japanese astronomy printed color diagrams of the phases of the moon in 1593, a century after Venice had done so [ 75 ]. In China in 1606 the Jesuit Matteo Ricci directed the color printing of four woodcut copies after Wierix and de Passe engravings. Then as now, the Japanese and Chinese printed sky colors by spreading soft, absorbent paper on watercolored woodblocks and pressing the paper with a smooth disk of palm leaf. Each tint is added from a separate block, over which the paper is exactly placed by fitting the long edge into two nicks chiseled in the plank. Such transfer·watercolors achieved the first exquisite coloring in any prints in a demonstration of classic Chinese ways of painting flowers and rocks [ 694 ].

The Orient's great printmaking began in 17th-century Edo (now Tokyo), already Japan's most populous city, where for the first time in the East there were enough connoisseurs to absorb mass-produced works of art. In the 1680s the first masterpieces there were black and white woodcuts imitating the smashing brush line of current paintings. They dramatized the subjects that were to fascinate Edo for the next two centuries—sumptuous, sulky courtesans, and young actors willowing in women's silks [ 695 ]. Sex and show filled the leisure of the first rich Japanese mer-

**694** Rocks and grass. Color woodcut by Wang Kai and brothers, The Ten Bamboo Studio, Nanking (Ying Po), 1679

**695** The Actor Sawamura Kodenji Dancing in a Female Role. Hand-colored woodcut by Torii Kiyonobu, 1698

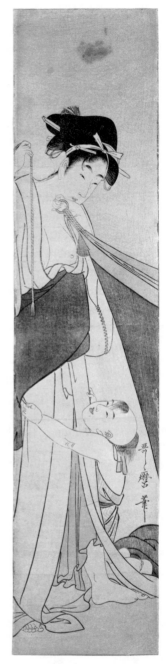

**696** Plum Blossoms by Lantern Light. Color woodcut by Harunobu, about 1768

**697** Tying the Mosquito Net. Color woodcut, pillar print, by Utamaro

chants, and the feudal lords immobilized at Edo under the apprehensive eye of the Shogun. Like the French nobles that Louis XIV had then fastened to Versailles, these Japanese used their day-long idleness to scrutinize works of art, women, and

elaborate clothes, to smile at everything sacred, and to take nothing seriously but flowers, snow, the moon, and Fuji. Prints of these subjects could be published in quantity when the stabilizing of Japanese currency facilitated marketing and allowed an artist to be paid in cash instead of the feudal retainer's reward of a banquet or a kimono.

Japanese picture printing achieved full color in 1764 when Harunobu started to combine up to ten blocks. His dream girls drifting like smoke past the exact geometry of a lattice or a balustrade [ 696 ] were adapted from black and white book illustrations printed at the imperial capital of Kyoto. In 1770, when Harunobu died suddenly in his 40s, he had perfected the last original creation of Eastern art. Among the hundreds of his followers at Edo, three especially affected the West. Utamaro arranged tall, intensely occupied women in striking placements that were

**698** Fuji and the Wave. Color woodcut by Hokusai for Thirty-six Views of Fuji, series begun 1823

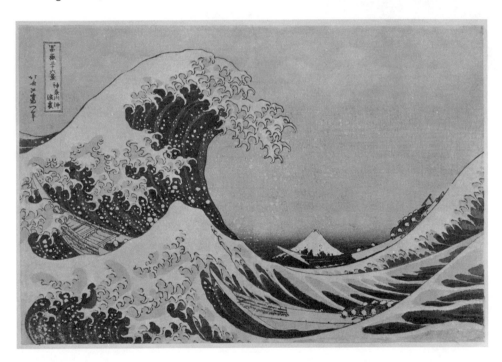

studied by Whistler, Degas, and Cassatt. They also learned from his ingenuity in slicing off the sides of a figure to narrow it into the theatrical posters [ 697 ] displayed on the wooden posts of Japanese buildings. Utamaro's singleness of style contrasts with the many models that Hokusai followed during his 89 years in something like 50,000 prints and drawings. He turned his back on the high-flown shams of the stage to draw the artisans and beggars shouting in the slums. Such frantic runts also labor in landscapes [ 698 ] that he stylized in the gorgeous swirls of 17th-

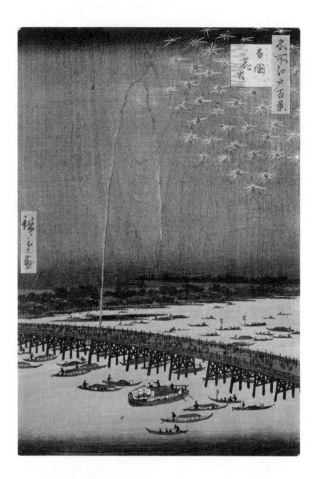

**699**
Spring Fireworks over Edo.
Color woodcut by Hiroshige

century court screens, thus transmitting to art nouveau a line as free as a string in
the wind. The last master in the old tradition, Hiroshige, developed effects of rain
and twilight in the natural kind of landscape print introduced by Utamaro. The
wood grain that he printed in some of his skies [ 699 ] suggested a technique that
Munch [ 711 ] transmitted to Western printmakers. These later Japanese prints
show that European views had penetrated Japan long before Commodore Perry in
1853 let in such a flood from the West as to disturb forever the Japanese mastery
of flat pattern.

**Meryon and Whistler**   About 1850 Charles Baudelaire discovered that rare
thing, a valid new theme for art, in the personality of the modern city. Paris plucked
at his sleeve like a noonday ghost. He found an artist similarly haunted in Charles
Meryon, the son of a Parisian dancer by an English physician who soon left her
but kept in touch with his child by inviting him to Florence when he was 13 and
by writing him to encourage his boyish efforts to draw. When he was 16 the lonely

boy joined the navy for ten years. During cruises in the Mediterranean and the South Pacific he studied perspective and tried watercolors that showed him to be color blind. A year after he quit the navy he took his first lessons in etching and copied about 15 prints, mostly 17th-century Dutch landscapes that he liked for their *"franche simplicité."* Finally at 29, with only six years of sanity left to him, Meryon began to etch moonstruck views of Paris in which Baudelaire recognized his own vision so clearly that he asked Meryon if he might write poems to be published with the etchings. The etcher silently stared at the ceiling.

Meryon prepared his views by drawing notes on scraps of paper secreted in the hollow of his hand and then pasted together at home. With the brittle logic of the obsessed, he always pushed his pencil or his etching needle in the direction in which buildings grow, upward. The somber hardness of his etchings (which he was the first to deplore) kept them from being routine city views, but it also kept them from selling, even at 25 or 30 francs ($5 or $6) for all 22 of the Paris set [ 700 ]. When fears closed in on Meryon, his skies began to swarm with ravens, balloons, even flying sharks [ 701 ] as his mind returned to sunlit days in the South Pacific.

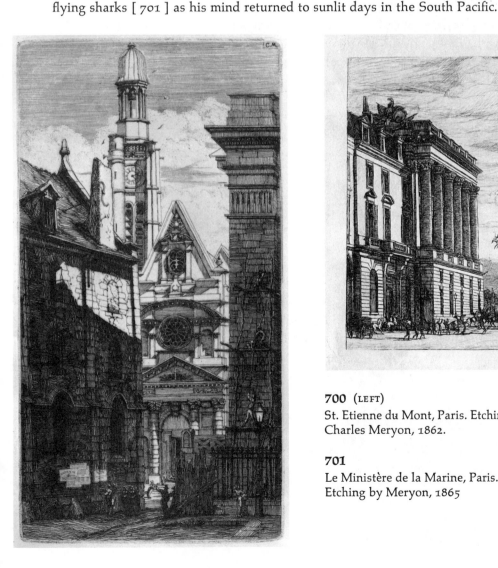

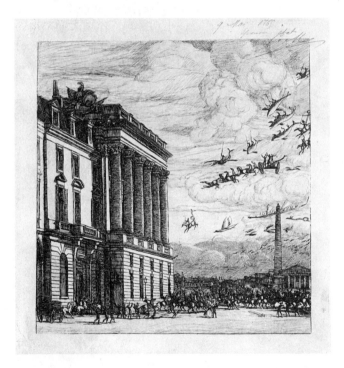

**700** (LEFT)
St. Etienne du Mont, Paris. Etching by Charles Meryon, 1862.

**701**
Le Ministère de la Marine, Paris. Etching by Meryon, 1865

Paris disturbed Meryon as an astonished, distracted native, but if an artist moves too often to be native anywhere, he compares places like so many decorative backdrops. This was the case with Whistler, born in New England, transplanted to Saint Petersburg at nine while his father spent six years building a railway to Moscow, then trained as a soldier for two years at West Point. After a few drawing lessons he etched maps and shorelines for the U.S. Coast and Geodetic Survey and made a couple of amateurish lithographs. At 21 he began in earnest to study painting in Paris, and then based himself in London. There he introduced the French artists' practice of etching and lithographing as seriously as one painted. Though he disliked what Meryon was doing in Paris, he etched the London docks with something of the same distinctness, and with an inherited engineer's delight in the distribution of masts and rigging [ 702 ]. From France he also brought the new discovery of electroplating steel on copper to make plates print more good impressions. When he was 45 he finally discovered his personal manner during a year in Venice by etching some 40 plates outdoors on the spot. With his eye on the scene before him, he rehearsed each stroke by swinging or circling his needle above the copper before swooping down to open the line. In his hotel room he bit his plates flat on a table (which he ruined) by dripping acid, swashing it with a feather to speed the biting and to prevent bubbles from disconnecting the lines. Since the center of the copper bit deeper than the edges, he concentrated on the center of his subject and worked

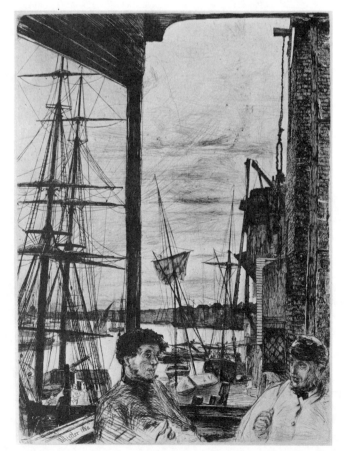

**702**
Rotherhithe. Etching by James Abbott McNeil Whistler, 1860

**703** (OPPOSITE PAGE, LEFT)
The Garden, Venice. Etching by Whistler, 1879/80

**704**
Comte Robert de Montesquiou. Lithograph by Whistler, 1895

outward only as far as it interested him [ 703 ]. Such wispy scribbles would have looked scrubbed without the atmospheric film of ink that he left on his plates. He authenticated each impression that he so deftly printed on paper torn out of an old book by penciling his butterfly (developed from a W) on a marginal tab left when he trimmed the print.

Just before going to Venice, Whistler returned to lithography with mature experience, drawing conveniently on transfer paper from which the crayon strokes were pressed onto the stone. These papers were translucent enough to place upon previous tries for tracing with improvements. He thus repeated attempts, which he considered failures, at the portrait of his equally delicate and equally waspish contemporary, the Comte de Montesquiou [ 704 ]. When he published his first set of lithographs in 1887, he started a new practice by charging £4/4/0 for sets signed in pencil, and half as much for unsigned impressions, even though all were printed alike in a lithographic shop. Arbitrary restrictions to raise prices had been institutionalized in 1847 when the Printsellers' Association was formed to limit the number of proofs that might be printed, thus obtruding rarity into a kind of picture that had traditionally been everybody's. Such snobbery appealed to Whistler, whose dandyism in dress, art, and sarcasm generated more publicity than any other English-speaking artist ever achieved. Yet the esthetic fragility that he imposed on England and North America lacked the vitality to spread further.

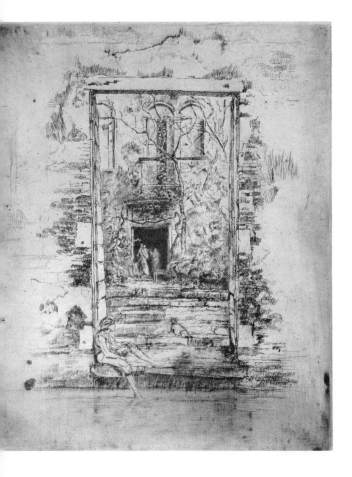

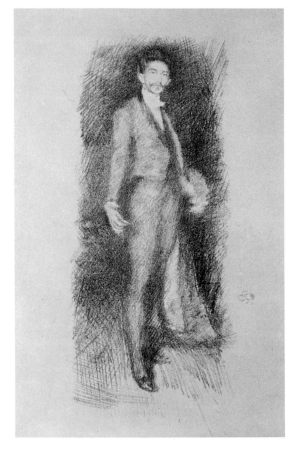

**The line block** Shortly before photography was announced in 1839, printers devised ways for turning line drawings into relief blocks mechanically. In 1834 Daumier, always eager to experiment, tried out one such invention, scratching a drawing through a plaster coating on a steel plate, after which molten type metal cast the incised lines as relief for printing with type like a woodcut [ 705 ]. In Paris in the 1870s photography was applied to the principle of the gillotype [ 665 ] to make today's line block. Firmin Gillot's son placed a photographic negative of a line drawing on a metal plate coated with albumin and sensitized with bichromate. Wherever light struck through the negative it waterproofed the albumin, sticking it to the metal. After water washed off the rest, acid ate down the bared metal, leaving the protected lines in relief. Since the special photographic negative regis-

**707**
Madame Réjane. Ink
drawing by Aubrey
Beardsley for line-block
reproduction, 1894

tered black and white but ignored pale blue, the draftsman could study his picture
with blue crayon and on top of this inert preparation dash off a sketch in photo-
graphable black. This premeditated spontaneity revolutionized illustrations for
books and especially for magazines of humor. For the first line-block illustrations
of artistic importance, Daniel Vierge drew with skinny lines to allow for their
thickening slightly in reproduction [ 706 ] and also revived the black blot of the
*Hypnerotomachia* [ 223 ].

The black blot and the flat pattern of Japanese prints distinguished the incredible
outpouring of line-block illustrations drawn by Aubrey Beardsley during the last
half dozen of his 25 tubercular years [ 707 ]. The young invalid's flippancy stung
like death. As an amateur actor, he characterized with grotesque pungency. As an
instinctive decorator, he originated a style that was directly imitated in Vienna and
Saint Petersburg and that cleared out representational clutter for the drawings of
Matisse and Picasso.

**708** Yvette Guilbert. Lithograph by Henri de Toulouse-Lautrec, 1898

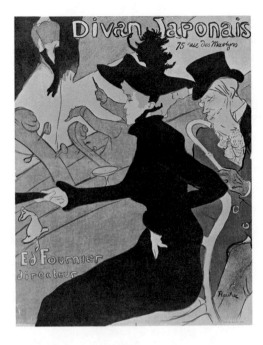

**709**
Yvette Guilbert Singing in the Divan Japonais, Jane Avril in the Audience. Color lithograph poster by Toulouse-Lautrec, 1892

**Toulouse-Lautrec**  The great Chinese ink painters came from a bureaucratic aristocracy trained to a semipictorial writing. Although European gentlefolk used to be taught to draw as they were taught to write, the aristocracy of Europe, so rich in remarkable authors and investigators, has produced only one remarkable artist: Count Henri-Marie-Raymond de Toulouse-Lautrec Monfa. Lautrec would probably have painted no better than his father if the breaking of both his legs in his teens had not saved him from wasting his life hunting with his cousins. Casehardened with an aristocrat's contempt for middle-class circumspection, he threw himself into the Paris of prostitutes and hoofers, who also had to put on a show and shrug off suffering with a jest. His fever for living burned out his life when he was 36. He had drawn since he was a baby. After the sketchiest instruction in painting, he found in Degas and in Japanese prints the sifting of appearances that he needed for summing up a person or an animal in a few tingling lines. This pictorial shorthand looked like caricature—the distortion of a physical feature—but actually expressed an insight as innocent, and therefore as alarming, as a child's. Looking upward from his child's height, he caught people at startling angles in pictures to be hung high [ 708 ]. He exercised his command of line and his joy in color through printers trained in color lithography by Chéret [ 641 ]. Lautrec drew his first color lithograph for a poster when he was 26. In the ten years that he yet had to live, his oils, vibrant though they often are, changed the course of art less than his lithographs, and especially his posters [ 709 ], which still startle by their strategy of attack. When their yellow and orange and black first flared in the gaslight of the boulevards, no one could miss the fact that art had taken a new turn.

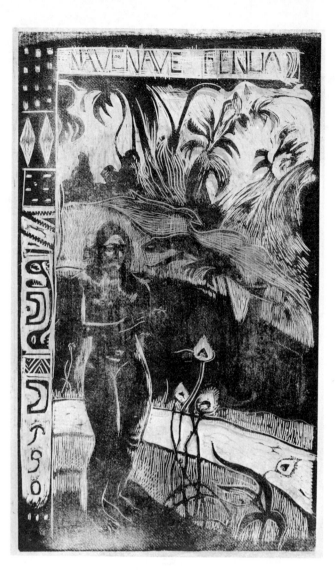

**710**
Lovely, Lovely Earth. Woodcut by Paul Gauguin, 1893/94

**711**
The Kiss. Color woodcut by Edvard Munch, 1897

**Gauguin and Munch**  By 1757 woodcut had declined to the point where Papillon, the first historian of woodcutting, complained that printers bothered to ink blocks only once for every five impressions. Woodcut suddenly returned as a spectacular modern medium when Gauguin, coming home in 1893 from Tahiti, prepared to publish his prose poem *Noa Noa (Fragrance, Fragrance)* with woodblocks almost as large as the largest lithographs that Manet had drawn for Poe's *Raven* eight years before [ 681 ]. Gauguin, his hand trained after five years of carving doors and furniture, gouged ten big end-grain boxwood blocks that set the mood for his reveries by recombining figures that he had painted in the South Seas. Where other artists would have counterfeited themselves, Gauguin profited from the restrictions of woodcut to create his most original, most widely imitated works in any medium. The brutal idols that he had long been painting he now dematerialized on the wood by spinning around them a cocoon of luminous filaments

scratched on the end grain with the needles and coarse sandpaper that he must have
seen lithographers using to shape soft forms out of a solid black coating on stone.
Blocks cut as no other end grain had ever been attacked before, with the broadest
gouges and the finest scratchers, became decorative reliefs that might incidentally
serve for printing. Gauguin continued to experiment, sometimes printing the same
block in black over burnt orange, smudging the register to enrich the tone, and
sometimes fogging the design by pressing the inked block against paper under a
mattress on which he sat or stood. The resulting visions of night in the tropics blur
and glimmer, dim with vapors, dreaming of love and danger [ 710 ]. He had in-
vented the most original woodcuts since Blake's little Virgil illustrations of 1821
[ 610 ].

But Gauguin's innovations, unlike Blake's unnoticed experiments, quickly ener-
gized artists in Germany and elsewhere, even though his dream book never came
into being as a whole. Gauguin's woodcuts, rather than his paintings, prepared
artists for African sculpture and conveyed his mastery of decoration to art nouveau.

Art nouveau, the only original decoration since rococo, writhed and whipped
across walls and posters in France and exploded into neurosis in Norway when
Edvard Munch became obsessed with the sick adolescent girl and the vampire
woman. Although Munch was financed by government grants until rich patrons
began to care for him, his cyclone of self-pursuit tormented him as poverty never
tormented Gauguin. Munch's woodcuts, more than his etchings, his lithographs
or even his paintings, created the language of style for the German expressionists
[ 744 ]. Like Hiroshige [ 699 ], he printed the grain of the plank [ 711 ], and like
Gauguin, he excited the voids with the debris from the accidental splintering of the
gouge [ 712 ].

**712**
Winter Landscape.
Woodcut by Munch,
1898

**International virtuosos**   The interlude of peace from 1812 to 1914 allowed more people in the Western world to accumulate wealth than ever before in history. The new millionaires summoned portraitists to wide and constant travels. As these painters from varied origins visited the great galleries and studied the universally admired old masters—Velázquez, Hals, Tiepolo, Boucher, Fragonard, Reynolds, and Gainsborough—their styles converged in an international virtuosity that summarized appearances with a flashing ease obviously worth serious financial investment. Some of these painters, such as Sorolla and Sargent, made few prints. Another, Zorn, made many as reductions of his oil portraits for the sitters to give to relatives and friends. He also etched nudes indoors and outdoors (often from snapshots) with a declared sensuality that rescues them from photographic banality. He laid his deeply bitten lines in a slanting rain of brilliance that simply and boldly moves bulk in depth [ 713 ]. When a first try disappointed him, he threw the plate aside, repeated the subject until he got a promising start, and then continued to retouch throughout the printing. However intricate his decisions, he resolved them to an effect of promptness.

**713**
The Toast. Etching by Anders
Zorn, 1893

**714**
Watteau Drawings.
Drypoint by Paul
Helleu, about 1900

An even more direct sketching in drypoint served Paul Helleu for perhaps 2000 interchangeable heads of pretty ladies in identical hats and hairdos, interrupted by occasional inspirations of femininity as seductive as anything out of the 18th century [ 714 ].

A more vivid energy went into the few drypoints that were casually thrown out by Giovanni Boldini, the last of the traveling Italian virtuosos. He had practiced art in his father's Ferrarese studio even while learning to talk. His lifelong sport of all-day drawing and painting developed an intoxicating illusion of spontaneity in arresting the movement of horses, musician's fingers, and serpentine women. The opalescence that he deduced from a white satin gown or a black fur cape also gave "color" to the drypoints [ 715 ] that he never bothered to publish.

**715**
Whistler Dozing.
Drypoint by
Giovanni Boldini,
1897

**Prints by French sculptors and painters** In 1755 the Parisian Académie de Peinture admitted engravers only if they promised not to paint. The jealous guilds imposed specialization until they were destroyed by the French Revolution, thereafter leaving artists as free as their Italian Renaissance predecessors to take up new media in mid-life. Thus Daumier, Degas, and Renoir discovered fresh possibilities in sculpture because they ignored the professional sculptor's don'ts, and Renoir, Cézanne, and Rodin did the same for printmaking. Kneading clay and chiseling marble strengthened Rodin's hand to pull a drypoint needle through copper as flowingly as another hand might move a pencil over paper. He made his few drypoint heads sparkle like bronze [ 716 ], giving them more personality than any copperplate portraits since Rembrandt and Van Dyck. When he sketched from the nude, he fixedly scrutinized the model to release his pencil from the censorship of his eye, relying on his sculptor's grip on form to waft bodies in and out of space as lyrically as Michelangelo. Rodin made five such elusive drawings on lithographic transfer paper, while many more were sensitively transposed to stone by the printer Auguste Clot, who convincingly copied even the sopping of Rodin's watercolor washes [ 717 ].

This virtuoso craftsman, Clot, implemented the great conquest of French printmaking in the 1890s—color. In old European prints color had amounted to little

**716** Victor Hugo. Drypoint by Auguste Rodin, 1886

**717** Lithograph after Rodin in Octave Mirbeau, *Le Jardin des Supplices*, Paris (Vollard), 1902

**718** Pinning the Hat. Color lithograph by Auguste Renoir, 1898

more than a childish brightness in hand-painted Gothic woodcuts, a harmonious monochrome in Italian chiaroscuros, and candy-box tints in 18th-century copperplates. No singing subtlety could appear until Chéret [ 641 ] had brought the English skill in color lithography into France. Clot then put this refined technique at the service of the best painters, helping Renoir the way he had helped Rodin. Renoir in his 50s made a few prints in techniques handy for a pencil draftsman and watercolorist—soft-ground etching and transfer lithography. He would watercolor a black and white lithographic proof for Clot to imitate in color lithography. The masterpiece of this collaboration, showing Berthe Morisot's daughter pinning a cousin's hat, took five years to mature through versions in pastel, oils, three etchings, and two lithographs. The final version [ 718 ], printed from 11 stones in black, gray, and nine colors, achieves a sensuous grandeur rarely seen since Titian and Rubens, and a design, like theirs, bold enough to survive execution by an assistant.

**719** Bathers. Color lithograph by Paul Cézanne

**720**
The Kitchen. Color lithograph by Edouard Vuillard in PAYSAGES ET INTERIEURS, Paris, (Vollard), 1899

**721** (OPPOSITE PAGE, LEFT)
The Courtyard. Color lithograph by Pierre Bonnard in QUELQUES ASPECTS DE LA VIE DE PARIS, Paris (Vollard), 1895

**722**
Lithograph by Bonnard in Paul Verlaine, PARALLELEMENT, Paris (Vollard), 1900

The same lithographic printer added the colors to Cézanne's nudes that bulk like cliffs under the chalky sunlight of Provence [ 719 ].

Printed color became even more inventive in 1895 when Clot helped artists to work directly on the stones, starting with Bonnard's Aspects of Life in Paris. This set of prints was sponsored by a newcomer from Réunion Island, Ambroise Vollard. Vollard sold paintings for a canny fortune that he threw away by spendthrift plunges into publications on which he lavished a frantic care, even though most found few buyers for the next 20 years. To break away from routine manufacture, he commissioned prints from artists who were not professional printmakers. When he organized his stable of adventurous painters, Vollard, Bonnard, and Vuillard were all 28, and Lautrec was 31. Vollard encouraged Bonnard and Vuillard to suppress line in lithography for a riddle of tangles meeting, overlapping, or scrambling into each other to shape sunlight into a nursemaid or to sink an aunt into the wallpaper. It took repeated trials to soften colors into Bonnard's dust grays and brick pinks, and Vuillard's spotlights of surprise. Opalescent wit transformed the street corner, bridge traffic, kitchen [ 720 ], even the middle-class parlor, while the design of a courtyard [ 721 ] anticipated abstract paintings like Mondrian's. Vollard followed these portfolios with over 20 illustrated books in which the text sometimes overlays the picture [ 722 ], as it does on Japanese fans. He left many books unfinished when a motor car killed him in 1939. As that rare animal, an unliterary Frenchman, his example made the typical 20th-century de luxe book into a set of prints boxed with any old text.

*Beautés passant, au lieu de sous,*
*Faites à ce mauvais garçon*
*L'aumône seulement . . . de vous.*

86

**723** La Parisienne. Color aquatint by Jacques Villon, 1902

**724** The poet J.-P. Dubray. Etching by Villon, 1933

**Villon**   Ways of seeing changed totally during Jacques Villon's half century of etching. Born near Rouen and christened Gaston Duchamp, he was the elder brother of the cubist sculptor Raymond Duchamp-Villon, and of Marcel Duchamp, who painted the Nude Descending a Staircase when he was 25 and then mocked at all art with Dada. Their notary father gave his three sons a passion to analyze and formulate, while their grandfather, an etcher, accustomed them "to smell etching acid and to listen to an aquatint ground whispering as it melts." When he went to Paris, aged 20, Gaston changed his name to Jacques Villon because, like the poet François Villon, he "loved the freedom of an ardent life [*une vie chaude*]." Also like Villon the poet, the painter Villon proceeded to grasp at life as hard as he hammered at artistic form. For 15 years of drawing for comic magazines he pursued people walking and talking, instead of studying posed models. He had etched since he was 16, but he now began in earnest with color aquatints [ 723 ], whose elegant spotting and Parisian smartness recall Lautrec. In 1906 Villon retired permanently

to the suburbs, where he and his brothers discussed cubism, helping to crystallize it during those magical farewell years of peace. Villon's cubism rationalized the open window of the impressionists by screening it with a fishnet of crisscross lines that catches objects on contact [ 724 ]. This scheme particularly suited his needle because, as he remarked, while a pencil left him free to explore and retreat, "Etching grips like a lasso, exacting precision." In his color etchings and his paintings planes began to intersect like sheets of fire, for his cubism did not renounce the excitement of color. His years of drawing people instead of models kept his intellectual logic alert to a sitter's particularity. He said, "When a sitter reveals something, grab it. A portrait is a holdup."

**Matisse**   In the 1890s the beginning deluge of photographic halftone illustrations made verisimilitude so cheap it also cheapened the paintings that competed with photographs in naturalistic detail. Alert painters realized that they could recapture expressiveness only by unloading the clutter of literalness. But to divest oneself of a skill is as hard as to acquire one, and the renunciation is blamed instead of praised. Matisse, who did not begin to paint until he was 20, soon started to fight his way out of the representation that he had learned in the Louvre by copying Poussin, Boucher, and Chardin. By his mid-30s this "apostle of the ugly" was shocking Paris with the violence of his *fauve* (wild beast) paintings, and by his even more distorted sculptures and linoleum cuts. Linoleum—the stuff that hobbyists botch—is cut with knives and gouges like wood, but coarsens all detail. Brutality of effect suited Matisse's new course as he followed Cézanne for a figure's unity of structure and action, van Gogh for the strokes of air that encase her, and African idols for the clash of scales—giant head and tall torso on dwarf legs [ 725 ].

**725**
Nude in Chair. Linoleum cut by
Henri Matisse, 1906

Throughout his life, Matisse made prints by fits and starts. Even though the First World War did not grip him, it still interrupted his painting enough to turn him back to printmaking. By then he had learned to hide the drudgery that he always underwent to batter his way to an appearance of serenity "as comfortable as an armchair." No one will ever know how many lithographic transfer papers he filled with drawings of a woman's back before finally flowing the fewest lines into living thrusts and counterthrusts that equal the great Chinese and Japanese in selectiveness and surpass them in suggesting the body's construction [ 726 ]. "Once my line, inspired by a life of its own, has shaped the light of the empty paper without spoiling its bloom of white, I stop." In the 1920s Matisse surprised by returning to academic representation [ 727 ], though with a shorthand gained by his long efforts to simplify. Wealth and fame now freed him to concentrate on the closed world of his sensuousness, on the odalisques endlessly lolling among embroideries, and on the still lifes grouped around his own sculptures and paintings.

He broke out of this autointoxication in his early 60s by illustrating books that forced fresh subjects on him. His first, and perhaps greatest, illustrations were his 29 etchings for Mallarmé's poems. He always etched with his eye on the model, often brushing a rhythm of lines on the grounded copper to guide his needle. The Mallarmé contains his portrait of Baudelaire, who died two years before Matisse

*Matisse*

**728** Charles Baudelaire. Photograph by Etienne Carjat, 1863

**729** Etching by Matisse in *Poésies de Stéphane Mallarmé*, 1932

was born. The artist's adaptation of a photograph [ 728 ] reveals what he habitually extrapolated from his model, and why. By raising the eyebrows, and opening and slanting the eyes, as Raymond Duchamp-Villon had done in his cubist bust, Matisse deformed fact to disengage the truth of the poet's vision [ 729 ]. The calculated distortion does not destroy the likeness, but interprets it. Other distortions might vary the emphasis while still preserving the central personality. For his last and most joyous book, *Jazz*, Matisse cut and pasted colored papers to be reproduced by stencils. His impression of lagoons [ 730 ] recalls a glimpse from an airplane into the wonders of the airscape, which he here introduced into art. Whatever may become of Matisse's reputation, he will always be able to say with Poussin, "I neglected nothing."

**726** (OPPOSITE PAGE, LEFT)
Nude. Lithograph by Matisse, 1914

**727**
Odalisque in Striped Trousers.
Lithograph by Matisse, 1925

**730**
Lagoons. Color stencil by Matisse
in JAZZ, 1944–47

**Picasso** dominates the 20th century as Dürer dominated the 16th, and for similar reasons. With technical mastery and electrifying inventiveness, each developed the styles of his time in a mass of inescapable images. Picasso has lived as long as Hokusai, moved about as restlessly, and left as staggering a multitude of works by molding life into every canvas, gutter finding, paper napkin. He has made the civilized world react through love or shock and express itself in more critical writing than any other artist has ever inspired during his lifetime. Over half of this writing is in French and English, but only a fraction is in Spanish or Catalan, Picasso's native tongues.

By mastering traditional drawing and painting while still a child, Picasso freed himself all his long life to enjoy the reckless delight of a child who builds a tower of blocks to kick it down. He summed up his skirmishes with boredom by saying "I play many instruments." By the time he was 14 vagrancy had been built into him by his having been shifted from the poetry of his native south of Spain to the business drive of the northwest and then to the bizarre crosscurrents of the northeast. At 20 Barcelona had matured him into a Catalan, with the Catalan's stinging language, his drastic originality, and his view out across the Pyrenees. The momentum of change next swept him northward into France, where for over 60 years he camped out at a succession of addresses as willful as the succession of his styles. When he had acquired several manners, he began to date his prints and drawings even before signing them, as though he were publishing a diary, the diary of an expatriate whose adopted country has never possessed his eye, while his native country has dissolved into a tourist vaudeville of toreros and castanets.

At 26 he broke irrevocably with the past when he and Braque, "like two mountain climbers roped together," explored beyond Cézanne's reduction of forms to the cube, cylinder, and cone to assemble these shapes as though they were partly transparent and partly turned upward, downward, or sideways. Only Picasso had the power and the humanity to join irreconcilables by juggling this solid geometry into recognizable portraits of individuals [ 731 ]. He and Braque analyzed banal objects familiar enough to recognize in fragments: bottle, pipe, newspaper, guitar, cigar, with lettering indicating planes and identifying objects. They enjoyed the play of wit engendered by turning their subtlest distorting glasses onto the stuffiest middle-class trumpery.

After Picasso had discovered in cubism a world that no one had suspected, he derived his later transformations of actuality from past styles such as Romanesque painting, Pompeian frescoes, and African, Iberian, or Cycladic sculpture. He developed their implications into manners that delight and surprise but should not disconcert any museum-goer who has really looked. Even more than Cézanne, Picasso could call his works "reminiscences of museums." As he explored new manners he did not drop old ones, any more than a musician would abandon the piano just because he later mastered the violin. As his work stretched into decades, his com-

pulsion to change became a pattern of return that alternated manners in the same week, ultimately in the same morning. Rembrandt also varied his attack from etching to etching, and Shakespeare modified his syntax and vocabulary to suit the theme of each play. But while Rembrandt deduced his different treatments from the nature of his various subjects, Picasso would draw a bull or a bowl of fruit in such an arbitrary variety of ways that it looked as though he had few subjects to choose from. Actually, he lived in a whole gallery of obsessions—the mountebank's family and the blind beggar, the littered table, jazz musicians, massive girls and husky boys, the bull and the man-bull, the artist and his work, his own children and their assorted mothers, or himself as an imp quizzing Rembrandt and Velázquez. One theme ran through from beginning to end—woman, either as man's submissive

**731**
Mlle Léonie. Etching by Pablo Picasso in Max Jacob, SAINT MATOREL, Paris (Kahnweiler), 1911

**732**
The Frugal Meal.
Etching by Picasso,
1904

**734** (OPPOSITE PAGE)
Satyr Unveiling Sleeping Woman. Aquatint
by Picasso, 1936

comforter, or, if demanding, as a biting, clawing monster. When he was 23 and poor, she was a tender El Greco Madonna and his refuge should he suffer the worst that a painter can suffer—blindness [ 732 ]. She becomes the enigma of elegance when he has captured the world's attention [ 733 ]. In his middle age she is the dream of desire to the rough faun—the Minotaur's cousin—who unveils her in the

**733** (LEFT)
Jacqueline. Etching by Picasso in Gongora VINGT POEMES, Paris (Les Grands Peintres Modernes), 1946–48´

**735** (OPPOSITE PAGE, LEFT)
The Sculptor and His Model. Etching by Picasso, 1933

**736**
Woman Picking Flowers. Linoleum cut in colors by Picasso, 1962

troubled moonlight of a Goyesque aquatint [ 734 ]. Drawn in lines as pure as those engraved on Etruscan bronze [ 109 ], she lies in antique nudity beside Jove-Picasso turned sculptor [ 735 ]. In a division of light like an Italian chiaroscuro woodcut [ 492 ], some Andean girl's doll inflates into a pinheaded dinosaur that could pluck stars as easily as flowers [ 736 ].

So adventurous a lover as Picasso naturally liked printmaking for the gamble of the outcome and for its leaving a record of each state or transformation as a possible start for a new work on another stone or copper—or perhaps a new canvas or sculpture. Instead of the usual modifying to perfect a print toward a preconceived ideal, Picasso replaced one image with another that was not necessarily better, but was at least different [ 737, 738 ]. Though he upset the grand manner of Delacroix or Velázquez as cavalierly as anything of his own, Picasso could not help admiring their construction, elaborated by a slugging patience that he could not stomach for himself. (He attacked his Guernica in such eager disorder that he finished it while basic inspirations were still coming in, too late to incorporate.)

A man so lacking in the ordinary printmaker's patience could achieve prints only when he found technicians to take on the methodical drudgery. In 1958 he wearied of the delays in sending etchings and lithographs from the south of France to Paris for proving, and so began to cut some of his boldest and most expressive prints in linoleum [ 736 ] simply because a neighbor could prove the blocks overnight. In the rationed postwar winter of 1945/46 he left his icy studio to work for four months in Mourlot's heated lithographic pressroom. This sharing of work with assistants

**737** Women of Algiers. Zinc lithograph by Picasso after Delacroix, 1955. First variation

may be what made Picasso shy of depicting his family in prints, as he did in the paintings that he worked on in solitude.

Whether feeling tender, truculent, impish, or tragic, Picasso strikes us with as "primitive" a shock of joy as the Altamira cave painter and the carver of an African mask, who assault us so directly because they worked for the demons rustling in their thatch and flickering in the fire that cooked their supper. Picasso had indeed deeper affinities with African sculptors than any non-African artist. In Africa the violence of man's energy never took the leap into intellectuality, be it into science, architecture, or the mere writing of words. No records of history, no plans for the future mitigated the helpless passing of the moment. Thus compressed into the now of his body, a force like implosion drove the African sculptor to evade his anxieties by remodeling his features with a visceral compulsion not found anywhere else. Picasso, indifferent to landscape, blind to architecture, and ignoring theories, invented fewer schemes to suggest the human body than the sum of all African sculptors but still contrived more innovations than any other single artist. And, again like the African, he exploited each discovery in busywork series.

Picasso shows us ourselves in the free and lonely roles into which he transformed

**738** Later variation, 1955

**739**

Two Harlequins. Color stencil by Picasso, about 1920

**740** (OPPOSITE PAGE, ABOVE)

Painter and Model. Etching by Picasso in Balzac, LE CHEF-D'OEUVRE INCONNU, Paris (Vollard), 1931

**741**

Death in the Sun. Drypoint by Picasso, 1933

himself. From the supple circus performer camping in vacant lots with his girl and their child he became the brilliant harlequin in the commedia dell' arte [ 739 ]. He revealed his inmost life of work in the sculptor fondling his mistress while he reconsiders his carving [ 735 ], and in the frowzy painter drawing, not what he sees, but what he wants to make us see through the fiction that convinces of the truth [ 740 ]. In inner anguish, he is both the slayer and the slain, knotted in the struggle of the picador lancing the bull who gores the picador's horse [ 741 ]. Picasso then split this triple image into the man-horse or centaur, and the man-bull, or Minotaur, who overwhelms a woman with the cataract of his muscles as the picador overwhelmed him when he was all bull.

Picasso has described how art invades actuality. "A glimpse of two people generates the sensation for a painting; then little by little their presence blurs; they become a fiction, and then disappear, or rather, are transformed into all kinds of problems. They are no longer two people, but forms and colors that prolong the tremor of their lives."

**The expressionists** From about 1900 to 1950 German art was hagridden by the foreboding and the aftermath of national catastrophes. Anxiety drove artists from villages to group and regroup themselves at Cologne, Dresden, Weimar, Munich, and Berlin, scattered in a land that has always lacked a political and intellectual center. In ignorance and contempt of the outer world, these young artists twisted things into the shape of their introspection, deforming individuals into the imagined types of the Worker, the Sufferer. They created for the proletariat, who ignored them, while despising the middle class, who bought their works, exhibited them, and for them organized the pioneer museum of contemporary art in 1919. The Italianate restraint of balance, imposed by Dürer 400 years before, was at last broken by the examples of Matisse, Delaunay, Gauguin, and Munch. Even while Cézanne was leading young French painters to analyze shapes, Munch dominated young Germans by the ache of his introspection, his sexual pain, his withdrawn portraits, and by his revival of the color woodcut as a plank boldly gouged by the designer himself. Munch's color and Matisse's flared when blown by the German emotionalism of Corinth and Kokoschka. Corinth expressed his ever intenser anguish in paintings, and even more in prints, that finally match Grünewald's halluci-

**742** Crucifixion. Lithograph by Lovis Corinth, about 1920

**743** Walter Hasenclever. Lithograph by Oskar Kokoschka, 1918

nations in their desperation [ 742 ]. The more operatic abandon of the Austrian baroque reappeared in Kokoschka, who was run out of Vienna as "degenerate" when he was only 22. After 1904 he traveled widely, painting and lithographing obsessive and shaken portraits [ 743 ] and riotous landscapes.

The first closely organized German artists' group, Die Brücke (The Bridge) formed itself at Dresden in 1905 around Kirchner, who was then 25. At 18 he had started making woodcuts after seeing Dürer's and then turned to architecture and painting. In a vacant store he and his young friends painted, drew, and cut woodblocks with a visionary fever that for seven or eight years fused their personalities into a common style like that in a medieval guild shop. They authenticated their sincerity by "Gothic" slashing in woodcuts that were even more fractured than their paintings [ 744 ]. But since an artist can feel sincere without convincing others, the bulk of expressionist art registers as a routine of agony as automatic as the 18th-century routine of charm. In 1906 the Bridge group was visited by Nolde, an intractable North Sea peasant some 15 years older than the others, with a longer experience in drawing, carving, and painting. The ecstasy of the younger men broke through into Nolde's stubbornness to release his deepest powers. Seawater surged through his veins when he etched tugs buffeting the chop of squalls [ 745 ]. Gauguin inspired him with a longing to escape from cities into the supposed purity

**744** Dinner in the Asylum. Woodcut by Ernst Ludwig Kirchner, 1916

**745**
Hamburg Harbor. Etching by Emil Nolde, 1910

**746**
Saint of the Inner Light. Color lithograph by Paul Klee, 1921

of primitive peoples, a longing that Nolde satisfied in 1913 by crossing Russia to the German colonies in the South Pacific. After the Bridge group broke up in 1913, some of its members regrouped in Berlin around the periodical *Der Sturm (The Tempest)*, which published their work from 1910 to 32.

From 1919 to 32 several young German artists taught at the Bauhaus in Weimar, where they contributed little compared to the school's far-reaching innovations in architecture, furniture, and typography. But the school's spirit of innovation certainly stimulated a Swiss member of the teaching staff, Paul Klee, as he explored and subtly readjusted the drawings of children and the insane to unveil a world of endless unexpectedness [ 746 ]. Theoretical, like almost all Germanic artists, Klee modernized the emblem [ 221 ]—the unit of picture plus caption—as images "pushed themselves" upon his waiting watchfulness along with the titles that clue us into his secret wit. Perhaps because Klee was Swiss, he escaped the expressionists' slavery to hatred. The German artists had heroism thrust upon them by the torment of two vast defeats and a dictatorship that exiled the lucky ones and suppressed and killed the rest.

**The American scene** After Whistler's death in 1903 North American etching followed his lead for a generation. Though, as usual, painters did lively work as a sideline [ 747 ], specialist etchers flooded the market with a dependable product that was bought—even subscribed to sight unseen—by collectors in the United States and England who were lured by the rise in price of Whistler's prints. This industry collapsed when the market for etchings disappeared in the financial crash of 1929. Many American artists then lost their livelihood, or perhaps, as the painter John Sloan put it in 1933, "Artists have always been in a depression. It's just that other people have joined us now."

In 1931 a committee of New Yorkers, and then the state legislature, began to pay artists to decorate public buildings. The Treasury in 1933 and the Congress in 1935 enlarged this start in the first great test of John Maynard Keynes' economic theories by voting federal funds for creating jobs "to help men keep their chins up and their hands in." The pioneer relief agencies for artists coalesced in the Works Projects Administration (WPA), which was soon financing some 350 centers in 44 states where over 5000 artists could count on subsistence pay and free materials of all kinds. Many printmakers profited by the chance to experiment without fear of

**747** The Lonely House. Etching by Edward Hopper, 1922

**748**
Laisser-faire. Silk-screen print
after Ben Shahn, about 1950

**749**
Abstraction 1947. Engraving
and texture etching by Stanley
William Hayter, 1946

cost and to make pictures of social protest in quantities (11,285 were printed in generous editions) that no free market could have absorbed. Some printmakers continued to etch, more turned to lithography, and still others tried silk screen [ 748 ], which had recently been taken up by artists in New York. This most versatile form of stencil printing, patented in England in 1907 and widely used for commercial posters since the 1920s, prints colors more simply than any other process. Germans call it "sieve printing." Silk gauze, stretched on a frame, is varnished wherever whites are to result. When a paste of pigment is scraped across the silk, the color is held back where the varnish has sealed the weave, and seeps through everywhere else onto the paper beneath. Each color is added through a separate screen.

The WPA's swoopstake rescue naturally gathered up some amateurs and would-be artists, thus contributing to the subsequent anomaly that while scientists are required to study more and more, a few "artists" manage to make a brief effect with less and less preparation. Although the WPA produced much heavy-handed clumsiness, soured by the gloom of the depression, it built up a tidal wave of printmaking and technical experiment that swept on past 1941, the year when Congress stopped the funds. At this opportune moment the helter-skelter enthusiasm found a direction when S. W. Hayter came from Paris to the United States for most of the 1940s, bringing the free copperplate engraving that Paris had started in the 1920s. Instead of the old laborious conventions evolved for copying oil paintings, the graver now got its head to explore. Hayter started from the doodles called "strikes" [ 172 ] that writing masters used to swirl with all the relish—and absence of passion—of a skater cutting a figure 8 on ice. Hayter charged these empty loops with violence and printed them by combining and inventing techniques—no matter how farfetched or homegrown—and by mixing colors with a skill learned from his early training in chemistry [ 749 ]. While he did not teach, his endless ingenuity and his eloquent force magnetized mature artists around him and inspired them to experiment. His impact on American printmaking—the first generative push since Whistler—resulted in the spreading of American art through prints rather than through paintings.

**The world within**  The photomechanical processes that developed from the 1840s to the 90s rerouted printmaking by ruining the bulk of printmakers, those who had lived by engraving reproductions of other men's pictures of famous faces, views, scientific specimens, and other facts. To survive, printmakers had to turn from what they saw to how they saw, the rare birthright of personality. (African carvers similarly changed functions when they ceased to make equipment as useful as X-ray tubes for detecting the unseen and fighting sickness and began instead to tempt tourists with curios. The new African souvenir can be as skillfully made as

**750** Color lithograph by Wassily Kandinsky in *Kleine Welten*, Berlin, 1922

**751** Silk-screen print by Jackson Pollock, 1951

the old magical mask, but it is cut off from the vitality of service to a higher power. Among us, no painter has for centuries sat down to his easel with a prayer, as Cennini recommended around 1400.) The Russian painter Malevitch said, "Old works of art do not reveal their value as art until life has left them for other aims, but new works of art begin by being art without practical usefulness."

Art began the final abandonment of practical use in 1913 when Malevitch's friend Kandinsky entered his Munich studio one evening at dusk to be astonished by the shapes and colors on a canvas propped against the wall. A second look showed him that it was a half-finished canvas of his own, unrecognized on its side. Such a double glimpse happens to all of us, but Kandinsky pressed his surprise for its implications: "I realized that *objects* interfered with my painting. An abyss opened before me. What should replace the object? I saw the danger of decorative painting, and shrank from the fiction of stylized form."

To jettison the object may have been less hard for a Russian than for western Europeans, who have concentrated since Giotto on organizing appearances. Byzantium, on the other hand, permanently directed the Russian toward states of soul, first expressed in hieratic formulas, then with the witness of naturalistic detail as corroborative as Tolstoy's descriptions. Kandinsky did not aim at adding a new style but at vaporizing all representational styles the way the new physics was then vaporizing the world's solidity. In 1922 he expressed states of emotion without depicting objects in the first abstract prints, which he called Small Worlds [ 750 ].

To organize these shapes and colors required traditional training, but in the next step, when the artist tracks the path of a gesture [ 751 ], he has withdrawn into the dead center of instinct, where everyone becomes more or less alike. (Our skulls look more mass-produced than our colored eyes and hair.) Unable to penetrate deeper into the engulfment of personality, artists then fled from all personality with found objects [ 752 ] or imitations of machine tooling. All these innovations break equally with the past, for none requires the artist to submit to a discipline as rigid as a ballet class in the hope of eventually infusing some strain of his own into a revered tradition. We may have to wait until the end of our age of fossil fuels to see just where the new vision will lead, but it clearly will change art as totally as the Western Christians did when they flattened and wasted classical form.

**752** Coat Hanger. Lithograph by Jasper Johns, 1960

# Terms and Abbreviations found on Prints

According to Act of Parliament [date]
    copyrighted in England (1735–1911)

Aere
    on copper

Aere exarat per [name]
    engraved on copper by

App[ress]o Wagner
    published by Joseph Wagner
        (Venice, 1739–80)

Apud [name]
    sold by

Aqua fecit [name]
Aqua forti [name]
    etched by

Auctore [name]
    designed by

A[vec] P[rivilège] D[u] R[oy]
    officially registered in France (1686–1790)

Bon à tirer
    hand written by printmaker on proof, indi-
        cating quality desired for edition (after
        about 1850)

Caelavit [name]
Chalcographus [name]
    engraved by

Chez [name]
    sold by

Composuit [name]
    designed by

Cum gratia et privilegio regis
    copyrighted with the king's permission
        (usually French, before 1790)

Cum gratia et privilegio Sac[rae]
Caes[areae] Maj[estatis]
    copyrighted in Germany and Austria (be-
        fore 1806)

Cum licenza de' superiori
    passed by Italian ecclesiastical censor
        (about 1575–1870)

Cum privilegiis Regis Christianissimi
Serenissimae Infantis, et Ordinum
Confaederatorum
    copyrighted in France, Belgium, and Hol-
        land by Rubens, 1620–40

Cum privilegio Summi Pontif[icis]
    copyrighted in papal states (before 1870)

C[um] P[rivilegio] S[acrae]
C[esareae] M[ajestatis]
    copyrighted in Germany and Austria
        (before 1806)

Del[ineavit] [name]
    drawn by

Déposé à la Bibliothèque Impériale
    passed by the French censor (1804–1814);
        impression occasionally deposited for
        legal purposes

Déposé à la Bibliothèque Nationale
    passed by the French censor (1848–52;
        1870–present)

Déposé à la Bibliothèque Royale
    passed by the French censor (1814–48)

Déposé à la Direction
    passed by the French censor (October 1795–
        November 1799)

Descripsit [name]
Disegno [name]
    drawn by

Divulgavit [name]
    published by
D[ono] D[edit] D[edicavit]
    given and consecrated as a gift

Eau forte par [name]
    etched by (1700–1900)

Effigiavit [name]
    drawn by, usually indicating engraver's
        working copy after original

Epreuve d'artiste
    hand written on impression made for artist's
        use, not included in numbered edition

Epreuve d'essai
   hand written on proof in finished state to test inking

Epreuve d'état
   hand written, usually on proof before finished state

Epreuve de passe
   hand written on extra impression to substitute for poor one in numbered edition

Ex Archetipis [name]
   designed by

Exc[udit] [name]
   published by

Excud[it] A[ugustae] V[indelicorum]
   published in Augsburg (about 1600–1800)

Excud[it] Col[oniae]
   published in Cologne (about 1600–1800)

Excud[it] Antw[erpiae]
   published in Antwerp (about 1600–1800)

Excud[it] Lug[dunum] Bat[avorum]
   published in Leiden (about 1600–1800)

Excusum Londini
   published in London (about 1600–1800)

Exculpsit [name]
   engraved by

Exhibitore [name]
   reproductive engraving by

Ex officina [name]
   from the press of

Faciebat [name]
Fecit [name]
   made by

Figuravit [name]
   drawn by, sometimes indicating engraver's working copy after original

Formis [name]
   published by

Gravé par [name]
   etched or engraved by

Imp[ressit] [name]
Imp[rimé] [name]
   printed by

Inc[idit] [name]
Incidente [name]
   engraved by

Inv[enit] [name]
   designed by

Lith. [name]
   lithograph drawn or printed by

Pinxit [name]
   painted by

Probedruck
   hand written on proof in finished state to test inking

Scalpsit [name]
Sc[ulpsit] [name]
   engraved by

Sumptibus [name]
   at the expense of

Sup[eriorum] licentia
Sup[eriorum] perm[issu]
   passed by ecclesiastical censor (about 1575–1870)

3/50
   hand written on third numbered impression, but not necessarily the third to have been printed, in an edition of 50 prints (after about 1850)

# Notes on the Illustrations

Most of the illustrations reproduce prints bought by the Metropolitan Museum out of funds given by various donors in the Museum's early years and by Myra Carter Church, Harris Brisbane Dick, Mr. and Mrs. Isaac D. Fletcher, Mary Martin, David Hunter McAlpin, Joseph Pulitzer, Jacob Rogers, Jacob H. Schiff, Anne and Carl Stern, John B. Turner, and Elisha Whittelsey. The sources for the rest are:

The Library of Congress, 1, 116, 609; Gift of Gillette Griffin, 2; Gift of Paul Pelliot, 4; Gift of Emile Protat, 5; Die Alte Kapelle, Regensburg, 6; Albertina Graphic Art Collection, Vienna, 7, 121, 275, 280, 473; John Rylands Library, Manchester, 9; Forlì Cathedral, Italy, 10; Bequest of James Clark McGuire, 11, 21, 79, 91, 114, 260; Gift of Mrs. Richard Riddell, 12, 13; Bequest of Mrs. Annie C. Kane, 15; The British Museum, 16, 17, 23, 122, 138, 145, 152, 154, 266, 173, 284, 337, 509; Gift of Robert Hartshorne, 18; Gift of J. P. Morgan, 19, 221, 223, 569; Ashmolean Museum, Oxford, 25; Herzog-August Library, Wolfenbüttel, 27; Gift of Junius S. Morgan, 29, 151, 262, 274, 335, 568; The Pierpont Morgan Library, New York, 33, 59, 74, 176, 211, 444; Art Institute of Chicago, 35, 89, 124, 167, 294, 307, 504, 745; Grunwald Graphic Arts Foundation, University of California, Los Angeles, 45; Gift of Felix M. Warburg and his family, 47, 120, 126, 132, 303, 332, 477, 480, 484, 488, 489, 499, 505; Biblioteka Kapitulna, Breslau, 48; Bibliothèque Nationale, Paris, 51, 259, 528, 585; Collection of Philip Hofer, Cambridge, 55; Museo di San Marco o dell' Angelico, Florence, 60; Academy of Fine Arts, Venice, 61; Christ Church, Oxford, 63; Gift of Paul J. Sachs, 64, 75, 625, 688, 739; Conservatori Museum, Rome, 69; Bavarian State Library, Munich, 70, 76, 206; State Museum, Berlin-Dahlem, 77, 112, 141, 315, 472, 510, 744; Gift of William E. Baillie, 81; Gift of Leo Wallerstein, 82; Gift of Anne and Carl Stern, 85, 543; Bequest of Mary Strong Shattuck, 86; The Friedsam Collection, Bequest of Michael Friedsam, 90; Gift of Mrs. W. Murray Crane, 98; Gift of Monroe Wheeler, 99; Gift of Mortimer L. Schiff, 102, 162, 208, 281, 636; Bequest of William Gedney Beatty, 105, 177, 237, 239, 240, 242, 544; Gift of Florance Waterbury in memory of her father, John I. Waterbury, 107; The Edward W. C. Arnold Collection of New York Prints, Maps, and Pictures, Bequest of Edward W. C. Arnold, 108; Gift of J. Pierpont Morgan, 113; William H. Scheide Library, Princeton, 117; National Gallery of Art, Washington, D.C., 128, 593; State Museum, Amsterdam, 129, 334, 443, 503; The Museum of Modern Art, New York, 135, 711, 723, 724, 725, 727, 728, 729, 730, 731, 733, 734, 735, 740, 743; Vatican Apostolic Library, 155; Church of Or San Michele, Florence, 163; Gift of Felix M. Warburg, 170, 172, 283, 285, 295, 299, 302, 313; Società Colombaria, Florence, 173; Hispanic Society of America, New York, 180; Collection of H. P. Kraus, New York, 183; Galleria degli Uffizi, Florence, 186, 192, 351; Gift of Mrs. J. Woodward Haven, 188; Museum of Fine Arts, Boston, 189, 194; Palazzo Ducale, Mantua, 197; Bequest of Edwin De T. Bechtel, 200, 455, 457, 458, 459, 460, 661, 665, 666; The Charles Allen Munn Collection, Bequest of Charles Allen Munn, 226, 292, 635; Gift of Christian A. Zabriskie, 252; The North Carolina Museum of Art, Raleigh, 256; Gift of A. Hyatt Mayor, 258; The High Museum of Art, Atlanta, 268; The John Taylor Johnston Memorial Collection, 270; National Library, Madrid, 288; Gift of Joseph Verner Reed, 291; State and City Library, Augsburg, 296; Gift of Henry W. Kent, 325; Musée du Louvre, Paris, 340; The Sylmaris Collection, Gift of George Coe Graves, 355, 476, 479, 481; New York Public Library, 365, 534; Gift of Albert TenEyck Gardner, 375; Gift of Herbert N. Straus, 377, 586; Kupferstichkabinett, Dresden, 388; Gift of New York Academy of Medicine, 394; Gift of Janos Scholz, 400, 564; Gift of Henry Walters, 410, 419, 482, 486, 490, 494, 495; Plantin-Moretus Museum, Antwerp, 428; Bequest of Mrs. H. O. Havemeyer, 1929, The H. O. Havemeyer Collection, 433, 475, 478, 483, 496, 500, 501, 502, 670, 673, 697, 700; Historisches Museum, Frankfurt am Main, 441; Bequest of Jane E. Andrews in memory of her husband, William Loring Andrews, 445; Gift of Georgiana W. Sargent in memory of John Osborne Sargent, 468; Cincinnati Art Museum, 471; The National Gallery, London, 474, 485; Victoria and Albert Museum, London, 491; Bequest of Ida Kammerer in memory of her husband, Frederic Kammerer, M.D., 497; The Gertrude and Thomas J. Mumford Collection, Gift of Dorothy Quick Mayer, 513; Collection of the Duke of Devonshire, Chatsworth, 527; Estate of Mrs. Robert B. Noyes, 536; Gift of Mrs.

Morris Hawkes, 556; Gift of Mrs. R. W. Hyde, 560; Gift of Philip Hofer, 565, 662; Gift of Harry G. Friedman, 570, 633; Gift of Miss D. Lorraine Yerkes, 571; Essex Institute, Salem, 573; Gift of William H. Huntington, 575; Gift of an Anonymous Donor, 608; Gift of Fitzroy Carrington, 614; Gift of Miriam B. Clark, 638; Gift of Mrs. Bessie Potter Vonnoh, 641, 642; Gift of William Loring Andrews, 644; Gift of Howard Mansfield, 645; Gift of David Low, 650; Bequest of Adele S. Colgate, 651; Gift of Jean Charlot, 652; Gift of I. N. P. Stokes and Edward S., Alice Mary, and Marion Augusta Hawes, 653; Alfred Stieglitz Collection, 655; Collection of Mme. le Garrec, Paris, 660; Gift of David Keppel, 674; Gift of Theodore DeWitt, 676; Gift of F. H. Hirschland, 678; Gift of Mina Curtiss, 683; Anonymous gift in memory of Francis Henry Taylor, 686; Gift of William M. Ivins, Jr., 690; Henry L. Phillips Collection, Bequest of Henry L. Phillips, 698; Gift of Arthur Sachs, 705; Gift of Mrs. H. Wolf, 708; Bequest of Blanche S. Guggenheimer, 713; Estate of Peter H. Deitsch, New York, 741; Brooklyn Museum, 746; Gift of The Pippin Press, 748; Gift of the estate of John Taylor Arms, 749; Gift of Mrs. Herbert C. Lee, 752

# Index

Numbers in **bold-face type** refer to illustrations; numbers in ordinary type refer to discussions adjacent to the illustrations. These abbreviations are employed in the index:

|  |  |  |
|---|---|---|
| a. after | bet. between | Fr. French |
| b. before | c. century | Ger. German |
| ab. about | d. died | w. worked |

Ackermann, Rudolph (1764–1834, Germany, London), 374–376, 604
Adam, Robert (1728–92, Edinburgh, Rome, London), 392, 541
Adamson, Robert (1821–48, Edinburgh), 655
*Aenead*, 56, 57
Aesop's *Fables*, 94–99
Agricola, Georgius (Georg Bauer), **105**
Alcega, Juan de: *Libro de Geometria pratica*, 381
Aldegrever, Heinrich (1502–bet. 1555–61, Paderborn, Soest), 316
Aldus Manutius (1450–1515, Venice), 170, 221, 223
Algardi, Alessandro (1602–54, Bologna, Mantua, Rome), 391
almanacs, 83–86, 568
Altdorfer, Albrecht (b. 1480–1538, Regensburg), 87, 304–308
Amman, Jost (1539–91, Zürich, Frankfurt), 411
anatomy, 65, 184–186, 321, 394–396
Angelico, Fra (Giovanni da Fiesole) (1387–1455, Florence, Rome), 60
*Antiquities of Athens, The*, **242**
Antonio da Trento (w. first half 16th c., Parma), 352, **353**, 355
Apianus, Peter, **446**
Apocalypse, 208, 259, 260, 262, 358
Apollo Belvedere, 279
aquatint (Ger. *Aquatintamanier*; Fr. *gravure au lavis*)
    in England, 376
    technique, 229, 230
    yields to lithography, 614

architecture, 237–242
    and Italian woodcuts, 72, 73
Ardizoni, Simone di (w. 1475, Reggio, Mantua), 188, 189
Aretino, Pietro (1492–1556, Perugia, Venice), **341, 405,** 406
arithmetic treatises, 164, 165
Arrighi, Ludovico degli (called Vicentino) (d. ab. 1527, Vicenza, Rome), **170**
armor decoration, 228
*Ars Moriendi.* See *Art of Dying*
*Art de graver au pinceau*, 229
*Art of Dying*, 23–25
Arundel, Earl of (Thomas Howard) (1585–1646), 344, 534
assemblies of prints, 91–93
*Association Mensuelle, L'* (1832–34), 661
*Astronomicum Caesareum*, **446**
astronomy, 75, 446
Augsburg
    color printing, 76
    end papers, 570
    illustrated books, 33, 34
    ornament prints, 567

Baldini, Baccio (w. ab. 1470–85, Florence), **113,** 156
Baldinucci, Filippo (1624–96, Florence), 479
Baldovinetti, Alessio (1425–99, Florence), 92
Baldung, Hans (called Grien) (1476–1545, Strassburg), 310–312
banknotes, 4, **635**

Barbari, Jacopo de' (ab. 1450–b. 1516, Venice, Germany), **45**, 277
Barberiis, Philippus de (w. 1475–81, Rome, Sicily): *Discordiantie*, 66–68
Barocci, Federigo (1528–1612, Urbino, Rome), 433, 436–438, 586
Bartolozzi, Francesco (1727–1815, Florence, Venice, London, Lisbon), **226, 323, 345, 563**
Baudelaire, Charles (1821–67, Paris), 640, 661, 664, 700, 728, 729
Baudouin, Pierre Antoine (1723–69, Paris), **596**
Bauhaus (school), 543, 746
Baxter, George (1804–67, London), **537**
Beardsley, Aubrey (1872–98, London), 223, 707
Beccafumi, Domenico (1486–1551, Siena), 399
Beham, Bartel (1502–40, Nuremberg, Munich, Italy), **315, 317**
Beham, Hans Sebald (1500–1550?, Nuremberg, Frankfurt), 318
Bell, Thomas (w. 1750s, Dublin, London), 574
Bellange, Jacques (w. 1602–17, Nancy), 453, 454
Bellini, Gentile (ab. 1429–1507, Venice, Constantinople), 61
Bellini, Giovanni (1429–1516, Venice), 61, 268
Bening, Simon (1483/84–1561, Bruges, Ghent), **183**
Bergamo, Jacobus Philippus de, **42, 72**
Berghe, Jan van den (w. 1452, Louvain), 23
Bernini, Gian Lorenzo (1598–1680, Rome), 199, **214**
Bervic, Charles-Clément Balvay (1756–1822, Paris), **343**
Bewick, Thomas (1753–1828, Newcastle), 636
Bibiena, Ferdinando Galli (1657–1743, north Italy, Barcelona, Vienna), 178
Bibiena, Giuseppe Galli (1695–1757, Bologna, Austria, Germany), **548**
*Bible of the Poor*, 21
bindings. *See* book covers
Blake, William (1757–1827, London), 608–611, 690
blockbook (Ger. *Blockbuch;* Fr. *livre xylographique*), 19–21, 23, 66, 260
Bloemart, Abraham (1564–1651, Utrecht), 322
Boldini, Giovanni (1845–1931, Italy, Paris, United States), 715
Boldrini, Niccolo (w. 1566, Venice), **199, 403**
Bonington, Richard Parkes (1801–28, Paris, London), 614
Bonnard, Pierre (1867–1947, Paris), 642, **720, 722**
book covers, 86, 206, 207, 209, 210
bookplates, 79–82
books. *See also* blockbook
    Augsburg, 33, 34
    children's, 450–452
    early, 19
    18th c., 562–565
    follow manuscripts, 26, 27
books of hours. *See* prayer books
Borgognone, Ambrogio (1455?–1523, Milan), 216
Bos, Cornelis (1506–70, Antwerp), **246**
Bosch, Jerome (ab. 1462–1516, Bois-le-Duc), **134**
Bosse, Abraham (1602–76, Paris), 110, 456, 461, 462

botany, 100–103
Botticelli, Sandro (1445–1510, Florence, Rome)
    Dante drawings, 152, 155, 156
    and Florentine engravings, **144, 145**
    and Florentine woodcuts, 161
    and Roman woodcuts, 67
Bouchardon, Edmé (1698–1762, Paris), **203**
Boucher, François (1703–70, Paris), 587–590
Bouts, Dieric (ab. 1410–75, Haarlem, Louvain), 21, 23
Boys, Thomas Shotter (1803–74, London, Paris, Brussels), **349**
Boyvin, René (ab. 1530–98, Angers, Rome, Paris), **354, 356, 357,** 413
Brady, Mathew B. (1823–96, New York, Washington), 565
Brant, Sebastian (1457–1521, Strassburg), 56, 57
Breenbergh, Bartholomeus (1599–1659, Holland, Rome), 370
Bresdin, Rodolphe (1825–85, Marseilles, Paris), 678
Bretschneider, Andreas, II (ab. 1578–1640, Dresden, Leipzig), **380**
Breydenbach, Bernhard von (w. 1450–97, Mainz, Jerusalem), 43, 212
Brooks, John (w. 1750s, Dublin, London), 575
Browne, Sir Thomas (1605–82), 199
Brücke, Die, 744
Brueghel, Pieter (ab. 1530–69, Antwerp, Italy), 422–426
Brunfels, Otto (1488–1534, Mainz, Strassburg, Bern), 102
Burgkmair, Hans (1473–1531, Augsburg, Venice), 263, 293–297
Burlington, Third Earl of (Richard Boyle) (1694–1753, Italy, London), **366**
Burnacini, Lodovico (1636–1707, Vienna), **546**
Busch, Wilhelm (1832–1908, Munich), 634
business books, 164–166
Buytewech, Willem (1591/92–1624, Rotterdam, Haarlem), 469, 470

Calcar, John Stephen of (1499–bet. 1546–50, Flanders, Venice), 394–396
Calder, Alexander (1898–  , Paris, New York, New England), 99
Callot, Jacques (ab. 1592–1635, Nancy, Rome, Florence), 455–460
calotype (Ger. *Kalotypie;* Fr. *calotype*), 372, 654
Cambiaso, Luca (1527–85, Genoa, Escorial), 400, 401
Campagnola, Giulio (ab. 1482–a. 1514, Venice), 225, 267
Canaletto (Antonio Canal) (1697–1768, Venice, London), 46, 576
Caraglio, Giovanni Jacopo (ab. 1500–65, Italy, Cracow), 341
Caravaggio, Michelangelo Merisi da (1573–1610, Venice, Rome, Sicily, Malta), 439
caricature, 198–200
*Caricature, La* (1830–55), 659–661
Carjat, Etienne (1828–1906, Paris), **728**
Carpaccio, Vittore (1455–1525, Venice), 65

Carracci, Agostino (1557–1602, Bologna, Parma), 410

Carracci, Annibale (1560–1609, Bologna, Rome), 202, 516

carriages, 374, 561

Cartari, Vincenzo (w. 1551–69, Reggio Emilia, Venice), 234

Carteron, Etienne (ab. 1580–?, Chatillon-sur-Seine), **415**

Cassatt, Mary (1845–1926, Philadelphia, Paris), 688

Castiglione, Benedetto (1616–70, Genoa), 526, 527

Castiglione, Giuseppe, S. J. (1698–1768, Genoa, Pekin), **365**

catalogues, 393, 533–535, 556–561

Catherine de' Vigri, St. (1413–63), 397, 398

Cesariano, Cesare (1483–1543, Milan, Como), 237

Cézanne, Paul (1839–1906, Paris, Aix-en-Provence), 719

Chambers, Ephraim (ab. 1680–1740, London), 449

Chardin, Jean-Baptiste-Siméon (1699–1779, Paris), 464

*Charivari, Le* (1832–a. 1900), 662–665

Charles V (Holy Roman emperor) (1500–58), 49, 253

Chassériau, Théodore (1819–56, Paris), 621

Chatsworth, 532

Chéret, Jules (1836–1932, Paris, London), 641

*Chevalier Délibéré, Le*, 49

chiaroscuro woodcut (Ger. *Hell-Dunkel-Holzschnitt*; Fr. *gravure sur bois en camaïeu*), 347, 420, 421, 492

Chippendale, Thomas (ab. 1718–79, London), 392

Chodowiecki, Daniel (1726–1801, Berlin), 568

Cleve, Joos van (1500–1554?, Antwerp), **90**

*cliché verre. See* glass print

Clot, Auguste (1858–1936, Paris), 717–719

Cochin, Charles-Nicolas, II (1715–90, Paris), 291, 338, 565, 591

Cock, Jerome (ab. 1510–70, Rome, Antwerp), 373, **422**

Coeck van Aelst, Pieter (1502–50, Italy, Antwerp, Constantinople), **384**

Colonna (Columna), Fabio (1567–1650, Naples), 103

Colonna, Francesco (1433–1527, Venice, Treviso, Padua), 221, 223, 224

colophons, 26, 211

color printing. *See also* chiaroscuro woodcut; color woodcut. 26, 75, 76, 347–349
  Jules Chéret, 641
  Lucas Cranach I, 303
  Auguste Clot, 717
  Japanese woodcuts, 694
  posters, 640

color woodcut, 295, 303, 352

Comenius (Komensky), Jan Amos (1592–1670, Moravia, Sweden, Hungary), 450

comic strip, 634, 648

Constable, John (1776–1837, Suffolk), 515

copyright, 45, 181, 182, 486, 550–555

Corinth, Lovis (1858–1925, Munich, Paris, Berlin), 742

Cornelisz van Oostsanen (b. 1470–ab. 1533, Amsterdam), **90**

Corot, Jean-Baptiste-Camille (1796–1875, Paris), 675

Cort, Cornelis (ab. 1530–78, Antwerp, Rome, Venice), 408

Cossa, Francesco (1435–77, Ferrara), 16

costumes, exotic, 385

counterproof (Ger. *Abklatsch, Umdruck;* Fr. *contre-épreuve*), 427

Cousin, Jean, I (ab. 1490–1560?, Sens, Paris), 361

Cousin, Jean, II (1522–94?, Sens, Paris), 360, 361

Cozens, Alexander (ab. 1717–86, London), 531

Cranach, Lucas, I (1472–1553, Vienna, Wittenberg), 298–303

Cranach, Lucas, II (1515–86, Wittenberg), **264**

Crystal Palace, London, 449, 537

Currier, Nathaniel (1813–88, New York), and Ives, James Merritt (1824–96, New York), **108**, 651

Daguerre, Louis Jacques Mandé (1787–1851, Paris), 653

Dance of Death, 54, 55, 326

Dante Alighieri (1265–1321), 152–156, **677**

Daubigny, Charles-François (1817–78, Paris, Auvers-sur-Oise), 675, 676

Daumier, Honoré-Victorin (1808–79, Marseilles, Paris), 200, 255, 659–669, 705

Debucourt, Philibert-Louis (1755–1832, Paris), 606

*De Claris Mulieribus*, **72**

*Découverte du procédé de graver au lavis*, 229

Degas, Hilaire-Germain-Edgar (1834–1917, Paris, Italy, New Orleans), 339, 670, 683–688

Delacroix, Eugène (1798–1863, Paris), 230, 619–623, 737, 738

*De la Pirotechnia*, **445**

della Bella, Stefano (1610–64, Florence, Paris), **18**, 520, 521, 538, 545

*Della Trasportazione dell' Obelisco Vaticano*, **106**

Delorme, Philibert (ab. 1512–70, Ivry, Rome, Lyons, Fontainebleau, Paris), 254

Demarteau, Gilles (1722–76, Paris), 588

Dente da Ravenna, Marco (d. 1527, Rome), **342**

*De Re Metallica*, **105**

*De Re Militari*, **104**

Diaz Morante, Pedro (1566–1636, Toledo, Madrid), 171

Diderot, Denis (1713–84, Paris), 449

Domenico dalle Greche (w. 1543–88?, Venice), 404

Donatello (1386–1466, Florence, Padua), **194**

Donwell, John (w. 1753–86, London), 366

Doré, Gustave (1832–83, Paris, London), 677

dotted print (Ger. *Shrotblatt*; Fr. *gravure au criblé*), 114

drawing books, 320–322, 522, 531

drawings, imitated in prints, 344–346

drypoint (Ger. *Kaltnadel*; Fr. *pointe sèche*), 124–129, 478, 483, 484

Ducerceau, Jacques Androuet (1510?–84?, Paris, Orleans, Rome), 362, **389**
Dufour, Joseph (1752–1827, Paris), **573**
Duperac, Etienne (ab. 1525–1604, Paris, Rome), **369**
Dupré, Jean (w. 1481–1504, Paris), 51, 52, 247
Dürer, Albrecht (1471–1528, Nuremberg, Venice), 48, 78, 216, 265–276, 335
    Apocalypse, 208, 261, 262
    copied by Marcantonio, 336
    copied by Robetta, 146
    copies taroc cards, 17
    drypoint, 127
    portraitist, 282–284
    and proportions, 277–281, 319
    star map, 181
    woodcuts for Emperor Maximilian, 151, 284, 615
Duvet, Jean (1485–a. 1561, Dijon, Langres, Geneva?), 358, 359

Earlom, Richard (1743–1822, London), 514
échoppe, 456
*Eclogues* (Virgil), 610, 611
*Edelstein, Der*, 27
Eichler, Gottfried, II (1715–70, Augsburg), 236
electroplating process, 702
electrotype (Ger. *Klische*; Fr. *cliché*), 633, 677
Elsheimer, Adam (1578–1610, Frankfurt, Rome), 440–442
emblems, 221, 222
embroidery designs, 377, 380, 592
enamel designs, 414–416
*Encyclopédie*, 449
engineering, 104–108
engraving (Ger. *Kupferstich*; Fr. *gravure au burin*). *See also* niello
    for banknotes, 635
    broad-manner (Florence), 92, 144, 147
    copyist's method, 25
    earliest, 109, 111, 112
    fine-manner (Florence), 143
    Florentine, 141, 142
    graver, 110
    line, 419
    for maps, 180
    national differences, 93
    reproductive, 192, 285, 338
    standardization of, 408
    supplants woodcut, 103, 411
    workshop illustrated, 461
Ensor, James (1860–1949, Brussels), 135
entrances, royal, 253–258
Epinal, source of folk prints, 649
*Epistole et Evangelii*, **161, 162, 227**
ES. *See* Master ES
éstampes galantes, 596–601
etching (Ger. *Atzen*; Fr. *gravure à l'eau-forte*). *See also* aquatint; soft-ground etching
    échoppe, 456
    invention of, 228
    technique, 350
    varnish ground, 455
    workshop illustrated, 461

Euclid, 74
exhibitions, 533, 536, 537
expressionism, 742–746

Fantuzzi, Antonio (ab. 1508–50, Bologna, Fontainebleau), 355
*Fascicolo di Medicina*, **65**
*Fasciculus Temporum*, **40, 41**
fashion magazines, 382
Fattori, Giovanni (ab. 1825–1908, Florence), 682
festival books, 253–258
Fischer von Erlach, Jothann Bernhard (1656–1723, Graz, Prague, Italy, Vienna), 241
Fizeau, Hippolyte-Louis (1819–96, Paris), **658**
Flint, Paul (w. 1590–1620, Nuremberg), 309
flock print (Ger. *Sammt-Teigdruck*; Fr. *empreinte veloutée*), 6, 569
Florence
    engravings, 92, 93, 141–147
    view of, 173
    woodcuts, 159–163
Floris, Frans (ab. 1517–70, Antwerp), 417
Flötner, Peter (d. ab. 1546, Nuremberg), **388**
folk prints, 646–652
Fontainebleau school, 246, 354–357
Forster, Hans (w. ab. 1570–84, Augsburg, Vienna), **14**
Fragonard, Jean-Honoré (1732–1806, Italy, Paris), 598
Francia, Francesco Raibolini (1450–1518, Bologna), 397
Franco, Giacomo (ab. 1550–1620, Venice), **321**
Frederick the Great (1712–1786), 633
Friedrich, Caspar David (1770–1840, Dresden), 632
frontispiece, 212–214, 361
furniture, 388–393, 539, 560
Fuseli, Henry (1741–1825, Zürich, London), 607
Fust, Johann (ab. 1457–66, Mainz), 26
FVB. *See* Master FVB

Gardens, 123, 362–363, 532, 572, 605, 606
*Gart der Gesundheit*, **101**
Gauguin, Paul (1848–1903, France, Tahiti), 710
Gavarni (Sulpice-Guillaume Chevalier) (1804–66, Paris, London), 672, 673
Geertgen tot Sint Jans (1450s–90s, Haarlem), 49
Géricault, Théodore (1791–1824, Paris, London), 617, 618
*Geschichte Friedrichs des Grossen*, **633**
Gheyn, Jacques de, II (1565–1629, Antwerp, Holland), 468
Gillot, Charles (w. 1870s, Paris), 705
Gillot, Claude (1673–1722, Paris), 562
Gillot, Firmin (1820–72, Paris), 665
gillotype, 665
Giorgione (c. 1470–1510, Venice), 225
Girardon, François (1628–1715, Paris), 535
Girtin, Thomas (1775–1802, London, Paris), 643
glass print (Ger., Fr. *cliché verre*), 675
Goethe, Johann Wolfgang von (1749–1832), 615, 619

Golden House of Nero, 243, 541
Goltzius, Hendrick (1558–1617, Haarlem), 286, 419–421
Goudt, Hendrik (1585–1630, Utrecht, Rome), 442, 443
Goujon, Jean (d. 1564 or 68, Paris), 224, 254, 360
Goya y Lucientes, Francisco de (1746–1828, Zaragoza, Italy, Madrid, Bordeaux), 344, 622, 624–631
Graf, Urs (c. 1485–1527, Basel, Zürich), 77
Grandville, J. J. (Jean-Ignace-Isidore Gérard) (1803–47, Nancy, Paris), 640
Grasset, Eugène (1867–1941, Paris), 416
graver, 110
Greco, El (Domenikos Theotokopoulos) (ab. 1541–1614, Crete, Venice, Rome, Toledo), 272, 350, 646
Greuze, Jean Baptiste (1725–1805, Paris), 600
grotesque ornament, 243–246
Grüninger, Johann (w. 1483–1531, Strassburg), 32, 56
Guercino (Giovanni Francesco Barbieri) (1591–1666, Cento, Rome), 345, 518
guide books, 367
Guillain, Simon (1580–1658, Rome), 202
Gutenberg (Johann Gensfleisch) (ab. 1400–68, Strassburg, Mainz), 3, 26, 27, 112, 117, 533

Haden, Sir Francis Seymour (1818–1910, London), 125
halftone engraving (Ger. *Autotypiecliché*; Fr. *cliché demi-tons*), 658
handwriting, 170–172
*Harper's Weekly* (1857–1916), 638, 639
Harunobu (ab. 1725–70, Edo), 687, 696
Hawes, Josiah Johnson. *See* Southworth, Albert Sands
Hayter, Stanley William (1901–    , London, Persia, Paris, United States), 749
Heemskerck, Martin van (1498–1574, Haarlem, Rome), 417
Helleu, Paul (1859–1927, Paris, United States), 714
Henry II, king of France (1515–1559), 254, 359
herbals, 100–103
Hill, David Octavius (1802–70, Edinburgh), 655
Hiroshige (1797–1858, Edo), 699, 711
Hogarth, William (1697–1764, London), 550–555
Hokusai (1760–1849, Edo), 670, 698
Holbein, Hans (1497–1543, Basel, London), 219, 324–329
    printers' marks, 28, 29
    title pages, 213
Hollar, Wenzel (1607–77, Prague, Cologne, London), 344
holy pictures, 11–13
Homer, Winslow (1836–1910, Boston, Maine), 452, 639, 693
Hopfer, Daniel (1493–1536, Augsburg), 228
Hopper, Edward (1882–1967, New York), 747
Hoppner, John (1758–1810, London), 513
Houghton, Arthur Boyd (1836–75, London), 692
Housebook Master (Erhard Reuwich?) (w. ab. 1475–1500, Utrecht, Mainz), 124–129, 139
*Hypnertomachia Poliphili*, 221, 223, 224

IM. *See* Master IM
Ingouf, Pierre Charles (1746–1800, Paris), 600
initial letters, 26, 325
ink, printers', 3, 112
interior decoration, 538–543, 584
Ives, Frederick Eugene (1856–1937, Utica, Philadelphia), 658
Ives, James Merritt, *See* Currier, Nathaniel

Jacob of Strassburg (w. 1494–1530, Strassburg, Venice), 56
Japanese prints, 694–699
Jegher, Christoffel (1596–1653, Antwerp), 430, 432, 510
jewelry designs, 413–415
Johns, Jasper (1930–    , New York), 752
John Stephen of Calcar. *See* Calcar
Jones, Robert (w. 1750s–60s, Dublin, London), 574
Julienne, Jean de (1686–1766, Paris), 586, 587

Kandinsky, Wassily (1866–1944, Moscow, Munich, Berlin, Paris), 750
Ketham, Johannes de, 65
Kirchner, Ernst Ludwig (1830–1938, Dresden, Berlin, Switzerland), 744
Kiyonobu, Torii (1752–1815, Edo), 695
Klauber, Joseph Sebastian (1700–68, Augsburg), 13
Klee, Paul (1874–1940, Switzerland, Germany), 746
Klinger, Max (1857–1920, Munich), 82
Kneller, Godfrey (1648–1723, Lübeck, Amsterdam, Italy, London), 512
Kokoschka, Oskar (1886–    , Vienna), 743

Lace designs, 378, 379
La Fontaine, Jean: *Fables*, 98
Lafrery, Antoine (d. 1577, Besançon, Rome), 368
Lami, Eugène (1800–90, Paris, London), 671
landscape, 307, 420, 528–532
Laocoön group, 199, 342, 343
Launay, Nicolas de (1739–92, Paris), 596, 597, 599
Laurentii, Nicolaus (w. 1477–86, Breslau, Florence), 152
Lavater, Johann Kaspar (1741–1801, Zürich), 292
Le Blon, Jacob Christoph (1667–1741, Frankfurt, Rome, Amsterdam, The Hague, Paris, London), 348
Lebrun, Charles (1619–90, Paris), 538
Leonardo da Vinci (1452–1519, Florence, Milan, Amboise), 169, 174, 185, 198, 217, 237, 344, 394
Leoni, Ottavio (1574–1630, Rome), 287
Leopold, Joseph Friedrich (1668–1726, Augsburg), 570

Leopold William, archduke of Austria (1614–62, Vienna, Brussels), 534
Lepautre, Jean (1618–82, Paris), 538
Le Prince, Jean-Baptiste, 229
lettering, 167–172
Licherie, Louis (1629–87, Paris), **85**
Lievens, Jan (1607–74, Leiden, Amsterdam, London, Antwerp, The Hague), 509, 510
Linder, Philippe-Jacques (Paris, first shown Salon of 1857), **465**
line block (Ger. *Strichcliché*; Fr. *cliché trait*), 705, 706
linoleum cut (Ger. *Linolschnitt*; Fr. *linogravure*), 725, 736
Liotard, Jean Etienne (1702–89, Geneva, Istanbul), 595
Lippi, Filippo (ab. 1457–1504, Florence), 92, 146
lithography (Ger. *Steindruck*; Fr. *lithographie*), 349, 612–620, 641, 642, 709, 718–720
Little Masters, 315, 317
Lorrain, Claude (1600–82, Nancy, Rome), 528–530
Louis XIV, king of France (1638–1715), 85, 463, 538, 545
Louis-Philippe, king of France (1773–1850), **200**, 258, 659, **705**
Lucas, David (1802–81, London), 515
Lucas (Huygensz.) of Leiden (1494–1533, Leiden), 285, 330–334, 487
Luther, Martin (1483–1546), 264, 299, 300
Lützelburger, Hans Franck (w. 1516–26, Augsburg, Basel), **326, 328**, 329

Manet, Edouard (1832–83, Paris), 340, 639, 680, 681
Mantegna, Andrea (1431–1506, Padua, Mantua), 16, 187–197, 490
manuscripts
    illustrations imitated in prints, 120, 140, 182, 183
    and printed books, 26, 27, 33, 34
maps, 179–181
Marcantonio Raimondi (ab. 1480–b. 1534, Bologna, Venice, Rome), 315, 331, 335–341, 397
Marchant, Guyot (w. ab. 1483–1505, Paris), 54
Marche, Olivier de la (1425–1502), 49
Marcolini, Francesco (1500–a. 1559, Venice), 405
Marillier, Clément-Pierre (1740–1808, Paris), **565**
Marot, Daniel (1663–1752, Paris, The Hague), 539
Master ES (ab. 1430–67, Rhineland or Lake Constance), 21, **25**, 118–123, 141, 142, **167**
Master FVB (w. 1480–1500, Bruges), 136
Master IA of Zwolle (w. 1480–1500, Holland), 137, 330
Master IM, 64
Master Nicolas, 179
Master of 1446 (Rhineland or Lake Constance), **112**
Master of the Housebook. *See* Housebook Master
Master of the Playing Cards (w. 1430–50, Upper Rhine), 115–117

Master of the Sforza Book of Hours (w. ab. 1470–a. 97, north Italy), **244**
Matisse, Henri (1869–1954, Paris), 725–727, 729, 730
Maulpertsch, Franz Anton (1724–96, Vienna), 566
Maximilian, Emperor (1459–1519)
    Burgkmair's work for, 294, 296, 297
    Dürer's work for, 151, 615, 284
    portrait by Lucas of Leiden, 285
Meckenem, Israhel van (b. 1450–1503, Bamberg, Bocholt), 138–140
Meissonnier, Juste Aurèle (1693–1750, Turin, Paris), **540**
Mellan, Claude (1598–1688, Rome, Paris), 289
Memling, Hans (ab. 1435–94, Bruges), 132, 136
Menzel, Adolf (1815–1905, Berlin), **616**, 633
Mercator, Gerard (1512–94, Antwerp), 180
Meryon, Charles (1821–68, Paris), 700–702
metal cut (Ger. *Metallschnitt*; Fr. *gravure sur métal*), 51
metal relief print, **100**, 114
mezzotint (Ger. *Schabkunst*; Fr. *manière noire*, *manière anglaise*), 511–515
Michelangelo (1475–1564, Florence, Rome), 66, 133, 331, 396, 608
Mignon, Jean (w. 1537–40, Paris), **246**
Mignot, Daniel (w. 1591–95, Augsburg), **414**
Milan, woodcuts of, 215–217
Millais, Sir John Everett (1829–96, London), 690
Millan, Pierre (w. 1525–30, Paris), 356
Millet, Jean-François (1815–75, Normandy, Barbizon), 674
*Mirror of Man's Salvation, The*, 22, 33, 34
missals, 51, 247, 293
model books, 117, 320–322
Monge, Gaspard (1746–1818, Paris), 178
monotype (Ger. *Monotype*; Fr. *monotype*), 8, 482, 527, 685, 686
Montagna, Benedetto (1470–1540, Vicenza), 223, 232
Montpensier, Antoine Philippe d'Orleans, Duc de (1775–1807, Versailles, Twickenham), **613**
*Monument du Costume, Le*, 599
Moreau le jeune (Jean-Michel) (1741–1814, Paris), 599, 600, 671
Morghen, Raphael (1758–1833, Florence, Rome, Paris), **580**
mottoes, 221, 222
Moxon, Joseph (1627–1700, London), 448
Munch, Edvard (1863–1944, Oslo, Paris, Germany), 711, 712

Nanteuil, Robert (1623?–78, Paris), 290
Napoleon (1769–1821), 542
needlework designs, 380
Neeffs, Jacob (1610–a. 1660, Antwerp), **434**
Negker, Jost de (ab. 1485–1544, Antwerp, Augsburg), **295**
niello (Ger. *Schwarzschmelz*; Fr. *nielle*), 89, 113, 184
Niepce, Joseph Nicéphore (1756–1833, Châlons-sur-Marne), **657**

Nixon, Francis (w. 1750s, Dublin, London), 574
Nolde, Emil (1867–1956, St. Gallen, Dresden, Russia, South Pacific), 745
*Nova Iconologia*, 235, 236
*Nuremberg Chronicle*, 44, 173, **383**

Oberkampf, Christoph Phillip (1738–1815, Bavaria, Jouy), 574
Oppenord, Gilles-Marie (1672–1742, Paris), 535
ornament prints, 567
Orr, John William (w. 1853–58, New York), **107**
Ostade, Adriaen van (1610–85, Haarlem), 506
Ostendorfer, Michael (ab. 1490–1559, Regensburg), **446**
Oudry, Jean-Baptiste (1688–1755, Paris), 98, 540
Ovid, 231, 232

Pacioli, Luca (ab. 1445–1509, Borgo San Lorenzo, Venice, Perugia, Zara), **169**, 174
Palladio, Andrea (1508–80, Vicenza, Rome, Venice), 240
Palmer, Samuel (1805–81, Shoreham, Reigate), 611
panoramas, 572, 643
pantograph, 103, 292
paper, 1, 227, 531, 635, 636
paper relief (seal print), 19
Paris
    18th c. books, 562, 565
    15th c. books, 51–55
    prayer books, 247–251
Parmigiano (Francesco Mazzuoli) (1503/4–40, Parma, Rome), 350–353, 355, 360
Passarini, Filippo (ab. 1638–98, Rome), **391**
Pasti, Matteo de (w. 1441–67, Venice, Constantinople, Rimini), 147
pattern books, 377–381
Pèlerin, Jean (Viator) (ab. 1440–1523, Italy, Toul), 176
Pellipario, Nicola (w. 1525–42, Castel Durante, Urbino), **232**
Penni, Luca (d. 1556, Genoa, Lucca, Fontainebleau), **246**
*Penny Magazine, The* (1832–45), 638
Perelle, Gabriel (ab. 1603–77, Orleans, Paris), **364**
Perkins, Jacob (1766–1849, Newburyport, Philadelphia, London), 635
personifications, 231–235
perspective, 173–517
Peruzzi Baldassare (1481–1536, Siena, Rome, Bologna), 63, 64
Petrarch (1304–74), 147–150, 313
Pfister, Albrecht (w. 1460s, Bamberg), 27
Philipon, Charles (1800–62, Lyons, Paris), 200, 659
photography, 372, 653–658, 683
photogravure (Ger. *Photogravüre*; Fr. *héliogravure*), 657
physionotrace, 292
Piazzetta, Giovanni Battista (1682–1754, Venice), 323, 564, **579**

Picasso, Pablo Ruiz y (1881– , Spain, France), 634, 639, 731–741
Pictor, Bernard (w. 1476, Germany?, Venice), 211
Piero della Francesca (ab. 1416–92, central Italy), 319, 361
Pigouchet, Philippe (w. ab. 1488–1515, Paris), 249
Piranesi, Giovanni Battista (1720–78, Venice, Rome), 371, 542, 579, 582–584
Pisanello (Antonio Pisano) (ab. 1395–1455?), 96
Pitteri, Giovanni Marco (1703–86, Venice), 579
Plantin-Moretus Press, 252, 428, 429
playing cards, 14–16, 18, 116
Pleydenwurff, Wilhelm (d. 1494, Nuremburg), 44
Ploos van Amstel, Cornelis (1765–87, Amsterdam), 346
Pollaiuolo, Antonio (1432–98, Florence), 184–186
Pollock, Jackson (1912–56, New York), **751**
portraiture, 282–292, 299, 433, 434, 472–478, 729, 730
Posada, José Guadalupe (1857–1913, Mexico), 652
postage stamps, 635
posters, 640–642, 709
Potter, Paul (1625–54, Amsterdam), 257, 507
prayer books, 84, 182, 183, 247–252
Primaticcio, Francesco (1504–70, Bologna, Mantua, Fontainebleau), 355
printer's mark (Ger. *Druckermarke*; Fr. *marque d'imprimeur*), **26**, 28, 29
printing. *See also* color printing
    on china, 575
    on cloth, 5, 6, 574
    earliest, 2, 3
    steam press, 638
Prud'hon, Pierre-Paul (1758–1823, Paris), 601
Pugin, Augustus (1762–1832, Normandy, London), 604
*Punch* (1841– ), 638, 691

Raphael (1483–1520, Urbino, Florence, Rome), 244, 337–339, 347, 473, 491, 580
Ratdolt, Erhard (1462–1518, Augsburg, Venice), 74–76, 211
Redon, Odilon (1840–1916, Paris), 679
relief etching (Ger. *Hochätzung*; Fr. *gravure à l'eau-forte en relief*), 609
Rembrandt Harmensz. van Rijn (1606–69, Leiden, Amsterdam), 443, 444, 472–505
Reni, Guido (1575–1642, Bologna, Rome), 133, 410, 517
Renoir, Auguste (1841–1919, Paris), 718
Repton, Humphry (1752–1818, Bury St. Edmunds, Aylsham, Ireland, Essex), 532
Reuscher, Jan (w. 1650s, Holland), **503**
Reuwich, Erhard (Housebook Master?), (w. ab. 1475–1500, Utrecht, Mainz), 22, 43, 101, 124, 212
Réveillon, Jean-Baptiste (1725–1811, Paris), 571
Revett, Nicolas. *See* Stuart, James
Reynolds, Sir Joshua (1723–92, London), 513
Reynolds, Samuel William (1773–1835, London), **513**

Ribera, José (1588–1652, Valencia, Naples), 522, 523

Ricci, Matteo, S. J. (1552–1610, Rome, China), 694

Richter, Ludwig (1803–84, Dresden), 451

Riessinger, Sixtus (w. 1468–83, Strassburg, Naples, Rome), **67, 68**

Ripa, Cesare (w. ab. 1600, Perugia), 235, 236

Robetta, Cristofano (1462–1522, Florence), 146

Rodin, Auguste (1840–1917, Paris), 716, 717

Rome
  15th c. book illustration, 66–68
  guide books, 367
  map production, 179
  printmaking, 580
  views of, 368–373

Rosa, Salvator (1613–73, Naples), 524, 525

Rosselli, Francesco (1448–bef. 1513, Florence), **173**

Rossetti, Dante Gabriel (1828–82, London), 689

Rosso Fiorentino (Giovanni Battista di Jacopo di Guasparre) (1494–1540, Florence, Rome, Fontainebleau), 341, 356, 357

Rota, Martino (ab. 1520–83, Sebenico, Florence, Rome, Vienna), 181

Rowlandson, Thomas (1757–1827, London, Paris), 204, 602–605

Rubens, Peter Paul (1577–1640, Antwerp, Italy, Madrid, London), 256, 412, 427–432

Ruisdael, Jacob Isaac (1629–82, Haarlem, Amsterdam), 508

Rupert, Prince, Count Palatine (1619–82, Prague, Amsterdam, Germany, London, France), 512

Saint-Aubin, Augustin de (1736–1807, Paris), **291, 593, 635**

Saint-Aubin, Charles-Germain de (1721–86, Paris), 90, 592, 593

Saint-Aubin, Gabriel-Jacques de (1724–80, Paris), 594

Saint-Mémin, Charles-Balthazar-Jean Fevret de 1770–1852, Dijon, United States), 292

Sanctis, Hieronymus de (w. ab. 1478–94, Venice), 250

Santurini, Francesco (1627–82, Venice, Munich), **547**

Savonarola, Girolamo (1452–98, Ferrara, Florence), 157, 158

Schedel, Hartmann (1440–1514, Nuremberg), 44, 173, **383**

Schinkel, Karl Friedrich (1781–1841, Berlin), 549

Schlaffer, Hans (w. 1475–1500, Ulm), **8**

Schoeffer, Peter (1457–1502, Paris, Mainz), 26, 101

Schön, Erhard (1491?–1542, Nuremberg), 319

Schongauer, Ludwig (b. 1440–94, Ulm, Augsburg, Colmar), 36

Schongauer, Martin (b. 1445–91, Colmar), 21, **35,** 36, 118, 130–133

Schübler, Johann Jacob (1689–1741, Nuremberg), **539**

Scolari, Giuseppe (w. ab. 1580, Vicenza), 402

seal print (Ger. *Siegeldruck*). *See* paper relief

Seghers, Hercules (ab. 1590–ab. 1645, Haarlem, Amsterdam), 443, 444, 471, 472, 503

Senefelder, Alois (1771–1834, Munich, Paris, London), 612

Serlio, Sebastiano (1475–1554, Venice, Fontainebleau), 238, **544**

Shahn, Ben (1898–1969, Russia, New York, New Jersey), **748**

Siegen, Ludwig von (1609–a. 1676, Utrecht, Kassel, Amsterdam, Regensburg, Mainz), 511

silk screen (Ger. *Siebdruck;* Fr. *sérigraphie*), 748

silverware designs, 308, 309, 357, 556, 557

soft-ground etching (Ger. *der weiche Grund;* Fr. *vernis mou*), 595, 607

Solario, Andrea (w. 1495–1522, Venice, Milan), 217

Southworth, Albert Sands (1811–94, Boston), and Hawes, Josiah Johnson (1808–1901, Boston), **653**

*Spechio de Anima*, **216**

*Speculum Humanae Salvationis (Mirror of Man's Salvation)*, 33, 34

*Sphaera Mundi*, **75**

*Spiegel der Menschen Behaltniss, Der. See Mirror of Man's Salvation*

sporting prints, 602

Spranger, Bartholomeus (1546–1611, Antwerp, Italy, Prague), 418

Stabius, Johannes (d. 1522, Nuremberg), 181

stage scenery, 544–549

stencil (Ger. *Schablone;* Fr. *pochoir*), 51, 65, 80

Stephen of Calcar. *See* Calcar, John Stephen of

Stieglitz, Alfred (1864–1946, New York), 655

Stimmer, Tobias (1539–82, Schaffhausen), 412

stipple engraving (Ger. *Gepunktiermanier;* Fr. *manière du crayon*), 225, 226

Stothard, Thomas (1755–1834, London), **637**

street criers, 201–205

Strixner, Johann Nepomuk (1782–1855, Munich), **615**

Stuart, James, and Revett, Nicolas, 242

*Supplementum Chronicarum*, **42**

Sweynheym, Conrad (w. ab. 1464–77, Mainz, Subiaco, Rome), 179

Syrlin, Jörg (d. 1491, Ulm), 94

Szczodrowski, J. (w. 19th c., Russia), **205**

Talbot, William Henry Fox (1800–77, London), 372, **654**

"taroc cards of Mantegna," 16, 17

Temple of Vespasian, Rome, 220

Teniers, David, Jr. (1610–90, Holland, Vienna), 534

Tenniel, Sir John (1820–1914, London), 344, **691**

Tennyson, Alfred Lord (1809–92), 210, 689

Terence, *Comedies*, 32, 39

Testa, Pietro (1611–50, Rome), 519

textiles, printed, 5, 6, 574

Thiry, Leonard (d. ab. 1550, Antwerp, Fontainebleau), 354

Tiepolo, Giovanni Battista (1696–1779, Venice, Würzburg, Madrid), **578,** 581, 598, 624, 682

Tiepolo, Giovanni Domenico (1726–1802, Venice, Madrid), 577, 578
Titian (Tiziano Vecellio) (1477–1576, Venice), 199, 395, 403–406, 408, **474**
title page, 211, 213, 324, 428, 429
tone block, 77, 78
Tory, Geoffroy (1480–1533, Paris, Italy), 182, 251
Toulouse-Lautrec, Comte Henri-Marie-Raymond de (1864–1901, Albi, Paris), 708, 709
Tozzi, Pietro Paolo (w. b. 1596–1626, Rome, Padua), 379
Trollope, Anthony (1815–82), 690
Trouvain, Antoine (1656–1708, Paris), **463**
Turner, Joseph Mallord William (1775–1851, London, Europe), 644, 645
Turrecremata, Johannes de (1388–1468): *Meditationes*, 58–60

Uccello, Paolo (ab. 1396–1475, Florence), 160, 319
Ugo da Carpi (ab. 1450–ab. 1525, Venice, Rome), 347, 492
Ulm, illustrated books of, 35–37
Utamaro (1754–97, Edo), 688, 697

Valturius Robertus, 104
Van Dyck, Sir Anthony (1599–1641, Genoa, Antwerp, London), **346**, 433, 434
Vasari, Giorgio (1511–74, Arezzo, Rome), 130, 152, 287, 321, 344, 399
Vecellio, Cesare (ab. 1521–1601, Venice), 387
Velázquez, Diego Rodriguez de Silva y (1599–1660, Seville, Madrid, Rome), 288, 624
Velde, Jan van de (1642–86, Amsterdam), 229
Velde, Jan van de, II (ab. 1593–1641, Rotterdam, Haarlem), 470
Veneziano, Agostino (Agostino de' Musi) (1490?–1540?, Venice, Rome), 342
Venice
    book illustration, 211, 218, 563, 564
    life in, 387
    prayer books, 250
    print making, 576–579
    views of, 40–46
Vérard, Antoine (1485–1513, Paris), 53, 55, 248
Vermeyen, Jan (1500–59, Haarlem, Spain, Tunis, Brussels), 467
Verrocchio, Andrea (1436–88, Florence, Rome, Venice), **163**, 270
Vesalius, Andreas (1514–64, Flanders, Paris, Padua), 394–396
Vico, Enea (1523–67, Parma, Rome, Florence, Venice, Ferrara), **385**
Vierge, Daniel Urrabieta (1851–1904, Madrid, Paris), 706
Vignola, Giacomo Barozzi da (1507–1573, Rome), 177, 239

Villamena, Francesco (w. 1590–1622, Rome), 409
Villon, Jacques (Gaston Duchamp) (1875–1963, Paris), 723, 724
Virgil, **56, 57**, 610, 611
Visentini, Antonio (1688–1782, Venice), **46**
Vitruvius, 237, 243
Vogtherr, Heinrich, I (1490–1550, Strassburg, Augsburg, Zürich, Vienna), 320
Vollard, Ambroise (1867–1939, Paris), 720–722
Vredeman de Vries, Jan (1527–a. 1604, Antwerp), 390
Vuillard, Edouard (1868–1940, Paris), **466**, 720

Wachsmuth, Jeremias (1711–71, Augsburg), **567**
wallpaper, 569–573
Wang Kai and brothers (w. 1680–1705, Nanking), **694**
watermark (Ger. *Wasserzeichen*; Fr. *filigrane*), 1
Watteau, Antoine (1684–1721, Valenciennes, Paris), 585–587
Wefring, Basilius (w. 1550s, Basel), **105**
Weiditz, Hans (b. 1500 w. till 1536, Strassburg, Augsburg), 102, 313, 314
West, Benjamin (1738–1820, Philadelphia, Rome, London), 612
Weyden, Rogier van der (1399?–1464, Brussels), 47, 130
Whistler, James Abbott MacNeil (1834–1903, Baltimore, Paris, London), **435**, 702–704, **715**
Wolgemut, Michael (1434–1519, Nuremberg), 44
woodcut (Ger. *Holzschnitt*; Fr. *gravure sur bois*). *See also* chiaroscuro woodcut; color woodcut
    architecture and, 72, 73
    composite, 30, 31
    copyist's technique, 24, 41, 42
    cutters' distortions, 38, 39
    cutters' and designers' pay, 50
    earliest, 4–10
    limitations of, 227
    national styles, 47–50, 70–72
    supplanted by wood engraving, 636
    yields to copperplate, 103, 179, 411
wood engraving (Ger. *Holzstich*; Fr. *gravure sur bois debout*), 636–639
Works Progress Administration (WPA), 748
Wright, Joseph (1734–97, Derby), 514

Zainer, Günther (w. 1468–78, Reutlingen, Strassburg, Augsburg), 33, 34
Zainer, Johann (w. 1473–1500, Reutlingen, Strassburg, Ulm), 36, 94
Zoan Andrea (w. ab. 1475–1500, Mantua, Milan?), 188, 189, **244**
Zorn, Anders (1860–1920, Sweden, Europe, United States), 713